A National Joke

THE UNIVERSITY OF
WINCHESTER

Comedy is crucial to how the English see themselves. This book considers that proposition through a series of studies of popular English comedies and comedians in the twentieth century, ranging from seaside postcards to the work of Mike Leigh and contemporary sitcoms such as *The Royle Family*, and from George Formby to Alan Bennett and Roy 'Chubby' Brown.

Relating comic traditions to questions of class, gender, sexuality and geography, *A National Joke* looks at how comedy is a cultural thermometer, taking the temperature of its times, why vulgarity has always delighted English audiences, why camp is such a strong thread in English humour, why class conditions what we laugh at and why comedy has been so neglected in most theoretical writing about cultural identity. Part history and part polemic, it argues that the English urgently need to reflect on who they are, who they have been and who they might become, and insists that comedy offers a particularly illuminating location for undertaking those reflections.

Andy Medhurst works in the Department of Media and Film at the University of Sussex. He has been teaching and writing about issues of identity, representation and popular culture since 1980. He is the co-editor of *Lesbian and Gay Studies* and the author of a forthcoming book on *Coronation Street*.

A National Joke

Popular comedy and English cultural identities

Andy Medhurst

Routledge
Taylor & Francis Group

LONDON AND NEW YORK

First published 2007
by Routledge
2 Park Square, Milton Park, Abingdon, Oxon, OX14 4RN

Simultaneously published in the USA and Canada
by Routledge
711 Third Avenue, New York, NY 10017

Routledge is an imprint of the Taylor & Francis Group, and informa business

Transferred to Digital Printing 2011

© 2007 Andy Medhurst

Typeset in Bembo by Keyword Group Ltd

British Library Cataloguing in Publication Data
A catalogue record for this book is available from the British Library

Library of Congress Cataloging in Publication Data
Medhurst, Andy.
A national joke: popular comedy and English cultural identities/Andy Medhurst.
 p. cm.
Includes bibliographical references.
 1. Comedy films–Great Britain–History and criticism. 2. Television comedies–Great Britain–History and criticism. 3. English wit and humor–History and criticism. 4. National characteristics, English.
I. Title.
 PN1995.9.C55M44 2007
 791.43'6170941–dc22 2007011485

ISBN 10: 0-415-16877-5 (hbk)
ISBN 10: 0-415-16878-3 (pbk)

ISBN 13: 978-0-415-16877-9 (hbk)
ISBN 13: 978-0-415-16878-6 (pbk)

For Mum and Dad

Contents

List of figures ix
Acknowledgements x

1 Introduction 1

2 Concerning comedy 9

3 Notions of nation 26

4 Englishnesses 39

5 Music hall: Contours and legacies 63

6 Our gracious queens: English comedy's effeminate
 tradition 87

7 Lads in love: Gender and togetherness in the male
 double act 111

8 Thirty nibbles at the same cherry: Why the
 'Carry Ons' carry on 128

9 Bermuda my arse: Class, culture and 'The Royle Family' 144

10 Anatomising England: Alan Bennett, Mike Leigh,
 Victoria Wood 159

11 Togetherness through offensiveness: The importance of
 Roy 'Chubby' Brown 187

12 Conclusion: A national sense of humour? 204

 Bibliography 210
 Index 226

Figures

5.1 George Formby in *Much Too Shy*, directed by Marcel Varnel,
 1942. Courtesy of Gainsborough/The Kobal Collection 75
6.1 Frankie Howerd in *Up Pompeii*, directed by Bob Kellett,
 1971. Courtesy of Associated London/MGM-EMI/The
 Kobal Collection 97
8.1 Kenneth Williams in *Carry on Regardless*, directed by
 Gerald Thomas, 1961. Courtesy of G.H.W/Anglo
 Amalgamated/The Kobal Collection 133
10.1 Alison Steadman, Mike Leigh and Roger Sloman, 1976.
 Courtesy of The Kobal Collection 176

Acknowledgements

As this is a book I have been threatening to finish for a very long time, the list of people I need to thank is lengthy.

For all kinds of support and input at different stages, in many cases before and beyond this particular project, many thanks to these friends, mentors, role models and co-conspirators (a free gift to anyone who can put each name in the correct category, the catch being that many need to be in several): Maggie Andrews, Charles Barr, Caroline Bassett, Gill Branston, Charlotte Brunsdon, Jim Cook, Jonathan Dollimore, Richard Dyer, Christine Geraghty, Geoff Hemstedt, Val Hill, Maurice Howard, Alun Howkins, John Jacobs, Carol Jenks, Carol Kedward, Joanne Lacey, Kate Lacey, Stuart Laing, Terry Lovell, Carole Martin, Mandy Merck, David Alan Mellor, Linda Merricks, Margaret O'Brien, Judy O'Day, Marc O'Day (Clive to my Derek and/or Derek to my Clive), Bill Osgerby, Mandy Quick, Vincent Quinn, Brian Short, Roger Silverstone, Alan Sinfield, Roy Stafford, Yvonne Tasker, Graham Walker, Eddy Waller, Roger Whittaker, Janice Winship, Nancy Wood, Shiona Wood and Eileen Yeo. They're not all here any more, which is the saddest thing I have to write in this book about comedy.

Many of the themes, arguments and issues discussed here were road-tested, with instructively different degrees of success, in lectures, talks, classes and papers given at Bolton Institute, Bradford Film Theatre, Brighton Museum, the University of Brighton, Bristol Watershed, the British Film Institute, Buckinghamshire Chilterns University College, the University of Cardiff, Chichester Institute, Cinema City Norwich, Cumbria College of Art and Design, the University of East London, Edinburgh Filmhouse, Glasgow Film Theatre, Goldsmiths' College, Hull Film Theatre, Leicester Phoenix, Leeds Metropolitan University, the London School of Economics, Middlesex University, the Museum of the Moving Image, the National Film Theatre, the University of Portsmouth, Queens' University Belfast, the University of Southampton, the University of Sunderland, the University of Surrey Roehampton, Sussex University, Tate Britain, Tyneside Cinema and the University of Warwick. Thanks to those who invited me to speak and those

who responded constructively and/or provocatively, in particular John Airlie, Nanette Aldred, José Arroyo, Brian Bates, Cary Bazalgette, Anita Biressi, Stephen Bourne, Sandy Brewer (and her wonderful Class class at UEL), John Caughie, Ian Christie, Kim Clancy, Liam Connell, Barry Curtis, Helen De Witt, Terry Diffey, Mary Eagleton, Carol Anne Farquhar, Lilie Ferrari, Alan Finlayson, Frank Gray, Helen Grundy, Sue Habeshaw, Nick Haeffner, Gary Hall, Mike Hammond, Sue Harper, John Hartley, Claire Hemmings, Dave Hesmondhalgh, Leon Hunt, Michael Jamieson, Pat Kirkham, Marysia Lachowicz, Vicky Lebeau, Steve Mardi, Bill Marshall, Melinda Mash, Colin McArthur, Leslie Moran, Laura Mulvey, Steve Neale, Nicky North, Margaret O'Connor, Ken Page, Roberta Pearson, Tessa Perkins, Lance Petitt, Duncan Petrie, Deborah Phillips, Laraine Porter, Mike Ribbans, Jeffrey Richards, Martin Ryle, Emma Sandon, Bill Schwarz, Beverley Skeggs, Janet Thumim, Alan Tomlinson, Lisa Tsaliki, Clare Tylee, Carol Walker, George Walter, Judith Williamson and Simon Wortham. I am indebted to Philip Dodd, Pam Cook, Nick James, Leslie Felperin and Ed Lawrenson for offering me space, licence and encouragement to think about comedy and/or Englishness in the pages of *Sight and Sound* (some material first published there is reworked here) – and thanks also to Peter Burton, Chris Granlund, Charlotte Raven, James Saynor and Lucy Tuck for giving me elbow room, thinking time and style-honing opportunities in other publications.

There are many former students of mine whose insights into cultural politics more broadly, or comedy specifically, have helped me to test and reflect on mine, especially Kavita Amarnani, Salome Asatiani, Graham Barnfield, Michelle Bava, Adrian Brooks, Paul Burnand, Jane Carr, Lynette Carr, Paul Carr, Christine Clegg, Daniel Cuzner, Nick Danagher, Glyn Davis, Chris Derbyshire, Kay Dickinson, Rob Evans, Morwenna Farwagi, Ben Gove, Angela Gover, Paula Graham, Edwina Griffith, Arwa Haider, Jamie Hakim, Chris Hale, Lisa Harkins, Nicky Harper, Murray Healy, Paula Hinks, Anne Hole, Ian Huffer, Sharna Jackson, Irmgard Karl, Julie Kear, Chris Kelleher, Ewan Kirkland, Marcy Krich, Tom Lacey, Sue Lapwood, Sarah Lee, Kate Leys, Gita Malhotra, Sarita Malik, Darren Marks, Karen Morden, Helene Mulholland, Sanja Muzaferija, Katie Myerscough, Julie Nalletamby, Sam Noonan, Liz Pearce, Claudette Purville, Julius Renn-Jennings, Hannah Richards, Lucy Robinson, Peter Robinson, Hannah Sale, Andy Simmonds, Anna Snowman, Lucy Stone, Stephen Troussé, Charlotte Tucker, Imogen Tutt, Martin Warren, Sarina Woograsingh and Martin Wyatt. Sharif Mowlabocus belongs in that list but deserves elevation to de-alphabetised singularity (get the madam) for cerebral and practical help beyond the call of duty, not least his ability to mobilise the indefatigable Bunty.

The School of Cultural and Community Studies (RIP) at the University of Sussex contributed to this book in two ways – pragmatically by granting me two periods of study leave and profoundly by offering an intellectual environment which took it as read that most conventional academic demarcation lines were

obstacles to genuine intellectual progress. Thanks to all (well, almost all) CCS colleagues, long since evicted by the bulldozers of restructuring. In a newer ecosystem, I'm grateful to Sue Thornham of the Department of Media and Film at Sussex for wangling me just, to quote the fourth-best single of 1970, a little more time. The University of Sussex Library and the National Sound Archive at the British Library resourcefully located recalcitrant texts. Steven Arnold generously made available some Kenneth Williams obscurities, Phil Whickham altruistically sought out some *Royle Family* material, Kevin Orford speeded my search for Hylda Baker, David Matless proved that flattery pays dividends, Laura Marcus clarified some points about proper culture, and Paul Baker did likewise about a decidedly improper culture. Many staff at Routledge have shown considerable forbearance in waiting for this book's completion – saddling up for various furlongs were Rebecca Barden, Christopher Cudmore, Lesley Riddle, Aileen Irwin and Charlotte Wood

Many tried their best to stop me writing – Sita and Karen and Cher, Vanessa's usurper, the thankful checkout queen, Brendan's bickering brood (forza Pasquale!), the Pinball Swedes, the redhead's victims, Lucy and her zoo pals, the pig/duck/bull combo, the inmates of the Blue Room, the denizens of the Doll House (Scarlett was robbed), the unfortunately scheduled flettics, el guapo Sr Vasquez, the adenoidal porcine princess, the dogfish panorama, the view of Pahchachrispanh, the road to Maggieknockater, the return of the West Midlands repressed, Serena and her underlings, the Oedipal exemplars of Long Island, the former Worthing pizza-packer overseeing the unprepared of Estepona and the muffin-munching population of Auckland's premier health care facility – but to no eventual avail.

This book, like everything I do, owes most of all to three people: to my parents Kath and Len for all their love, belief, videotapes and unflagging support (and for only asking 'is it finished yet?' about one-tenth of the times they really wanted to); and to Phil Ulyatt, my other half, for time spent with Pam Doove and the Viking Spike, for living through all the ups and downs of tapping and knowing exactly when to call the wappy police, and for continually being, as the song says, something wonderful.

Chapter 1

Introduction

It is the job of the popular cultural historian to chart a map of pleasure, to discriminate between different types and to show continuities and innovations.

(Harper 1992: 101)

[C]omedy is ideology in motley

(Samuel 1998: 209)

Being English used to be so easy.

(Paxman 1998: ix)

This book is an attempt to negotiate the spaces between and around those three quotations. It aims to draw a map of certain trends and traditions in English popular comedy during the twentieth century, paying as equal attention as is feasible to their pleasures and their politics. The need to draw such a map stems from my conviction that comedy plays an absolutely pivotal role in the construction of cultural identity, and a consequent belief that English comedy widely acclaimed by English audiences contributes significantly to how English culture has imagined its Englishness. Such a statement inevitably raises several fraught and contentious questions, and since they are questions that hover over this book like baleful vultures, it might be as well to air them here and now. Doesn't analysing comedy destroy its pleasures? Doesn't most academic writing about comedy occupy a quicksand zone made up of regrettable jargon and solemn pomposity? Can a study of the politics of comedy prevent itself from becoming a humourless harangue? What is at stake in writing about England rather than Britain? How can an account of national identity avoid endorsing nationalistic politics? Don't accounts of Englishness risk flirting with racism? Haven't the forces and trajectories of globalisation made the idea of national identity irrelevant? How can anything intelligent or useful be derived from a study of Roy 'Chubby' Brown? Feel free, dear reader, to add others to the list.

Answers (including partial, evasive or tendentious ones) to those questions can be found in the chapters that follow. What I want to do in this introduction is to reflect briefly on the book's sensibility and approach. Three declarations (or warnings) are in order. The first point to stress is that I have not been able, or willing, to stay within the docile parameters of one academic discipline. My arguments draw on a reckless promiscuity of paradigms, poaching shamelessly from cultural studies (itself already a hybrid field), media studies (ditto), film theory, literary criticism, social history, cultural history, sociology, politics, anthropology, art history, cultural geography, theatre studies, linguistics, philosophy, social and even experimental psychology. Not all of those fields are treated respectfully or equitably, and my decision to stir-fry together so many disparately flavoursome ingredients may upset delicate stomachs used to more palatable menus. Needless to say, the rich variety of my ignorances in many of those areas will be all too apparent to specialists in each, but none could be omitted if I had the remotest hope of conveying the complexity of the topic. Secondly, this is not a book that worships at a single, undefiled theoretical altar, it is not in thrall to any one academic or conceptual 'ism', for the simple reason that signing up to just one of those clubs seems to me to guarantee a short-sighted tunnel vision. Thirdly, many of the sources I have raided lie outside the parameters of academic writing altogether – journalism, reviews, reportage, autobiographies, memoirs, anecdotes, interviews and other assorted writings that pay no attention to those zealous rubrics of footnoting and citation which we academics are obliged to use to shackle our thoughts. Such texts may be flagrantly unreliable in terms of testable hypotheses or verifiable truth, but they yield wonderful insights in terms of flavour and feel – and if the words 'flavour' and 'feel' set alarm bells ringing in any readers' heads, this might be the moment to suggest they put this book back on the shelves and turn instead to something more trustworthy. In short, I have made no special investment in any particular methodology, but then I have often felt that methodology (such a soul-shrivelling word) is the last refuge of the imaginatively challenged. This is a jackdaw book – but fittingly so, I think, because comedy is a jackdaw subject. J.S. Bratton once lamented that the Victorian music hall was a seductive but difficult topic to analyse on account of its 'kaleidoscopic, self-reflexive, endlessly slippery surfaces' (1986: xiii), and her words can be extended to refer to the whole comic field. If writing this book has taught me anything, it is the awareness that no single intellectual viewpoint can hope to account for the complexities of comedy, so I have made use of what will seem to some an irresponsibly broad frame of references. Emblematic of this might be the fact that at one time, as I assembled my working bibliography, the serendipities of alphabetisation placed Larry Grayson, once the most (unjustly) disreputable and vilified of English queer comedians, next to Stuart Hall, the individual customarily (and accurately) lauded as the single most influential voice in the development of the field of cultural studies. Sadly, later entries to the bibliography drove Larry and Stuart apart, but in some ways this book remains an

attempt to eavesdrop on the conversation they might have had if they had been left side by side.

One reason for reaching, where appropriate, past the parched soil of academic writing to the lusher territories beyond is that the longer I looked at popular comedy, the importance of performance loomed ever larger. Treating a joke or a larger comic exchange purely as a verbal text, which is how the vast majority of academic studies of humour tend to proceed, can only ever tell some of the story. Consider this exchange between Les Dawson and Roy Barraclough, in drag in their Cissie and Ada personas, two Northern housewives whose friendship survives the nuanced class differences between them. They are on holiday in Greece, and the pretentiously pseudo-refined Cissie (Barraclough) is asking the robustly corporeal Ada (Dawson) about her culinary and cultural consumption during the trip:

Cissie: Have you had the shish kebabs?
Ada: Since the moment we arrived.
Cissie: Have you been to the Acropolis?
Ada: I've never been off it.

An account of this based purely on its words would undeniably be able to point out the drift of the humour – the linguistic play that relishes turning respectable conversation into mischievous innuendo, the marking out of cultural differ- ence between English and Greek cultures (and between class fractions within Englishness), the carnivalesque cunning that takes an iconic edifice of Western high culture and recasts it as a receptacle for excrement, and so on. Yet to see and hear the sketch rather than just read its dialogue is to uncover so much more, from the governing ridiculousness of the sight of two portly men in chain-store drag, via the outlandish facial contortions and bodily adjustments that accompany every syllable, to the brilliant rapidity of the delivery (there is only a fragment of a second between Cissie's questions and Ada's answers). Performative skill can weave spells from even smaller units of 'text', mining comic gold from the tiniest of territories, so that an unexceptional single word, or even part of a word, can become a memorable comic moment if the per- formance is bold, crafty and precise enough. Listen to how the simple syllable 'Dave' becomes drenched in daringly sinister comic menace when uttered by the character Papa Lazarou in that most extraordinary of recent English televi- sion comedies, *The League of Gentlemen*, note how Maggie Smith, that peerless comic actress, can detonate comic explosions with nothing more than what one critic astutely called her 'loaded coloration of vowel sounds' (Coveney 1992: 159), and remember how, for decades, Frankie Howerd's whole career rested on the inflections wrung from non-words, half-words, stranded words, noises, interjections and pauses – 'ooh … ah … no … listen …'.

Clearly, comedy on film, stage, television or radio is never merely a matter of words on a page, a fact which poses huge problems for any attempt (this book

included) to pin down comic meaning in a purely written medium. Michael Mulkay's book *On Humour* is a fascinating study of certain philosophical aspects of comedy, yet it contains the following words in its chapter on television sitcoms:

> I have at my disposal the scripts of the twenty-one episodes of *Yes, Minister* which have been revised and published in the form of a 'political diary' … This text is particularly helpful because, in transferring *Yes, Minister* from the screen to the printed page, the authors have been led to describe explicitly much that was left implicit in the television presentation or that was conveyed indirectly through the mannerisms, phrasing and deportment of the actors
>
> (Mulkay 1988: 187).

What is so notable here is Mulkay's misplaced faith that after-the-event annotations can account for indispensable elements in the comedic achievement of the series, elements which he dismisses, with a rather touching quaintness, as 'the television presentation' or the 'mannerisms, phrasing and deportment of the actors'. He goes on to produce a plausible and stimulating reading of the text at his disposal, but that text is not *Yes, Minister*, only a reduced, partial off-shoot from it, partial for the simple reason that *Yes, Minister*, like all performed comedy, is a text where 'presentation' and 'deportment' are vital threads in the overall web of meanings. Comedy is never only textual – it is performed, enacted, an event, a transaction, lived out in a shared moment by its producers and consumers. J.S. Bratton is once again helpful here, in her account of the comic songs of music hall:

> Since humour … is a powerful element in the music-hall style, nothing was fixed or inevitable in any performance or response. Tone, and therefore meaning, would depend not only on the song, the rest of the act, the previous turn and those expected to appear later, but also on the status and customs of the hall, the day of the week, and the mix and mood of each individual audience.
>
> (Bratton 1986: xi–xii)

Little wonder, then, that conventional textual analysis, let alone philosophical musing over the printed word, has a hard time trying to explicate 'tone, and therefore meaning' in comic performance (audience response is a further can of even more wriggling worms). Raphael Samuel once noted how reluctant historians were to let go of the familiarity of the written word as a trustworthy source, remaining fearful of taking the risky plunge into analysing images, pictures, the spoken word, symbols of various kinds: 'Books from an early age are our bosom companions … giving a talismanic importance to manuscripts' (1994: 269). Yet until we wean ourselves off the comforting bosom of the

printed word, the teat of conventional text, we can never hope to make sense of comedy's multi-faceted operations. Sizeable, and often crucial, amounts of comedic meanings reside in inflection, timing, nuance, gesture, the balance of sound and silence, the unexpected or wilful pronunciation of key words, the raising of eyebrows or the flipping of wrists. Consequently, it is often necessary to turn to first-hand accounts of such performances, to journalistic accounts unencumbered by that academic baggage which manifests itself as the rigmarole of protocol. To read Kenneth Tynan (1990: 12–15) on Sid Field or Michael Billington (1977 passim) on Ken Dodd is to find not just invaluable clues as to how performance skills strengthen comic impact but also flesh-and-blood testaments to the power of comedy which have no parallel in the worthier, more desiccated zones of officially intellectual analysis. Thus I have attempted where appropriate to supply my own detailed accounts of particular performances, since in many of the comedies I am concerned with here, the content and implication of the humour is utterly inseparable from its mode of delivery.

Evocations of performance are also important inasmuch as they allow the pleasure of comedy to retain its rightful centrality. Popular comedy matters as much as it does because it delights as much as it does – if it did not thrill large audiences into grateful devotion its ideological implications would be of little concern to those of us who study popular culture – but that delight can be the first casualty once comedy undergoes analysis. To many people, any critical study of popular texts risks ruining their pleasure, but comedy is seen as both especially undeserving of such treatment and especially unlikely to survive the attack. The analyst of comedy is the definitive killjoy, literally so: the assassin of enjoyment, who takes what was life-affirming and renders it inert, or the slaughterer of laughter, hauling the still-warm body of comedy into the ana-lytical abattoir before felling it with the deadening blows of uber-scrutiny and eviscerating it with the scalpels of hyper-analysis. 'Humour can be dissected', wrote E.B. White, 'as a frog can, but the thing dies in the process and the innards are discouraging to any but the pure scientific mind' (quoted in Bergan 1989: 35). While it should be painfully clear by now that I am not the owner of a pure scientific mind (not that any kind of pure mind has much hope of grasping the essential *im*purity of comedy), White's barb is one I have tried to keep in my head as a warning. I love comedy too much to want to nullify its joyfulness, but at the same time I am too aware of its cultural power to absolve it from exploratory inspection, so I have tried to use only local anaesthetic on my frogs while subjecting them to some fairly stringent keyhole surgery. Sometimes, however, the frog still fails to recover. This may be a cause not for regret but for celebration. Some jokes and comic scenarios are so freighted with reprehensible attitudes that destroying their efficacy through analysis seems like a mercy killing. To say that, however, is not to claim that comedy analysis is some sort of ideological purifying agent, scouring away dodgy gags in the service of the greater good. Comedy is too devious, too multiple, too wily ever

to be susceptible to such a naive approach. Plenty of racist, sexist, homophobic and otherwise despicable jokes are, in formal terms, brilliantly successful. What comedy analysis can expose, however, is the weakness of thin, inadequate, poorly structured comedy. If frogs of that ilk expire on the operating table, it suggests that they were pretty feeble frogs to begin with, however much the laughter of their fans attempts continual resuscitation. I have grown increasingly convinced that knowing how comedy works, understanding its internal conventions, its performative dimensions and its ideological implications, causes no harm to its pleasurability unless the comedy under scrutiny was flawed from the outset. Though I don't have the space to develop this speculation fully, it seems to me that one key index of the power of any comic text, performance or moment is its ability to withstand analysis and emerge not only still funny, but actually funnier for being better understood. Weak comedy, lazy comedy, over-hyped and merely modish comedy (*Absolutely Fabulous*, say, or anything involving Steve Coogan or Armando Iannucci) may buckle and crumble under sustained study. Yet if I think of some of the funniest things studied during the process of writing this book – a list which might include the third series of *Round the Horne*, the first series of *Whatever Happened to the Likely Lads?* and the second series of *dinnerladies*, the way Brenda Blethyn says 'Mind my kidneys, Mandy' in *Grown-Ups* and the soldiers' dance at the beginning of *Demobbed*, Maggie Smith's interweaving of primness and steel in *A Private Function* and Kathy Burke's greedy pursuit of ghastliness in *Gimme Gimme Gimme*, Sid Field's golfer and photographer sketches and Les Dawson and Roy Barraclough's Cissie and Ada routines, Ken Dodd's relentlessness and 'Chubby' Brown's ruthlessness, Frankie Howerd's emphases and Eric Morecambe's pauses, Charles Hawtrey's 'oh hello' and Julian Clary's stickiest moments – then their ability to leave me helpless with laughter has survived unscathed, despite years of fretting over their meanings. If anything, the lustre of great comedy glows even brighter after emerging from a squeezing through the analytical mangle, since a deepened knowledge of how complex comedy truly is can only increase an admiration for those who succeed in making it work so well.

Given what this book is about, the role of popular comedy in the construction of English identities, its potential cast list was gigantic, so some difficult choices needed to be made about who to put in and who to leave out. To begin with, let me sketch what I have included. The three chapters that follow this introduction aim to survey the three broad frameworks within which the more specific analyses take place: firstly the question of how comedy might usefully be thought about as a distinctive cultural mode, secondly the debates over whether national identity remains a viable concept in an increasingly globalised world, and thirdly the complexities of the terms 'English' and 'Englishness' in the contemporary social and political climate. Chapter 5 considers the meanings and the legacy of the comic sensibilities first forged in the Victorian music hall, sensibilities that might exceedingly crudely be summarised as attempts to find humour

in the raw material of English working-class lives, and subsequently carried into later decades by key performers such as George Formby, Frank Randle, Hylda Baker, Les Dawson and Ken Dodd. Chapters 6 and 7 centre on two aspects of the sexual politics of English popular comedy, taking as their respective case studies the history of comic effeminacy and the gendered dynamics of the male double act. Chapter 8 traces the seemingly endless appeal of the Carry On films, while Chapter 9 zooms in on one particularly important television sitcom, *The Royle Family*. Chapters 10 and 11 return to the focus on pivotal practitioners; firstly by examining how Englishness figures in the comic work of Alan Bennett, Mike Leigh and Victoria Wood, and secondly by focusing on English comedy's most scandalous success story, Roy 'Chubby' Brown.

Some of the absences from the book may seem even stranger than some of the inclusions, but I was keen to avoid two traps. Firstly, I saw no point in retreading well-covered ground – the post-war Ealing comedies, for example, merit attention in any full account of constructions of comedic Englishness, but Charles Barr's study of them (Barr 1977 and later editions) is so astute and remains so definitive that I could add little to it. My preference here has been to look for some less well travelled roads, some performers, styles and texts that exemplify important trends but have received relatively little academic coverage. Secondly, I spared myself the masochistic chore of grappling with comedy that makes no substantial inroads into my own laughter, which is a rather pretentious way of saying that everything studied closely here is something that still makes me laugh (even after the analytical butchery). Thus you will look in vain for extended considerations of *The Goon Show*, *Monty Python*, or the 'alternative comedy' of the 1980s. (Although the Pythons' dead parrot makes a special guest appearance in graphic form on the book's cover.) All three are hugely important, but all three make me laugh far less than the things this book looks at in detail. More regrettably, considerations of space have also compelled me to leave out some of the funniest comedy I know, so there are no detailed accounts of Al Read, Tony Hancock, the *St Trinians* films, Spike Milligan's Q series, *Fawlty Towers*, Harry Hill, Jo Brand, that mystifyingly maligned sitcom *Barbara*, Peter Kay, Catherine Tate, *The League of Gentlemen*, and *Little Britain*. They will have to wait their turn – and in any case the last four more properly belong in a study of English comedy in the present century, not the previous one. Another difficulty I have encountered stems from the fact that many of the case studies concern performers in mid-career and texts that might not be finished – having completed the chapter on *The Royle Family*, for example, this apparently deceased text returned in late 2006 for a one-off episode, while the stage and film success of Alan Bennett's *The History Boys* has added yet further depth to his concern with the English question. Such are the perils of analysing contemporary popular culture – any attempts to be definitive can come distressingly unstuck.

A final point about choices, and about personal investment: deciding to focus on examples of English comedy that work for me is one way of ensuring that my

own involvements with Englishness don't escape scrutiny. This is important, because far too much writing about comedy sets itself the stern, intrusive, pseudo-objective task of studying what Other People laugh at and why Other People laugh. This has the damaging consequence of letting the critic's own sense of humour off the hook, and that lack of self-reflexivity both prevents a full exploration of comedy's political complexities and contradictions and risks turning the analysis of funny things into a sermon about what it is correct and incorrect to find funny. If we are to ensure that an honest, open and productive debate continues about the often contradictory meanings of English cultural identities, then those of us who are English cannot avoid looking closely at who we think we are and why we think that way. This study of comedic Englishnesses (please note that plural) is offered as a contribution to that debate and therefore cannot be a book about Other People.

Chapter 2

Concerning comedy

> Comedy itself is too diverse to subserve a single, exclusive quality or function; that is why … 'Comedy' has to be recognised as a matrix term that embraces miscellaneous impulses.
>
> (Gurewitch 1975: 48)

> Jokes occur because society is structured in contradiction; there are no jokes in paradise.
>
> (English 1994: 9)

This chapter is not, emphatically not, a comprehensive overview of classic and contemporary theories about comedy. Others have toiled to collect, comment on and navigate through those theories, and readers seeking such insights into the processes of the comedic should, in order to expand and contextualise the claims made in this chapter, consult texts such as Bentley (1965); Berger (1997); Chapman and Foot (1977); Chiaro (1992); Critchley (2002); Davis (1993); Gurewitch (1975); King (2002); Lauter (1964); Neale and Krutnik (1990); Nelson (1990); Palmer (1984); Palmer (1987); Palmer (1994); Purdie (1993); Ross (1998) and Sypher (1956). Here, I have no wish whatsoever to put forward anything as grand as a totalising theory of humour and laughter. Murray Davis, one of the more interesting writers to undertake such a quixotic challenge, summarised his project in this way:

> I will study instances of humour, then, less to discover the features of our specific society that led to their special creation than to discover the abstract universal properties of society that allow the creation of humour in general.
>
> (Davis 1993: 31)

Those words represent a polar opposite of my aims. Although I will, at times, be looking at what makes particular comic texts, performances or moments funny (and that always entails considering the complexities of 'funny for whom?'),

my primary concern will be to relate those comedies to specific questions of cultural identity, to explore the relationships between popular comedy, social context and the shifting configurations of ideas of Englishness. This requires me to engage with some of the cultural studies literature on the politics of identity, in fact my bafflement at the rareness of references to comedy in that literature (some possible reasons for that rareness are considered later in this chapter) is one of the reasons this book exists. Nonetheless, I have also borrowed, where relevant, ideas and insights from those who strive to paint the bigger comic picture. Some might see it as unworkable to try to cross-fertilise the sweeping and often outlandishly unrooted claims of comedy theory with an interest in the historical specifics of cultural representation, but I would insist that each needs the other if comedy is ever to be fully understood. Let me elaborate a little on that insistence.

The lure of the big C

The primary problem in trying to find useful pointers in comedy theory for my work on comedic Englishnesses is that comedy theory can seem irredeemably besotted with Comedy – not comedy, the jumble of texts and pleasures, but Comedy, the essence of the thing itself. My sights are set on the particular implications of particular texts, but those who quest after that big C are rarely interested in anything as lowly as particularity. They want to unearth the core, their goal is definitiveness. If they're of a literary persuasion, they roam in search of The Comic Vision and The Comic Spirit. If they belong to a more scientific tribe they draw graphs and plot charts, and even, in a terrifying article called 'Mirth Measurement: A New Technique', tape record the laughter in people's conversations in order to quantify its 'frequency, rhythmicity, supra-glottal modification, movement and synchrony' (Mair and Kirkland 1977: 106). They begin sentences with 'Comedy is …' or 'Comedy does …' – just as I did in the Introduction to this book and will most likely do again many times below. Evidently, this yearning to track down the big C is contagious. Yet surely it is also doomed, this 'misguided determination to define or construct a model of the *joke-as-such*' (English 1994: 4, emphasis in original), since comic texts and performances are always produced and consumed in specific cultural and historical contexts. What can reduce one audience to helpless laughter will leave another one stonily unamused, hence those laborious footnotes appended to editions of Shakespearean comedy, which gamely try to disinter long-dead gags for unimpressed modern readers, or the fact that almost all the humour in the Ealing comedy *Passport to Pimlico* falls flat unless you have a reasonable grasp of the British political landscape in 1949, or the way that certain jokes in the British Asian comedy series *Goodness Gracious Me* sail over the perplexed heads of many white viewers (myself included). Topical or satirical comedy, indeed any humour which presupposes familiarity with or recognition of specific figures or events, is especially vulnerable here.

As one literary scholar, referring to nineteenth-century male comic novelists, argues:

> We can account for the tone of a comic expression, for its manner of pre-senting its material, only if we can locate the writer's position in his society and discover what he is responding to ... Abstract declarations about the function of the comic ... are ... insubstantial unless we can watch the writer at work, manoeuvring among the shibboleths and sacred assumptions of his day, coping with his own inhibitions, and breaking free into art and wit.
>
> (Henkle 1980: 4)

Yet a handful of pages later, the same critic is seduced into flirting with the big C:

> Comedy's particular vision of life, and what it seeks to transmit to us, is that once a social code or line of conduct ceases to be treated as a fiction and is instead sanctified and taken seriously ... then existence grows oppressive and sterile. Comic works characteristically expose pomposity and smug self-deception ... and undermine dull and inhuman mores. By toppling those authorities ... comedy encourages us to understand what is masked by rigorous, sombre approaches to human behaviour.
>
> (Henkle 1980: 12–13)

Both of these quotations seem to me to be accurate and useful, though they apparently contradict each other. The first warns against decontextualised abstraction, but the second goes ahead and practises it. The first wisely coun-sels that comic meaning is fundamentally related to the preconceptions of its social moment, yet the second produces a generalised formulation that might, once due care is taken to filter it through particular historical contexts, pro-ductively be applied to several of the comics and comedies analysed later in this book – the scrofulously subversive films of Frank Randle, for example, or the heterosexual-baiting queer wit of Julian Clary. These ambivalences and contradictions (comedy as precise social barometer versus comedy as transcen-dently timeless) are, I suspect, unavoidable in any study of comic texts and performances. Yes, there are aspects of comedy which are indissolubly tied to their cultural moorings – Clary can only stage his queer onslaught against heterosexual hegemonies because of historical changes in the social placing of male homosexuality; but there are also deep comedic structures which can be found recognisably re-occurring in very different times and places. The fact that Clary uses comedy, rather than another cultural discourse, means that he invites comparison with others, from different locations and contexts, who have used similar means of expression, which means that his use of camp can be both likened to and differentiated from the use of camp by queer comics of older generations like Kenneth Williams or Larry Grayson, precisely in order

to tease out how an ongoing comedic tradition responds to and is remodelled by social changes (this particular example is pursued at length in Chapter 6). Understanding that process and others like it requires a double-edged approach: simultaneously taking care to locate comedies in their specificities of time and place, while also considering how they relate to broader histories and traditions of what is deemed to be funny, though of course such histories are never straightforwardly linear and such traditions are constantly open to contest and contradiction. Every comedy belongs simultaneously to both its own moment and its wider cultural antecedents, as the following case study should illustrate.

Were the Crazy Gang from New Guinea?

In his very useful survey of the anthropological literature on jokes and humour, Mahadev Apte states categorically that comedy is contextual:

> Familiarity with a cultural code is a prerequisite for the spontaneous mental restructuring of elements that results in amusement and laughter … Individuals are not conscious of this requirement, because they already possess the cultural knowledge to which they compare the humour-generating stimuli. An individual who is not a member of a specific culture and therefore has not internalised its behavioural patterns and value systems may not experience humour.
>
> (Apte 1985: 17)

Indeed. After a Canadian friend of mine walked out of a screening of Mike Leigh's film *Life Is Sweet*, she told me it was because it was 'too English'. Clearly she, in Apte's regrettably inelegant terms, did not experience humour due to a lack of familiarity with the codes called upon by the humour-generating stimuli. Apte's book goes on to cite numerous studies which painstakingly relate the comic activities in various cultures to their overall belief systems, social hierarchies and cultural frameworks. Yet certain comic devices and figures seem to recur, he notes, in quite separate locations, in particular the use of clown figures in cultural and religious rituals. These clowns are 'temporarily freed from social sanction' (176), their comic manoeuvres include sexual humour, scatology, burlesque, ridicule, inversion, cross-dressing, parody, slapstick and acrobatics. They:

> chase spectators, play practical jokes on the members of the audience and each other, engage in banter and horseplay, simulate sexual behaviour, drink and eat all kinds of non-edible objects, wear absurd-looking costumes or no clothes at all, jump, dance, exaggeratedly imitate others, perform numerous types of antics, and generally frolic.
>
> (Apte 1985: 155)

Such ritualised clowning, Apte reports, has been found in several regions of Africa, amongst many Native American cultures, and in a range of other settings from Nepal to New Guinea. The following description, from a markedly different source, seems to suggest it could also be found on the West End stages of London in the 1930s, 40s and 50s:

> During their years together, the Crazy Gang act was like no other. Instead of merely entering, performing their piece, then exiting into the wings as variety performers have done before and since, they involved themselves with other acts and with the audience from start to finish of the show. Ten minutes before the curtain went up a pair of them would take over a stage box and greet the audience to a running fire of comment, pelting them with rice if feeling so inclined. 'Sorry to disturb you, madam', Teddy Knox would say, dressed as an usherette and falling on some woman's lap ... audiences ... seemed to relish dust-sheets spread over them in the front stalls and rolls of lino or sacks of potatoes were enthusiastically passed along the rows ... the Gang thrived on embarrassment and delicate feelings were a waste of time.
>
> (Owen 1986: 8–9)

There are grave dangers in placing those two accounts side by side, since to suggest an uncomplicated continuity, or trans-cultural symmetry, between the ritual clowns of varied 'tribal' cultures and the Crazy Gang, that troupe of delectably lowbrow comics who delighted British audiences for three decades, would be to overlook the massive differences in location, period, function and context that divide them. Yet some similarities seem hard to ignore, much as when Apte later describes the Trickster figure who occurs in some African and Native American mythologies as someone whose 'basic biological urges know no bounds. He is always hungry ... has an insatiable desire for sexual gratification ... and ... has no control over the bodily processes of waste elimination' (215). Few connoisseurs of vulgar English comedy would have trouble in calling to mind several figures who might wear that label proudly – Roy 'Chubby' Brown merits it more than most, while many characters from the pages of the adult comic *Viz* (Johnny Fartpants, Sid the Sexist, the Fat Slags) jostle lasciviously behind him. Indeed, in the 1970s the television producer and writer John Fisher, in his superb survey of British comedians (Fisher 1976), invoked the legacy of the Trickster in discussing Frank Randle, the purposefully disreputable Lancashire comic who was one of the more controversial inheritors of music hall modes (Randle is discussed in more detail in Chapter 5). Apte's summaries of clowns and tricksters also invite cross-reference with the tropes and tendencies of Rabelasian carnival, as so influentially analysed by Mikhail Bakhtin (Bakhtin 1968). The danger with all these echoes and interplays, however, is that they risk establishing an anti-historical model of comedy, where the undimmed appeal of bodily function jokes and the joyful

upheaval of misbehaviour override any relationship between comic text and cultural context, the relationship that this book is keen to claim as profoundly important.

That model is not, however, as anti-historical as it may first appear. While there may be many physical, carnival types of comedy that seem from one angle to fuse the Crazy Gang, the medieval revellers that intrigued Bakhtin and Apte's Nepalese ritual clowns into a single context-transcending blob, those comic patterns are still enacted at specific times, in specific places, for specific audiences and to serve specific functions. The general structures may share broad similarities (an assault on taboos, a stress on the body, a mockery of authority figures, a relishing of mayhem and a disregard for boundaries) but the details (the specifics of which particular taboos, authorities and boundaries) undeniably vary. I would argue, for example, that the Crazy Gang's performances were as resonant and memorable as they were because of the abrasions they sparked between the deep structures of carnival excess and the immediate context of respectable mid-century Britishness. They occupied a point of intensely fruitful intersection between long-standing (some might say primordial) comic tropes and socially specific reference points. In any case, the Gang always intermixed their unleashing of carnival appetites and their celebrations of unrepentant physicality with gags based on topical events or puns drawing on contemporaneously popular film or song titles. Like those variety sketches of the early 1900s which Lois Rutherford (1986) sees as fusing centuries-old carnival sensibilities with an attention to up-to-the-minute here-and-now concerns, the Gang's frolicsome scandalousness was a site where ancient met immediate, where deep-rooted met freshly minted, and where the cherishably familiar met the enliveningly novel. To understand the comics and comedies I'll be placing under the lens in later chapters, then, it is always necessary to hold in place that tension, keeping in focus both the widescreen crane shots of big C theorising, which offers insights into the deeper structures, and the more nuanced close-ups of context and specificity.

Shunning the grubby touch

Taboo, tension, mayhem, assault, abrasion – the presence of such words in the previous paragraph indicate that comedy is a matter of conflicts as well as pleasures. According to the literary critic James English:

> Comic practice is always on some level or in some measure an assertion of group against group, an effect and an event of struggle, a form of symbolic violence. The inescapable heterogeneity of society, the ceaseless conflict of social life, the multiple and irreconcilable patterns of identification within which relationships of hierarchy and solidarity must be negotiated – these are what our laughter is 'about'.
>
> (English 1994: 9)

If so, and I have made much the same points elsewhere myself (Medhurst 1989), the neglect of comedy in academic debates over the meanings of cultural identity looks all the more odd. There are, admittedly, passing references to comedy scattered across various books and articles concerned with the ideologies of identity. Several writers have seized upon ethnic stereotyping in jokes and television comedies as emblematic of wider cultural and media racisms (Hall 1981; Lawrence 1982; Kearney 1991; Manzo 1996; Lyon 1997), though having done so they rarely linger to sift through the specificities of comedic meaning (an important exception is Husband 1988). Mike Featherstone (1996) cites the films of George Formby and Gracie Fields as indicating a culture of regionality that partly challenged ideas of national culture in 1930s Britain, while David Morley and Kevin Robins (1995) turn a brief spotlight on the cartoon character Andy Capp and the stand-up comedian Bobby Thompson as ambivalent cultural icons for the North-East of England. Anthony Cohen (1986) employs the example of a culturally specific joke as his opening anecdote in an account of how communities use shared narratives to construct a sense of togetherness, while Jonathan Rutherford (1997) stages an analysis of the film *Four Weddings and a Funeral* (allegedly a comedy) to try to prise open the meanings of contemporary English white middle-class masculinity. Susannah Radstone (1996) and Terence Hawkes (2000) have both used idiosyncratic comedians, Tommy Cooper and Gillie Potter respectively, in idiosyncratic essays on the meanings of belonging, and a number of contributors to the collection *Popular European Cinema* (Dyer and Vincendeau 1992) signal the importance of comedy to any understanding of popular, national film cultures. George Formby again bobs cheerily into view several times in David Matless' outstanding study of landscape and Englishness (Matless 1998), while that inspirationally maverick historian Raphael Samuel peppered his always insightful reflections on nation and nationality (1989a, 1989b, 1989c, 1994, 1998) with momentary allusions to Gracie Fields, Robb Wilton, Tony Hancock, Joyce Grenfell, Stanley Holloway, Frankie Howerd, the seemingly inescapable George Formby, *Genevieve*, *Dad's Army*, *Blackadder* and the Carry On films. In probably the strangest case of all, Paul Gilroy (2000) has offered as telling evidence in his argument that all cultures today are irreversibly hybridised the fact that the controversial hip-hop artist Luther Campbell named as one of his cultural icons that indelibly English yet internationally popular comic Benny Hill, while Gilroy himself has subsequently included *The Office* and Ali G as reference points in his characteristically thoughtful discussion of twenty-first century English identities (Gilroy 2004).

It's refreshing and instructive to stumble across such references, but in the exponentially swelling panoply of academic literature on questions of identity they don't exactly amount to a substantial tendency, and very few of them indeed dwell at any length on the comics, comedies or jokes they cite (Matless is the main exception, shrewdly rummaging through comic texts at several points in his study).

Comedy tends to be a token rather than a touchstone. It is nodded at, pointed out, gestured towards, but thereafter fled from, as if serious analysis can't risk getting too close. At least, however, those writers have acknowledged that comedy exists and might matter. Elsewhere, outside of the demarcated field of comedy theory or texts dealing with particular comedic genres or practitioners, most academics seem to fear that comedy might dirty their dignity, and shy away from its grubby, tainting touch. This can reach bizarre proportions. In a useful collection of essays on British cinema in the 1990s, for example, the editor notes in his Introduction that: 'In retrospect, comedy, which has been Britain's most important contribution to world cinema in the 90s, ought to have had its own chapter' (Murphy 2000: xi). The paragraph continues by recommending some articles printed elsewhere to fill that gap (including, I note immodestly, what Ernie Wise would call some what I wrote), but the oddity remains – if comedy is so important, why keep it out? The book does deal with comic films, but they shelter under the more sober rubrics of 'class' and 'gender'. Clearly, comedy in its own right remains a troublesome customer.

As for why this should be so, some tantalising speculations can be found in a brilliant essay by Allon White (1993). According to White, our cultural categories of seriousness and triviality are profoundly intertwined with questions of social power, and those categories and questions are often played out in terms of different forms of language. Certain ways of speaking indicate particular points in the social hierarchy, so that comic characters in many of Shakespeare's plays speak in prose, often use regional dialect and come from the 'lower' social classes, whereas tragic characters speak in poetry, use dominant forms of language and come from 'higher' social echelons. In many fields (law, medicine and the military among others), the connections between 'high language', seriousness and social status are deep and long-standing; few of us would expect an Old Bailey judge to start cracking gags in a rich Geordie accent. These linkages between class, dialect, regionality and comedy have clear implications for many of the comic texts and practitioners I shall be studying in later chapters, but it is another aspect of White's essay that is most relevant here. 'Seriousness', he declares, 'always has more to do with power than with content. The authority to designate what is to be taken seriously (and the authority to enforce reverential solemnity in certain contexts) is a way of creating and maintaining power' (128), and one key arena in those processes of designation and enforcement is, he argues, education. White sees school classrooms as spaces premised on hierarchy and order and consequently dedicated to an insistence on a particular notion of seriousness, whereas outside the classroom walls lies the playground, a site of 'games, exuberant bodies, scatology, sexual exploration, dirt, jokes and pleasure' (132). In this binary, 'a teacher in the classroom spends much of the time ensuring that the space of knowledge – whatever that may be – is kept uncontaminated by low discourses' (134), those low

discourses being, quite literally, embodied in the playground's subversive delights.

Studying comedy, I would argue, makes that binary impossible to sustain. Much of the comedy covered in this book represents a sustained revelling in White's playground pleasures. His catalogue of misbehaviour – games, exuberant bodies, scatology, sexual exploration, dirt, jokes and pleasure – looks like the raw material of a Carry On film, a guided tour of *Round the Home*, the Crazy Gang's favourite menu, Ken Dodd's 'Things To Do' list, an X-ray of *Nearest and Dearest*, or an evening in the company of Roy 'Chubby' Brown. So how can the classroom cope, how can it maintain its investment in the promulgation of solemnity and its status as a vehicle for the transmission of high knowledges, if the walls break open and the playground comes surging in? What might happen if the gates of the knowledge factory were thrown open to admit the spirit of perpetual play? One way of staving off such a threat is to put extra effort into keeping the walls between learning-zone and low-zone strong and impermeable, and in this respect the absence of comedy from most areas of cultural analysis represents a staunch determination to keep the pleasures of the playground at bay. This is especially important for relatively new academic fields such as media studies. Already under suspicion from many quarters for not being serious enough (a 'Mickey Mouse' subject, to use the tellingly playground-flavoured epithet often hurled in its direction), its need to affirm seriousness is particularly pressing. This is somewhat easier to achieve if the media texts under scrutiny are relatively respectable (news, documentaries, drama), but vulgar comedy, the gleefully lowest of the disreputably low, poses acute problems, and it tends to be warded off or simply ignored. A further alternative, found across a wide range of disciplines, is to deal with the dangers of comedy by smothering it with hyper-seriousness, making the playground more classroom-like than the classroom itself, which seems to me why some academic accounts of comedy are so obsessive about stripping themselves of pleasure or laughter. There is, of course, no reason why studies of cultural forms should reproduce the affective dimension of their object – nobody expects analyses of horror films to be frightening, although those of an abstrusely psychoanalytic tendency scare the hell out of me. Yet the distance between the joys of comedy and the joylessness of most comedy theory (it would be invidious to single out any particular texts in this regard, though many of them fester and sulk in this book's Bibliography) seems so vast and so strenuously maintained that it can't be wholly accidental. Those who like to poke fun at intellectualised comedy analysis tend to conclude that academics who investigate comedy are both distinguished and fatally flawed by their own lack of humour, to the extent where their humourlessness itself becomes ridiculous (Jacobson, 1997, has fun with these paradoxes). There may be grains of truth in that, but I would rather apply Allon White's formulations and see the desperately dour nature of much comedy analysis in a different light. Such writings spring from a guilty anxiety about being interested in the comedic, they represent an attempt to

impose classroom logics on playground life, entombing themselves in purifi-catory solemnity by striving to exorcise the evil spells of low laughter and to sidestep the banana skins of undercutting mirth. I am, very probably, placing too much weight on White's brief essay, and I am undoubtedly hijacking it for my own purposes – he never actually focuses on comedy as such, much less the academic study of it. Even so, the essay's implications are exciting. White claims that the 'social reproduction of seriousness is a fundamental – perhaps *the* fundamental hegemonic manoeuvre' (134, emphasis in original). If so, then an academic study of popular comedy which resisted the temptation to suf-focate that comedy with blankets of dehumanised abstraction, a study which tried to meld classroom logics and playground joys into a productive synthe-sis, might have significant consequences beyond its immediate neighbourhood. Such speculations will have to be left there for now; I want to move on by looking at how the introduction of comedy as a reference point can help to open up cultural studies debates on issues of identity.

Identity and belonging

Rather than conducting a broad survey of relevant texts, I have decided to use as a focal point one key article, Stuart Hall's 'Who Needs Identity?' (Hall 1996). It shows Hall at his eloquent best, magisterially condensing screeds of complex issues into a small handful of pages, yet the grasp and the brevity which are so impressive also leave the article languishing on the plane of abstraction. Its arguments need testing out on some concrete example (as I have often been told by students made grumpy by being obliged to read it), and com-edy offers the ideal solution. What Hall does in the piece is to summarise and champion the view that social and cultural identities, in which people invest so deeply and heavily, are far from being fixed and secure entities. In Hall's words, 'identification is ... a construction, a process never completed – always "in process" ... conditional, lodged in contingency ... it requires discursive work, the binding and marking of symbolic boundaries, the production of "frontier-effects". It requires what is left outside, its constitutive outside, to consolidate the process' (2–3). Identities, Hall states, are 'produced in specific historical and institutional sites, within specific discursive formations and prac-tices, by specific enunciative strategies. Moreover, they emerge within the play of specific modalities of power' (4). Identities are 'the product of the marking of difference and exclusion ... Throughout their career, identities can function as points of identification and attachment only *because* of their capacity to exclude, to leave out, to render "outside", abject'. (4)

It seems to me that no cultural form operates along these lines more clearly, concisely and vigorously than comedy. Look again at Hall's terms. Comedy is a type of 'discursive work' (a consciously undertaken way of uttering and shaping meaning), it is founded on 'the binding and marking of symbolic boundaries' (it divides people into distinct groups in order to set them laughing at each

other), it is a 'specific enunciative strategy' (it has its particular communicative codes, linguistic rules and significatory protocols), it is intimately related to 'modalities of power' (groups with more social standing are more frequently invited to laugh at those with less and vice versa), it works ceaselessly to draw lines of 'difference and exclusion' (insisting on gender and ethnic differences, promoting fixed stereotypes of minorities, using humour to firm up the lines that separate), and it allows those inside any given identity category to shore up their sense of self by enabling them to use laughter 'to leave out, to render "outside", abject' those perceived as occupying contrasting or challenging identities. Comedy fits Hall's arguments like a glove, and it would be easy to proceed from here to attack comedy as divisive, exclusionary, in league with prejudice, a weapon of the powerful, an activity dedicated not only to supporting inequalities but also to cloaking them in an aura of inevitability, a way of selling us bigotry in the name of entertainment. It is all of those things, but it is not and never can be only those things. Indeed it can be quite the reverse: unifying, inclusive, a weapon against prejudice, a voice for the marginalised, a way of exposing discrimination through highlighting its absurdities, a place where anti-establishment views can achieve wide circulation through the use of approachable comedic codes. Most of the time, needless to say, it oscillates between those poles, and its exact position in that spectrum shifts constantly, depending on content, context and the standpoint from which it is viewed.

Above all else, comedy is an invitation to belong. In Hall's framework, the security, reassurance and stability promised by belonging are deceptive: you may place yourself (or be placed) in a group or body or culture or subculture or class or gender or ethnicity or nation or minority or fellowship or identity through a declaration or an assignation of belonging, but that placing will always remain temporary, contingent, fluid and contested. Yet this, I would insist, is exactly why comedy can be so nourishing. It is exactly because identities are so disputed, so slippery, so rocky and so anxious that the celebration of belonging offered by comedy is all the more welcome. Belonging may be a fiction, but it is a fiction from which solidarity and sustenance can be drawn. Comedy is a brief embrace in a threatening world, a moment of unity in a lifetime of fissures, a haven against insecurity, a refuge from dissolution, a point of wholeness in a maelstrom of fragmentation, a chance to affirm that you exist and that you matter. Comedy's consoling fantasy is that however difficult life might be, however much forces way beyond your control try to rip you to pieces, there can still be moments where – right here, right now – you can join those who are like you in a celebratory rite of communal recognition. Comedy says to us: you're among friends, relax, join in. So, of course, do all manner of alarming projects (fundamentalist Christianity, fascism, U2 concerts) but comedy's invitation to belong, its compulsion to recruit, has no inevitable ideological leaning. The direction of comedic politics is contingent on time, place, practitioner and audience. One stand-up comedian can invite his white

audience to seek solace and delight in their whiteness through mocking Asians and blacks, another can use exactly the same methods to encourage her lesbian audience to recognise and celebrate their shared disdain for the absurdities of heterosexual gender games.

It's all about belonging, and the comic text or practitioner can call on a variety of devices in proffering the invitation. Belonging is why most television comedies have laugh tracks, why narrative film comedies will fade or cut or leave visual pauses when they think a great line has just been delivered and thereby reassure the audience that this is the right time to laugh, why stand-up comedians are filmed in theatres or studios with audiences present and why there are frequent cuts away from the comic to the convulsed consumers, why there are few more rapturous communal experiences than being in an audience rocking and hooting at the same gag, and why there are few finer pleasures in life than a group of old friends remembering and cementing their bonds through helpless, heedless laughter. And yet, as ever, this has its uglier opposite. Belonging can be spun round, turned excludingly against you, a fence keeping you out as much as a gate letting you in. Being laughed at is a surefire way of feeling put in your place – your place being absolutely not the place of those doing the laughing (I have written elsewhere, for example, about the wounds that homophobic jokes once inflicted on my sense of homosexual self – see Medhurst 1994). Of course, any fully fledged devotees of postmodern indeterminacy reading this may want to barrack this recurring chorus of 'belonging', to tell me how quaint I sound. Doesn't Hall's article detonate any credibility in the idea of fixed, stable selves? Only an idiot, surely, could still believe in belonging when the globalised, digitalised, post-structuralised era we live in has consigned all that secure-identity romanticism to the waste basket of past myths. Perhaps, but even though Hall's arguments make intellectual sense, they leave me feeling distinctly unsettled emotionally, and the fantasy of belonging wrapped up in the comedic invitation is a very settling alternative. However momentarily, comedy settles you, and the place you feel settled is often the place you call home.

Seaside incident

The implications of what can and might be meant by 'home' will be explored more fully in the next two chapters. I want to conclude this one by offering a deliberately distended case study of the multitudinous complexities of considering comedic politics. One trap that bedevils much comedy theory, and which this book is keen to avoid where possible, is indulging in overly lengthy dismemberments of individual jokes. The whole point of jokes is their brevity, their ruthless condensation of assumptions into epigrams. Unpacking a joke in order to mull over every last morsel of meaning subjects the joke to an elephantiasis of explanation – it forces back on all the deadening weight that the joke had slimmed off. As Murray Davis puts it, ' "slowing down" jokes

to illuminate their operation spoils their surprise: the sudden shift of meaning that produces a laugh' (1993: xiii). This book is much more interested in the cultural implications of things that have been found funny than the tiniest details within those things that led to the label of 'funniness' being applied. Nonetheless, one excursion into protracted dismemberment might be useful at this point, in order to try to tease out the complexities of form and ideology within humour. One of those complexities centres on the apparent contradiction that it is perfectly possible (unless you have reached a state of ideological hygiene unattainable to those of us embroiled in the messiness of everyday life) to be amused by a joke which advances political positions you would otherwise find unacceptable. That end result is often due to the performance skills of the joke-teller. Les Dawson's mother-in-law jokes trade in deeply predictable sexual politics, but it would be a peculiarly impervious sensibility, an outlook so unimpeachably of the classroom that it has never risked dirtying itself in the playground, that couldn't find humour in the interplay between Dawson's verbal dexterity, his impeccable sense of rhythm, pace and emphasis, and his roguish awareness that his jokes thrive on the tension between the predictability of the sentiments and the inventiveness of the verbal play. Yet outside the realms of professionalised joke-telling, sometimes an individual joke can be so striking as to bring these issues of pleasure and politics into uncomfortably sharp focus. It was in the appropriately carnivalesque setting of a bar on Brighton's Palace Pier that I was told, several years ago, the joke that crystallises this tension (formal delights versus ideological concerns) better than any other I know. The barman waited until the female friend I was with was out of earshot and then asked me a question: What do you call a dog with a spade up its arse? I confessed ignorance, so he told me the answer: Dawn French.

Thus one of the best and worst jokes I have ever heard came into my possession. If Susan Purdie is right to claim that 'joking always involves an unusual attention to language' (1993: 91) and that 'joking always constructs discursive power, and in this sense its operation is always political' (1993: 127), it will be instructive to unravel why that simultaneously superb and indefensible joke had such an impact that over a decade later I can still feel the shudder of simultaneous joy and revulsion that ran through me on hearing it. The fact that this joke may need explaining to readers not conversant with the minutiae of English popular culture, in other words its cultural specificity, is one of the many reasons I have decided to place it under such crazily microscopic scrutiny. This book, after all, is concerned with how comedy, if it is to be effective and meaningful, must construct, consolidate and call upon a framework of references shared by both producer and consumer, performer and audience, text and public. One of my main contentions is that any analytical consideration of how ideologies of belonging are forged and sustained through cultural forms needs to give comedy a prominent place, since laughing together is one of the most swift, charged and effective routes to a feeling of belonging together. Comedy is a short cut to community. So like any comedic text, the joke I was told on the pier (I will

refer to it hereafter as 'the Brighton joke') offers a whole series of invitations
to belong. It sets out entry qualifications for joining the joke's community
of appreciators, checking the passports of those seeking to gain entry to its
territory – and I use that last metaphor, with its lurking images of immigration
and racism, quite deliberately, since the Brighton joke, like any joke, can only
promote belonging by identifying those who do not belong. The first hurdle
this joke places in front of any listener is the name Dawn French. If that has
no connotations, and it suggests no kind of pun or other purely verbal play,
then the joke dies then and there. You need to know who she is to book your
space in this joke's sinister playground. The joke thus only works for British
listeners, or non-British listeners aware that Dawn French is an acclaimed and
successful comedian, writer and actress. This is still not enough to make the joke
work, since that description would also fit Jennifer Saunders, French's partner
in many projects, but 'What do you call a dog with a spade up its arse? Jennifer
Saunders' is not funny (except to a few stray surrealists). The punchline 'Dawn
French' works because of the second most widely known fact about French,
that she is a white woman with a black husband, the similarly acclaimed and
successful comedian, writer and actor Lenny Henry. They make up, thanks
to their separate individual fame and the intensified celebrity exuded by any
relationship comprising already famous people, what is probably British popu-
lar culture's best-known 'mixed marriage'. This has made them a high-profile
target for criticism from racists, fascists and sundry other deranged devotees
of ethnic purity. A favoured technique used by racists to intimidate those of
whom they do not approve is to post through their front doors an envelope
containing human excrement. The Brighton joke is, in effect, another of those
envelopes – another means of communicating racial and sexual disgust in a
neatly parcelled form, another container crammed full of shit.

So the deeper and far more troubling invitation the joke sends out is an
invitation to share disgust at inter-racial relationships. That it does so through
the use of the dated English slang term 'spade' to mean 'black man' is another
index of its reliance on shared cultural competences. Told as it was by one white
male to another, the Brighton joke is an attempt to elicit ethnic and gender
complicity. The barman did not utter the joke in front of my female friend, and I
cannot imagine he would have told it to me, at least not with such conspiratorial
confidence, if I was not white. There are yet further assumptions and values
steaming away in the joke's tightly packed envelope: French is a 'dog', an ugly
woman, and by ideological extension one more likely to 'resort to' sex with an
ethnic other, and that sex is not conventional heterosexual penetration but 'up
the arse', with the 'deviancy' of this act only to be expected, in the joke's world,
from those perverted enough to take part in sexual relations beyond the bounds
of ethnic sameness and codes of attractiveness. The Brighton joke is a coded
way of saying 'Sexual relations between blacks and whites are disgusting', and
from there a whole lexicon of racist anxieties, sexual protocols and connections
between them can be deduced. Both French and Henry are clearly under

attack as figureheads of what the joke labels as unacceptable behaviour, though I suspect that she is made to carry more of the 'blame', deemed and damned as some sort of 'race traitor'. (It would be fascinating to know if there was a parallel joke, emanating from a black separatist mindset, where Henry was the main target.) Henry's name is not used, whereas hers is; they are both given a slang referent ('spade' and 'dog'), but hers both imputes a failure to measure up to norms of female beauty and implies an animalistic interest in non-normative sexual practices, thus doubly placing her beyond consensual femininities. Reducing her to a dehumanised 'it' takes the process one stage further; the joke would have the same general meaning and some of the same impact if its question was worded 'What do you call a bitch with a spade up her arse?', but the version as told to me manages to cram in two more attacks on French (her supposed ugliness and that depersonalising 'it'). Finally, she is the 'passive' partner in anal intercourse, enabling the joke to draw on traditions of homophobic ideology, where the one who is penetrated during anal intercourse is always thought to be more demeaned than the one doing the penetrating.

In the mere fourteen words of the Brighton joke, then, lie the compacted traces of large, complex and wholly reprehensible ideological beliefs. As both a card-carrying anxious-white-liberal and a gay man with a long-term stake in issues of sexual politics, the joke should appal me – and it does, the moment I begin to think about what it envelops and entails. I am also appalled by the circumstances of its telling, the barman's assumption that as a fellow white male I was a suitable recipient for the joke's contents. Retrospectively I want to bristle at him, to insist that my politics compel me to find the joke offensive and disgraceful, to distance myself from the whiteness and maleness he could see by flourishing the queerness he could not (though homosexuality is of course far from being a guarantee against sexism and racism), to decline in forceful and affronted tones his invitation to subscribe to the joke's tightly bound knot of reactionary prejudices. I want to do this retrospectively, because at the time I did none of the above. Instead, I laughed. That statement may well disqualify the whole of the rest of this book in some people's eyes. To laugh at such an atrocious joke must make me a racist, a sexist, a bigot beyond ideological redemption. Worse still, I have above described the joke as superb, stated that one of the responses it elicited from me was 'joy', and declared that it is one of the best jokes I have ever heard. That is because, if looked at from a certain standpoint, it is. Formally, in terms of streamlining a worldview into the shortest number of words possible, the Brighton joke is phenomenally impressive. It says in fourteen lethally incisive words what I need several lumbering paragraphs to explicate. (Those who feel that to analyse comedy is to kill it may seek solace at this point in the fact that the joke in question is an exceptionally ripe candidate for execution.) It is a joke that proves how effective comedy can be in honing whole belief systems into single verbal events. In terms of verbal artistry, it is a dazzling joke – wrongfooting the new listener into expecting a punchline

based on animals, conjuring up Tom-and-Jerry style images of excruciating violence rendered comic because practised in the unreal world of animation, then driving home the shocking punchline like a blade in the ribs, only then revealing its hand, leaving the listener breathless at the audacity, the economy, the sheer intensity of concentrated venom curled up at its core. It is a beautifully crafted poison dart, fashioned from loathing, fear and hatred into something astonishingly sleek, unremitting and purposeful.

The reason I have lingered on this joke so excessively should, I hope, be clear. It is both, and simultaneously, formally very brilliant and ideologically very repulsive. To lose sight of either quality is to make a full understanding of the politics of comedy impossible. Comedy is never just a question of content – questions of form, style, consumption, context and (often the most crucial of all) performance must always be in play. It is because the Brighton joke is so skilfully constructed that its impact is so great. Yet in saying all of this, of course, my whiteness and maleness need to be taken into account, much as that barman took them into account on the Palace Pier. The joke offends my politics, but doesn't (except glancingly in its co-option of homophobia) target me directly. My assertion that such a joke should not be evaluated on ideological grounds alone might be harder to sustain if I was in the firing line of its comedic assault. When I quoted that joke in a lecture (to a predominantly white audience – I have never, for what it's worth, felt able to recount it to a predominantly black audience), several women afterwards told me how offended they had been, one even saying she felt 'violated' by hearing it, a strength of response unlikely to greet the more humdrum sexism of the average mother-in-law joke. It might be helpful here to shift the focus to another joke on another pier. When I saw Roy 'Chubby' Brown at the seaside resort of Great Yarmouth, he told the following joke. 'Why does Kenny Everett wish he'd taken up golf? Because in golf one bad hole won't kill you'. (Cultural context: at the time of the joke, Kenny Everett, the gay broadcaster and comedian, was in the final stages of HIV-related illness, dying shortly afterwards.) Comparing this to the Brighton joke is not just a matter of textual evaluation, but also one of context and response. Did I laugh at the Yarmouth joke? Not exactly. I smiled at the inventiveness of the wordplay and relished the wicked timing of the delivery, but I winced at the homophobia that made gay men's deaths laughable and thus (within a logic of homophobic mockery) gay men's lives less valuable, all the more so because the vast majority of the audience roared as appreciatively as they, and I, had done at Chubby's other jokes. In the cool light of analysis, I can see that the Yarmouth joke is not actually as startling, precise and unforgettable as its Brighton rival, primarily because there's less surprise. Naming Everett in the first half contextually cued the listener that homosexuality and probably AIDS were likely to be the key reference points, and in verbal gags of this brevity, such predictability dulls the impact. Yet in the heat of the performing moment it wasn't the formal shortcomings of the joke that prompted my unease, it was feeling got at, feeling excluded, being targeted

as the object of communal ridicule, being informed that I was a queer interloper in an overwhelmingly heterosexual environment. I wouldn't go as far as saying I felt 'violated', but I certainly felt expelled from belonging. I couldn't have fun in that joke's playground because it rendered me, in Stuart Hall's terms, outside and abject. It was a chastening experience, underlining that, while a rigidly political response to comedy, where the content is vetted and other elements ignored, is often blinkered and reductive, it would be equally limited to ignore the fact that jokes can be manifestoes in microcosm, that they can wound and damage as much as they enthral and delight, and that if you belong to the group being vilified so that those who occupy another space of belonging can feel validated, the niceties of textual exegesis are not liable to be at the top of your agenda.

These are difficult issues, and the only certainty I have about them is there can be no universal answer. An ideologically purified comedy would not be funny, because complete agreement over any given topic would eliminate the conflict on which comedy depends. Moreover, a society without disharmony would be a society without laughter (as James English says in the quotation at the head of this chapter, there are no jokes in paradise) and I am not sure that I could breathe in such a rarefied atmosphere. Equally and oppositely, to give a joke free rein to insult and cause strife, merely because it was textually well-structured and formally satisfying, would be to abdicate from social responsibility. Some kind of balancing act needs to be attempted. I described the Brighton joke as one of the best and worst I have ever heard, but perhaps it is better categorised as best-and-worst (or worst-yet-best?), with those hyphens serving as the tightropes along which analyses of comedic ideology must warily tread. Needless to say, however, the equilibrium required for such a balancing act is not an easy critical stance to maintain, especially when comedy concerns itself, either directly or obliquely, with something as fraught, contested and unstable as questions of 'the nation'.

Chapter 3

Notions of nation

National identity means a great deal to some people and precious little to others. My purpose in writing this book was not to decide whether nationalism is inevitably good or bad (it is always both).

(Manzo 1996: vii–viii)

I am not against the nation (we have to put it somewhere).

(Gilroy 1993: 72)

The academic literature on theories of 'the nation' is so vast that all this chapter hopes to do is to commit a few strategic thefts from the shelves of that daunting library. Readers seeking useful introductions and contributions to the broader debates will find much of interest in Balakrishnan (1996); Cubitt (1998); Easthope (1999); Gillis (1994); Ignatieff (1993); Manzo (1996); Nairn (1997); Smith (1991) and Stychin (1998). My aim here is to give brief consideration to some key questions in order to underpin what later chapters will have to say about comedies and Englishnesses. Those questions are these: what does it mean to call the nation an imagined community? Have national sites become increasingly irrelevant in an era of globalisation? What are the tensions between a sense of national belonging and a commitment to cosmopolitanism? How easy or difficult is it to prevent an acknowledgement of the significance of the nation and the national sliding into the troubling politics of triumphalist nationalism?

Imagining nationally

The inescapable starting point for contemporary thinking about these issues is Benedict Anderson's formulation of the nation as an imagined community (Anderson 1983): 'community' because nations offer themselves as focal points of shared interests and outlooks, magnets for loyalty and belonging, but 'imagined' because those who identify themselves as adhering to a national label can never literally meet all the others living in that nation in order to ascertain

whether interests and outlooks truly are shared. To think nationally is to take a leap of faith, and the religious suggestions of that metaphor are appropriate, given that, in Kathryn Manzo's useful summary, 'nationalist practices ... are political religions that create boundaries, separating sacred kin and alien kind' (1996: 3). The imagined nation does not, of course, stay in the realm of conceptual speculation. It takes concrete form in the politics and institutions of the nation state, it is visualised and dramatised in symbol and ritual. To inhabit a nation state is to live amongst countless, daily, unavoidable images of that nation's ideas of itself. Undertaking the simplest economic transaction can involve an encounter with symbolised national rhetoric, since, as Marcia Pointon (1998) observes, every time citizens of most countries pull bank notes from their pockets, they have in their hands a rectangular assertion of national specificity (the potential erosion of this specificity through the policy of monetary union being a chief cause of concern for those opposed to Britain's joining the 'single European' currency). Michael Billig (1995) points out that even ascertaining whether or not you need to pack an umbrella can require you to ingest assumptions of nation, with television weather forecasts using maps that show frontiers and using phrases like 'sunny in the western half of the country'; forecasts on British TV, for example, are often ambivalent and unsure about mentioning the climatic prospects for the Irish Republic, even though it usually shares the cartographical space of the maps they use on screen.

Although Anderson's concept of imagined community is now a virtual truism, it is not without limitations. Firstly, it is not simply national communities that are imagined, since a region, a town, a village, a street, even a shared household is also, in Etienne Balibar's felicitous words, 'based on the projection of individual existence into the weft of a collective narrative' (1991: 93). It could be argued, then, the imagination of nation is different only in scale, not kind. Secondly, although Anderson himself was never guilty of this, his term can be twisted so that the force of 'imagined' becomes so dominant that it comes to imply that nations move from being constructs, which they undeniably are, to becoming nothing but fictions. The historian Geoffrey Cubitt helpfully distinguishes between construct and fiction:

> ... nations are best regarded as imaginative constructs. They develop, no
> doubt, out of social and political experience, but they are the products
> of an imaginative ordering of that experience, not its revealed reality. To
> describe them as fictions is to draw too sharp a line between mental con-
> struction and social reality: nations (like many other social formations) exist
> to the extent that discourse and behaviour and institutional structures are
> organised around the assumption of their existence. Yet this existence is
> always ontologically unstable: however institutionalised they become and
> however well established the symbolism that denotes them, nations remain

elusive and indeterminate, perpetually open to contest, to elaboration and
to imaginative reconstruction.

(Cubitt 1998: 3)

The latter part of Cubitt's formulation places him close to Stuart Hall's insistence
that all identities are fluid, mobile, always unfinished and inevitably uncertain.
Yet national identities, perhaps more than any other kind, constantly project
themselves through pomp and ritual and the trappings of tradition as fixed
and whole. Rituals of nationhood, which in a British context would include
annual ceremonies such as the State Opening of Parliament and rarer but even
more charged events like royal coronations or funerals, drape themselves in
heritage drag to manufacture the illusion of timelessness, to exude and imbue
national confidence through the masquerade of unbroken continuity. To admit
that such rituals are far from immemorial or that such events are anxiously
policed exercises in ideological theatricality would be dangerous for those who
invest intensely in nationhood, since, as Carl Stychin puts it, the 'success of
"nation" … rests in large measure on how it has managed to camouflage its
constructedness' (1998: 3).

One core element in the construction of nation is the ascertaining and
labelling of those who do not belong, bearing out Hall's thesis that identi-
ties are forged and maintained partly by reference to their constitutive others.
This means, first of all, identifying others who are outside, competing and con-
trasting identities located in different places. ' "The nation" defines the culture's
unity', argues James Donald, 'by differentiating it from other cultures, by mark-
ing its boundaries' (1993: 167). A sense of national belonging is strengthened
through comparison with another identity demarcated as definitely elsewhere,
so one way of feeling belonging in a British identity would be to feel not-
French. That particular distinction has a long and important history, as shown
in Linda Colley's influential study of the construction of Britishness in the
late eighteenth and early nineteenth centuries (Colley 1992). Colley sees the
mobilisation of anti-French sentiments in a period of potential and actual war
with France as a central device in the forging and popularising of a sense of
shared British purpose. The geographical nearness of France to Britain was a
key factor here, since it is the nearer others, the closer others, that require
the most stringent keeping at bay if national belonging is to be reinforced.
These processes work similarly in comedy, of course, which is why British
(and especially English) comedians have been so devoted to the Irish joke but
have no need of Portuguese jokes, and why jokes about West Indians and Pak-
istanis only took hold in British popular culture once post-war immigration
brought large numbers of people from those cultures to make their homes in
Britain. (I am prepared to bet that British comedy will see an increasing number
of jokes about Eastern Europeans in the near future, in response to migrants
arriving from states such as Poland and Bulgaria which have recently joined
the European Union.) As those examples suggest, nation construction is also

involved in the business of identifying internal others, who are seen by those subscribing to an imagination of national community wedded to closed, fixed and impermeable versions of belonging, as threatening groups that are *on* the inside but must on no account become *of* the inside. Nationalists invested in those kinds of imaginations can never risk acknowledging that any sense of national cultural unity can only ever be 'fictional ... because the "us" on the inside is itself already differentiated' (Donald 1993: 167), resulting in scenarios where belonging is only ever a matter of looking inward and backward and where extreme, ethnic nationalism offers 'a last refuge from social change' (Cook 1996: 2). One such set of changes, which has had profound consequences for how people conceptualise belonging, goes under the umbrella label of globalisation.

Global, cosmopolitan, local

At the beginning of the 1990s, Anthony King hypothesised that the era of national belonging, the period when feeling national was a primary strand in most people's sense of self, was coming to an end: 'It is not just that, increasingly, many people have no roots; it's also that they have no soil. Culture is increasingly deterritorialised' (King 1991: 6). These are not words that were taken to heart in Rwanda, East Timor and Bosnia. As many recent events bloodily show, the nation is far from over, yet King's argument does have some credibility in other ways. In a later chapter, I will be arguing that the enormous popularity of the stand-up comic Roy 'Chubby' Brown depends in part of his ability to call on a particular set of sensibilities of Englishness – in that sense, he is an intensely national figure. Yet any English audience member attending Brown's performance in any English town may well have driven to the show in a South Korean car, listening to the French-Canadian singer Celine Dion on the German car stereo, stop for a McDonald's on the way there, enjoy an Australian lager and a packet of tortilla chips in the interval, and end the evening at home eating an Indian takeaway while watching a Spanish football match recorded on a Japanese DVD. In terms of cultural consumption, globalisation has opened up the world for purchasing – if, of course, you have the money to finance your supra-territorial spree, since globalisation, in many ways, is an intensification of privilege for the already favoured few. But what has this shrinking of time and space in the service of capitalism, what Mike Featherstone has called 'the intensification of global time-space compression through ... the power of the flows of finance and commodities' (1996: 46) meant for the ways in which people think about placing themselves? In some influential intellectual circles, it has led to an assumption that all previous versions of place and belonging have been rendered redundant, and that to attempt to hold on to them is at best deluded and at worst reactionary. David Harvey, for example, has written almost contemptuously of 'all those manifestations of place-bound nostalgias that infect our images of ... region, milieu and locality' (1989: 218).

A similar view is captured in the back cover blurb for an academic collection of essays about culture and globalisation:

> Positioned at the crossroads of an altered global terrain, this volume ... analyses the evolving transnational imaginary – the full scope of contemporary cultural production by which national identities of political allegiance and economic regulation are being undone, and in which imagined communities are being reshaped at both the global and local levels of everyday existence.
>
> (Wilson and Dissanayake 1996, back cover)

Phew! While it is the assigned role of advertising copy to be excitable, the breathless gee-whizzery of that blurb strikes me as being particularly telling. It cheerleads for national dissolution, it makes no bones about equating the national with the past and the global with the future. Get on the global bus before it leaves you behind, it urges, and wave goodbye to the nation before you get stuck there and, to borrow David Harvey's lurid metaphor, get infected. In another strenuously fashionable 'post–national' collection, its co-editor mocks the belief in national belonging as 'the childish reassurance of belonging to "a" place' when we are inevitably 'connected to all sorts of places' (Robbins 1998: 3). Here the national is not only passé, but childish, and which self-respecting academic can risk being seen to consort with either of those adjectives? Well, I think I'll risk it, if only because the rhetoric of globalisation seems to me to be just a refocused variant of the fractured identity paradigm beloved of the more gung-ho branches of postmodernism. In the 'transnational imaginary', there is no place to call home – except perhaps the airport departure lounge that leads to the lecture theatres of the international academic conference circuit – and as should be clear by now, I think home matters.

Many writers feel differently, however, most of all those who subscribe to one or another variety of cosmopolitanism. Pam Cook makes a vigorous case for the cosmopolitan cause, using as her starting point the conviction, reminiscent of Hall's identity theory and Donald's account of nation, that:

> the quest for authentic identities is ... doomed. Not only does it depend on a process of expulsion of perceived negative, inauthentic elements which inevitably return to haunt the legitimated culture, but identity formation is a fluctuating, fractured affair which militates against any final settlement ... identity is, from the beginning, lacerated, torn between self and other.
>
> (Cook 1996: 2)

Rather than chasing the impossible grail of authentic, settled belonging, Cook argues, we should acknowledge, work with, even revel in our status as migrants, travellers, cosmopolitans:

As travellers, we cross boundaries and, through identification with other cultures, acquire a sense of ourselves as something more than national subjects. This may smack of cultural tourism – but what is culture, after all, if not a collection of souvenirs?

(Cook 1996: 4)

I am uneasy about this, and my unease centres on the seemingly innocent phrase 'identification with other cultures'. Just what kind of identification is possible in a brief, or even an extended visit to other places, except an identification premised on consumption and voyeurism? Cook's cosmopolitan manifesto does indeed smack of cultural tourism, and it smacks even more ringingly of a desperate desire to scrub 'home' away. Yet even the most inveterate traveller starts from somewhere once upon a time, somewhere called home, so does that starting point magically evaporate once a certain number of air miles have been clocked up? As Ulf Hannerz puts it in his dryly sceptical account of cosmopolitanism:

Perhaps real cosmopolitans, after they have taken out membership in that category, are never quite at home again … Home is taken-for-grantedness, but after their perspectives have been irreversibly affected by the experience of the alien and the distant, cosmopolitans may not view either the seasons of the year or the minor rituals of everyday life as absolutely natural, obvious and necessary.

(Hannerz 1990: 248)

In that respect, cosmopolitans are intellectuals who have chosen to self-dislocate, to dis-locate the self from its original placing. This may well be a recipe for broadening one's horizons (Hannerz sees cosmopolitanism as a branch of connoisseurship), but it can also be little more than an exercise in turning other people's homes into raw material for the self-absorbed self-development of the visiting, privileged traveller – think of all those ineffably patronising white English students who 'do India' in their university vacations. Such cosmopolitans are in the business of turning travel into trophies, making 'surrender abroad into a form of mastery at home' (Hannerz 1990: 240), they bring home their supposedly non-touristic immersion in exotic elsewheres as a badge of existential depth, much as Victorian tiger-hunters filled their Surrey villas with the striped carcasses of their slaughtered quarry. One reason they did so was to keep the ordinariness of Surrey at bay, to assert cultural status by putting a distance between themselves and those who had stayed locked in the everyday embrace of 'home'. Cook suggests that culture is just a collection of souvenirs, and for the inveterate cosmopolite maybe it is, but souvenirs are mementoes of places visited infrequently. You don't need souvenirs of where you live, because the

culture of everyday life there embeds you in a complex, slow-moving set of rooted relations. Unless you are so spectacularly cosmopolitan as to be forever gallivanting (a tiny, disproportionately influential, clique of individuals), or so unfortunate and dispossessed to be constantly displaced from where you would like to be (a much larger group than the cosmo-clique but one with scarcely the slenderest fraction of its cultural capital), you don't need souvenirs of home.

Perhaps I have been unfair to Cook's arguments, especially since they are only a brief introduction to a lengthier and predominantly splendid defence of British cinema's much-maligned Gainsborough melodramas, in which Cook persuasively identifies a dissatisfaction with constrained versions of 'home' as a key element in the appeal of those 1940s films for female British audiences. Besides, Cook stands no chance of being the most extreme tub-thumper for the cosmopolitan cause while there are those like Bryan S. Turner making such a concerted lurch to snatch that title. In the course of a brief essay aiming innocuously to summarise the ideas and importance of the Palestinian–American theorist Edward Said, Turner announces, with a startlingly reductive over-certainty, that 'anybody who takes the calling of an intellectual life seriously cannot be at home in their home' and that 'the radical intellectual is always an exilic intellectual' (Turner 2001: 383, 384). Such claims espouse both a determination to equate intellect with rootlessness (a very male, very white, very bourgeois pose drawn more from second-rate road movies and fifth-rate Bruce Springsteen songs than from any more thoughtful sources) and a distinctly condescending exile-envy, where the settled Western intellectual whiningly pines for the dislocation chic of the thinker from less privileged circumstances. That the exiled or diasporic intellectual may in fact be filled with grief or longing for the place they have left or been obliged to leave never seems to occur to Turner. In the mindset he embodies here, strutting its adolescent stuff at the most extreme outpost on the cosmopolitan trail, anyone interested in 'home' is a lower form of intellectual life, though happily there are numerous more rounded studies which take 'home' very seriously indeed, paying appropriate attention to the complexities and ambivalences of the concept. (For important examples of such work, see Massey 1994; Brennan 1997; Naficy 1999; Friedman 1999; Morley 2000.)

One way of dealing with the complicated implications of 'home' is to rename and reposition it as 'the local', a term almost invariably deployed in a binary relationship with the term 'global'. Mike Featherstone acknowledges that in the face of the globalisation steamroller, 'the desire to return home' exerts a powerful allure, 'regardless of whether the home is real or imaginary' (1996: 47) and he, along with many others, dubs this desire localism. Stuart Hall has also spoken of the power of the local, its comforting sense of manageable familiarity; the local, he states, offers:

> a respect for ... roots which is brought to bear against the anony-
> mous, impersonal world of the globalised forces which we do not

understand ... fact-to-face communities that are knowable, that are locatable, one can give them a place. One knows what the voices are. One knows what the faces are.

(Hall 1991: 35)

Michael Ignatieff concurs, with this observation about belonging: 'To belong is to understand the tacit codes of the people you live with; it is to know that you will be understood without having to explain yourself. People, in short, "speak your language"' (1993: 7). Many of these comments are very suggestive in regard to comedy – the bond of belonging that unites comic performer and comedy consumers is very much one of tacit codes and knowable, locatable voices, as most of the later case studies in this book hope to testify. There is always, however, a danger of romanticising the local space of home. It tends, covertly or flagrantly, to be held up as a site of good, with the global thereby rendered bad – in Alan McKee's neat summary, such a binary means ' "Global" is shorthand for "global capitalism"; and "local" is shorthand for "local resistance"' (1999: 181). Under such a rubric, a kind of rose-tinted down-home moralism can hold sway, where global means homogenised, invasive and inauthentic, and local stands for distinctive, rooted and true. This picture – a fairy tale where Ronald McDonald is the Big Bad Wolf menacing the Three Little Pigs of authenticity, organicism and community – is somewhat simplistic, yet romanticising home is always a temptation. What might be called the knowability of home offers real comforts, comforts that popular comedy is both very eager to evoke and very accomplished at providing.

Waved and unwaved flags

I have often wondered why it seems so hard to uncouple national from nationalistic, particularly when there are so many evident examples of cultural phenomena that clearly stem from a specific national context without remotely advocating nationalistic views. Paul Willemen makes this important point with reference to an especially pertinent case study, films made during the 1980s and 1990s by black British filmmakers such as John Akomfrah, Maureen Blackwood and Isaac Julien. These films, Willemen insists, 'are strikingly British, and yet in no way can they be construed as nationalistic. They are part of a British specificity, but not of a British nationalism' (Willemen 1994: 209). Exemplary proof of this can be seen in the BBC documentary *A Touch of the Tarbrush*, made by John Akomfrah in 1991, which took as the starting point of its reflections on ethnic hybridity in England a section from J.B. Priestley's 1934 book on the meanings of Englishness, *English Journey*. After decades of disdain from the intellectual establishment, Priestley is now becoming an increasingly cited reference point in debates about Englishness (see Davey 1999; Baxendale 2001, and several occurrences in this book), but it is noteworthy that the first and

very prescient indication of this came from Akomfrah, whose illuminating film is both wholly nationally specific and utterly anti-nationalistic. Like Willemen, John Hill has argued that 'it is quite possible to conceive of a national cinema which is *nationally specific* without being either nationalist or attached to homogenising myths of national identity ... which works with or addresses nationally specific materials ... [but] which does not assume the existence of a unique or unchanging "national culture" ' (Hill 1992: 16, emphasis in original). In which case, is it feasible to reserve for the term 'national' a less rigid, a less ideologically predetermined, even a value-free matrix of meanings, leaving 'nationalistic' as a more precise term designating the aggressive defence or celebration of a nation state? Judging by the drift of his fascinating book *Banal Nationalism* (Billig 1995), Michael Billig would answer with a very loud no. For Billig, the glue fixing that 'istic' on to 'national' is impossible to dislodge, though it is applied in largely unnoticed ways, via what he terms banal nationalism. This is not the brazen nationalism of the ceremonial ritual but a surreptitious dripfeed that passes nationalistic assumptions into every citizen's veins; it is 'not a flag which is being consciously waved with fervent passion; it is the flag hanging unnoticed on the public building' (1995: 8). This matters, Billig argues, because such everyday, banal national imagery fosters an ongoing sensibility of belonging that can swiftly be cranked up into more aggressive forms of national assertion should the 'need' arise – the paramount kind of 'need' being war. Banal nationalism creates the conditions of belief in which it is widely thought that 'the homeland is ... worth the price of sacrifice' (175).

Billig tirelessly seeks out signs of banal nationalism, those unnoticed everyday unwaved flags, ranging from the cartographical ideologies of television weather maps that I mentioned earlier to the unremarked use of plural pronouns ('we' or 'us' meaning 'the British') in media news and sports coverage. By highlighting these, he defamiliarises them, instructively revealing how the attachment to imagined community is so deeply ingrained as to seem wholly natural. Given the globalised culture he and his readers inhabit, Billig sees a refusal to shed the nation as baffling and troubling, he declares himself keen to discover 'the reasons why people in the contemporary world do not forget their nationality' (7). Yet he seems not to recognise the most important reason, even after having put it into print. In a section of the book coyly titled 'A Confession', Billig acknowledges his own participation in supporting British teams or individuals in sporting events: 'If a citizen from the homeland runs quicker or jumps higher than foreigners, I feel pleasure. Why, I do not know' (125). And again: 'International matches seem so much more important than domestic ones; there is an extra thrill of competition, with something indefinable at stake' (125). This evasive disavowal is both disappointing and odd; from a man of Billig's evident perceptiveness, 'I do not know' really won't do. He does know, like I know from weeping with frustration and (exceedingly occasionally) joy at watching England play international football, that although the 'something at stake' may

be in some ways hard to define, it is certainly not hard to name. Its name is belonging, a feeling of mostly illusory yet deeply sustaining togetherness, a point of heightened intermingling between (in Balibar's terms) individual existence and collective weft.

Perhaps an esteemed social scientist like Billig feels the need to retreat from the full implications of his 'confession' since those implications are fundamentally emotional ones, or perhaps extreme emotional involvement in a football match is, to recall Allon White's terminology, just too playground to find a place in the classroom. Whatever the reason, belonging's emotional pull, its invitation to join the embrace of like-mindedness, leaves him at a loss for words. There are two further limitations in his study that need mentioning here. Firstly, he is at sea with the issue of tone as he is with the problem of emotion. A flag for him is always an index of nationalism, yet how would he account for a flag waved ironically or subversively or in vulgar jest? A Union Jack is not an uncomplicated sign, and its already complex implications can be further complexified by changing contexts. It can be waved to punctuate the shouts of 'rights for whites' at a neo-fascist rally, turned into shorts to encase the groin and backside of a stereotypical lager lout, sit rolled up in the conservatory of some politically dubious neighbours who live in the street next to mine, be draped around a black British medal-winning athlete in international competitions, adorn Noel Gallagher's guitar as part of the mid-1990s Britpop sensibility, barely cover the torso of the Spice Girls 'girl power' propagandist Geri Halliwell, flutter on the top of amusement arcades on Brighton seafront, squat like a spider in the corner of the flags of some Commonwealth countries, bloom in multitudinous hands at the climax of that annual orgy of queasy middlebrow jingoism The Last Night of the Proms, or be consumed by flames in the Sankofa Film Collective's moving and angry meditation on British racism, *Territories* (one of the films cited by Paul Willemen in his observations on the differences between British specificity and British nationalism). Given those, and thousands of other, possibilities, Billig's stance of seeing that flag as an unvarying icon of nationalistic promotion seems a little reductive. I have even seen Union Jack patterned toilet seats for sale, and it would require extravagant ingenuity to see that usage of the flag as an index of unalloyed chauvinistic pomp. There is also the complex relationship to consider between the Union Jack as a flag indicating Britishness and the flag bearing the cross of St George as a symbol of Englishness, the latter becoming increasingly common amongst fans supporting English teams at sporting events (though what are we to make of those who do not remove their St George flag once the sporting event is over?). The second shortcoming in Billig's argument is that he doesn't have any substantial alternative to put in place of the nation as a rallying point for the expression and satisfaction of belonging. He makes a few loose asides about the benefits of cosmopolitanism, but there is nothing more. For a rather more sophisticated consideration of how to situate the nation within contemporary frameworks of cultural analysis, it is necessary to turn to the work of Paul Gilroy.

Putting the nation somewhere

Anyone (especially anyone English, and very especially anyone white and English) who attempts to write about the politics of identity in the context of the nation must look long and hard at Gilroy. He is one of the sternest and most implacable critics of certain visions of Englishness, as will be seen in the next chapter, but here I want to look at his interventions into wider conceptual debates over nation, belonging and identity. Gilroy has staged a long-running battle against what he calls ethnic absolutism, which he defines at one point as a viewpoint in which culture is seen as 'a fixed property of social groups rather than a relational field in which they encounter one another and live out social, historical relationships' (1993: 24). Under the flag of ethnic absolutism, versions of national belonging have tried to proclaim themselves as predicated on racial homogeneity and cultural fixity. Much of Gilroy's earlier work (especially Gilroy 1987) was dedicated to exposing the collusions between ethnically absolutist concepts of Englishness and the racist politics first given mainstream voice by the Conservative politician Enoch Powell and later, albeit in more coded forms, put into legislative practice by the government led by Margaret Thatcher. In the essays collected in *Small Acts* (1993), Gilroy began to take a slightly less confrontational, but no less passionate or politically urgent, stance. While he still remained convinced that the 'language of national belonging and patriotism has acquired a series of racial referents that … will not … go away' (1993: 67), he was also prepared to refer to himself as 'both black and English in addition to everything else that I am' (68). He still saw the nation as an inadequate, partial and often culpable configuration, but he recognised that as an important concept it needed to be studied and understood, hence while 'writing national histories … is certainly insufficient', it 'may still be necessary' (79). What he calls 'merely national histories' (72) can only ever tell some of the story, but their perspective can still yield insights. (I have, of course, a vested interest in emphasising this, since the book you are currently reading is very much a 'merely national history'.)

It seems to me that since the nation exists – even if some might prefer to wish it away by consigning it to the pre-history of globalisation, disavowing it under a flurry of cosmopolitan consumerism, stigmatising as 'infected' or 'childish' any who continue to see it as relevant, or evading it to shelter in the softer arms of 'the local' – then we have to follow Gilroy's parenthetical advice offered at the head of this chapter and 'put it somewhere'. In a later article Gilroy (1996) reiterated his argument that the nation needed dethroning from its pretensions to being any kind of governing master-category, but it had a place in an analytical framework where 'identities deriving from the nation could be shown to be competing with subnational (local or regional) and supranational (diaspora) structures of belonging and kinship' (1996: 47). Anthony Easthope helpfully echoes the last point in his claim, that while nationalism is a particularly directed form of political belief, the nation has no inherent ideological leanings,

being more of 'a ... lived experience in a relationship between social structures and subjectivity, more like kinship or religion or gender' (Easthope 1999: 8). As Easthope underlines (1999: 6), rhetoric pivoted on national belonging can serve aims at every point on the political spectrum – from Nazi atrocities at one pole to anti-imperialist struggles in Vietnam at the other. In Gilroy's most daring, eloquent and moving book, *Between Camps*, he looks deeper into the underpinning of identity. He sees it as a concept designed to divide – 'Nobody ever speaks of a human identity' (2000: 98) – but also as a way of making sense of the relationship between self and other:

> Identity helps us to comprehend the formation of that perilous pronoun 'we' and to reckon with the patterns of inclusion and exclusion that it cannot help creating. Calculating the relationship between identity and difference, sameness and otherness, is an intrinsically political operation. It happens when political collectivities reflect on what makes their binding connections possible. It is a fundamental part of how they comprehend their kinship – which may be an imaginary connection, though none the less powerful for that.
>
> (Gilroy 2000: 99)

Yet the danger of identity, he says, is that if it is appropriated 'in manipulative, deliberately oversimple ways' it can 'become a platform for the reverie of absolute and eternal division' (101). In certain ethnic arenas, identity issues become saturated with notions of biological difference, becoming 'something mysterious and genetic that sanctions especially harsh varieties of deterministic thinking' (103). The end result of this process is that 'identity ceases to be an ongoing process of self-making and social interaction. It becomes instead a thing to be possessed and displayed. It is a silent sign that closes down the possibility of communication across the gulf between one heavily defended island of particularity and its equally well fortified neighbour' (ibid.).

Faced with such gloomy probabilities, Gilroy proposes an audacious and utopian escape. He calls for a rejection of narrow identity categories in favour of a 'planetary humanism' (2), and as pointers towards that utopia he calls for and champions formations of cultural identification and belonging that draw on 'the idea of movement' rather than the 'sedentary poetics of either soil or blood' (111), that are 'placeless' (111), founded on 'will, inclination, mood and affinity' (133). He notes with particular approval 'diaspora identities ... creolised, syncretised, hybridised and chronically impure ... mutable forms that can redefine the idea of culture through a reconciliation with movement and complex, dynamic variation' (129–30). This may at first glance sound like cosmopolitanism, but if so it is significantly distinct from that souvenir-happy branch of the cosmopolitan tendency in which the already privileged raid the less well-placed in search of consumable exotica. Gilroy's vision of placelessness is a utopia of equal footings, not merely a disguised and denial-ridden

reworking of established geopolitical power relations. It is an exciting prospect, but not, I fear, one espoused by the comedies analysed in this book. In the field of English comedy, Gilroy's call for productively impure mutability might best be demonstrated by a television series like *Goodness Gracious Me*, where British Asian writers and performers meld and mash and mock and comedically mutilate precisely those fixed, fortified, heavily defended versions of ethnicity, nationality and belonging which Gilroy urges his readers to transcend.

Goodness Gracious Me is a text that signals one possible future, but the main focus of this book is historical, since as Gilroy insists in the opening pages of *Between Camps*, the histories of identity formation must be understood if its future is to avoid the mistakes of its past. That's not to say my intention in this book is to construct a catalogue of chastisement, reprimanding English comedies for the ideological shortcomings of their representations of ethnicity. It would be easy enough to write such a history, to weave a tapestry of dreadfulness that followed racist humour from the Irish stereotypes of music hall jokes and George Formby songs like 'Hindoo Man', via its apotheosis in that ambivalently monstrous Enoch Powell of the sitcom, Alf Garnett, to thoughtless irritants like *Mind Your Language* and worrying success stories like Jim Davidson. That is an important narrative, if a familiar one (as early as 1979, one of the first British television programmes to launch an influential attack on media racism took as its title *It Ain't Half Racist Mum*, a pointed swipe at the lamentable ethnic stereotyping of the hit 1970s sitcom *It Ain't Half Hot Mum*), and I have contributed to those debates elsewhere (Medhurst 1989). Nonetheless I want to spare this book the fate of degenerating into a protracted exercise in white liberal guilt, of succumbing to what Dave Russell has called, in a critique of the over-use of hindsight, 'a tendency to offer political theory lessons to dead generations' (1997: 141). Neither does it seem appropriate for this white-written book to look in detail at comedies rooted in black British and Asian British experience. It will be more challenging, and more attuned to the complex politics of comedic discourse, to look at how notions of white Englishness – after all, to paraphrase Gilroy, I am white and English in addition to everything else I am – are variously established, defended, qualified, refracted, reinforced, subverted, protected, implicated and extrapolated in a series of key comic sites. Before that, however, I need to map out one final framework, which will forgo the relative generalities of this and the previous chapter, in order to engage more directly with the difficulties of Englishness.

Chapter 4

Englishnesses

The moment of the rediscovery of a place, of one's roots, of one's context, seems to me a necessary moment.

(Hall 1991: 36)

The fragility of all identifications is the reason for the constant political and cultural attention which is paid to our national identity … If it were simply Old, Deep and Enduring, Englishness, like an oak table, wouldn't need much more than an occasional polish.

(Davey 1999: 20)

England's as happy
As England can be
Why cry?

(The Sundays, 'Can't Be Sure', 1994)

According to Robert Colls and Philip Dodd, 'Englishness has had to be made and re-made in and through history, within available practices and relationships, and existing symbols and ideas' (1986: Preface). The main aim of this book is to explore how and where comedy fits into those processes, since I see comedy as absolutely central to their operation. Comedy, after all, is a cultural and social practice that is both shaped by and contributes to historical conjunctures; it pivots on contested and ambivalent relationships of power; it constitutes a repository of symbols that can be drawn on to indicate how, where and why people place themselves; it is a prime testing ground for ideas about belonging and exclusion. What I hope to show in later chapters is that amongst the multitudinous versions of Englishness that were in circulation during the twentieth century, many have been played out, overtly or covertly, on comic sites. Before investigating a series of case studies of such sites, however, this chapter seeks to sketch some of the ways in which the idea of Englishness has been conceptualised.

Englandographies

Many writers who have aspired to reflect on the meanings of England and
Englishness share an addiction: they seem compelled to make lists. Every
Englandologist, it seems, needs an Englandography, a talismanic catalogue of
the images, individuals, places, sounds, qualities, events, moments and texts
that conjure up and exemplify the version of Englishness each writer seeks to
advance or endorse. It would not be inappropriate, then, to begin this chapter
by listing a few of those Eng-lists which strive to pinpoint the English. Some
of them are well known and much-cited reference points in the evolving and
contentious debate over what Englishness might mean, while others are less
familiar but usefully indicative of the themes I want to explore both explicitly
in the rest of this chapter and implicitly throughout the remainder of this book.
Such a collage will, I hope, bring into play some of the key tropes, myths and
landscapes which comprise the vocabulary and grammar of the English ques-
tion. A suitable starting point is the (in)famous list that formed the centrepiece
of a speech made in 1924 by Stanley Baldwin. A leading Conservative politician
who would become Prime Minister for three separate terms of office, Baldwin
painted an English picture which was wholly rural, steadfastly anti-modern, and
made up of sensations (sights, sounds, smells) rather than thoughts or ideas:

> England comes to me through my various senses ... The sounds of England,
> the tinkle of the hammer on the anvil in the country smithy, the corncrake
> on a dewy morning, the sound of the scythe against the whetstone, and the
> sight of a plough team coming over the brow of a hill, the sight that has
> been seen in England since England was a land ... The wild anemones in
> the woods in April, the last load at night of hay being drawn down a lane
> as the twilight comes on ... and above all, most subtle, most penetrating
> and most moving, the smell of wood smoke coming up in an autumn
> evening ... These things strike down into the very depths of our nature,
> and touch chords that go back to the beginning of time and the human
> race ... These are the things that make England.
>
> (Giles and Middleton 1995: 101–2)

Seventeen years later, during the Second World War, George Orwell borrowed
Baldwin's method of depicting Englishness through impressionistic imagery to
offer the following list:

> The clatter of clogs in the Lancashire mill towns, the to-and-fro of the
> lorries on the Great North Road, the queues outside the Labour Exchanges,
> the rattle of pin-tables in the Soho pubs, the old maids biking to Holy
> Communion through the mists of the autumn morning – all these are
> not only fragments, but *characteristic* fragments, of the English scene ... Yes
> there *is* something distinctive and recognisable in English civilisation ... It is

somehow bound up with solid breakfasts and gloomy Sundays, smoky towns and winding roads, green fields and red pillar-boxes. It has a flavour of its own. Moreover it is continuous, it stretches into the future and the past, there is something in it that persists.

(Orwell 1970: 75–6, emphasis in original)

Many of Orwell's specific items embrace broader, more modern social or cultural actualities which would have horrified Baldwin (industry, unemployment, the North of England, motor transport, Americanised popular culture), but the underlying device remains the same, England apprehended through a kind of sensual montage and serenaded by a selectively panoramic lyricism, and both lists share the commitment to continuity and tradition. It is probably that last point which enabled a much later Conservative Prime Minister, John Major, speaking in 1993, to appropriate, not exactly accurately, the most Baldwinesque component of the Orwell list for his own short menu of English essentials:

Fifty years from now, Britain will still be the country of long shadows on county grounds, warm beer, invincible green suburbs, dog lovers and pools fillers and – as George Orwell said – 'old maids cycling to holy communion through the morning mist'.

(Quoted in Paxman 1998: 142)

Major was much ridiculed for the dated quality of his imagery, but the controversy sparked by the speech showed how this kind of listing, for all its evident limitations, could still generate heat over the contours and contexts of Englishness.

Let's scrutinise some more of these Eng-lists, from a variety of historical moments. For the eminent film critic C.A. Lejeune, writing in the 1930s, the comedy star Gracie Fields was 'as much a part of English life as tea and football pools, our green-hedged fields and the Nelson column' (quoted in Higson 1995: 103). For the poet T.S. Eliot, a decade later, English culture was symbolised by 'Derby Day, Henley Regatta, Cowes, the twelfth of August, a cup final, the dog races, the pin table, the dart board, Wensleydale cheese, boiled cabbage cut into sections, beetroot in vinegar, nineteenth-century Gothic churches and the music of Elgar' (1948: 31). In a curious 1970s anthology called *The English Experience* (Jennings and Gorham 1974), the nation reveals itself in village fetes, allotments, trade union banners, market towns, pigeon racing, fox hunting, working-men's clubs and steam trains, offering a patchwork quilt of English threads so accommodating that even the then-shocking Glam Rock tactics of David Bowie could be soothingly defused into a national tradition of eccentric individualism. In Martin Parr's 1999 BBC documentary *Think of England*, images of Englishness included the Henley Regatta, the Glastonbury Festival, suburban streets, village fetes, seaside resorts from the brash buzz of Blackpool to the sedate quaintness of Hunstanton, teenage drunks crowding

the pavements of market towns, and an elderly man cheerfully championing the racist politics of Enoch Powell. For an English journalist returning home in 2001, after some time working in the United States, listening to the radio while driving 'down a still-bright Cornish lane well past 9 PM, hearing Mozart's 40th Symphony bursting out, live, from Cheltenham Town Hall: that's what it means to be English' (Stephen 2001: 21). For one Anglophile Dutch writer, everything emblematic of Englishness can be found along one road that runs for ninety miles across Sussex and Hampshire: 'There is more to England than the A272. You knew that. Of course. But my contention is that at the end of these ninety miles you have already seen it all. The A272 is the most English of English roads. With all its history. With the people along the way. With its hills and valleys, its forests and rivers, its towns and villages … The A272 is England' (Boogaart 2000: 191–2). Jeremy Paxman specifically set out in his book on Englishness to deliver a contemporary spin on Orwell and lists forty-seven ingredients in his recipe for Englishness, ranging from Cumberland sausages to twitching net curtains, Women's Institutes to punk, curry to *Monty Python* (1998: 22–3). If asked to provide my own Eng-list (and I would not require much prompting), it would go something like this: *Coronation Street, Brief Encounter, Inspector Morse*, 'I Want To See The Bright Lights Tonight' by Richard and Linda Thompson, Blackpool Tower Ballroom, the Grand National, 'Waterloo Sunset' by The Kinks, queuing up properly, Shepherd Neame beer, Eccles cakes, 'The Poacher' by Ronnie Lane and Slim Chance, the novels of Barbara Pym and E.F. Benson, the voices of Robert Wyatt and Eliza Carthy, 'Ghost Town' by The Specials, *Michael Barrymore's My Kind of Music*, Jack Hawkins in *The Cruel Sea*, 'Billericay Dickie' by Ian Dury and the Blockheads, Sheringham in Norfolk on a Sunday afternoon, Mansfield in Nottinghamshire on a Friday night, '(White Man) In Hammersmith Palais' by the Clash, the *Radio Times*, seaside piers, chip-shop-curry-sauce flavour peanuts, 'Nightvisiting' by Jim Moray, any speech by Boris Johnson, any television series written by Kay Mellor or Debbie Horsfield, any film with Kathleen Harrison or Sam Kydd or Phyllis Calvert, 'Babies' by Pulp, Lubin's café on the seafront at Morecambe, the view from the south wall of Greenwich Park towards Blackheath Village, the view of the Uncle Joe's Mintballs factory from Wigan North Western station, 'There Is A Light That Never Goes Out' by The Smiths, and, of course, the vast majority of the comic texts and practitioners surveyed in this book.

Another listing tendency avoids selecting cultural artefacts in favour of character traits seen as particularly heightened among or redolent of the English. There is a long history of this, as Paul Langford demonstrates in his study of how English identity was perceived between the mid-seventeenth and mid-nineteenth centuries (Langford 2000). His conclusion is that perceptions of English specificity, as seen by mostly European writers during those eras, can be grouped into six broad characteristics, which he terms energy, candour, decency, taciturnity, reserve and eccentricity. Proof that such lists are not

merely historical artefacts can be found in Jeffrey Richards' book (Richards 1997) on British cinema and British national identity (though in fact it is a book primarily about English cinema and Englishness). This is peppered with mini-lists of what he sees as long-standing and exemplary national characteristics – 'honour, duty, service, decency' (19), 'compromise, law-abidingness … individualism, anti-intellectualism' (17), 'Chivalry and sportsmanship' (20), 'tolerance, fair play and restraint' (25). Richards' book traces with dismay the cultural shift from the stiff upper lip of the classical English sportsman to 'the sight of unshaven, track-suited, lager-swilling English cricketers' (4) giving a television interview. Those same unshaven chins unsettle an infinitely more reactionary writer than Richards, the journalist Clive Aslet, whose book *Anyone for England?* is a protractedly spiteful howl of resentment against the changing shapes of English identity. As well as those scandalously bristly cricketers (Aslet 1997: 47), his markers of un- or anti-Englishness include lesbians having babies through artificial insemination (61), pub menus that favour Mexican pork over Lancashire hotpot (77), people openly spitting in the street (137), and the fact that historic buildings are required to modify their architecture in order to give access to wheelchair-users (244). For the conservative philosopher Roger Scruton, whose book *England: An Elegy* (Scruton 2000) offers a more considered right-of-centre counterpart to Aslet's rantings, there are several regrettably lost or worryingly threatened emblems of authentic Englishness. His Eng-list, scattered delicately through various chapters rather than subjected to anything as vulgar as the tabulation I shall now impose upon it, includes the Reithian BBC, the obligatory study of Chaucer, un-modernised Anglican church services, repressed homosexual desire between schoolmasters and their male pupils, Ealing Studios films, addresses without postcodes, Gothic revival architecture, bell-ringing, gentlemen's clubs, barn owls and newts.

Many Englands are on offer here, all begging multitudes of questions, some complementing each other and some contradictory, and matters could be complicated still further by adding further listings from those who compiled them, not out of unashamed affection or ambivalent attachment, but expressly in order to show the perceived shortcomings of England and the English. Despite the profusion of examples on display, however, these lists do demonstrate certain similarities. The cultural artefacts listed, for example, are predominantly white and male, which should come as little surprise given that every list-maker cited except one (the C in C.A. Lejeune stood for Caroline) is a white man. I don't say that to score cheap points, but as a shorthand way of indicating that other identity formations besides 'the national' will always inflect and interweave with any individual's attempt to delineate emblematic Englishness, given that national identity is only ever one element in the 'mosaic of subjectivities' (Howe 1989: 137) that make up any person. The lists also tend towards the retrospective, most spectacularly so in the case of Stanley Baldwin, where Englishness is abducted from any recognisably specific historical setting to be held hostage

in a decontextualised domain of mythologised nature, seeking validation in a soft-focus version of a deep and deeply vague past. Even in the less nakedly myth-mongering lists, a degree of looking back is frequently present, stemming perhaps from the feeling that it is safer to nominate as 'very English' things that have shown themselves amenable to that description over a period of time, though a less charitable analysis of the retrospective drift of the lists might also point out that their whiteness is also relevant here, in that it is easier to sustain an equation between whiteness and Englishness if more recent English culture is by and large excluded. As Clive Aslet's blimpish attack on lesbians and wheelchair-users discloses, what and who these lists leave out, stigmatise as inauthentic or wish to expel is just as revealing as what they put in (thus bearing out Stuart Hall's contentions on identity as discussed in Chapter 2). Hence Boogaart's eulogy to the A272 speaks volumes through its silences, in that his snapshot of 'England' leaves out of its frame all those Englishnesses that do not remotely resemble the mostly middle-class, almost exclusively white, culturally privi-leged, Conservative-voting, heritage-saturated terrain crossed by his favourite road. (A very different England would be conjured up by a book that sought to lionise the A627 from Oldham to Rochdale.) The comfortable stretch of the South which leaves Boogaart so besotted is indeed an England, but to award it iconic status, rather than recognise it as one England among many, lets loose a whole slew of hierarchies, assumptions and values. Similarly, what seems like the disproportionately intense froth of anguish worked up by Richards and Aslet over a few unshaven cricketers is both explicable and revealing once you realise the symbolic significance of the figure who stands as those cricketers' opposite, the ideal they defile with their slovenly yobbishness, the implied Other at whose shrine Richards and Aslet wish (and wish us) to worship – the clean-living, square-jawed public-school cricket captain, embodying tradition, duty, class hierarchy and heroic manliness as he slots away another drive to the sun-dappled boundary.

One final list needs considering here. Writing at the beginning of the 1990s, Bernard Crick noted how few studies had been written by English writers on the question of Englishness, and speculated as to whether that paucity itself revealed a prevailing set of English characteristics, what he called 'conservatively English traits of understatement, taking things for granted, distrust of theory and explicitness ... a calm contentment that needed no words, and euphemism and suppression' (Crick 1991: 92). Crick's suggestion is an intriguing echo of another comment made (with, all things considered, striking hypocrisy) by Stanley Baldwin in 1930: 'the Englishman ... is not apt to speak before strangers either of his land or of himself, and when he does the less English-man he' (preface to Priestley 1930: v). What Baldwin describes here might be characterised as the blithe silence of the confidently powerful. Baldwinite Englishness had little need to reflect on its constituent parts and inner work-ings as long as it could subscribe to the fiction of its own innate superiority, a fiction buoyed up by Baldwin's studiously misty rhetoric of timelessness

and tradition (for more on Baldwin, see Schwarz 1984). This may help to explain why Crick's comments about the absence of a substantial 'literature of Englishness' now seem so oddly dated. His 'calm contentment that needed no words' has given way in the years since to a clamorous babble comprising more and more discussions of Englishness – this book is yet another – and the reasons are clear. The serene myths of Baldwin's Englishness, and the untroubled arrogance that they cloaked, have been rendered absurd by a combination of social and cultural changes too familiar to need detailed consideration here – Scottish and Welsh devolution, the particularly tense complexities of Northern Ireland, snowballing European integration, increasing ethnic diversity (and at times ethnic conflict) within England and Britain, and the onslaught against any sense of national culture from the 'borderless' new communication technologies. Consequently, conventional Englishness can no longer pretend to occupy any guaranteed position of cultural centrality, which means that it can no longer take itself, its place or its power for granted. That's an especially uneasy realisation for the English to make, since, as Crick's list announces, taken-for-grantedness has always played a large role in conventional conceptions of Englishness. In the mid-1990s, the social psychologist Susan Condor conducted a study of what English people felt about being English, and found that few of her sample had particularly strong nationalistic feelings. She concluded that 'the non-salience of Englishness may be attributed to the security of the national category' (1996: 57), and that this in turn suggested that 'group membership may be less salient to members of dominant social groups' (59). Any security or dominance attached to Englishness, however, is rapidly evaporating, meaning that much as masculinity, heterosexuality and whiteness have become objects of intensified reflection and study once those identities' assumptions of cultural dominance were called into question, so Englishness is now open to increasing interrogation. Crick's 'euphemism and suppression' are unable to handle such a scenario – questions are being asked about Englishness all the time now (Colls 2004 and Weight 2002 offer useful examples of this trend), and the rest of this chapter aims to sift through some of them.

Mythical maps and comic geographies

If Englishness is currently undergoing some species of identity crisis, then this is not only a matter of what Englishness might mean, it also involves the question of where England is. This may sound strange – hasn't the physical shape of England and its spatial relationship to neighbouring territories been fixed for some considerable time? Perhaps, but the picture is more complicated than it first appears, not least because space, place and location have repeatedly featured in debates over English identity. Many of the lists cited in the previous section reveal or assume particular geographical preferences (that *this* part of England is more typical or emblematic than *that* part), and geographical terminologies have always been crucial in attempts to define English specificity. There are

centuries of rhetoric, from Shakespeare to Churchill and beyond, that trumpet the English as an 'island race' or England as an 'island nation', even when the most cursory glance at a map of England will expose the plain wrongness of such a claim. England shares an island with Scotland and Wales, and the state of the United Kingdom encompasses yet more islands and parts of islands, to the extent that one historian has suggested that 'Britain' or 'the British Isles' might be better thought of as an 'Atlantic archipelago from Sark to the Shetlands' (Pocock 1995: 295). Yet the discourse of England-as-island has a symbolic currency that overrides mere accuracy, for to think of England as an island not only evokes ideologically conservative narratives of embattlement and isolation (see Cohen 1998 for a telling account of this), but also colludes in the politically loaded linguistic slippage that conflates England with Britain. This is a mistake commonly made by non-British commentators on British culture (almost every American academic account of British cinema will at some point sloppily use 'England' and 'Britain' as interchangeable counters) and sometimes, more alarmingly, by English writers themselves. Jeffrey Richards, for example, covers representations of Scotland, Wales and Ireland in British cinema in a section of his book called 'Regions' (Richards 1997: 175–251), a decision which might most generously be called curious.

My concern in this book, however, is very much English comedy. 'British' always strikes me as an evasive, baggy, smothering label, its limitations soon exposed once I reflect, for example, on the times I have spent as an Englishman in Scotland. This does not mean I cannot enjoy Scottish comedy – my life would be significantly impoverished without the bone-dry drollery of Chic Murray or *Rab C. Nesbitt*'s lust for life (on the latter see McArthur 1998) – but it does mean I am very aware that there are reference points, assumptions, imaginaries and sensibilities built into Scottish comedy (in effect, a multiplicity of Scottish-nesses) that I can never know from the inside, leaving my appreciation of those comedies inevitably placed at some remove. My relationship to comedies of Englishness, however, is rooted in an inside view. But inside where? If Scotland and Wales are full of contested identities and internal divisions (Bowie 1993 is instructive on the tensions within Welsh cultures, while Ascherson 2002 brilliantly dissects the complexity of trying to pinpoint the meanings of Scotland), and the matter of Ireland is even more complex and intractable, then it is impossible to deny that the same processes operate inside and across England. In 1861 a parliamentary committee investigating the mining industry had to hire an interpreter to translate the 'English' spoken by Northumberland miners (Samuel 1998: 54), and if such an extreme example seems unlikely today, there are still innumerable cases of regional difference across England, leaving the whole notion of Englishness perilously close to detonation from within. What can Clapham have in common with Cornwall (especially given the discourses of Celtic culture and romanticised isolation operative in the latter – see Vernon 1998)? Are the suburbs of Ipswich more or less English than inner-city Manchester? Are Sunderland and Chipping Sodbury in the same England

at all? Pursuing such questions can lead to irresolvable fragmentation, where any sense of English collectivity shatters on the sharp edges of clashing regionalities. This is precisely where myths of Englishness step in, offering balm for the wounds caused by such shattering. The sustaining fiction of Englishness is the fiction of unity overriding difference, where contradictions and conflicts wither overshadowed by rhetorics of common purpose and shared tradition.

Baldwin may have resisted associating his immemorially pastoral England with any recognisably specified terrain, but there seems little doubt that for the wider conservative mindset in which he was such a pivotal figure, the rural England that stood for Englishness was specifically located in the south of the country (see Howkins 1986). That equation, with all the networks of inclusion and exclusion that it implied, swiftly took root in popular discourses. A travel book written in the 1950s for American tourists visiting England contains the following assertion:

> the three south-eastern British counties – Kent, Sussex and Surrey – are, for Americans brought up either on calendars or on Chaucer, the classic England of our dreams. East Anglia is flat, fascinating and strange; the Border Country is unaccountably wild; even the Cotswolds and the golden stone villages of the Shakespeare country are a surprise. But Kent *is* the picture on the calendar, Sussex *is* the illustration from the sixth-grade geography book, Surrey *is* the travel poster ... This *is* England.
>
> (McKenney and Bransten 1951: 196–7, emphasis in original)

This book took its exclusions seriously: it prints a map of England on which not a single town or city in Lancashire or industrial Yorkshire is recorded. The North figures in terms of market towns and ruined abbeys, a manageable 'heritage North', but industrial England is erased (though an equivalent book today might well include sites in the North where the architectural remnants of extinguished industries have been turned into 'heritage'). Given such evidence, it would be easy to equate the Southern rural template of Englishness, which is still alive and well in Pieter Boogaart's love letter to the A272, with a political disposition of conservatism, nostalgia and anti-modernity. Many have done so, seeing the English romance with rusticity as little more than a reactionary exercise in avoiding the realities of modernity (see Worpole 1989), but this does not mean, as both Alison Light (1991) and David Matless (1998) have shrewdly pointed out, that either conservatism or nostalgia are uncomplicated terms. The complexities of that debate are beyond the scope of this chapter, but it is important to note here, given the theme of this book, that the tracts of England and the tropes of Englishness venerated in celebrations of the rural are strikingly lacking in comedy. A map of England drawn from a comedic perspective could erase the rural South just as confidently as McKenney and Bransten's travel guide obliterated the industrial North. The capital of Comedy England might well be Blackpool, and Manchester, Wigan, South Yorkshire,

Birmingham, Tyneside and the East End of London would all be significant centres of power. It is far more an Orwell England, even here and there a Major England, than a Baldwin England. As Victoria Wood epigrammatically put it in a 1996 interview on *The South Bank Show*, 'There's no comedy in scenery', and the history of English popular comedy in the twentieth century would appear to bear this out. Such comedy is overwhelmingly urban, springing from cities or industrial towns, flexing its muscles at the seaside resorts visited by the urban working classes, occasionally taking a bourgeois detour into suburbia to visit Ealing Studios or the trim lawns of sitcom (on the latter, see Medhurst 1996). Baldwin's corncrake, it's safe to say, would struggle to make itself heard at Blackpool Pleasure Beach.

In the myth-topographies of rural England, the vulgar delights of the sea-side holiday were replaced by an appreciation of nature, a respect for tradition and a mystical reverence for the land itself. Urban dwellers who explored the countryside were expected and instructed to abide by those parameters, with considerable anxiety arising from working-class trippers who behaved 'improperly' in rural spots, resulting in what David Matless has called an 'ecology of pleasures [which] maps people and their practices onto environments ... assumes an unbridgeable and hierarchical cultural geographical divide, whereby if one enjoyed, for example, loud music and saucy seaside humour, one could not and would not want to connect spiritually to a hill' (1998: 68; see also Matless 2000b). The reference to the seaside here is crucial: the seaside is a key site of comedic Englishness precisely because it brought the raucous brashness of the industrial city into a previously non-urban domain. The seaside, with its carnival emphasis on the temporary unsettling of everyday social, cultural and sexual norms, was a space for taking risks, where the repressions and constraints which bounded social life for all the non-holiday weeks of the year could be tested and occasionally defeated. In 1946, for example, Frank Randle's Blackpool summer show was subjected to a prosecution for obscenity, and much of the discussion in court centred on 'the difference between what may be considered offensive at the seaside as opposed to what is offensive nearer the hearth' (Nuttall 1978: 83).

The English geographies that recur in this book, then, are almost entirely urban, with a side order of seaside. (For further reflections on the significance of the seaside, see Chapters 8 and 10.) This is not meant to imply that rural Englands are wholly devoid of laughter, but Victoria Wood's one-liner does seem broadly accurate. There are, inevitably, exceptions – British television's longest-running situation comedy, *Last of the Summer Wine*, makes much of the rural landscape of Yorkshire, but as its title and its mostly elderly cast imply, the flavour of the series is retrospective, its pace is sedate, and it seems happy to utilise rural locations as an index of a gently declining, largely superseded English imaginary. Its continuing popularity resides in its ability to offer its audience a comforting soak in a herbal bath of bucolic backwardness. A similar strategy earned huge ratings in the early 1990s for *The Darling Buds of May*, another

comic wallow in retrospective rurality, but in this case with an acknowledged, and lavishly recreated, period setting (the 1950s), rather than the covert anti-contemporary emphasis of *Summer Wine*, which although set in the present day bears infinitely little resemblance to any England of the past forty years. One of the few English television comedies to risk a different rural scene was Simon Nye's remarkably dark, edgy and underrated series *How Do You Want Me?*. Set in a tiny Sussex village, not far at all from that neo-Baldwinite highway the A272, it showed how a new arrival in the village (an Irishman from London, thus doubly different and doubly distrusted) was received by the far-from-bucolic locals with a mixture of suspicion, cruelty and even violence. It was hardly the rustic England of soft-focus myth, and it was at times hardly comedy either (as signalled by its unusual lack of a laugh track), so sour was its vision and so difficult is it to place contemporary comedy in the countryside, unless that comedy is as flat and bland as all those cases of *Summer Wine*, as unabashedly reactionary as the hugely successful sitcom *To The Manor Born*, which from 1979 to 1981 turned audiences into forelock-tugging peasants peeking gratefully into the lives of the landed gentry, or as debilitatingly retrogressive as *The Vicar of Dibley*, the cloying village sitcom in which Dawn French supervises a cast of comic relief country-bumpkins not often seen beyond the confines of a Miss Marple novel or that most wholly rural and wholly conservative of Ealing's English comedies, *The Titfield Thunderbolt*. (More recently, *The League of Gentlemen* launched a frontal assault on conventional comedic ruralism by setting its deep-dark antics in a village planted as much in horror film soil as in sitcom territory, but as a twenty-first century text it lies outside the scope of this book.)

Liberal guilt and suet puddings

In an ideal world, the term 'Englishness' would carry no inbuilt political leanings. Like any social or cultural identity, it can be pulled in a variety of ideological directions and it comes steeped in histories, narratives and disputes that are ideologically complex, and as such, as a descriptive statement of place-ment, it ought to have no singular, predetermined political drift. Yet to many white English people who see themselves as occupying progressive or radical political positions, the idea of Englishness is so imbued with nationalistic or even racist connotations that they reject any sense of national belonging. Telling a roomfull of such people (who are, after all, only people like me) that English-ness is an identity that need not be seen as inherently reactionary, as I have done on many occasions in universities and other educational contexts, is an interest-ing exercise. Asking representatives of the English left and liberal intelligentsia to reflect on their Englishness tends to have the effect of plunging them into cringed contortions of guilt, embarrassment, denial, displacement, discomfort and apology. Self-reflection on the meanings of Englishness is highly valuable, but it cannot proceed usefully if self-flagellation is the only, and the foregone,

conclusion. There are, undeniably, loudly proclaimed versions of English-ness that remain draped in flags and enthralled by fantasies of lost imperial glory, but these need to be contested, otherwise the notion of Englishness becomes a fiefdom of the far right. Jonathan Rutherford has succinctly cap-tured the stricken guilt which has prevented many on the left from seeking ways to discover or recuperate any alternatives to conservative models of the nation:

> Who wanted the risible, sometimes ugly, baggage of Englishness? Every-thing which signified Englishness – the embarrassing legacy of racial supremacy and empire, the union jack waving crowds, the royalty, the rhetoric about Britain's standing in the world – suggested a conservative deference to nostalgia.
>
> (Rutherford 1997: 5)

That such iconographies of triumphalism exist and remain potent is not in dispute here, but what matters is the way in which a hostility to that partic-ular version of Englishness has led many to disavow Englishness altogether. Englishness, in that vein of thinking, is too tainted, too complicit, beyond rescue. James Donald and Ali Rattansi, for example, noted how such the pol-itics of the far right in Britain called on 'discourses of family and community, national belonging, English patriotism, xenophobia, and popular conservatism' (1992: 2). True enough, but the rhythm of that list sets up a kind of domino effect where one term instigates the next, so that 'national belonging' becomes a link in a chain leading to reactionary, racist attitudes. It is the implied inevitably of that chain which disturbs me, the disallowing of any suggestion that national belonging, like any form of belonging, can be inflected in many different directions. Watching the 1997 British General Election results, for example, gave me a sense of euphoric national belonging, in the sense that it seemed likely that things were about to improve significantly in the nation I inhabited. That has turned out to be a relatively forlorn hope, as it happens, given the way the Blair governments have, with a few exceptions, conducted them-selves, but the elation and investment I felt at that time was stronger and more profound than any analogous feelings I might have had seeing a progressive government elected in another country. In John Baxendale's words, 'Not all stories about the nation are conservative' (2001: 102) and at that moment in 1997 national belonging was anything but reactionary. Baxendale goes on to attack 'the recent fashion of interpreting "Englishness" in a single-mindedly conservative way, implicitly denying the possibility of any oppositional narra-tive of the nation … only a reactionary, we are implicitly told, would want to be English anyway' (108). However, part of the difficulty for any attempt to revive or construct a non-conservative Englishness is that the language available for thinking nationally is so enmeshed in conservative discourses. Jeremy Seabrook and Trevor Blackwell once attempted to state a case for

a 'patriotism which concerns itself with the recreation of the local and the familiar – a patriotism which offers the possibility of belonging to a community of which one need not feel ashamed, a patriotism which encourages a love of place which poses no threat to all the other places that other people love' (quoted in Barnett 1989: 143). This sounds attractive, the stress on locality and the known (key aspects of comedy, of course), the commitment to benevolent celebration of where one is and likes to be; but its utopianism is woolly and it fails to address several key questions. How could the 'loved place' be defended if attacked from outside? What about those who shared the locality but felt excluded by its assumptions and protocols? How would this somewhat self-contradictory state of unaggressive patriotism ignore the complex traces of the past, which would (in the case of England and Englishness) introduce a range of still potent and even overdetermining inflections of a 'love of place' which drew on reactionary and/or imperialist attitudes? Perhaps the biggest problem of all is the word 'patriotism' itself, stained as it is, and possibly indelibly so, by such a long history of belligerently reactionary usage.

The implications of 'patriotism' were no less problematic for the socialist feminist writer Beatrix Campbell in her revealing 1980s critique of George Orwell's 1940s essays on Englishness. Campbell was troubled by Orwell's patriotism, and by its roots in what she saw as Orwell's homogenised, white, familial construction of Englishness. At the end of her article, she dismisses the idea that accepting one's Englishness is inescapable for anyone from England: 'I never think of myself as English ... it's not a word I'd use to describe myself' (1989: 231), followed by 'I don't want not to be English, but neither do I want to be English. Why should I? I was only born here. All my allegiances oppose what England means in the world. I want us to stop being that kind of England' (232). Campbell wants to insist that identities rooted in class, gender and political affiliation should carry more weight than those related to national belonging, but this makes that familiar error of assuming that an investment in or even a mere acknowledgement of Englishness is suffused in reactionary politics – for Campbell, 'what England means in the world' has only one political drift. This is understandable, perhaps, remembering that Campbell's piece was written at the end of the decade in which Margaret Thatcher's calculatedly jingoistic handling of the Falklands War had reawakened a species of conservative nationalism not seen at the centre of British public life for decades (similarly, Orwell's patriotism is more easily comprehended bearing in mind that he wrote his most important reflections on Englishness during the early part of the Second World War, when defeat by Nazi Germany was a serious possibility). Yet when her words are looked at closely, Campbell does acknowledge that Englishness might be redeemable, despite her convoluted attempts to disown it. Her plea for 'us to stop being that kind of England' is crucial for two reasons. Firstly, it concedes that there is some kind of 'us' operative in Englishness, that it is a collectivity which still has claims on even the most reluctantly English,

and secondly it implies that Englishness might still be open to progressive interpretations, that Englishness might not be the crushing, monolithic burden that Campbell yearned to shift from her shoulders. For if there is 'that kind of England', the Thatcher kind, the Falklands kind, the Aslet and Scruton kind, the kind that haunted and shamed Jonathan Rutherford, there can be other kinds too.

 Few knew this better than Orwell, of course, which makes him an odd choice of target for Campbell to attack. His list of English emblems quoted earlier in this chapter is followed in the same essay by this statement about England's emotional pull:

> above all, it is *your* civilisation, it is *you*. However much you hate it or laugh at it, you will never be happy away from it for any length of time. The suet puddings and the red pillar boxes have entered into your soul. Good or evil, it is yours, you belong to it, and this side of the grave you will never get away from the marks that it has given you.
>
> (Orwell 1970: 75–6, emphasis in original)

The tone here is hardly one of rampant triumphalism. Englishness is not here seen as intrinsically good, let alone intrinsically superior to other national belongings, in fact it seems to hover between being a rash and a curse, but it is nonetheless distinctive, specific and known (indeed not so much known as felt). What Orwell is proposing is that it is wholly possible to see oneself as thoroughly English, but still to regard that perception with humour, scepticism, ambivalence, reluctance, even resentment. For a more recent example of such a proposition, consider this extract from an interview with the Pet Shop Boys, Neil Tennant and Chris Lowe, who were asked to consider whether there was a specific 'Britishness' about their music (and note the use of 'British' here when the discussion is so clearly about Englishness – yet another example of guilty English denial):

> Neil Tennant: Oh, that's true. For one thing, we never understood why [British] people sing in an American accent. Hence 'West End Girls', as I've said a million times before, was meant to be a rap in a British accent ... also I think we are British in our taste ...
>
> Interviewer: But it's hardly pride in Britain, is it? On the most superficial level you're both forever saying things like 'the only cars to buy are German'.
>
> Neil Tennant: Oh we're not *patriotic* (He spits out this word as if he can only just bear to say it).
>
> Chris Lowe (by way of agreement): Eurghhhh!

Neil Tennant: The Britishness is that we live in Britain and our experience of life is British, and that's what we're about ... the starting point is British life in a very direct sense ...

Interviewer: But do you think there is also anything peculiarly British about the whole Pet Shop Boys way of doing things?

Neil Tennant: There is a kind of *caricature* of Britishness that goes on ... of British reserve. We kind of play up to it.

(Heath 1990: 123–4, emphasis in original)

Much as the black British filmmakers discussed by Paul Willemen in the previous chapter were simultaneously specifically British but deeply critical of dominant versions of Britishness, so the Pet Shop Boys inhabit their national identity fully and un-guiltily. Yet they toy with it knowingly and ironically, mobilising a camp, queered Englishness that I find both recognisable and attractive, and they vehemently refute any suggestion of the patriotic, a category which prompts both verbal disdain and a beyond-words disgust. Chris Lowe's 'Eurghhhh' may not count as conventional critical discourse, but it says a great deal – and it does so in a comedic register.

The way forward, then, in thinking through the politics of Englishness must be to maintain an awareness of multiplicity, possibility and plurality (that is one of the many reasons this chapter is called 'Englishnesses'), particularly when the prevailing alternative is to collapse all the varieties and possibilities of Englishnesses into a rigid, inflexible and exclusionary oneness. For what that looks like in practice, consider Roger Scruton's *England: An Elegy*, where a highly specific Englishness (upper-middle-class, white, conservative, classically educated, Christian) becomes the paradigm against which all variations are judged. Working-class aspirations to escape poverty, for example, become for Scruton the marker of lives that 'strove to be orderly, self-sacrificing and respectable, and to proceed along recognised English lines' (2000: 143). But recognised by whom, and to serve whose purposes? What Scruton lauds throughout his book as qualities every English person should both emulate and espouse, could be seen by those of us hoping for different Englands as indicators of obedience, repression and deference towards an unjust social hierarchy. Any version of Englishness, like Scruton's, which seeks to fix and keep static its vision of the national must be contested. The national, like any category of identity, is never immobilised and singular, which is exactly why conservative versions of Englishness have to work so hard to deny that fact, often eulogising a purportedly mighty past in order to control the direction of the present (a device used as early as the 1530s – see Cressy 1994), to proffer an England where all that matter are myths of continuity and unity. Those are comforting discourses, provided you are included in their embrace, and comedy, as has already been stated, is centrally concerned with offering

comfort and security. Little wonder, then, that comedy can be enlisted in the support of closed, unitary and change-resistant versions of Englishness, as evidenced by the popularity of outspokenly conservative (and often Conservative) English comics and comedies – Jim Davidson, Bernard Manning, racist one-liners and stiflingly normative sitcoms all spring to mind. But comedy, like Englishness, is never one-dimensional, and the comedic Englishnesses discussed in this book do not speak with a unified ideological voice. Julian Clary's queer barbs and Roy 'Chubby' Brown's queerbashing quips hardly speak the same vocabulary of Englishness at all, but both remain profoundly English, if only in the sense that it is impossible to conceive of them coming from anywhere else.

John Baxendale has recently staged a spirited defence of the often-maligned middlebrow writer J.B. Priestley (who not only wrote one of the earliest books on English comedy's Englishness but was still reflecting on the subject five decades later – see Priestley 1929 and 1975), seeking to place him in a tradition of 'radical Englishness' (2001: 108). In this, Baxendale shares common ground with Kevin Davey, who included Priestley in a sextet of cultural figures he regarded as going against the grain of conservative, monolithic Englishness in order to explore the possibility of English alternatives. Davey's six out-riders (as well as Priestley they include Nancy Cunard, David Dabydeen and Vivienne Westwood) represent for him 'stages in an unfolding transformation of the English imaginary, essential steps towards ... creating new spaces in which new identifications could be made ... a range of reflexive and future-oriented explorations of Anglo-British whiteness ... a number of exploratory routes that have gone beyond the dominant Anglo-British identifications of their time' (1999: 1). Davey praises these figures for placing themselves at cultural friction points in order to unsettle taken-for-granted Englishness, to initiate new narratives of belonging, and most of all to pluralise the meanings of English identities. There are limitations to Davey's account – he is so under the spell of modernism and cosmopolitanism that he unquestioningly presents those discourses as inherently radical, and his use of the somewhat cumbersome term 'Anglo-British' hints at another outbreak of unproductive left-English guilt – but his book is a helpful contribution to the recent spate of English reflections. If nothing else, it is yet another reminder that there are far more varieties of Englishness to be unearthed, examined, and debated than the absurdly limited versions permitted by both the conservatives who weave myth-narratives of unshakeable continuity and those guilt-crippled leftists who, through their angst-ridden conviction that to speak of Englishness at all is to usher in a reactionary nationalism, paradoxically support the very positions they are so ostensibly eager to attack.

Ethnicity and empire

So far, this chapter has had little to say about one cornerstone element of debates over Englishness, the question of ethnicity. That question is a key

theme in the narrative of liberal guilt, since the anguish that many white English liberals exude when asked to consider their Englishness is almost invariably an anguish with its roots in race. This is hardly surprising. The histories, icono-graphies and ideological armouries of nationalistically triumphalist Englishness are wholly, gleamingly, whiter than white, while in those elegies or rants which see contemporary England as a shrunken, hollow fragment of a for-mer, greater self, empire (with all its racist referents) is always a substantial part of what has been lost. The 'baggage', to use Jonathan Rutherford's term, of conservative and far-right Englishnesses is weighed down with assumptions not only of white superiority over other ethnicities, but also of the inbuilt equation that turns English and white into synonyms. Nick Griffin, leader of the far-right British National Party, has spoken of white Englishness as 'our priceless genetic heritage' (quoted on *Newsnight*, BBC2, July 25th 2001). Small wonder that Paul Gilroy once insisted that 'discourses of nation and people are saturated with racial connotations' (1987: 56). For an extreme, and often absurd, example of this, consider the book *Our Englishness* (Linsell 2000a,b), a collection of essays published by a small company called, unap-petisingly, Anglo-Saxon Books and written by, to quote the summary on the back cover, 'seven authors who are positive about Englishness and their English identity'. The Englishness championed in this book is decidedly sin-gular, emphatically Anglo-Saxon and obsessed with purity and authenticity. What the writers seek, with different degrees of explicitness, is an un-mixed English bloodline stretching back beyond the Norman Conquest, an English-ness that is ancestral, undiluted and ethnically exclusive, an Englishness in which ethnic absolutism takes centre stage. 'We have to get behind and beyond the Normans', one argues, 'to the *authentic roots* of English culture … in the first 500 years of our existence as a nation' (Phillips 2000: 42, emphasis in original). Another dismisses the idea that Englishness is open to all who live in England: 'Englishness … [is] … determined by ancestry, culture and loyalties, not by place of birth or residence' (Linsell 2000a,b: 71). A third plays a more trumpeting note: 'Shedding the shrivelling skin of the United Kingdom, the folk of England may step out into a freedom we have not known since the Norman conquerors took it from us nine hundred years ago'. (Littlejohns 2000: 100), before summoning up the not exactly distant shadow of Stanley Baldwin: 'If we seek for our Englishness … through the manifold patterns in our English landscape, our English country, our English earth, we follow our Englishness to its roots, to its Anglo-Saxonness' (106). It would be easy to dismiss such stuff as the ramblings of a few fringe lunatics (though the internet is awash with compa-rable, and far worse, material), but as the final quotation shows, these arguments are only semi-detached from the mainstream of conservative rhetoric.

The editor of *Our Englishness*, Tony Linsell, is a founding member of the Campaign for an English Parliament, and support for that Parliament was voiced loudly in a 1999 edition of the television programme *Counterblast*, a BBC series which under a public service broadcasting remit allowed members of the public

to make thirty-minute documentaries expressing views from outside the usual political consensus. Its author and presenter Alan Ford wasted little time in taking the *Our Englishness* stance out of its antiquarian disguise and placing it in the contemporary political landscape, claiming that 'in multi-cultural Britain it seems that every ethnic group is free to celebrate its identity. The Scots, the Welsh, the Irish and every minority community get large government subsidies to promote their history, language and culture. Only one group is left out. I represent that group. I am white and Anglo-Saxon. I am English, the race that dare not speak its name'. (In passing, I am struck by the oddity of paraphrasing an Irish queer, Oscar Wilde, in a defence of Anglocentric ultra-conservatism.) Ford continues in this vein, perversely borrowing the lexicon of cultural rights coined to protect ethnic minorities against racism to craft an image of the white English as beleaguered and betrayed, lamenting the fact that St George's Day is not a public holiday, but studiously avoiding any concrete details concerning what Englishness might actually mean. It remains an essence, a given so sturdily self-evident that it requires no explanation, until at the end of the programme the driving force behind Ford's rhetoric is starkly disclosed. Once his English Parliament is established, he would want it to bring in legislation to end non-white immigration, to ban arranged marriages and to offer financial inducements to assist the 'repatriation' of non-whites living in England, including those born here. Suddenly all the myth-mongering bluster about legacy and heritage, all the calls for 'cultural autonomy', are peeled aside to show the punitively racist agenda beneath. There are few clearer examples of what Stuart Hall has characterised as 'defensive exclusivism … a very defensive and highly dangerous form of national identity which is driven by a very aggressive form of racism' (1991: 25–6).

The white superiority rhetoric of conservative and far-right imaginations of Englishness draws much of its imagery and sustenance from the iconographies of empire. Here is an extract from the opening page of *Arthur Mee's Book of the Flag*, a rousing hybrid of imperialist history and wartime propaganda published in 1941:

> Every one of us was born into a heritage of high renown. The world reels as we march to the middle of the Twentieth Century, but … it will be the Island and the Empire that will save mankind … this Island has … established liberty in every continent … sowing the seeds of happiness, lighting lamps in dark places, breaking the chains of slavery, lifting up the hearts of men … it is true to say of our country that she has laid down her life for the world.
>
> (Mee 1941: 17)

(The metaphor of 'dark places' is a particularly telling one in the context of the ethnic power relations of the imperial project.) In a parallel vein, Stanley Baldwin, in his 'whetstone and woodsmoke' speech, claimed that it was

the English love of nature which explained and justified colonial expansion, since those colonised places offered the English the wide open spaces they were increasingly starved of at home (Giles and Middleton 1995: 102). These conservative connections between Englishness in England and Englishness in the empire were made so vigorously and repeatedly that even the most avowedly anti-imperialist variants of Englishness cannot afford to ignore them. All Englishnesses are, in Bill Schwarz's words, 'connected by an intimate set of relations to the workings of colonial rule' (1996: 5). That is why Paul Gilroy has been so influentially scathing about the absence of questions of ethnicity and colonialism from the work of those influential British cultural historians (such as Raymond Williams, Richard Hoggart and E.P. Thompson) who contributed to the foundation of Cultural Studies. Gilroy declared himself:

> more and more weary of having to deal with the effects of striving to analyse culture within neat, homogenous national units reflecting the 'lived relations' involved; with the invisibility of 'race' within the field and, most importantly, with the forms of nationalism endorsed by a discipline which, in spite of itself, tends towards a morbid celebration of England and Englishness from which blacks are systematically excluded.
>
> (Gilroy 1987: 12)

A decade later he reprised his critique, chiding those texts and writers for their 'tacit collusion with Englishness', their 'morbidity and implosiveness' and their 'quietly nationalistic vision' (Gilroy 1996: 45–7). At this point my own sense of white liberal guilt starts its motor, since some readers of this book may choose to interpret my decision not to look in detail at black and Asian English comedy as just the kind of 'quietly nationalistic' systematic exclusion Gilroy set out to expose. Yet those comedies are not absent because of sinister or thoughtless reasons, and neither, just as importantly, are they included in a spasm of guilty tokenism. They do not feature here because my main concern in this project is to reflect on the Englishnesses which I know best, hence the frequent use of the personal voice. For the length of this book, at least, I want to reflect on the role played by comedy in the network of Englishnesses that I occupy myself, though to say that reminds me of a further warning from Gilroy: 'I am against the rhetoric of cultural insiderism, whatever its source, because I think it is too readily linked to unacceptable ideas of homogenous national culture and exclusionary national or ethnic belonging' (1993: 72). Here I would have to disagree. This is indeed a book written from a position of 'cultural insiderism', for no better reason than it cannot be anything else. I can only write from where I am, much as Gilroy (a paradigmatically diasporic intellectual, black British but with a global reputation) can only write from where he is, and where I am in terms of location, ethnicity and national identity is inside white Englishness. To be inside it, however, is not to see it as homogenised and

isolated from more culturally diverse influences, nor to endorse automatically its more reactionary articulations. Many, even most, Englishnesses may carry with them connotations of ethnic exclusivity, but an awareness of that fact might be the starting point for trying to forge new versions of English belonging, although Gilroy's book *Between Camps* (Gilroy 2000), advises the rejection of such a piecemeal move in favour of aiming to achieve a post-national, post-ethnic, post-identity utopia. I am not that ambitious, hence the narrower focus of this book. If the histories of white Englishness are to be understood, as part of the current rethinking of what Englishness can signify, they need to be studied, and some of those studies need to be from the inside. Gilroy's most telling point against those early British Cultural Studies texts was that they were accounts of Englishness that never acknowledged, or even recognised, their inbuilt ethnic bias; this book, by contrast, is fully aware that the Englishnesses it studies are only white ones. Stuart Hall once welcomed 'the long discussion, which is just beginning, to try to convince the English that they are, after all, just another ethnic group' (1991: 21), but that discussion can scarcely take place if white English left-liberals are too gnarled up with guilt to participate in the conversation.

Coming out of the national closet

This, then, is a study of white Englishnesses written from within them. Treating those Englishnesses as something distant and disassociated from me would be an interesting exercise, but, for me at least, an intellectual and emotional impossibility. I can only write as someone enmeshed in England, immersed in it, quite probably (recalling Orwell's notion of Englishness-as-ailment) a casualty of it. On a fairly banal level, this at least means I am able to avoid the howling mistakes about England and English cultures that I regularly find in American studies of the field. Ian Baucom, for example, in an achingly cutting-edge postcolonialist study of Englishness and empire (Baucom 1999), writes extensively about the meanings of the Handsworth riots which took place in a multi-ethnic area of Birmingham in the 1980s, but seems to think that Handsworth is a part of Manchester. Elsewhere an intrepid essay emanating from Los Angeles happily insists that the playwright Joe Orton, who only wrote comedies and only had plays staged in the 1960s, can be lumped in with the Angry Young Men of the 1950s who were 'obsessed with ... social realism' (Barber 1993: 224), while an otherwise interesting article by a Californian anthropologist studying the prevalence of racist jokes amongst stand-up comics in London (Kravitz 1977) is forever being held up and slowed down by his need to explain to his readership aspects of English life and English slang that any English reader would see as blindingly obvious. (Is it entirely a coincidence that Kravitz was the name of the witches' inquisitive neighbour in *Bewitched*, who always thought she knew what was going on next door, only to be outwitted by never quite grasping the inner knowledge of the culture she tried so desperately to fathom?)

Citing these may sound like nit-picking, but they, and there are so many others like them, reveal something telling. Anyone who published a study which claimed that the Bronx was in Chicago, or that Ernest Hemingway was a writer of light romantic verse, would soon look ridiculous, but to write about England and Englishnesses seems not to require detailed factual knowledge, provided that the right theoretical deities have been placated in the unfolding scripture of the analysis.

I am not suggesting that cultural analysis can only ever concern itself with its own back yard, as that would truly be a recipe for insularity and lack of dialogue, and sometimes an outside eye can see more clearly than eyes long resident. Yet there are advantages in knowing your culture well enough to be fully attentive to the idiosyncratic facets of its nuanced particularities. This may especially be the case in a study of comedy. David Thomson once joked that 'To keep up with Alan Bennett, one needs to be in England all the time' (Thomson 1994: 54), and there is a nub of a wider truth there. So I want to endorse the value of a critical space which prioritises reflection on where one is located, what Stuart Hall calls in the quote at the head of this chapter 'one's roots ... one's contexts'. Some traditional modes of scholarship have found that an unsettling prospect. In the 1950s the anthropologist Geoffrey Gorer was asked to undertake a study of English social attitudes, a prospect he found difficult since it would be difficult to leave his own Englishness out of the picture. For Gorer, surveying English culture was problematic because of his own relation to and place within the network of identities and issues being studied. He felt that in investigating a culture other than one's own, 'one is unplaced socially, for one's foreignness masks the lesser differences of class or region', but that 'these advantages are lost when one is working in one's own society. As soon as I start speaking I am placed as a graduate of one of the major universities (Cambridge, as a matter of fact) and ... nearly all ... English people will therefore respond to me as a member of a class, as well as an individual' (1955: 1). In other words, given Gorer's stake in and place within Englishness, a pretence of objectivity was not sustainable. His own particular Englishness (its privilege encapsulated in that serenely fake-disingenuous 'as a matter of fact') undermined his chance of securing detachment or disinterest, a fact which he saw as damaging but which I see as advantageous, since clutching at objectivity in any study of cultural identity is at best a fond illusion, at worst a severely hampering deception. In the decades since Gorer's study, speaking consciously and reflectively from within a social and cultural position has become an accepted approach, indeed an autobiographical inflection was present from the very beginnings of Cultural Studies (see Medhurst 1999 for more on this). The influence of feminist work has strengthened this tendency, as have interventions from black and queer critics, many of whom have taken the route of self-reflection both as a means of setting up productive dialogues between the personal and the political and as a response to a wider postmodern climate where any lofty claims to objectivity would be difficult to sustain.

As Charlotte Brunsdon has said, the 'autobiographical turn is not currently unusual in critical intellectual work, assailed as its practitioners are by anxieties about inappropriately speaking for others and a reluctance to appear to endorse the grand narratives which might permit an impersonal voice' (2000: 5–6).

Given all of this, why have I still been greeted with all that white English liberal angst when I have spoken about Englishness from within Englishness? Why is a critical voice that locates itself, with all due sensitivity, as coming from an English identity, not given the easy ride generally offered to voices reflecting on other specific identity locations? I am all too aware of the difference – speaking as a queer critic has opened certain doors for me in academic contexts (though others have doubtless been closed with a homophobic slam), but speaking from within my Englishness has prompted very different responses. Once again, the culprit is that guilty reflex of the white English left, that panicky warding off of the spectres of colonialism and racism, that caricature which recasts any acknowledgement of national location as a lurch into shrill flag-waving. Such panics manifest themselves in various techniques of apology and distancing: observe how the editors of one academic collection of essays on belonging and location note that their volume includes studies of 'British national identity, whose cultural contours and pathologies are explored in this collection "from the inside" (uncomfortably) by James Donald and Iain Chambers' (Carter, Donald and Squires 1993: x). Here the pathology of guilt is made concrete in the twisted syntax – the speaking-as-British position is doubly apologised for, corralled away behind both brackets and quotation marks. The political motivation for that strategy is understandable, but it seems to me that it is time to move on, to put the apologies away. Englishnesses are not the sole and permanent property of conservative reaction. So this book is not an exercise in exorcising guilt; I see no need to be apologetic about Englishnesses, including my own, not while so many of their components, facets and dimensions remain to be unravelled and mapped. As for the merits and limitations of speaking from inside Englishness, this quotation seems particularly pertinent and resonant:

> I only enjoy to the full the architecture of these islands. This is not because I am deliberately insular, but because there is so much I want to know about a community, its history, its class distinctions, and its literature, when looking at its buildings, that abroad I find myself frustrated by my ignorance. Looking at a place is not just for me going to the church or the castle or the 'places of interest' mentioned in the guide book, but walking about the streets and lanes as well … I like to see the railway station, the town hall, the suburbs, the shops, the signs of local crafts carried on in backyards. I like being able to know for certain where to place what I am looking at … This I can do in my own country, but am not so sure about in someone else's.
>
> (Betjeman 1956: 4–5)

I find those remarks by John Betjeman enormously sympathetic, but that sympathy is dotted with serious reservations. The first reservation is the figure of Betjeman himself, since from the vast majority of contemporary critical perspectives it would be hard to conceive of a more derided representative of inward-looking, anti-modern, middlebrow Englishness. (Though if J.B. Priestley can be rethought in the light of current concerns, Betjeman might not be far behind – one sympathetic critic has recently hailed him as 'piercingly prescient' – Martin 2006: 55.) Secondly, a phrase like 'my own country' risks buying into that homogenising sense of the national that smothers regional, class, gender and ethnic differences under a blanket of sameness. Furthermore, 'these islands' stages a raid to engulf Scotland, Wales and Ireland from a position of English superiority. Despite all these concerns, however, I would still want to hang on to aspects of the argument. Its stress on the small-scale and the everyday as well as the monumental or the official heritage site is very relevant to a study of popular comedy, which is almost always located in territories of ordinariness and concerns itself with the details of the everyday. Similarly, its insistence on a non-chauvinistic specificity is important, its sense that England is made up of varied and distinct somewheres that need to be understood in their own contexts. It stages a defence of critical practice based on an inside view, it makes an argument that in-depth familiarity can facilitate a particular sort of knowledge, it comprises a low-key manifesto for immersionism, and that makes it valuable for all its dangers and drawbacks. Reflect on what you know about and what you feel about where you're from, it counsels, and that is the approach, with all its pitfalls, taken by this book.

In short, I want this study to make a case for reclaiming the national, not nationalistically but in the sense that if there is a place for a critical practice where the identity formation of the critic plays a role in shaping her or his analytical agendas and cultural conclusions, then why should national identity be ejected from that array of identifications, allegiances, baggages and belongings? Englishnesses do exist, and English people occupy them in varied and often contradictory ways. David Matless puts this very well:

> It is not so simple to be the people of England. And it is also not so simple to be their enlightened and/or cosmopolitan opponents. Identity tugs all ways ... in part because through all this complexity there runs a resilient singularity. Not an essence, not a continuity of identity back to King Alfred or Hengist and Horsa or Boadicea or whoever one picks out as a national origin, but a singularity which means that, however complex and hybrid an individual's ancestry and biography might be, however much a person's identity can be self-consciously mobile and multiple, the answer to the question 'are you English?' can often be a straightforward and unreflective 'yes' – if not as a matter of pride, then as a matter of living.
>
> (Matless 2000a: 82–3)

For Matless, Englishness is a 'plural, puzzling and powerful singularity' (2000a: 85) – a plural singularity that I have tried to capture in calling this chapter 'Englishnesses'. That plural is there partly to indicate the hubbub of competing constructions of Englishness, to acknowledge the continued debates about what Englishness does/did/could/should/shouldn't mean, and also to suggest further that individuals who affix the label of being English to themselves will invariably find (unless they are of a irretrievably conservative persuasion) that there can never be just one version of the label that fits, suits or feels comfortable. To be English is never to be *just* English. All English people occupy several Englishnesses at once – I inhabit a white Englishness, a male Englishness, a queer Englishness, a southern Englishness, to pick just the first four that come to mind – and these multiple Englishnesses live in abrasive adjacency as much as harmonious proximity, often meeting at what Malcolm Chapman has called 'a particularly high-voltage junction' (1993: 207) where hard-to-reconcile ideological discourses collide. There are tensions, for example, between the working-class inner-city Englishness in which I was raised, and which still strongly moulds and haunts my sense of self, and the middle-class suburban Englishness which my professional life has enabled me, relatively recently and somewhat schizophrenically, to enjoy. Negotiating those shifts in place, space, class, belonging and capital (both material and cultural) can be troubling in the extreme, but the disputes they set off within and around me still take place on a single yet multi-faceted English terrain. A plural singularity indeed, much as the myth-making lists which began this chapter collate pluralities in a vain search for singularity. All attempts to define England hope to persuade and enlist, but there are always too many pluralities of Englands for any one version to stand unchallenged. Englands and Englishnesses are always destined to coexist in fractious conflict, a gallery of pictures uncontainable within a single frame. When I first typed the word 'Englands', my computer spellcheck underlined the word in red, which is its blunt way of telling me that as far as its hegemonic grasp of vocabulary is concerned, a word doesn't exist, but Englands do exist, on multiple planes and in confusing profusion. What remains to be done in the rest of this book is to map out how some of those Englands can be found in various traditions of twentieth-century popular comedy.

Music hall
Contours and legacies

Part of being a great comedian lies, consciously or unconsciously, in being attuned to the refrains of society, in hearing its melodies, in orchestrating them, and in playing them back.

(Eric Midwinter 1979: 13)

[B]y the end of his stage show – be it in London or Liverpool, Bournemouth or Manchester – he has invariably converted a motley collection of strangers into a liberated, uproarious and unified assembly.

(Michael Billington 1977: 5 on Ken Dodd)

It was much broader humour then, and I think that we're quite frightened of broad humour now. I think it's all got to be a bit clever and, er, up its own arse really.

(Jane Horrocks 1997, interviewed on *Heroes of Comedy: Les Dawson*)

Music hall is the motherlode of English popular comedy. This chapter seeks to explore that contention, to see how and why the styles, strategies, semiotics, rhetorics and social imaginations of a popular cultural mode that evolved over the last two-thirds of the nineteenth century can still be found, pumping like a heartbeat, throughout the popular comedy of the century that followed. To do so, I need first to offer an overview of the meanings of music hall in its original Victorian contexts, then make a brief detour into cultural theory, to test the applicability and the shortcomings of Mikhail Bakhtin's concept of the carnivalesque. In order to avoid vanishing into abstraction (the most uncarnivalesque move imaginable), I then want to trace the developments and inflections of music hall comedic modes in a small number of key twentieth-century practitioners. The field to choose from here is truly an embarrassment of riches, though the agony of selecting is made easier by the fact that many who either drew or still draw in different ways on music hall (the Crazy Gang, Sid Field, Frankie Howerd, Morecambe and Wise, the Carry On team, Roy 'Chubby' Brown, Reeves and Mortimer and Victoria Wood among them) appear in other chapters under other rubrics. Even so, having to neglect great and influential figures like Gracie Fields, Will Hay, Nellie Wallace, Max Miller,

Arthur Lucan and Robb Wilton from detailed consideration is deeply regret-
table, though the decision to omit other significant performers like Arthur
Askey, Tommy Trinder, Norman Wisdom and Benny Hill caused me a little
less grief. Of those I do look at in detail, two performers enjoyed their greatest
successes in the 1930s and 1940s – George Formby and Frank Randle; and
three carried the music hall torch into subsequent decades – Hylda Baker, Les
Dawson and Ken Dodd.

Ragged hats and consolation: Interpreting Victorian music hall

This is not the place, and there is not the space, for a detailed history of the
nineteenth-century music hall (such things can be found in Bailey 1986; Bratton
1986; Kift 1996; Russell 1997, and on a less academic level in Beaver 1979
and Lee 1982). To summarise ruthlessly, the music hall was Britain's first fully
commercialised entertainment industry, originating in the early decades of the
nineteenth century in concerts put on by pubs and other drinking establish-
ments. The popularity of these concerts was noted by prescient entrepreneurs,
who took the risk of building dedicated venues, the music halls themselves.
These found an eager public and as the century progressed several large halls
were opened in every British city. An evening's offerings would last several
hours and could include singers, comic sketches, acrobats, jugglers, perform-
ing animals, magicians, ventriloquists, contortionists and dancers. What does
need considering here are a series of questions related to class, politics, pleasure
and consumption. If the sensibilities and worldviews originating in Victorian
music hall are as influential on twentieth-century English popular comedy as I
think they are, then some mapping of them, however skeletal, needs attempt-
ing. The quickest way of doing this is by looking not so much at the history
of music hall, but the historiography of it, the ways in which it has been
unravelled, conceptualised and argued over by cultural historians. The issue
that reverberates most loudly and contentiously through academic studies of
Victorian music hall is the issue of politics. The influential conclusion of two
important studies from the first wave of cultural historians to take music hall
seriously (Stedman Jones 1982; Summerfield 1981) was that music hall was an
essentially conservative institution, fundamentally concerned with reconciling
its working-class audiences to their lowly status, diluting any chance of radical
political sentiment or action, taking 'the existing social order as the inevitable
framework' (Stedman Jones 1982: 117). Music hall songs and comic patter
about the everyday experiences of working-class urban England were content,
according to these historians, to wrest entertainment from depicting a stylised
version of life as it was, shunning any sense of agitating for life as it could be.
Music hall is damned in these accounts for not being radical enough, for pre-
venting its audience from mounting an assault on the evils and exploitations
of Victorian capitalism by getting them laughing and singing, stopping them

from building the barricades by keeping them in the stalls. Music hall culture was 'compensatory' (Summerfield 1981: 233); its world was one where the prevailing and constraining class hierarchy was 'a life sentence, as final as any caste system' (Stedman Jones 1982: 110); its overall sensibility was that of a 'culture of consolation' (ibid.: 117). Later analyses have concurred, at least in part, with those early verdicts. According to Dagmar Kift, 'music hall did not attack the dominant system. If it can be called political at all it was conservative' (1996: 182), while Dave Russell echoes Stedman Jones in observing that music hall's outlook was characterised by resignation and fatalism, where the 'social order was immutable' and where life 'simply happened to music-hall characters: they had no control over their destiny' (Russell 1997: 126). These views are undoubtedly accurate in many ways. Music hall songs were usually observational narratives drawing on recognisable experience, surveying such topics as work, holidays, romance and family life, a range very similar to the subject matter offered by the twentieth-century stand-up comedians whose work is rooted in music-hall modes. Like all popular comedy, the music hall comic song was an invitation to belong, to acknowledge and celebrate likemindedness, to say 'yes, life's like that, let's laugh at it', and it would be hard to see that as anything other than a conservative message.

Yet the picture is more complex than that summary allows, not least in Stedman Jones and Summerfield's inference that conservative is identical to reactionary. There have been comedians in both music hall itself and its mass-media descendants, who used this sensibility of consoling resignation as a springboard into overtly flag-waving, difference-hating xenophobia (the word 'jingoistic' itself is derived from the lyrics of a music hall song about the Crimean War). Yet in some critiques of music hall I cannot help but detect a middle-class Marxist impatience with the proletariat's refusal to seize the glorious mantle of revolution. For one thing, there are pleasures in comfortable communality which are too readily overlooked by the zealous asceticism of the Stedman Jones school. What exactly is so wrong with consolation, especially for audiences whose working day comprised the sort of repetitive and soul-destroying labour most academics could not begin to imagine? Secondly, 'life's like that' is not at all the same as 'life is wonderful': music hall was rarely blind to the material realities of hardship, indeed some of its most famous sentimental ballads chronicled the damage done by economic inequalities, as in the elderly couple forcibly separated by poverty in 'My Old Dutch', but mostly it spoke about the small joys to be found (a day at the seaside, a night in the pub or at the music hall itself) amid a larger landscape of grimness and grime. If this favoured consolation over change, then what was the alternative – a culture with no joys at all? Perhaps a more useful formulation than the influential but always damning 'culture of consolation' is Jeff Nuttall and Rodick Carmichael's 'survival laughter' (1977: 24), a laughter that is communal, collective, resigned, blunt, basic, a way of getting by, of alleviating the depressing limitations of low horizons, and it is this laughter that runs, not identically but still recognisably,

from the Victorian halls all the way to Roy 'Chubby' Brown. Invoking Brown's name there suggests another way in which the consolation model needs to be rethought. Music hall was often vibrantly vulgar, testing the limits of censorship and questioning the stranglehold of 'decency', so often a code word for attempts to foist the constrictions of middle-class propriety on to working-class lives; and music hall was also committed to celebrating the joys of leisure in those brief temporal spaces when work took a back seat to pleasure. As Dagmar Kift puts it:

> The values propagated in the music hall – hedonism, ribaldry, sensuality, the enjoyment of alcohol, the portrayal of marriage as a tragi-comic disaster, and the equality of the sexes at work and at leisure ... were diametrically opposed with those propagated by and attributed to the Victorian middle-class: asceticism, prudery, refinement, abstinence, a puritanical work ethic, marriage and the family as the bedrock of social order with the woman's role as housekeeper and mother.
>
> (Kift 1996: 176)

The halls, in effect, became the primary cultural space in which these alternative values were articulated, and the articulation took concrete, collective shape in the punchy, combative performance styles of the singers and comics and in the audiences' active participation. A middle-class visitor to the halls in 1856 noted that the songs 'are sung, or rather roared, with a vehemence that is stunning, and accompanied with spoken passages of the most outrageous character. At the end of every verse the audience takes up the chorus with a zest and vigour which speaks volumes – they sing, they roar, they yell, they scream, they get on their legs and waving dirty hands and ragged hats bellow again till their voices crack' (quoted in Bailey 1994: 148). The term 'passages of the most outrageous character' is presumably a decorous inference that the dirty joke was thriving on that stage, as it was elsewhere in the same decade when the social reformer Henry Mayhew observed a music hall audience collaboratively singing along to an innuendo-strewn song: 'ingenuity had been exerted to its utmost lest an obscene thought should be passed by, and it was absolutely awful to behold the relish with which the young ones jumped to the hideous meaning of the words' (quoted in Bailey 1994: 150).

What emerges from these accounts, these intrigued and horrified peeks at the urban underbelly, and what is persuasively argued by music hall historians like Peter Bailey and Dagmar Kift, is a sense that the halls were where the urban working classes (which, as ever in England, overlaps into the lower-middle classes) sought, received and rewarded with their applause, participation and ideological complicity a culture that spoke directly to their own specific experience. Victoria Wood told one television interviewer that the role of comedians is to say to audiences 'this is how our life is' (how this applies to

Wood herself is explored in Chapter 10), and that above all is the seed planted by music hall and the garden tended by popular comedy ever since. Peter Bailey sees nineteenth-century music hall as a popular cultural form which responded to a time of immense and disquieting social change, during which the modern urban working class took shape in the unprecedented tumult of the Victorian city. Those cities required more people to live in closer proximity to each other than would have been conceivable just a few decades previously, obliging their cramped and compressed inhabitants to face what Bailey calls the 'difficulty of reading strangers in the flux of big-city life' (1994: 152), to survive in a world of 'compacted, anonymous and fleeting everyday negotiations' (153), to find a way of 'Getting by in this milieu' (ibid.). The sheer newness and alarming complexity that configured Victorian urban life required ordinary people to adopt new sets of survival skills, and the survival laughter of the jokes and songs from the halls sprang from this rapid acquisition of street-wisdom. Textually and performatively – for the craft skills of the singers and comics were just as crucial conduits for these sensibilities as the jokes or lyrics themselves – music hall constructed a world where working-class lives were, quite literally, centre stage, explored and reflected upon with multi-faceted detail and attentive respect. As Dagmar Kift suggests, the halls provided:

> food and drink, entertainment and instruction, sociability and space, a place where one could be oneself without being disciplined and 'improved' by one's superiors ... The comic song in particular celebrated the culture and the life-style of the 'little man' – and woman. In doing so it raised the self-esteem of a social group which at work were reduced to the status of 'hands' (i.e. to that part of their body which was necessary to dealing with tools and machinery) and who outside work were generally regarded as uncivilised savages and targets for middle-class reforming efforts. In the halls by contrast, they were accepted and welcomed for what they were.
> (Kift 1996: 176)

Cultural critiques of music hall that accuse it of lacking a radical edge are, it seems to me, the inheritors of those bourgeois discourses of 'improvement' and 'reform', and so are many of the attacks on the perceived conservatism of popular English comedy more broadly. Music hall may not have been radical but it was resistant, in particular resistant to the assumption that the cultural mindsets and the moral frameworks of the English middle classes represented the ideal way of life. Music hall, and the comedy that continues to flow from it even today, stood for something else, something simple but profoundly political: a belief in the value of working-class experience. That belief, emerging in different ways in many of the comedies and comedians studied in this book, may remain, in Peter Bailey's words, 'inescapably subordinated in the larger systems of society', but as he continues, it also remains 'a countervailing dialogue that sets experience against prescription, and lays claim to an independent

competence in the business and enjoyment of living' (1994: 155). This above all is the sense in which I would see music hall as the bedrock of English popular comedy.

Carnival: Mayhem, control and utopia

Mikhail Bakhtin's theory of carnival and the carnivalesque is probably well known already to most readers of this book; however, a short account of it, and some critiques of it, should be helpful here for two reasons. Firstly, because much of the comedy rooted in music hall can be called carnivalesque, and, secondly, because Bakhtin's work offers a more theoretically inflected complement to the more historically specified work of those who have studied the Victorian halls. My sketch of Bakhtin is unavoidably brief (those seeking more considered evaluations and applications should start with Hirschkop and Shepherd 1989, Rowe 1995 and Stallybrass and White 1986) but I have a twofold interest in the carnivalesque: in its replaying on a more conceptual stage Bailey and Kift's notion of music hall as a popular cultural discourse set in opposition to official languages of morality and control, and in its insistence on the significance of a cultural expression that is concrete, corporeal and collective. Bakhtin derived his interpretation of carnival from a seductive, if speculative, reading of the work of the early modern French writer Rabelais. In Bakhtin's account of Rabelais, the periods of carnival in which the usual hierarchies of order and codes of behaviour were suspended and inverted could be seen as opening doors into a set of bodily pleasures and appetites which were rigorously policed and suppressed during the rest of the year. Crucially, carnival was not a spectacle to be consumed by an audience, but actively participated in by an entire community, and although this might at first glance distinguish carnival from more contemporary popular culture, where there is a stage or screen to be watched, the level of involvement demanded by most stand-ups and the recirculation of dialogue and mannerisms among devotees of popular television and film comedy calls into serious question any idea that their consumption is 'passive'. Carnival was a time of excess, inversion, disrespect, parody, the grotesque and the overflowing, made emblematic in events and activities including feasting, drunkenness, mockery of authority, cross-dressing, sexual licence, swearing and both symbolic and actual violence. Carnival, Bakhtin claimed, was 'a second world and a life outside officialdom' (1968: 6) it was also a world in which the body, and a very particular model of the body, overruled the respectability and decorum controlled by the mind. This shows itself not just in the emphasis in carnival culture on bodily actions and functions (eating, drinking, sexual acts, the emptying of the bladder and bowels) but also in the tone and topics of carnival verbal exchange: 'Wherever men laugh and curse, particularly in a familiar environment, their speech is filled with bodily images. The body copulates, defecates, overeats, and men's speech is flooded with genitals, bellies, defecations, urine, disease, noses, mouths

and dismembered parts' (1968: 319). For Bakhtin, the carnival body was the polarised, inverted counterpart of the classical body; the latter was the regulated, beautiful, noble body of classical sculpture, whereas with the carnival body 'the emphasis is on ... apertures ... convexities ... ramifications and offshoots: the open mouth, the genital organs, the breasts, the phallus, the potbelly, the nose' (1968: 26). Clearly, all of this has relevance for plenty of the comedies studied later in this book – the toilet-factory setting and the carnival coach trip in *Carry On At Your Convenience*, the lavatorial preoccupations of *The Royle Family*, Frank Randle's bodily misbehaviour, Roy 'Chubby' Brown's relish for life below the belt, the scandalising incontinence of the pig in Alan Bennett's *A Private Function*, the episode of *dinnerladies* borne aloft on wafts of fart, and many more.

The most disputed aspect of Bakhtin's work centres on what, if any, ideological interpretation can be made of carnival. As many of his critics have pointed out, to see carnival as a point where subversive, authority-challenging ideas were let loose is to overlook two problems. Firstly, those in social control still demarcated the temporal boundaries of carnivals (related to the agricultural and ecclesiastical calendars, they were set to last a prescribed number of days), and secondly, the finite nature of carnivals meant that they were in many ways simply compensating doses of respite: you could splash around in muck and mayhem for a short while, but then it was back to work, and back to hierarchy. Given this, carnival could be seen as a sly instrument of social control, a safety valve which defused tensions by allowing the peasantry some brief relief so that they returned more contentedly afterwards to their allotted place at the bottom of the pile. This case has been put most pungently by Umberto Eco:

> Carnival can exist only as an *authorised* transgression ... If the ancient, religious carnival was limited in time, the modern mass-carnival is limited in space: it is reserved for certain places, certain streets, or framed by the television screen. In this sense, comedy and carnival are not instances of real transgressions: on the contrary, they represent paramount examples of law reinforcement. They remind us of the existence of the rule.
>
> (Eco 1984: 6, emphasis in original)

This is a serious point, but in some ways it reminds me of the 1980s attacks on music hall I discussed above. Like them it seems to presume that any study of popular culture has as its primary aim the unearthing of some quality that can be called 'transgressive' or 'radical'. Yet it has never been my assumption that English popular comedy, even in its most unbridled carnivalesque outposts, could represent a coherently radical project. Like Victorian music hall, popular comedy offers points of identification, recognition and celebration for working-class audiences, and in my eyes this makes it political, but it is primarily a politics of defence not attack, of refusal not uprising, of embracing your own, of consolidation against condescension. Bakhtin has also been criticised

for celebrating carnival uncritically, of lapsing into what Terry Eagleton has har-rumphingly called 'sentimental populism' (1989: 183). Noting, quite rightly, that theorists tend not to inhabit the same class positions as those participat-ing in or consuming carnivalesque texts and experiences, he expresses concern that any decision by privileged intellectuals to champion vulgar rowdiness can look 'truly unseemly, indecent even' (1989: 179) and wonders whether this exemplifies 'the intellectual's guilty dues to the populace' (1989: 178). This acerbic diagnosis hits me where it hurts, as the bulk of this book could be accused of such a project (and its reviewers may choose to follow that line), yet as I have noted elsewhere (Medhurst 1999), not all academics were raised in circumstances of comfortable privilege, so perhaps one reason that I still cherish and have chosen to analyse popular comedy lies in my trying to make sense of how my own class identity has shifted, complicatedly, over time. There are questions of strategy and emphasis here, too, as from my position I tend to see the risk of over-valuing popular culture as politically less sinful than rubbishing it (which is so often a none-too-subtle code for rubbishing the people whose culture it is). Mikita Hoy sees Bakhtin as making a similar move, noting that he 'tends to idealise popular culture in order to rescue it from the patrician pessimists' (1994: 14) – a strategic move, then, not a naive faith in 'the people'. As for Eco's insistence that carnivals control far more than they unshackle, it is worth stressing that Bakhtin himself was fully aware of the temporary, bounded nature of carnival outpourings:

> The feast was a temporary suspension of the entire official system ... For a short time life came out of its usual, legalised and consecrated furrows and entered the sphere of utopian freedom. The very brevity of this freedom increased its fantastic nature and utopian radicalism, born in the festive atmosphere of images.
>
> (Eco 1984: 89)

So, although there is the claim here for radicalism which raised Eco's suspicions, it is twice named as utopian, rather than systematic, and it is that utopian glimpse of something better, some sort of rearranged world where the pleasures of the many unseat the clampdowns of the few, that carnivalesque comedy, at its best, can still provide.

Music hall must never be thought of as identical to carnival – the historical, geographical and economic contexts are far too dissimilar, and music hall looked at how to manage and find joy in the everyday far more than it ever yearned for utopia. Music hall and carnival come from very different places, and sometimes display conspicuously different aims, but there is also an overlap zone between them of shared attitudes, ontologies and structures of feeling. Anne Hole has said that music hall was 'carnival brought small, penned within a saloon' (2000: 7), yet although this suggests a sense of constraint and loss, it also reminds us that comparisons between the two are worth pursuing. English comedy rooted in

music hall continually echoes carnival's commitment to what Terry Eagleton, in an earlier more Bakhtin-friendly moment, dubbed 'a celebration of the licentious politics of the body' (1986: 118). The debilitatingly over-revered cultural theorist Slavoj Zizek has more recently proposed that 'the comic dimension stands for the triumph of life at its most opportunistically resourceful' and that the 'stuff of comedy is precisely this repetitive, resourceful popping-up of life – no matter how dark the predicament, we can be sure the small fellow will find a way out' (2000: 29). These phrases are both distinctly Bakhtinian and highly applicable to traditions of English vulgar comedy (the second half of the second quote is a pop-Freudian summary of a Norman Wisdom film). As for the carnival body, neatly summarised by Ann Jefferson as 'a collectivised jumble of protuberances and orifices' (1989: 166), it lumbers slobberingly through English comedy in an unquenchable variety of guises – Frank Randle, Hylda Baker, the Carry On crew, Jim Royle, the Fat Slags, Kathy Burke's Lynda La Hughes in *Gimme Gimme Gimme*, Julie Walters' Petula Gordeno in *dinnerladies*, the rubber-masked 'celebrities' in *Bo Selecta*, Mr Blobby. Whatever the political question marks about carnival, or the strategic responses we make to them, or the problems in yoking together Rabelasian and Victorian, there is one key quality found in both carnivalesque humour and comedy with music hall roots: they offer some respite from the burdens of hierarchy to audiences stuck on low social rungs, and that respite is encapsulated in laughs. In the rest of this chapter I want to look at five of the comic performers who drew deeply from music hall to deliver those laughs.

The fireman and the shaman

George Formby and Frank Randle were both born in Wigan, in Lancashire, at the beginning of the twentieth century, Formby in 1904, Randle in 1901. Childhood friends who became intense professional rivals, they were among the most successful performers of their era; indeed Formby, whose sequence of feature films made him a top box-office star throughout the late 1930s and the Second World War, had no real equal at that time in terms of public affection. Yet while both drew on their regional backgrounds to craft memorable comedies of working-class identity, there were striking differences between them in terms of content, performance style, reputation and meaning. C.P. Lee has called them 'the Yin and Yang of Lancashire comedy' (1998: 43), a useful formulation inasmuch as it emphasises both their difference and their complementarity. The historian Patrick Joyce has noted how 'a series of strictly maintained distinctions' were operative in perceptions of the Victorian urban working class, and that one of these was between 'the "rough" and the "respectable"' (1991: 151–2), while the social theorist Beverley Skeggs (1997) has traced how those crude but always potent polarities have persisted to the present day, and she suggests that respectability was in many ways a middle-class quality that only the portion of the working class which aimed

to 'better itself' could hope to strive to attain. The others, the 'rough', were demonised and stigmatised, as they still are in middle-class moral panic discourses about 'scroungers' and the 'underclass'. As Jeffrey Richards has observed (1997: 269), Formby and Randle can be linked to those models of working-class identity. Their comedy sprang from and was originally aimed at the Northern English working classes, but as their careers diverged, with Formby becoming a national figure and Randle staying a regional hero but little known elsewhere, it became clear that underlying their textual differences and relative popularities, their comic personas stood for the two sides of that respectable/rough coin. Formby was respectable, cheeky and lively but essentially decent, Randle was rough, fecklessly drunk and chronically work-shy. As Lee puts it, 'Formby ... was "safe". Even if his ukelele tunes were slightly risqué, you wouldn't mind your daughter going out with him ... Randle was dangerous, he ... trod too near the boundaries of taste' (1998: 43). As was discussed in the previous chapter, Randle sometimes found himself in court on obscenity charges, something that would never have happened to Formby, even if one or two of his songs were banned at one time from BBC radio by virtue of their moderate innuendo.

Given this dichotomy, it is unsurprising that Randle is more in tune with contemporary tastes. There is more cultural capital in championing the dangerous than the cheeky. Formby is still alive and well in the English national popular cultural memory as an icon of cheery, slightly naff downmarket humour – his name crops up in Victoria Wood's *dinnerladies* more than once, and indeed some of Wood's own comic songs (as Phil Ulyatt perceptively pointed out to me) bear more than a passing resemblance to Formby's in their combination of dry Northern observation, mildly naughty wordplay and generally bouncy demeanour. Formby has also, as I indicated in the previous chapter, figured as a reference point in a few academic discussions of popular culture and regional identity. Yet nothing written about Formby begins to approach the poetic, wayward recklessness of Jeff Nuttall's extraordinary book *King Twist* (Nuttall 1978), which makes Frank Randle the totemic centrepiece of a howling lament for the decline of a particular version of Northern culture. Nuttall makes Randle the revered focal point in a broader search for a lost, localised culture that is being replaced by internationalised, corporatised consumerism. This is from the book's opening section:

I am looking for a memory to defend me. I am exposed and threatened. I need a myth and I need a hero. The rolling eye of a manic little lecher scorches through the years. I recall a billygoat toper, a varicose buttock-pincher, a dyspeptic ale-swiller. I need him and I'm setting out to find him ... a hero who ... might in some way defend me against a tide that is rising over my country steeply and rapidly ... The tide isn't human. It is grey. It is concrete. The motorway is concrete and there is only one. The city centre is concrete and there is only one. A legion of spotty boffins

who see themselves as civic thinkers are paving my country over because they think that this is the way the window must be dressed ... A legion of men no one has ever seen is disguising my country as Dusseldorf. I am journeying ... through the rising tide of concrete in search of a man, a memory, that will act as a talisman against an age that is somehow trying to cancel me out.

(Nuttall 1978: 1–2)

What follows is not, it should be plain, a conventional biography or an obedient academic analysis, but a hymn to a vanished England. Randle, for Nuttall, is emblematic of the known, the everyday, the manageable, all being submerged by the demands of globalisation. As this was written in the 1970s it might seem prescient, as it predates by many years much of the recent academic literature that aims to champion the local, yet also dated, as the 'Dusseldorf' reference would today need to be Seoul or Shanghai. Nuttall's 'local', however, is in fact national – note the phrase 'my country' – it is England that is disappearing for him, not just the North. Or rather, for him, England *is* the North, not inappropriately so, since that's just what it was for Randle. Even though his stage shows and shoestring-budget films filled theatres and cinemas in the North, he rarely played south of Birmingham, and virtually none of his films were given London press shows or even screened in the capital at all.

Formby, conversely, became a truly national star, primarily thanks to Ealing Studios, who signed him up to a film contract in 1935, having noted the huge success of the films he had made for the regional company Mancunian. Formby's Ealing films capitalised on his established Northern persona and popularity, but stealthily relocated him both geographically and semiotically. In his first Ealing film, *No Limit*, he plays a lad from a fictional Northern town (ungenerously called Slagdyke) of small terraced houses with backyard sheds, but spends most of the film in the holiday, carnival atmosphere of the Isle of Man. The dialogue in his first scene with co-star Florence Desmond quickly sketches the cultural dynamics of Ealing's Formby project. Desmond (known to national audiences for radio appearances and to London audiences as a star of stage revues) says 'I've come all the way from London'. Formby replies 'I can tell that by the daft way you talk', a neat swipe at metropolitan superiority, with the telltale Lancashire vowel in 'daft'. 'I've come from Slagdyke', he continues. Desmond's response is to adopt a parodic exaggerated Northern accent and say 'Ee lad, I can tell that by daft way you look'. This sets the terms of Formby's Ealing career (and for the films he made for Columbia from 1941): his Northern identity was eminently marketable, but had to be kept within controllable boundaries. He is able to perform regional-pride songs like 'The Emperor of Lancashire', or sing lines about 'tripe and trotters and cow heels too', but he is usually partnered with an on-screen girlfriend who speaks with a cut-glass Home Counties accent and in some films he either lives or visits London. Formby comes to embody a North that the South can cope with, a respectable

working-class lad, symbolising, according to Patrick Joyce 'the kind of working people their superiors wished to see' (1991: 307). This did not impede Formby's popularity with his working-class public, as for them he represented 'one of ours' who had achieved enormous success. He was also shown making fun of upper-class pretensions, as in the delicious scene in *Much Too Shy* (1942) where he finds himself in an art college. The art students (including a young Charles Hawtrey) are a clutch of drawling bohemians, painting sub-surrealist canvases that leave George baffled. Confronted with their pretentious tattle, he sighs 'Well there's one of us daft and I'm alright'. The students mock his naivety and provincialism, but as soon as he clutches his trusty ukelele they change tack, and by the end of the song they are gathered behind him in that grinning semicircle which he always attracts in his musical numbers. As ever, he is a figure of unification, ironing out social and cultural differences with toothy bonhomie. The sunny good-naturedness of Formby's films, with their harmonious conclusions of George getting the girl, or winning the race, or (in a wartime context) unmasking the Nazi spy, were carefully wrought wish-fulfilment fantasies, tapping into that utopian strand of working-class comedy with its 'vision of a better, fuller life than was evident in the common run of things' (Joyce 1991: 307).

Randle was no utopian, no unifier and likelier to dispense drizzle than sunshine. While Jeffrey Richards has pithily summarised Randle's persona as 'disreputable and subversive ... toothless, lecherous, combative and insubor-dinate' (1997: 269), Jeff Nuttall, typically, prefers a more extravagant tribute, focusing on Randle's carnivalesque physicality:

> he reduced himself to little more than a vigorous digestive system, simul-taneously taking on characteristics of the infantile and the geriatric. This further unfettered his audience by transporting them into life-stages in which all is forgiven, all responsibility waived. His spittle would spray. A mouthful of ale would fall in a sudden cloudburst down his chest. Ponderous belchings and dredgings of his system would fill his rubber face with some ludicrously imagined body juices which he would immediately use as a weapon.
>
> (Nuttall 1978: 59)

In one of Formby's best-loved cheeky songs, he rhapsodises about his little stick of Blackpool rock ('it's nice to have a nibble at it now and again', he sang, and who would begrudge such a jaunty endorsement) but it would surely be a thin, sweet, childish phallus compared to whatever unimaginably lurked in the depths of Randle's rancid trousers. Randle was (the half-pun is unavoidable) randy, a hormonal tramp fuelled by beer and leering. He was also, allegedly, nightmarish to work with, upstaging and undercutting fellow performers, smashing up dressing rooms, and rumoured to be actually drunk during his celebrated on-stage drunkard routines. He took criticism very badly, and in a Bakhtinian

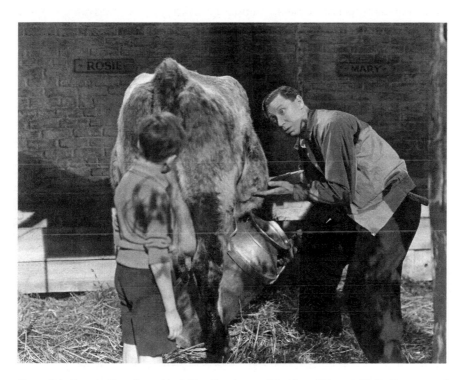

Figure 5.1 George Formby in *Much Too Shy*, directed by Marcel Varnel, 1942. Courtesy of Gainsborough/The Kobal Collection.

gesture one can only applaud, responded to being banned from appearing on stage in Blackpool by hiring an aeroplane and dropping toilet rolls on the town. Evidently, here was a man fully in touch with the baser needs of the human body and the comedy that waited to be wrung from them. Randle's films, made by Mancunian, the studio Formby had left in search of profile, cash and fame, are gruesomely poor in many respects, often literally so with their all-too-obviously tiny budgets. Where Formby's films had gloss, polish and a plausible, if simple, storyline, Randle's disregarded credibility and just became excuses for him and his troupe of reprobate collaborators to freewheel, misbehave and gurn. Many of the scripts given to the performers (according to the Channel 4 documentary *Mancunian Presents*) had blank pages with just 'BUS' written on them. This was short for 'business' and indicated that this gap in the story and dialogue was to be filled by the stage tricks and clowning routines they had learned from their seaside shows, variety turns and circus days. Randle himself was a skilled tumbler, with trapeze and trampoline experience, and the physical skills of his relentless antics are exceptionally impressive. Unfortunately, for any audiences

watching the films today, these eruptions of carnival 'BUS' are required to stop so that the skinniest semblance of plot can be inched forward. Randle's films employ what are supposed to be young romantic leads, but they are a parade of epicene chaps and gymkhana girls weighed down by accents so aristocratically fluty that their casting almost seems to be an act of surreptitious class war. The critic Gavin Lambert once suggested that low-budget English comedy films of this era were 'absurdist before the fact' (2000: 197), a proposal, I think, that they play such havoc with standard narrative, film conventions and audience expectations that watching them becomes an almost avant-garde experience. This is a clever notion, but rests on the unspoken premise that this would be a way for a middle-class audience to find a way of reconciling themselves to such lowbrow texts. For Randle's original working-class public, I suspect that the inconsistencies in stories and acting were simply chores to be sat through while you eagerly awaited the next bit of 'BUS'. Once Randle's chaotic excess was on screen, the surrounding shoddiness ceased to matter, and this is even the case in a film like *Demobbed* (1944) which features most of Randle's regular company but not the man himself.

Like many of the Randle films, *Demobbed* has an army setting for part of its plot, an ideal canvas in that it placed a bunch of disrespectful clowns in a rigid, hierarchical environment which they could then gleefully subvert and trash, thereby earning laughs from audiences all too aware, in that wartime period, of how military culture overflowed with petty rules and expectations of deference. This particular comic and social dynamic, where the under-lings outwit those placed in authority over them and in extreme cases shatter the structure of authority itself, has been noted by historians of music hall as recurringly popular. Lois Rutherford (1986) cites music hall sketches where wastrels triumph over magistrates, where teachers and lawyers are figures of fun, and where low cunning runs rings around educated knowledge. For Peter Bailey, Victorian music hall humour found rich source material in ridiculing the authority figures in factories, offices and schools, in this way reassuring the audience that 'they were nobody's fool or ... no teacher's dunce, no head-clerk's cipher, no foreman's stooge' (Bailey 1994: 160). Decades later, this still resonated not just in Randle's army farces, but across a wider scope of popular English comedy from Will Hay's incompetent schoolteacher and station-master to the assorted institutions (the army, the health service, the police force, the school system) sent up by the Carry Ons. George Formby wore a series of uniforms (the Navy in *Bell-Bottom George*, the Home Guard in *Get Cracking*), but was a rather more well-behaved conscript than most of his comic pre-decessors and peers, happy to salute his superiors as well as poke very gentle fun at them. Formby became so associated with the national war effort that his first peacetime film, *George In Civvy Street*, was an unexpected flop, after which he ceased making films and concentrated on stage performance. It is a very odd film, overloaded with symbolisms of Englishness, centred on a rivalry between two pubs called the Lion and the Unicorn and a dream sequence

which puts Formby in a Lewis Carroll world full of characters from the *Alice* books. There might be some mileage in cross-referencing the film to that 1940s artistic revival in English pastoral (see Mellor 1987 and Matless 1998) but as a Formby vehicle it is simply strange, introducing flavours of literary whimsy that curdle the usual Formby recipe. Randle's film career was able to lurch on a little longer, as he had none of the war-effort connotations which Formby had accrued. Formby's jolly wartime togetherness felt suddenly outmoded in a more fractured post-war atmosphere, whereas Randle's relatively timeless themes of gluttony on every front was not so bound up with particular social moments.

If Formby and Randle seem in many ways polarised, they are nonetheless also close – yin and yang fit together as well as stand apart. They could be, emblematically, two brothers who went different ways, yet still connected by roots and background. Although it is critically convenient to make Formby the compromised conformist against whom Randle's roughness rebelled, it should not be thought that their audiences did not overlap, at least in the North, where the raw material they differently drew on was the meat and drink of everyday experience. Besides, they also complement each other in demonstrating two of the chief functions that comedy can serve. In Eric Midwinter's useful formulation, comics of Formby's disposition are 'social firemen, dampening any flames of flickering disquiet' (1979: 46), and this edges him close to 'culture of consolation' territory. Yet he also gave 'temporary cheer to a hard-pressed people' (1979: 44), reminding them of the comforts of collective warmth, and it would take a dour and isolationist mind to disregard how important that can be. (The range and inventiveness of his song's innuendos should also be studied by any connoisseurs of the history of English filth – see Bailey and Foss 1974.) Randle provided a different kind of cheer, acting as a 'tribal shaman' (Lee 1998: 35), a totem of taboo, inviting audiences to forget decorum and follow him down to the irresponsible, irresistible zone of basic desires and bodily needs. Formby and Randle established crucial templates, and in many ways English popular comedy has been choosing one of them, or choosing to fuse them, ever since.

Are you calling me a painted husky?

Picture the time and place: it is August 1968 in England, the month when the Beatles released 'Hey Jude', when John and Yoko were the focal point of juicily appalled public gossip, when the talking-point film of the day was the cocktail of youth rebellion and unafraid sexuality that comprised Lindsay Anderson's *If . . .*, when the naked cast of *Hair* ripped up existing taboos on the London stage and London had its first major exposure to the work of Andy Warhol. Russian tanks entered Czechoslovakia to snuff out anti-Soviet tendencies, Los Angeles burned during the Watts riots, and the Parisian events of the previous May were still fresh inspiration to the unsettled young across the West. The 1960s were rarely

more 1960s-like than they were right then (for superbly evoked and detailed accounts of the era, see MacDonald 1994, O'Day 1994 and Rowbotham 2001). Yet what was the most popular new comedy on British television? It was *Nearest and Dearest*, the rampagingly vulgar and shamelessly antiquated tale of two ageing sibling pickle-factory owners, a text that must have seemed dated beyond belief to those who accidentally glimpsed it over their kaftan sleeves as they rolled another joint on the sleeve of Donovan's new album 'A Gift From A Flower To A Garden'. Yet despite those neatening, retrospective simplifications that paint the 1960s as the decade where peace, love, rock music, radical attitudes and mind-expanding narcotics changed the lives of absolutely everyone, there were many people who saw the youth cultures and pop cultures of the period as excluding and unfathomable. To such unsettled and unfashionable folk, the new cultural waves and surging social changes seemed prejudiced in favour of the already privileged (middle-class youth, primarily), disorientatingly internationalised and devoid of manageable moral boundaries. For that constituency, living in the Sixties but not in 'the Sixties', *Nearest and Dearest* was a refuge, a place where the working class, the middle-aged and the elderly still took centre stage, where sex knew its place (in the bedroom and not very often), where hippies needed a good wash and a haircut, where the old ways still crackled with vitality and where the strongest stimulants anyone consumed were brown ale and pickling vinegar. At the centre of the series, one of its two stars but its absolute focal point, was Hylda Baker. Short, stocky, bandy-legged and reliant on facial expressions that have been ungallantly but not inaccurately called 'rubber masks of unwieldy distrust' (Nuttall and Carmichael 1977: 35), she was not the kind of woman usually envisaged when one is asked to think of 1960s femininity, an incongruous figure alongside the Twiggyesque waifs and flower-garlanded Guineveres of the spaced-out generation. When the ideal woman of the period was, if the lyrics of one of that year's biggest pop hits are to be taken as a yardstick, 'a butterfly child, so free and so wild' (from 'Jesamine' by the Casuals), Hylda Baker ticked none of those boxes. Except perhaps 'wild' – because although Baker was as far as could be imagined from the fey princesses feted by youth culture, she wielded a wildness of her own, a very different wildness rooted in carnival clowning and decades of hard knocks on the lower slopes of provincial showbiz. Her story is remarkable, and one it would be impossible to repeat ever again (see Fergusson 1997 for an excellent biography).

Thanks in part to the youth landslide of the 1960s, we live today in a culture of instant and increasingly brief fame. The notion of achieving huge success in the entertainment industry in one's middle age is almost incomprehensible, yet Hylda Baker was fifty before she became a bona-fide star. Born in 1905, she had performed on stage since the age of ten, beginning as a supporting player in her father's established comedy act, touring on the halls for the next forty years, receiving good reviews and slowly inching her way up the bill, sometimes obliged to take on periods of factory work but sometimes able not just to appear

in shows but to produce them herself, making a living but never making much of a splash, landing the occasional radio appearance before securing a spot on the BBC's television homage to music hall, *The Good Old Days*. That series, hugely influential in establishing a particular image of music hall for audiences too young to have attended the real thing, featured acts who reproduced old music hall routines as well as those who used fresh material that drew recognisably on music hall modes. In March 1955, Hylda Baker appeared on the show and became instantly, nationally famous. At that time, the BBC was the only channel in existence, so everybody who watched TV that evening would have watched her. She performed her self-penned, well-honed 'Cynthia' sketch, in which she played the diminutive, belligerent, non-stop-talkative friend to the much taller, more patient and silent Cynthia, played by a male stooge in drag. This one appearance opened door after door: she was given her own radio series and headlined variety shows in both Blackpool and London's West End (the first woman to do so for decades). *Nearest and Dearest* was one link in a chain of considerable successes.

Like many performers with their roots in the carnivalesque end of music hall, Baker's comedy mixed verbal catchphrases, physical clowning, and a calculated deployment of the grotesque. Unlike most of them, however, she was of course female, and the complex implications of undertaking this kind of comedy as a woman are worth considering in some detail. It hardly needs stating that for a woman to succeed in working-class comedy, demure girlishness was not a viable option. Here is the highly evocative contemporary description of what happened when the music hall performer Bessie Bellwood, formerly a rabbit-skinner in Bermondsey, was heckled by a man in the audience:

> she ... hurled at him an insult so bitter with scorn, so sharp with insight into his career and character, so heavy with prophetic curse, that strong men drew and held their breath, while it passed over them, and women hid their faces and shivered. Then she folded her arms and stood silent, and the house, from floor to ceiling, rose and cheered her until there was no more breath left in its lungs.
>
> (Quoted in Lee 1982: 98)

Women on the halls needed to be tough to survive in the raucous atmosphere, and many of them came from tough upbringings that lent their personas a lived authenticity. Virginia Woolf, that icon of privileged modernism, saw Marie Lloyd perform on stage and wrote that she was 'a born artist – scarcely able to walk, waddling, aged, unblushing. A roar of laughter went up when she talked of her marriage. She is beaten nightly by her husband. I felt that the audience was much closer to drink & beating & prison than any of us' (quoted in Gillies 1999: 271). This is partly a marvelling at the resilience of the veteran performer, partly a realisation that the intense experiential bond between performer and audience would always render a high-bourgeois witness like Woolf an observer

who could never play a full part in the reciprocity and communality of the proceedings. By the time Hylda Baker secured national fame in middle age, she had worked in this milieu for decades. In the 1940s she produced, wrote, acted in and designed her own revues, including one where she appeared cross-dressed and played male roles, and another where she was the only woman in a cast otherwise comprised of female impersonators (this conjures up remarkable images, especially in the context of sexually normative post-war England). She had spent decades paying her dues, so it is perhaps not too surprising that, once she finally achieved national mainstream success, she reputedly became rather demanding and diva-like. Her reputation amongst colleagues began to sour as she was perceived to be 'difficult', but this would not be the first time that a woman with status in the entertainment industry was subjected to the kind of backbiting that was rarely inflicted on comparably successful men (see Archer and Simmonds 1986 for an interesting feminist take on the pressures on women placed in positions of stardom). This continued into the era of *Nearest and Dearest*, when she and co-star Jimmy Jewell were on constantly bad terms, a rivalry and dislike that sometimes seeps into their shared scenes on screen.

Nearest and Dearest dealt in narratives, assumptions and images familiar from music hall and seaside postcards (the latter are discussed further in Chapter 8). It was a world of outside toilets, coal fires, headscarves and corsets, where the word 'predicament' was always the cue for an innuendo, where the unwitting display of underwear was intrinsically hilarious, and where to describe someone as 'a man whose walnuts have to be seen to be believed' was guaranteed to bring the house down (and to my taste, quite rightly so). In the silent character of her elderly relative Walter, Baker had a new silent stooge so she could update her Cynthia sketches – or perhaps just simply revisit them, as most episodes of the series contain routines taken straight from the stage with no attempt to rework them for the new televisual context. It is a series where, in the language of Mancunian film studios described above, 'BUS' hits the sitcom. One of Baker's other established comic tricks was to mangle language into malapropisms, where not using quite the right word generates the laugh. 'Are you trying to deduce me?' she asks one possible suitor, which of course is exactly what we are trying to do when she makes these linguistic gaffs. Elsewhere, she recoils in horror from a teenage party, describing it as 'like Sodom and tomorrow', a lovely conflation that brings biblical outrage to bear on changing sexual times. In her later series *Not On Your Nellie*, she confronts someone for 'calling me a painted husky', a wry displaced comment on her own unattractiveness. The funny woman is very rarely conventionally pretty, because the raising of laughs often requires the lowering of dignity, and Baker enters into this with remarkable relish. Her comic abundance lies in her willingness to be undignified, indeed to show the processes and consequences of indignity, especially the collision between her aspirations to refinement and status (she aspires to join the Town Businesswomen's Club, for example) and the embarrassments and revelations

indignity brings about. Hence she is forever on the verge of showing her knickers, literally or metaphorically, or in the mortified aftermath of having done so. This discursive clash between respectable femininity and more vulgar kinds has parallels with some drag acts, such as Les Dawson and Roy Barraclough's Cissie and Ada, but it has more intensity of desperation about it when performed by an actual woman. After a reasonably successful film version of *Nearest and Dearest*, in which the best jokes revolve around Baker's constant inability to say correctly the name of her fiancé Vernon Smallpiece (her attempts include Mr Codpiece, Mr Smallfry, Mr Littlebit, Mr Bigpiece and the more informal Vermin), she was given a new starring vehicle, *Not On Your Nellie*, a series which has a fair claim to be the weirdest sitcom of the 1970s.

Without the rivalry with Jimmy Jewell to negotiate, Baker turns *Nellie* into a virtual one-woman show. The setting is a London pub, taken over by the very Northern Nellie, so a regionality clash is one of the main comic motors. There is also a wider culture clash, since the *Nearest and Dearest* feel of old-school comedy resisting the hegemonies of the 1960s is taken even further, since Nellie's pub is placed in a post-Swinging London, ensuring that her customers are a far more diverse array than ever ventured near that Lancashire pickle factory. There is a regular Asian character, for example, and a homosexual couple called, in an intriguing low-culture gag about the elite art world, Gilbert and George. (The couple are never overtly named as sexual partners, but their camp coding and close relationship are enough to signify, not to mention the crude jokes made at and about them.) Implausibly, but fascinatingly, Nellie imposes on the pub a kind of Formby-esque communality, inclusive to the point where the non-white and non-straight customers are part of the quasi-family, but excluding to the point where they still become the frequent butt of jokes. Gilbert is very tall and hardly speaks, making him yet another Cynthia stooge-figure for Baker's most famous routine, pulling out just the same (and just as funny) facial contortions and verbal elasticities she had been using since the 1950s. Gilbert is fond of outlandish clothes (sky-blue satin trews tucked into knee-high scarlet boots in one episode, red and white gingham suit with red fake fur collar and matching shoulder bag in another) and in each episode Nellie asks him 'what are you today?'; her conclusion and punchline every time is 'Oh you're one of *those* are you?'. On one level this is simply a homophobic jibe (though don't forget Baker's dalliances with several kinds of drag in the 1940s), but on another it serves to underline how in this repeated trope of explaining and translating for these silent stooges, so much of Baker's comedic persona rests on the play of voice and language. Her speech is garrulous, error-strewn, an onrushing flood of slip-ups and cock-ups, always letting her linguistic bloomers peek embarrassingly from beneath her conversational skirt. The lack of masculinity in the stooges (Cynthia was a female friend, Walter a virtual eunuch, Gilbert an outrageous queen) lets Baker be in complete charge, but because she never tries the same trick with 'real men', she is never truly threatening to the overall male order of things. One final point to register about the very curious *Not On*

Your Nellie is how often it spurns conventional narrative resolution at the end of episodes in favour of a throwback reliance on stage-show tropes and music hall echoes. It asks us to accept that in a mid-70s Chelsea pub, an evening could be livened up by listening to George Formby records, or that the customers would happily cluster around to watch Nellie do a Lancashire clog dance. Yet as this is Baker's show, there is an oddly touching defiance in these resolute refusals of the contemporary, as we watch a woman performing the way she has for sixty years, determined to the last to preach the old time religion of unrefined working-class popular entertainment. What a trouper.

Lavatories and cucumbers

Les Dawson and Ken Dodd are included in this chapter not because they were innovators, mould-makers like Formby and Randle, but because they proved to be the most memorable consolidators of the music hall mode in recent times. Dawson was born in 1931 and died in 1993, Dodd was born in 1929 and is still touring in 2007, carrying the torch of vintage English comedy more knowledgeably and more securely than any other performer. The core thematic concerns of their humour will not surprise anyone familiar with the tradition they inherited and prolonged – favouring gags about the affectionate warfare of marriage, the power-struggles of family life, the travails of the working week, the small absurdities of everyday life – though they have both brought to that familiar territory a particularly rich use of language and, especially in Dodd's case, an interest in the mechanics and meanings of comedy itself. They could both be called connoisseurs of comedy, savouring its curative properties and also secure in, but never arrogant about, their own exceptional levels of comedic skill. After Dawson died, the playwright Alan Plater paid tribute, saying that his absence would leave 'a lot of good jokes untold, a lot of good stories untold, a lot of truth unshared' (from Channel 4's *Heroes of Comedy*). The use of the word 'truth' there is especially significant, as for me it aligns Dawson with those older music hall performers whose bond with their public was cemented by acknowledged and negotiated bonds of recognition and shared experience, who, in Peter Bailey's words, provided for their audiences 'a fluid ... drama of self-affirmation that punctured official knowledges and preserved an independent popular voice' (Bailey 1994: 168). This was, and is, a comedy of observations, of concreteness, of not being fooled by voices and vested interests from further up the social ladder.

Dawson's performative calling card was his lugubrious face and his sharpest textual gambit was his rewriting of old-school jokes into deliberately overblown language. The face – stony, morose, cynical, plangent – helped him stand out from his peers, but it was a trick developed over time. In early television clips from the 1960s, his downbeat delivery is in place but he smiles at his own punchlines. This was gradually refined to reach the core of the style, rather like, if I may risk a high-flown comparison, sculptors like Constantin

Brancusi and Barbara Hepworth, who began their careers making reasonably representational pieces but pared away the inessentials to reach the core of the form. Dawson's classic style, the pure-gloom face that he maintained while audiences fell helplessly into laughter, enacted a clever game in which he masqueraded as genuinely hurt by the indignities life heaped against him, and set him apart from other comics whose laughter at their own jokes came across, by contrast, as needy and ingratiating. His fondness for linguistic excess took well-worn stand-up staples like the trip to Blackpool or yet another spat with the mother-in-law but inflated them into absurdity by describing them in far from everyday speech. A favourite move of his was to construct lengthy monologue passages stuffed to bursting with bad-poetry prose and then bring the whole edifice down with the crash of bathos; this is perhaps the best example:

> I was standing at the bottom of my garden a week ago, smoking a reflective cheroot, thinking about this and that, mostly that, and I just happened to glance at the night sky, and I marvelled at the myriad of stars glistening like pieces of quicksilver thrown carelessly on to black velvet. In awe I watched the waxen moon ride across the zenith of the heavens like an amber chariot towards the ebon void of infinite space, wherein the tethered bulks of Jupiter and Mars hung forever festooned in their orbital majesty. And as I looked at all this, I thought, 'I must get a roof put on this lavatory'.

Here, the lavatorial locale of the punchline helps to emphasise how funny we should find the absurd pretensions of the preceding phrases ('reflective cheroot', 'ebon void', 'orbital majesty'), reminding us with typical carnival logic that our aspirations to culture should not delude us that we have transcended the body. Dawson's insistence on the corporeal here is matched elsewhere by an eye for the humour of social inappropriateness. He sends up rose-coloured reminiscences of perfect childhoods with a joke like this: 'Mother used to sit me on her knee and I'd whisper "Mummy, Mummy, sing me a lullaby, do". She'd say "Certainly, my wee bundle of happiness. Hold my beer while I fetch me banjo" '. He offered a humour that punctured, that reminded us not to get above ourselves, and thus by implication placed value on the common factors that bind as opposed to any attempts to distinguish and divide. This even emerged in the drag sketches he performed with Roy Barraclough, where, as neighbours Cissie and Ada, they bitched about their neighbours by mobilising that English equation between dirty homes and moral laxity later explored by both Alan Bennett and *The Royle Family*; they remark of one such suspect, 'I wouldn't like to see her bedding', a line where the economy and non-specificity of expression only emphasises the severity of the judgement. Here the dividing lines that mark laughter are not between the pretentious and the rest of us, as they are in the 'ebon void' joke, but between the feckless and the rest of us, making Cissie and Ada two of those who comedically patrol the

borders between respectable and rough. They do so with special zeal because they are never entirely sure whether or not Ada (Dawson's character) is still clinging on to the lower slopes of respectability or has slithered down (or back) into the clutches of the rough. As ever with judgement jokes, those who make them say as much about their own anxieties as about the objects of their scrutiny.

As I mentioned in this book's introduction, Cissie and Ada, like all significant comic creations, need to be seen and heard as well as read. Dawson's wriggling, shrugging Ada borrows a lot from Hylda Baker, and from Norman Evans, the most acclaimed female impersonator of the 1940s, who appeared in several films including Mancunian's *Demobbed*. Having chosen to perform his 'first person' monologues in his signature deadpan mode, Dawson character sketches went to the other extreme, offering stylistic excess and delectably broad strokes. Many of his 1970s TV series featured a character called Cosmo Smallpiece, an exaggeratedly lecherous but romantically thwarted grotesque who was partly a homage to Frank Randle and partly an anticipation of Roy 'Chubby' Brown. Viewed too hastily, Cosmo might look like another of those groping pests that plagued English comedy for decades and whose patron saint would be Benny Hill (a comedian whose more cleverly realised caricatures are now hard to rescue from the long shadow cast by his interminable sexual harassment chases). Dawson, I would argue, was too clever for that, and Cosmo was a cartoon of masculine foolishness to parallel Cissie and Ada's burlesque of judgemental gentility.

Ken Dodd is, among other things, the best conceivable riposte to the accusation that studying comedy is a killjoy activity. He has read widely in comedy theory and in 1973 even wrote and performed a show called *Ha Ha* which aimed to put his thoughts about that theory on stage. During his tours he keeps meticulous written records of how the audience has responded to his set, and from this has extrapolated which jokes work best in which towns and regions, constructing a detailed geographical typography based on his observations. For example: 'Wigan likes hearty vulgarity without too much overt sex, while Brighton fancies weird humour with a tinge of spice' (cited in Midwinter 1979: 203; Dodd's journals are also discussed in McCann 1998). Dodd has consciously borrowed ideas from comic history, adding his 'tickling stick' to the act after reading about the festive devices used by medieval jesters (Howard Jacobson has also compared Dodd's tickling stick to both Charlie Chaplin's cane and Dame Edna Everage's phallic, thrusted gladioli – Jacobson 1997: 47). He cares about comedy as a thing in itself as much as a way of entertaining people, 'he grafts assiduously', to quote Eric Midwinter, 'at the sheer technology of his business. Some might call it manipulative, but we expect the same assiduity from our surgeons and bridge-builders' (1979: 205). Is there a risk here of Dodd seeming over-prepared and sterile, too focused on technicalities and measuring reactions, detached from the warm and affirming joys of comic interchange?

Fear of that risk might underpin a criticism from Jonathan Miller, who has praised Dodd's skills but expressed concern that he lacks spontaneity – 'Everything he does is rehearsed down to the smallest detail' (quoted in Billington 1977: 37). Yet this attention to detail is part of the pleasure in watching Dodd: when he walks on stage an audience knows it can expect gag after gag after gag, polished to perfection, flawlessly timed and contributing to an eventual crescendo of cathartic release. Miller's critique strikes me as emanating from an implicit preference for a very different kind of comedian, a Spike Milligan or a Peter Cook, whose devotees (almost invariably, I cannot avoid contentiously suggesting, middle-class men) will sit patiently through what seems like hours of unstructured rambling while waiting for the occasional nugget of undeniable genius. Dodd never rambles, although his legendarily long stage performances can seem endless, and blissfully so. He believes in precision, focus and drive, but his performance never seems mechanised. His jokes may have been worked over and refined, but they still sound fresh and, at their best, startlingly surreal and layered with levels of inference – 'What a beautiful day! What a beautiful day for sticking a cucumber through the vicar's letterbox and shouting "The Martians are coming!"'. This is the dirty joke reworked into allusive brilliance, with every subtext of perverse, penetrative, interplanetary sex and the dubious proclivities of the clergy as clear as day, yet nothing is spelled out and the whole enterprise is suffused with a delight in prankishness, misbehaviour and the significatory flexibility of language.

Michael Billington has described a Dodd performance as 'a structured orgy, a timed fiesta' (1977: 15) and the paradox built into those phrases is as good a way as any to sum up what Dodd does, why it matters, and how it links him to both music hall modes and carnival sensibilities. The mix of organisation and abandonment implied in that description recalls the tension between control and mayhem that characterises carnival, its invitation to run wild but only within defined boundaries. It is because Dodd is so practised, prepared and in charge of his material that his audience can surrender their inhibitions as vigorously as they do. Audiences trust him, in a way that it would be very unwise to trust a comic of the Milligan/Cook persuasion, not least because there is always the risk that the longed-for genius-nugget might *not* materialise; Dodd, conversely, will never disappoint, he is too invested in a belief in the transformative power of collective comedic climax to leave an audience cheated of a pay-off. He wants his comedy to unify through recognition and celebration. This is the thread that links those whose roots are in music hall, the wish to mine comedy from the everyday textures and common frameworks of working-class lives, even if, in the hands of writers and performers like Dawson and Dodd, the resulting jokes are constructed and delivered with very uncommon skill. The Victorian music halls were the first cultural spaces in which the lives of the urban working classes were taken as the benchmark reference point. In those spaces and their successors, working-class lived experience was the prism through which all social dynamics, all cultural competences and all relations

of power were viewed. Concerned Victorian middle-class opinion, from both liberal reforming and puritanical conservative perspectives, distrusted the halls, for the reason that they became an arena where previously uncontested class hierarchies could be held up for inspection, evaluation and sometimes ridicule. Dagmar Kift argues that 'The main achievement of the halls was the propagation of a culture which strengthened both the self-confidence and the consciousness of the working class. This might not have been class consciousness in the classic Marxist sense, but it was about class and about separate identities' (1996: 184). The culture forged in the halls, the legacies of which still exist in English popular comedy today, gave the urban working class a voice and a set of textual and performative codes through which to speak. What then gets to be spoken might not always be progressive (Ken Dodd's political views would appear to be at the conservative end of the spectrum, one index of which might be the frequent waving and using of the Union Jack in his act), but once a previously silenced voice makes itself heard, it cannot be expected to say only the things that suit certain outlooks. In any case, it is not always easy to affix labels like 'progressive' or 'conservative' to popular comedies, and in those minority of cases where it is absolutely easy to do so, this is usually a sign that the comedies concerned might not merit much attention in the first place.

Our gracious queens

English comedy's effeminate tradition

BBC studios in Maida Vale for the talk with Peter Haigh on 'Moviegoround'. He asked me for a definition of 'camp'. I said 'To some it means that which is fundamentally frivolous, to others the baroque as opposed to the puritanical ... and to others – a load of poofs'.

(Kenneth Williams' Diary, April 3rd 1968)

[D]ecoding various oblique representations of homosexuality can be seen as merely unearthing ... a cartography of hell ... but such investigation also allows for more nuanced and prehensile understandings.

(West 2000: 129)

The effeminate queen is a vital component of English popular comedy. In the gallery of sexual stereotypes that make the English laugh, his place is as assured as the nagging wife, the dirty old man, the obliging secretary and the interfering mother-in-law. All wrists and sibilants, he swishes through music-hall routines, pantomimes, radio sketch shows, downmarket films (from the Formby oeuvre to the Carry Ons and beyond), television sitcoms, and stand-up gags in every era and medium. English comedy in the past century is deeply indebted to him and unthinkable without him – imagine the tame drabness of a world without *Round the Horne* or *Up Pompeii*. The queen is a laugh magnet, although different audiences laugh for very different reasons, ranging from the laughter of the homophobes who are delighted to see their prejudices confirmed, to the laughter of fellow homosexuals, so schooled in and attuned to the codes of camp that they miss none of the in-jokes that glisten flirtatiously through the pursed lips and the trilled arpeggios of the comedy queen's innuendo-riddled banter. The queen is also controversial, and never more so than in the 1970s, when the emergent movement of gay liberationist politics flexed its muscles by lambasting him (most often in the persons of Larry Grayson and John Inman) as a reactionary and damaging misrepresentation, reinforcing a view of male homosexuals as weak, shrieking, sexless ninnies, a caricature constructed of fluff and fuss, a misfit made up of 50 per cent failed man and 50 per cent failed woman. Yet, seen from a different slant, the queen can be

a cause for gay celebration, an index of defiance, an embodiment of survival, and a fabulous refusal to conform and behave – proof that poofs endure. This chapter looks at certain emblematic figures and performances in the history of the English comedy queen, to see what he signified and to assess where to place him politically. There isn't an impartial page in this book (except possibly, and only possibly, the index) but this chapter is even more skewed than usual. As an English queer, and even an English queen when the company is congenial and the circumstances permit, I am hardly likely to occupy a dispassionate position. Please feel free to punctuate that last phrase with the Frankie Howerd eyebrow hoist or Kenneth Williams vocal inflection of your choice.

Oscar's offspring

In 1934, George Formby's first film *Boots Boots* featured its star as a lowly employee of a swanky hotel. One of the film's running gags is that Formby is obliged to wait in the hotel lobby as a succession of guests arrive, each one of them a quickly recognisable stereotype who seems to have stepped directly from the surface of a seaside postcard. They then act out a brief scene with Formby, in which his persona (still at a very early stage of development) spars with their cartoonish characteristics. One of these guests flounces in wearing Oxford bags (the excessively baggy trousers favoured by the wealthy young gentlemen of the era), spats, an elaborate pocket handkerchief, a lavish flower in his lapel buttonhole, and speaking in an exaggerated parody of an upper-class accent. 'I must have a pink room', he tells Formby, and when offered the alternative of a yellow room, replies 'I would positively *die* in one of those'. Formby exclaims 'Ooh fairies!', and then he and the guest go into a little skipping dance while they sing nursery rhymes. Both men appear to be wholeheartedly enjoying these antics until Formby slaps, kicks and ejects the guest, who flees from this slapstick attack with a shrieked, lengthy cry of 'Whoooooo!'. This is, to put it mildly, an extraordinary scene. It serves no narrative purpose, but then *Boots Boots* is a film in which narrative is remarkably irrelevant compared to its assemblage of songs, comic scenes and performances lifted directly from stage shows. What the presence of this outrageous queen would seem to indicate is that this stereotype was already familiar enough to the film's audience to require no explanation or context, an established part of the popular comic imaginary, funny not for doing anything in particular, but for being what he was and implying what he implied.

Exactly what he did imply, however, is more complex than it first appears. He is funny for the film's Northern, working-class, heterosexual audience because of the several ways in which he is distant from them. He is effeminate, bluntly labelled a fairy, too interested in appearances and too extravagant with language to be a real man, but this effeminacy is coded primarily in terms of class. His clothing and accent mark him out (especially playing against such a proletarian

star as Formby in a film as poverty-stricken as *Boots Boots*) as rich, while he is also coded as Southern, another crucial marker of difference given Formby's affinity with Lancashire. Effeminate, rich and Southern – three 'others' for the price of one, removed from Formby and the film's audience and a ripe target for their laughter by virtue of gender, class and regional difference. Given how the history of the comedy queen is, among other things, the history of homosexual men in popular culture, that list should also include a fourth identity category, sexuality, but that cannot be communicated as explicitly as his other characteristics. The hotel queen's effeminacy, wealth and regionality are unequivocally on display, but he can give no direct indication of his sexual orientation – for example he does not, as some later queens would, cast an appreciative sexual eye over his male on-screen partner. That is hardly surprising given the censorship operative at the time and the fact that this film refuses to allot its stereotypes anything remotely approaching characterisation, or indeed the screen time, to do anything other than appear, perform and exit. Any direct statement of homosexuality was not feasible in such a text at such a time, but the queerness of the queen is nonetheless a major part of what makes him funny for Formby and his audience, so the queen's queerness has to be deduced from the intersection of other signs that were representationally permissible. This queen is, in effect, one of Oscar's offspring, fitting neatly into the model of the queer that had been delivered into popular currency by the trials of Oscar Wilde and the scandalous publicity they generated. The archaeology of that stereotype has been meticulously unearthed by Alan Sinfield, who argues that before Wilde, effeminacy was not automatically linked to homosexuality, but that after Wilde the connection was made, growing over time into a cultural truism. The Wildean queen stood at the centre of a 'disconcerting nexus of effeminacy, leisured idleness, immorality, luxury, insouciance, decadence and aestheticism' (Sinfield 1994: 118), and all of those characteristics, with one important exception, are there to see in the brief, spectacular appearance of that queen in *Boots Boots*. Films like this were crucial conduits through which the Wildean template achieved wider cultural currency, consolidating the archetype into the comic raw material of a stereotype.

The exception, the one component from Sinfield's inventory not immediately present in the hotel queen, is immorality. This could only be inferred, since when it was made plain and pushed beyond inference it was quickly punished. Twelve years after the Formby film, Frank Randle's 1946 Blackpool summer show was prosecuted and fined for obscenity. One of the sketches cited in court featured Randle and one of his troupe 'taking the piss out of a pansy, pansy played by Aubrey' (Nuttall 1978: 83). Aubrey was Gus Aubrey, a loyal member of Randle's company and also a helplessly effeminate queen, constantly made the butt of jokes in Randle's ruthless carnival. Randle's 1952 summer show was also prosecuted, and one sketch mentioned during that trial showed 'Aubrey queening about in tight Boy Scout shorts ("a homosexual

impression" counsel stated) producing knitting when Randle stroked his arm' (Nuttall 1978: 84). Several things are worth noting here. Firstly, two decades on from *Boots Boots*, the word 'homosexual' can now be uttered in relation to the comedy queen, but note how that utterance can only occur in the regulatory space of the courtroom. In comedy, where different linguistic registers held sway, the queen was more liable to be a fairy or a pansy – 'homosexual', with its medical undertow and legal implications, is not exactly a word fizzing with comedic potential. Secondly, the image of Randle stroking Aubrey's arm is reminiscent of how Formby was perfectly content, even delighted, to join that hotel queen in his prancing and singing, both examples indicating a degree of ambiguous playfulness between the aggressively masculine lead comic and the supporting queer which scuppers any crude attempts to label such scenes 'homophobic'. Thirdly, the extent to which Aubrey's actual homosexuality was a factor in rendering his scenes with Randle open to prosecution when the Formby scene went unchallenged raises the issue of how much emphasis should be placed on the queerness of those who played queens. The queen in *Boots Boots* was played by Dan Young, a stage comic who also worked extensively with Randle, though his persona in Randle's product was that of an idiotic toff. The hotel queen was also, of course, an upper-class fool, but Young's later performances emphasised class rather than gender, relegating effeminacy to the background, or dropping it into the lap of the dependably unmanly Aubrey. A final point to glean from the Randle/Aubrey sketches is that they do not, as far as can be known from their brief summary in printed accounts, draw heavily on the Wildean model of queer queenliness. The Aubrey characters do not seem to have been wealthy or artistic, leaving the intriguing implication here that Aubrey was adopting the persona of a working-class queer, inhabiting a more everyday effeminacy, shedding the upmarket pretensions of the Wildean aesthete and just getting on with his knitting.

If the Aubrey sketches remain tantalisingly lost from full view, there is another remarkable 1940s performance of queenery that can be examined in detail. The most successful stage comedian in the early 1940s in England was the Birmingham comic Sid Field, whose character sketches (an incompetent golfer, a shifty spiv, a deranged orchestral conductor) were the most acclaimed part of his act. *London Town*, made in 1946, was an ill-conceived film which attempted to launch Field as a cinematic star; it failed dismally, but fortunately it did preserve a number of his sketches, including one in which he played, to quote the bluff summary offered by J.B. Priestley, 'an outsize pansy photographer' (1975: 162). In the sketch, Field is waiting for his old friend Whittaker to arrive. Whittaker (expertly played by Jerry Desmonde, who would later act as stooge in several Norman Wisdom films) has become the town mayor, and Field is about to take his official portrait photograph. There is little narrative in the sketch beyond the attempts to take the photo, leaving the comedy to arise from the conversation between the two men, the risky hints

they drop about the closeness of their friendship, and from Field's outlandish characterisation. His performance is astonishing, taking certain elements of the Wildean queen (artistic pretension, an obsessive concern with appearances, a feminised gentility, even the somewhat Edwardian décor of the room in which the sketch is set) but skilfully coarsening them into a stereotype more appropriate for popular comedy. He is excessive, vain, dandyish, over-emotional, gossipy, prone to tantrums, pays an unmasculine attention to the minutiae of domesticity, enjoys discussing his own and his guest's health and physical well-being in great detail, is unusually tactile, and talks in a mode of strategic extravagance which emphasises certain words with such effete forcefulness that he seems to speak them in lavender italics. He incorporates little skipping movements into his walk, he points his little finger when drinking cups of tea, and when speaking to Whittaker he gets so close and speaks with such enunciatory exaggeration that he seems to be on the verge of licking him. It is dazzlingly funny, and it contains the seeds within it of much of the tradition of camp queening that followed. There had been plenty of momentary sightings of queens before this (the 1939 Formby vehicle *Trouble Brewing*, for example, briefly features an opera-loving queen whose favourite adjective is '*divine*'), but here for the first time was a top-rated performer surrendering himself to the fabulousness of effeminacy, rather than bringing on a bit player to enact the queen stereotype, and making it the centrepiece of an evening's entertainment. It was massively influential – to see and hear Field in this sketch is to realise, for example, where many of Frankie Howerd's mannerisms and almost all of Larry Grayson's act originated. Where it differs from them, however, is that Field's queen, for all its daring and brilliance, was a performance of queerness enacted by a heterosexual performer. As such, one very plausible interpretation would be to see it as a ridiculing of effeminate queerness rather than a use of effeminate queerness as a platform from which to ridicule others (I do not myself subscribe to that view, but I would not dispute its plausibility). Field's sketch depends on the queen as object, rather than subject.

Later sections of this chapter explore the other path implied in that binary formulation, the uses and meanings of queenly comedy when practised by actual queers. Before them, it is worth tracing some key instances of the queen as object, in order to establish how pervasively the Wilde-derived queen embedded itself in English popular comedy. This was nowhere more prevalent than in the genre of sitcom, where cheap laughs at the expense of queens can be found in a distressingly large number of series from the 1950s through to (at least) the 1980s. The alarming figure of Gilbert in *Not On Your Nellie*, discussed in Chapter 5, is proof of that, as is Gloria, the stage-struck queen from the largely deplorable *It Ain't Half Hot Mum*. Two detailed examples will suffice here, indicative episodes from the long-running sitcoms *Steptoe and Son* and *Rising Damp*. In both, long-running relationships between heterosexual men are disrupted by the one-off introduction of a threatening queen, and in that respect these episodes need to be cross-referenced with the next chapter's

account of the sexual dynamics of the male double act. The *Steptoe* episode, 'Any Old Iron', first broadcast in March 1970, finds a new variation on one of the series' key structuring narratives, the question of whether Harold Steptoe will ever be able to move out of the family home he shares with his father Albert. In this episode, Harold is developing an interest in antiques, having become convinced that some of the objects he has acquired as junk through his job as a rag-and-bone man could in fact be very valuable. Enter a queen, in the shape of the elegantly epicene antique dealer Timothy Stanhope. He takes a keen interest in Harold, playing to the hilt the stereotype of a cultured Wildean queer captivated by a working-class bit of rough. Harold refuses to acknowledge any erotic dimension in their developing friendship, though Albert is under no illusions. Father and son argue over whether or not Timothy is a 'poof', a word that they manage to utter no less than ten times in sixty-six seconds during one verbal dispute, a hysteria of naming that reveals the intense anxiety of the topic in hand. (The episode's title is also relevant here – 'iron' being an abbreviation of 'iron hoof', Cockney rhyming slang for 'poof'.) Time and again, the episode conflates effeminacy, homosexuality, art, decadence and upper-class identity – the Wildean mix in full flow (see Sinfield 1999: 272 for another account of this episode). 'Anyone who dresses well, talks nice, with a bit of refinement, he's a poof', is Harold's summary of Albert's attitudes, while the latter is just about to call Timothy a 'jessie' to his face before amending the word to 'gent', a neat condensation of the gender and class dynamics operative within this particular discourse of queerness. The precise cultural moment of the episode allows a new variation in the pattern, with Harold dressing in full Carnaby Street queer-influenced regalia (see Dyer 1994, Medhurst 2001) for his visit to Timothy's flat – fringed jerkin, wide-brimmed hat, flowing cravat, leather shoulder bag and suede ankle boots, their suedeness (and thus, subculturally speaking, their queerness) foregrounded by a close-up shot of Harold brushing them. Once at Timothy's, Harold finally realises the direction of his new friend's intentions, after a scene of attempted seduction that is strikingly unambiguous for its time, and flees into the night.

In the *Rising Damp* episode, 'Stage Struck' (first broadcast in April 1977), the Wildean model is present in the character of Hilary, an actor who rents a room in the lodging house presided over by the series' star character, Rigsby. Hilary (note the gender ambiguous name) is linguistically and sartorially flamboyant, fussily houseproud, prone to hypochondria, wears cravats and Noel Coward-style dressing gowns, flirts outrageously with heterosexual men, speaks with an upper-class accent and in Field-queen italics, and is a stranger to any kind of everyday hard work. He has, according to Rigsby, a 'crippling fear of manual labour' and 'nearly ruptured himself putting up his chintz curtains'. *Rising Damp* was never a sitcom afraid of broad brushstrokes, and Hilary is a particularly brisk condensation of all the usual queen characteristics – not that this concerns the studio audience, whose laughter during the scene where

Hilary pretends to seduce Rigsby reaches feverishly extreme levels. Just like the comparable moment in *Steptoe*, this scene marks a landmark point for the queen stereotype because it promises to usher in the actuality of homosexual sex. It is a moment that teeters on the brink of showing what was then, given the historical and generic context, profoundly unshowable. As such, it is a moment that needs retreating from, so Hilary is revealed to be heterosexual after all, with an amorous interest in the female lodger Miss Jones. That this is not remotely credible, given what the rest of the episode has indicated, matters less than the ideological reassurance it offers a heterosexual audience by pulling back from that precipice edge where the queen was about to become unassailably and corporeally queer. The Wildean cultured-dandy queen could only remain a comic object if he was held back from the accomplishment of sexual activity. There was rich comic potential in threatening to break that boundary, especially if the man the queen desired was heterosexual, and the comedy embodied in Field's elasticated tongue, Timothy's solicitous hands, and Hilary's roving eyes was a comedy occupying precisely that boundary point, a comedy drenched in nervousness, tease and risk. To cross that line was unthinkable, since it would reverse the usual power relations between superior straight and inferior queer, making the queen a conqueror and the straight man an objectified prize. Such a move would require, in effect, the reconciling of the limp wrist and the stiff cock, and that particular anatomical and ideological union was not feasible until some time later, as this chapter's account of the career of Julian Clary will shortly show.

Before looking at Clary, however, we need to return to the era of Sid Field, since that period saw the debuts of English comedy's two most important queens. Both Frankie Howerd and Kenneth Williams became professional entertainers in the 1940s, both were queer, and both were often profoundly unhappy about being so, which was hardly surprising given the shadows of prejudice and persecution under which English queers of that generation were obliged to live. Both took the raw material of their queerness, and to some extent the related unhappiness, and used it to fashion hugely, if erratically, successful careers in comedy. I have no wish here to trace every detail of their careers (those stories can be found in Took 1992, William Hall 1992, Davies 1994 and Middles 2000) but intend instead to look at their particular styles of camp performance in order to see what they reveal about comedy, sexuality and the meaning of queening.

To dangle or to dazzle?

Like all of the greatest comic talents, Frankie Howerd can only be fully and truly appreciated in the performing moment. Transcribed into the flat banality of print, the stand-up monologues which showed him at his best lose much of their special flavour; you need to hear that voice and see that face to realise why he was such a gifted clown and significant figure. Only in full performative

flow can you grasp the importance of the pauses, the inflections, the diversions from storytelling to admonish or tantalise or conspire with the audience, the punctuational use of raised eyebrows and pursed lips, and the way that ostensibly meaningless syllables like 'ooh' and 'ah' can overflow with inference when falling from that restlessly mischievous mouth. In a monologue in one 1966 television show he was complaining, as he so often did, about his mistreatment by an uncomprehending TV executive: 'You don't fit in anywhere, you're neither one thing nor the other. I don't know what he meant by that. Sauce. He said ... he said ... Please. There's too much tittering'. This only becomes gloriously funny and paradigmatically Howerdian when those words are nudged and kneaded and transmogrified in the crucible of performance. He leaves a pregnant pause between the end of that first sentence and the beginning of the next, a pause perfectly timed to let the innuendo, with its implication of sexual nonconformity, sink in. To cap and intensify this, he italicises the word 'what' with a shudder of effeminately affronted dignity. The word 'sauce' then becomes both a rebuke to the man who has offended him in the story and a chiding of the audience for daring to decode what is allegedly a hidden meaning, but is in fact an obvious gag. The audience is by this stage laughing so hard that Howerd tries to begin a further stage of the story but has to say 'He said' twice, increasing the volume in an attempt to quash the laughter he himself has so brilliantly induced. The audience must be scolded once again, and this time he does so using the failsafe joke-word 'tittering', with its endemic double entendre and its status as one of Howerd's favourite terms combining to stoke the laughter higher still. All of this verbal play, this sculpting of syllables and silences, is accompanied by a three-ring circus of facial acrobatics. The eyebrows arch and knit, the lips pout and re-pout, there are sidelong glances that hover between a flirtation and a dare, grimaces that cross-fertilise louche world-weariness with pained embarrassment, and there is the ceaseless mobility of the tongue, literalising the cliché by being plunged into his cheek, or jammed between his teeth and lower lip to add one more twist to the array. It is a kind of facial drag, a countenance that Howerd contorts in order to convey truths and tell tales not permitted in the more stringently policed realm of actual speech. It's a face that looks back to Sid Field and Norman Evans, that anticipates Larry Grayson and Les Dawson, that is a considerably more feminine sibling of the face bestowed on Hylda Baker.

 All of that happens over the space of just thirty words and a few seconds. Clearly it would not be feasible to unpack every Howerd performance in such detail, but it is the detail which secures the comedy, and it is in the detail that Howerd's particular negotiations with effeminacy, gender, sexuality and camp were played out. He was sometimes obliged by the narratives of TV sitcoms or feature films to play at heterosexual masculinity, leering after slave girls in *Up Pompeii* or fending off Eartha Kitt in *Up The Chastity Belt*, but these were hopeless impersonations of lustful machismo. Howerd flourished as a gossip, a stirrer, a prurient fishwife whose aspirations to refinement prevented

the spelling out of what was being discussed. His career was founded on what Eric Midwinter accurately called 'the double-bluff of playing the woman in male clothing' (1979: 159). There was a lot of Field's photographer in this, but Howerd's stand-up persona had no yearnings for cultural uplift. He was a back-street nag, an over-the-fence telltale, beckoning you to listen to something you would enjoy being shocked to hear. His relationship with an audience was one of reciprocated conspiracy, and never more so than over the issue of sexuality. When Howerd's career began, it was impossible for any queer in the public domain to be open about their sexual identity, but the whole of his act was premised on such a wholesale rejection of conventional masculinity that only a queer could have had any reason for undertaking it. (His scripts were mostly written by heterosexual writers, but it is the queer performance which is crucial here, although the ramifications of an ongoing relationship between a queer performer and straight writers offer a rich seam for future exploration.) As Howerd spun ever more elaborate webs of language through the protractions, ellipses and diversions of his monologues, his sexuality became their unspoken, unspeakable but constantly underlined subject matter. His queerness was a glaringly obvious shameful secret, and his style and delivery dug comic gold from the complexities of that paradox. That secret became the unmentionable but ever-present mainspring of how he spoke, both subtext and superstructure of all the other secrets he enticed us in to witness. He was forever spilling the beans about others while never (and always) telling the truth about himself. The conspiracy we joined with him was that he knew he was queer, we knew too, he knew we knew, we knew he couldn't say, and he knew that although he couldn't say he couldn't help revealing it in every second that he never spoke about it. To laugh at Howerd was to laugh at the gap between what is known and what can be said, at the ever-present unavoidability of that which must be kept hidden, and at the ways in which the unspeakable could be spoken loudly as long as direct words were replaced with inference, emphasis, pauses, gesture and timing. As Howerd was all too aware, queers of that era could never risk directness, openness or honesty when speaking in the spaces of heterosexual culture. Hint and allusion were home turf for queers, a corner they were backed into, but Howerd took that fearful corner and built within it a scandalous palace of queer comic genius.

His style and method could only really work to full effect in live per-formance or in television or radio broadcasts that replicated live conditions. In films, he was almost always awful, denied the conspiratorial feedback of instant laughter. He made several films in the 1950s, which tried to make him an antic, Formbyesque figure, and even tugged him in the direction of Norman Wisdom-style sentiment. Howerd's home mode was ruthlessly free of sentiment, forever sending it up by pleading with his audience 'don't mock the afflicted', a phrase which of course meant its exact opposite (it was mostly uttered in relation to the supposedly deaf female pianist who accompanied him on stage, though it was also possibly a displaced reference to the 'affliction'

of homosexuality) . There are a few diverting moments in those Fifties films, mostly in *Jumping For Joy* (1955), which playfully throws a few scraps about sexual otherness to queer or clued-in audiences – Howerd's character is called Willie Joy, for example, and in one scene he goes into a bar and orders a double ginger beer (rhyming slang for queer). He later appeared in a couple of the Carry On films (far fewer than is often supposed) but looks ill-at-ease, a stranded stand-up surrounded by skilled comic actors. It was only in 1969, with the TV sitcom *Up Pompeii*, that he found a fiction framework which suited him, and it suited him so well because the rest of the cast performed a narrative story while Howerd did a stand-up act in the middle of them. He was dressed as a Roman slave and took an occasional interest in the plot, but the memorable moments in the programme come when he speaks directly to the audience, inviting them to share his mockery of the situation. He sends up the programme's storylines ('you wouldn't get this from Harold Pinter'), underlines its reliance on outrageous innuendo (asked 'Can you get Filthia for me?' he replies 'On *this* show?'), halts the action to make fun of the performances, and drops gossiping hints about the sexual proclivities of other actors. The film version of the series lets him play similar tricks, as did its sequels *Up The Chastity Belt* and *Up The Front*, but these like all films once again starved him of the instant nourishment of audience laughter, and all three soon wear out their welcome. Their pitch, rather too obviously, was to start a running series along the lines of the Carry On films, and the scripts do manage to squeeze some dirty-joke mileage from words like 'weapon' and 'smallholding', but where the Carry Ons could spread the burden among a dozen or so leading performers, Howerd is the constant focus in the *Up* ... series, to the extent where he sags under the weight. He mugs at the camera like the trouper he was, but that's not an adequate substitute for the extended duets he was able to play with flesh and blood audiences.

Kenneth Williams was also a master of live performance, though his bond with audiences was of a very different kind. Howerd lured audiences in, fed off them, played with them in a reciprocated game, but Williams needed them to witness and worship. Where Howerd dangled his audiences, Williams dazzled them. His constant, anxious yearning to show his cleverness was rooted in the fact that he was not a stand-up comic but an actor, who became typecast in low comedy but always felt he could have achieved what he saw as greater things. As the tortuous self-recriminations of his published letters and diaries proved, he was perpetually torn between exploiting his great gifts as a comic actor, mimic and clown, and resenting the fact that they imprisoned him inside a particular persona, that of the flamboyant queen. There is often an edge of desperation in Williams' performances wholly absent from Howerd's; Williams seems desperate to impress, to shine, to show off what he knows and just to show off. The chat show appearances that comprised most of his work towards the end of his life are exceptionally revealing in this respect. In them, he came to epitomise the public perception of a certain kind of queen – angular, spiky,

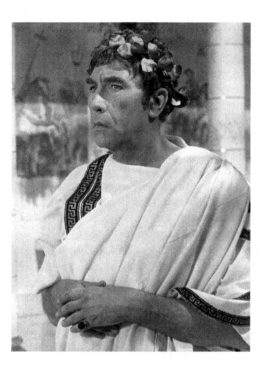

Figure 6.1 Frankie Howerd in *Up Pompeii*, directed by Bob Kellett, 1971. Courtesy of Associated London/MGM-EMI/The Kobal Collection.

showy, domineering, relentless, vindictive, mentally sharp and vocally agile, embroiled in a catfight between self-love and self-loathing, delivering a mono-logue even when supposedly engaged in conversation, unleashing a firework display of unstoppable linguistic gymnastics, unstoppable most of all by the queen at the centre of it all, afraid to stop, to take a breath, to staunch the lava flow of logorrhoea in case something as mundane as the real world or as weakening as an admitted emotion sneaked its way under the barbed wire bril-liance of all those words. Like Howerd, but to very different effect, Williams' face and voice were crucial players in these tirades. The face centred on his nostrils, seemingly on loan from a Gothic cathedral gargoyle and big enough to park a car in, flaring wider and wider as Williams' performance and language became more and more extreme. Nostrils are a neglected orifice in carnival theory, but it is worth remembering that Bakhtin (1968: 26) does include them in his catalogue of apertures, and Williams' unceasingly lavish nostril deploy-ment marked the one reckless display of bodily comedy in a man usually so traumatised by the thought of unbridled physicality that his own sex life was woefully unsatisfying. It is hard to suppress the thought that if he had been

as generous with certain other orifices as he was with those endlessly gaping and pulsating nostrils, Williams might have been a happier homosexual. As for the question of voice, it would be more accurate to speak of voices. Where Howerd kept securely within in his own, admittedly elasticated, voice, Williams housed a small repertory company in his larynx. He could do gruff Cockney, loud-mouth American, Oxbridge drawl, screaming queen, ham actor, slow-witted yokel, nasal whine, a frighteningly accurate Edith Evans impersonation and dozens more. A favourite trick in his celebrated chat show appearances was to switch vocal persona in mid-story, sometimes even mid-sentence, adding to that general air of pyrotechnic display, with everything always delivered at a manic pace which somehow never collapsed into gabble. It was campness captured in a single throat, leaping across octaves and pulling accents out of thin air, recounting scandalous stories while simultaneously staging a meta-commentary about their contents and protagonists, meshing neurotically precise enunciation with strategically efflorescent over-emphasis. To see and hear Williams on top form was to marvel at the collision of rococo velocity and effeminate ferocity.

Unsurprisingly, finding suitable vehicles for such a singular but unnerving talent was never easy. Williams made his name in popular comedy by taking on assorted supporting roles in Tony Hancock's radio series, but was edged out when Hancock felt that Williams was dealing in caricature rather than character and, worse still for Hancock's fragile ego, getting more laughs than the nominal star. These were tensions which ran throughout Williams' career. It is striking that, with the exception of the chat show appearances, Williams' best and best known work remains those texts in which he was part of a larger ensemble rather than stepping solo into the limelight. The Carry On films are the most obvious example, followed by his work on that most wonderful of radio comedy series, *Round The Horne*. The films have their own chapter in this book, but the radio series needs consideration here, in particular the regular sketches where the urbanely respectable host of the programme, Kenneth Horne, would visit some business or enterprise which, drawing on the sub-cultural queer slang of Polari (see Baker 2002) included the word 'bona' in its title – Bona Books, Ballet Bona, Le Casserole de Bona Gourmet, and so on. Here he was invariably greeted with the line 'Hello I'm Julian and this is my friend Sandy', spoken by that hugely underrated comedy queen Hugh Paddick. Williams played Sandy, the pushier and more volatile half of the partnership, and each sketch featured the pair's attempts to convince Mr Horne, as they always called him, to use their services or support whichever venture they were engaged in that week. Julian and Sandy were, until the 1990s, the most upfront queers in English popular comedy, achieving that remarkable status through a fortuitous conjunction of text, context and performance. Textually, the scripts (by Barry Took and Marty Feldman in the first three series, by Took alone in the fourth) were insanely inventive, crackling with a love of language and delirious with the delighted knowledge that by deploying Polari, and other

coded queer terminologies, things could be said in a nationally popular Sunday lunchtime radio series that would have been utterly taboo if expressed in mundane speech. Halfway through the 1968 series, for example, in 'Bona Song Publisherettes', Sandy informs Mr Horne that Julian is 'a miracle of dexterity at the cottage upright'. In the sketch's narrative, Julian is about to play the piano, and 'cottage upright' is a valid term for one variety of that instrument, but what the writers, performers and subculturally attuned listeners all knew was that in Polari, 'cottage' meant those public toilets in which queer sex was a frequent occurrence. Sandy's line, therefore, is actually a proud announcement that Julian is particularly skilled at manipulating his own and other men's erect penises in locales often raided by police in search of prosecutions for what was legally deemed to be 'gross indecency'. Fabulously daring stuff (or 'fantabulosa', as Julian and Sandy would say, stretching the penultimate syllable into queenly infinity), though it does raise the question of what listeners without the requisite subcultural knowledge would make of such a line. I was nine years old at the time of that broadcast, and listening to *Round the Home* was a weekly treat for me and my parents, but I am fairly certain (unless my parents have had more adventurous lives than I have hitherto realised) that we would not have realised that a joke about queers wanking and law-breaking had just sailed out of the radio. Yet the line is funny even without knowing its exact meaning – performatively, Williams rattles out the line so quickly it's as if he expects the police or the BBC censors to rush in at any moment, yet he also relishes each syllable of its beautifully constructed sound and shape, resulting in a micro-text of consummate effeminate brilliance. Besides, by this stage in the series' evolution even the straightest listener knew that even if these characters' language was not precisely decipherable, it was obvious that they were poofs telling a dirty joke. Nonetheless, it is a breath-taking line to utter in a mainstream text, and it was far from unique. In other sketches Julian and Sandy chatter about looking for sex with other men ('we often go cruising, don't we Jule?'), reveal their awareness of queer cultural history ('A bit Isherwood's Berlin if you ask me'), refer to queer celebrities whose sexuality at this historical moment was far from publicly acknowledged (Rock Hudson, Dirk Bogarde, Robert Helpmann, Danny La Rue), show a deep-rooted familiarity with queer subcultural spaces (East London queer pubs, West London private members' bars, holidays in Tangier), and hint through a panoply of sensational innuendos about assorted queer sexual practices ('I like to see anyone get on', 'just give us a free hand', 'I have to leap out and go straight down on the upright', and many, many more).

 Round the Home ran for four series between 1964 and 1968, and as such can be seen as one of the key texts of 1960s cultural liberalisation. In that precise social context, the laughs it generated were the sound of a public merrily devouring the new freedoms of changing times. The show often makes fun of the key cultural tropes of the era (Carnaby Street fashions, pop music, the whole rhetoric of 'Swinging London') but nonetheless draws on them greedily

and gratefully. For English queers, this period was especially momentous since it saw the passing of the 1967 Sexual Offences Act, partially decriminalising male homosexuality, a landmark which Julian and Sandy could hardly omit from their conversation. So in one sketch in early 1967, before the Act was passed, they are lawyers, a conceit which enables them to tell Mr Horne 'We've got a criminal practice that takes up most of our time'. A year later, after the Act, they are enthusing to him about the joys of outdoor leisure pursuits, insisting 'We feel there's a crying need in this country for men like us to get out into the open'. I wouldn't want to overstate this point – Julian and Sandy were never likely to become politicised, liberated gays, rooted as they were in the clandestine world of the showbiz queer with its covert codes and secretive venues. Yet through the use of Polari (the sketches were major influences in bringing words like 'camp' and 'butch' into wider circulation), the propitious climate of the time and, perhaps above all, the queenly majesty of Williams and Paddick's performances, Julian and Sandy represented a seismic shift in queer comedy. This was a very different kind of comedic queerness to Frankie Howerd's, it was much more (to use another word Julian and Sandy loved to fling flamboyantly from their lips) outrageous. They said out loud what he could only toy with saying, though the loudness and the out-ness of what they said was shielded from certain ears by the use of coded slang. Julian and Sandy were also far more attuned than Howerd to the wider queer subculture, and the proof of this can be heard in the significant eruptions of loud, male laughter from what can only be tickled-pink queers in the *Round the Home* studio audience. Keith Howes' information (1993: 698) that queers enjoying sexually speculative Sunday strolls on London's Hampstead Heath often took radios with them in order to pause and listen to this peerless pair of queens is yet further corroboration of Julian and Sandy's status within their subculture. Some later gay commentators, however, have not been so well-disposed to Julian and Sandy, with Alan Sinfield issuing a particularly unimpressed verdict: 'Often all this is recalled with great affection by gay men, but there is actually not much that is liberatory about it. You don't have to hide in the closet, it says, you can come out and be a grotesque for the amusement of straights' (1999: 272). That is indeed one possible reading of Julian and Sandy, but I find it a surprisingly simplistic one. For one thing, it expects to find singular political meanings in complex cultural texts, and for another it privileges the laughter of homophobic mockery (which Julian and Sandy did of course elicit) over the laughter of queer recognition. I would prefer to let that latter laughter, the laughter of queers celebrating a shared culture, a shared history and a shared carnivalesque assault on conventional masculinity, drown out the dim dull-wittedness of the former.

Kenneth Horne's death in 1968 brought *Round the Home* to an end, but the BBC tried to prolong its spirit by making Williams the star of a similarly structured show called *Stop Messing About* (a Williams catchphrase first used in his work with Hancock). It was moderately successful enough to run for

two series, but listened to today it isn't much more than a fascinating failure. The chief and revealing reason for this is that Williams sounded uneasy at the textual centre; with Hancock, in the Carry Ons, in *Round the Horne*, and in its less daring predecessor *Beyond Our Ken*, he had been part of a team, and never funnier when supposedly chafing at the limitations of that role and protesting that he deserved star status (he would later play similar games, very successfully, in the radio panel game *Just A Minute*). Ranting away at the suave, calm Horne, Williams could play to the hilt the persona of snubbed queen, proclaiming his unrecognised genius and lamenting the under-use of his talents. Without Horne to bounce off, Williams could become grating and shrill, which suggests that for all its bravura defiance, his brand of camp could only operate within certain limits. It worked brilliantly as a weapon from the wings, but as *Stop Messing About* demonstrated, it didn't know how to command centre stage. For a queer of Williams' generation, that was not surprising, since it would have required an ease and contentedness with his sexuality which was unlikely to exist. Williams had gone too far into outrageousness in *Round the Horne* ('I am an incipient queen' he yelled in one sketch; 'you all think I'm a raving madam' in another) to be able to use Howerd's double-bluff technique of saying everything through not-quite-nothing, yet he was too enmeshed in the heterosexually enforced self-hatreds of the guilty post-war queer to move decisively forward. That move could only be made by a younger generation, while Williams was obliged to take on his chat show persona of the firework fairy, hurling extravagance at the audience to keep his own demons at bay. For a remarkable glimpse of how he felt imprisoned by the very public image which sustained his celebrity, consider this letter he wrote in 1968 to George Melly, then the television critic of *The Observer*. Melly had reviewed one of Williams' television appearances, and Williams wished to contest both the words used and the inferences behind them:

> I have had notice after notice in which I have been called 'epicene' and 'feminine' and 'camp' ... When I first read these sort of notices I was appalled and deeply hurt. I thought to myself 'surely I do not come over like that?' but then it happened so often that I began to think it must be true. True that is for the objective outsider but NOT for me. If I really believed that I look in life like the kind of effeminate poof the critics describe, I think I would do away with myself ... I realise that I have been trapped in the façade of the persona I have adopted, but it was forced on me. If anyone calls you a pervert often enough, you adopt any shield you can get hold of to protect yourself.
>
> (Davies 1994: 88–9)

This suggests another, sadder side of the camp coin, painting a picture of Williams as a queer trapped in queening, resenting the fact that he has been

boxed into a narrow and destructive stereotype, or what he calls, in a double act of distancing that tries to push his image not one but two steps away from what he saw as his true self, 'the façade of the persona'. (In a suitably ambivalent decision, he decided against sending this letter, but kept it among his papers.)

Yet the man who wrote those pained words is also the performer whose Sandy was one of the masterpieces of queer comedy, who tore through the Carry On films like a lavender tornado, and who wrote plenty of other letters (and diary entries) in which he invests in the screaming queen persona with staggering gusto. Here is a 1971 letter in which Williams describes, or quite possibly invents, a visit to the toilets of a prestigious London department store:

> I was in John Lewis and I was bursting for a pee so I ventured into the door marked 'Gentlemen' on their basement floor. There were no gentlemen in there I can assure you ... there was a lot of heavy breathing. Three of them standing in the stalls were quite shameless and seemed oblivious of the fact that it was eleven and time for coffee, not for wanking. I had to go into the cubicle cos the effect was distinctly pornographic & gave me the half hard (as dear old Edward Everett Horton used to term it). That wasn't a good idea ... because the adjoining cubicle was occupied by someone who was emptying the bowels copiously and noisily. The smell was atrocious and certainly put paid to the half hard, Edward Everett Horton or no Edward Everett Horton.
>
> (Davies 1994: 145)

Williams' contradictions are enshrined in the tensions between this letter and the unsent letter to Melly. He was both the self-doubting anxious queer who hated being pinned down to a single, easily ridiculed type, and the shameless queen capable of constructing a scene of such freewheeling carnival excess, such a creative enmeshing of depravity and hilarity, that even his friend Joe Orton might have balked at some of the details. The second letter's yoking together of ruptured decorum, sexual longing, the detumescence occasioned by odorous defecation and the fluttering spirit of the prissiest of 1930s Hollywood film stars is a tour de force of inventive queenery, a print equivalent of the stories Williams would use to enslave chat shows and which reached their apex in his great swansong performance on Channel 4, *An Audience With Kenneth Williams*. A sternly gay-political eye might see that one-man show as another example of the queer as performing monkey, the queen of clowns concealing hurt with camp, and there is much in that critique which is valid. Yet an awareness of the limitations under which Williams worked should not blind us to his talent or his significance; if anything, such knowledge makes his arabesques of outlandishness, considering their context, all the more miraculous.

The men that got away

Writing in his diary in 1977, Kenneth Williams records being advised by his agent to cast an experienced eye over two newly successful camp comic performers. He was not impressed:

> the Grayson TV show is a complete crib of my stuff, and that Inman is doing the same thing on the BBC ... they've found other people to do it, and *cheaper* people in every sense.
>
> (Davies 1994: 533, emphasis in original)

Williams was not wrong, except perhaps for the typically acidic jibe 'cheaper'. Larry Grayson and John Inman had become sizeable stars in the 1970s for their particular variants of queen comedy. While Frankie Howerd was in one of his periodic career troughs (before a last triumphant reclaiming of the stand-up stage in the late 1980s and early 1990s), and while Williams tried to recover from the demise of *Round the Home* and the decline of the Carry On films, Grayson and Inman had stepped into their shoes. The two usurpers were very different, however; Grayson was a seasoned veteran of over twenty years in drag shows, pantos, seaside summer seasons and the dingiest lower rungs of the provincial touring circuit, who had been given a brief chance on a TV variety show and proved a sensational hit with audiences. His own sketch shows followed, and by the late 1970s he was hosting *The Generation Game*, then the BBC's most prestigious light entertainment show. Inman was a jobbing actor who landed one of the smaller roles in a sitcom pilot called *Are You Being Served?*, where he played a camp menswear salesman called Mr Humphries. The show took off, Humphries's role was expanded, and thanks to endless repeats and latter-day cult appreciation, Inman can be seen to this day mincing across the television screens of the world proclaiming 'I'm free'. There wasn't much more to Mr Humphries than that. He was The Poof in a cast of seaside postcard archetypes that included The Bird, The Geezer, The Old Trout and The Pompous Boss. *Are You Being Served?* was an unapologetic assemblage of puns, innuendo, slapstick, increasingly bizarre costumes, and a series of dance routines or fashion shows which turned the department store floor into a pantomime stage. There have been some over-ingenious attempts by a younger generation of queer critics to reclaim Inman and his Humphries as gay free spirits admirably unconcerned with homophobic prejudice (see Healy 1995), but compared to Howerd, Williams or even Grayson, the Humphries character was threadbare, a deftly performed walking catchphrase, perhaps, but nothing more and nothing less. Kenneth Williams was being unnecessarily self-deprecating in fearing that Inman had stolen his thunder. Five minutes with Williams in Sandy mode would have left Mr Humphries in severe need of tea and sympathy.

Larry Grayson was another matter, since he was a richly talented queer stand-up who plugged directly into the tradition inaugurated by Sid Field's

photographer and perfected by Frankie Howerd. Grayson's act resembled Howerd's in that he was doing a drag act but not in drag, a put-upon housewife in a man's lounge suit, forever lamenting the state of his health, disapprovingly revealing the poor standard of cleanliness in the studio ('look at the muck in here'), or weaving fantastic narratives around his cast of unseen friends – pre-eminently Slack Alice, Apricot Lil and 'my friend Everard'. The first two could have come from a Howerd routine, but my friend Everard was a new development, since it brought another queen into the frame, forsaking the relatively safe isolation of Howerd's standpoint and tiptoeing cautiously towards the full-blown queer subculture of Julian and 'my friend Sandy'. Grayson's scripts were never as riotous or as risk-taking as those on *Round the Horne*, however, lacking the radio series' gleeful comedic seizing of the cultural moment and offering instead a gentle, domesticated, retrospective camp that celebrated the friendships between working-class queens and their women friends. His monologues revelled in the kind of cobbled-street camp that can be found in many episodes of *Coronation Street*, or which might have fuelled the comic persona of Frank Randle's queer stooge Gus Aubrey. There was nothing abrasive or threatening about Grayson, he was a tame old auntie rather than a knife-sharp queen-bitch, though this softer emphasis still delivered plenty of rich and relishable comedy.

Homosexual visibility, or rumours and implications of it, was a cultural flashpoint in England in the early 1970s. The recently formed Gay Liberation Front was embarking on its early campaigns, while Glam Rock stars like David Bowie and Marc Bolan raided the wardrobes of camp to unsettle prevailing ideas about masculinity and sexual identity. Grayson's act was the end-of-the-pier variant on this cultural shift; he was able, no doubt more by luck than judgement, to capitalise on the new climate to take the Howerdian comic mode in a new and less creatively evasive direction. One of his catchphrases was 'What a gay day', a cry which would have made precious little sense to a mass heterosexual audience even five years earlier, since although the word 'gay' was part of the code used in the Julian and Sandy sketches, it was only television and press coverage of GLF events that had made the new meaning of the word widely known. In its early days, GLF drew heavily on camp theatricality and the use of drag to stir up controversy and challenge conventional gender hierarchies (see Power 1995), but Grayson's brand of camp still became the target of intense hostility from many activists in this new generation of politically outspoken gays. He was guilty in their eyes of two things. Firstly he was camp in the 'wrong' way – his was an older-generation, working-class, light-entertainment camp, a use of camp as a survival strategy, a bolt-hole for a fey provincial pansy who found showbiz camp the only possible social and cultural space where he could enact a version of himself. That meant serving himself up as a target for the laughter of heterosexual prejudice, though to see him as doing only that seems to be as reductive an interpretation of his persona and performance as Alan Sinfield's stern verdict on Julian and Sandy. Grayson's second offence from the

GLF perspective was his refusal to come out as gay. That was indeed regrettable, but a fuller understanding of class, generation and context surely make it more understandable. The righteous anger of the GLF position was an unforgiving stance, taking no account of the very different contextual circumstances that separated a group of young and predominantly middle class radicals, steeped in the 1960s counterculture, from an ageing camp comic born in 1924 and raised in an era of fearful discretion who finally saw the chance to achieve financial security after decades of underpaid slog.

Besides, how much more open could Grayson have been? He frequently catalogued the shortcomings of his tellingly named friend Everard ('Everard, you haven't been upsetting the coalman again have you? I've been waiting all week for him to drop his nuts and my coal cupboard is bare'). He always walked on stage to an orchestral rendition of the opening bars of Judy Garland's classic queer-venerated torch song 'The Man That Got Away' (appreciating the queer relevance of this required some subcultural knowledge; watching Grayson as a teenager, I had never seen Garland sing that song in *A Star Is Born*, and when I finally did see the film my first thought on hearing it was 'that's Larry Grayson's music'). When he hosted *The Generation Game*, the pre-eminently popular game show of its time, he would appreciatively eye up any rugged lads who appeared as contestants and pout 'seems like a nice boy'. In none of these examples does he resemble a man fearfully hiding his sexuality. His denials in interviews were sheer self-preservation, since to admit being queer then would have ended his stardom. The clues were there for those who knew how to read them, and those that did not know, or did not want to, could take cover under those mantras of denial he felt he was obliged to issue. GLF expectations that he should march to the beat of their 1970s agenda showed a woeful insensitivity to queer history. Grayson's success was very much a product of the 1970s, but his heart and mind were fixed decades before that, in those grim years when the diva-led dreams of Hollywood musicals, a scream over a gin with one or two (male) sisters, and the occasional grapple with an off-duty serviceman were the only regular pleasures a working-class queen could expect to enjoy. Through an odd twist of cultural history, he was able to bring the sensibility of a 1940s queen into 1970s prominence – exemplifying this, the two funniest books he published (Grayson 1980, 1983) deliberately harked back to recall the years of his childhood and young adulthood. This historical mismatch, I think, helps to explain why he was so misunderstood and vilified by the vanguard of GLF, and why even at the end of the 1970s *Gay News* was still seething 'as far as we are concerned they do not come much lower than Larry Grayson' (quoted in Medhurst 1994: 247). Gay political campaigners, schooled in the agitational urgencies of the counter-culture, were striving to bring about a better future, whereas Grayson, like so many other performers and texts in English popular comedy, was happiest looking back, in generating laughter from the shared memories and comforting certainties of a nostalgia for the past. Divided from Grayson by gulfs of class, age and political disposition,

the gay radicals saw him as a traitor to their cause, but now the dust has settled on that particular ideological tussle it is easier to understand where Grayson was coming from and to savour his significant contribution to the effeminate tradition.

Queering the queen

In the histories I have sketched so far in this chapter, there are several points where a what-if moment arrives. What if the one-joke queen of music hall comedy had been given more space and his own voice? What if Sid Field's photographer queen had been enacted by a real queer? What if we knew more about that shadowy mystery queen, Gus Aubrey? What if those queens who flitted through sitcoms had actually been given the balls with which to consummate their desires? What if Frankie Howerd had been less wary, Kenneth Williams less anguished or Larry Grayson more politically inclined? Enter, dressed to kill and taking no prisoners, Julian Clary. Out as gay and camp as a calendar full of Christmases, Clary is the queen turned queer – not the guilty-secret and coded-whisper old-style queer, but the unapologetic in-your-face born-again queer that emerged at the end of the 1980s. I don't want to suggest he is any kind of crusading radical, indeed at the end of 2001 he received a double accolade, if that is the right word, from Britain's entertainment establishment, appearing on the Royal Variety Performance (an annual showbiz gala performed to an audience that includes some members of the British royal family) and being the subject of *This Is Your Life*. Furthermore, much of his highest profile work now is as a panellist on comedic quizzes where he seems sadly constricted and under-employed. Julian Clary is not, by any means, about to rock patriarchal heterosexism to its foundations, but it is never wise to expect comic performers to set radical agendas. Even so, Clary has done more than most to take the tradition of the comedic queen into new and groundbreaking territory and he is the logical endpoint of the story this chapter has tried to tell. At his creative peak, in the early 1990s game show parody *Sticky Moments*, he was effeminacy made explosive, a mincing martinet forcing scared straights and conspiratorial queers to jump through the hoops of ridiculousness and ignominy required of them by the foolish games that made up the show. Heterosexual male contestants were singled out for particular humiliation, placed firmly under Clary's bent thumb, left in no doubt that the world they had blundered into was one subject to queer rules. If they edged away from Clary as he sidled up to them in lime green hot pants or sado-masochistic beachwear, he just edged even closer. If he suspected one of them of being less hetero than they proclaimed he would smile witheringly and invite the audience to share his disbelief, as when one discussion about contestants' jobs turned to working in furniture shops, inviting Clary to say to one victim, 'there's something in most closets, isn't there, Mark?'. *Sticky Moments* was a queer carnival set in a fabulous land where camp was the official language and innuendo the recognised currency; it was as if

Larry Grayson's *Generation Game* had come back from a queer politics seminar, as if Channel 4 had been seized for an hour by the radical drag faction of the GLF. Clary even took the term 'straight man' fiercely literally, employing a stooge who was mocked precisely for being straight, a neat and total inversion of the usual comic power relations between homo and het. When his straight man made some lame attempts at humour, Clary would sigh 'That's hetero- sexuals for you'. *Sticky Moments* was the furthest that English popular comedy's discourse of camp has ever travelled from those Formby-film moments when some silly pansy is wheeled out for general merriment; it reached a point where the queen was so in charge, so transformed from mocked object to controlling subject, that the only joke on offer that really mattered was the irredeemable preposterousness of heterosexuality.

Since then, Clary, not unlike Kenneth Williams after *Round the Horne*, has found it difficult to locate such a congenial vehicle. There was a fitfully amusing sitcom, *Terry and Julian*, which had some fun at the expense of heterosexual masculinity, some travelogue style shows where Clary was let loose on New York and Sydney, and another game show parody, *All Rise For Julian Clary*, where he passed judgement on less-than-serious disputes between friends or relatives. The pivotal moment in his career to date, however, remains the infamous joke he made at the 1993 British Comedy Awards, when on live television he announced that he had 'just been fisting Norman Lamont. Talk about a red box'. Lamont, a senior Conservative Party politician, was present at the ceremony, a fact which Clary clearly found hard to stomach, and the joke was a recklessly brave attempt to speak political protest through the medium of homosexual innuendo. As it happened, the cleverness of the punchline's pun (British ministers carry official papers in briefcases known as red boxes, and a red box might also more literally be what a certain bodily orifice looked like after it was subjected to the bracingly intrusive sexual act of fisting) was lost as the entire on-screen audience dissolved into hysterics after the word 'Lamont', too astonished and captivated by the single entendre to wait to hear the wordplay of the double entendre. The tabloid press went berserk ('OBSCENE', 'SICK TV GAG', and 'STORM OVER GAY CLARY'S TV SEX JIBE AT LAMONT' were three of the headlines) and Clary was not seen on British TV for some time. The Lamont joke showed, graphically, the limits of what a queen, even a carnivalesque queer queen, could actually get away with – making fun of everyday straight folk was one thing, but asserting a queer's right to ridicule those in positions of real and not just symbolic power was going too far. The comedy theorist Susan Purdie has argued that straight male laughter at the effeminate queen is a device used to place as much distance as possible between the two sexual identities involved, since the queen is 'the "near neighbour" from whom the patriarchal man must "other" himself ... this appears in the general popular construction of gays as ... *weak* men – and in their comic construction as the site on which "feminine" characteristics are constituted as laughable' (1993: 140, emphasis in original). This was the contract which Clary's fisting

joke so spectacularly shredded. His joke repositioned the effeminate queen, that epitome of fluffy, gossipy failed manhood, as a conquering aggressor, both in terms of making the straight male the sexually possessed and penetrated object and in terms of asserting the linguistic mastery to joke about it afterwards. Sexual penetration and joke-making are two things that heterosexual men like to think they monopolise; Clary's joke showed that this need not be so, but the response shows what a breaking-point joke it was. He had to be put in his place.

Yet eight years later, as I have mentioned, there he was in the Royal Variety Show and on *This Is Your Life*. Most probably, these show that he has been co-opted back into cultural acceptability, forgiven his excessive transgression and welcomed back on the understanding that he mustn't ever go so far again. *This Is Your Life* briskly cantered over the Lamont incident by saying to Clary 'you made a particularly bold remark that offends some viewers', but that subsequently television institutions 'have forgiven you'. One index of that forgiveness was that all but two of the guests on the show who praised and celebrated Clary were heterosexual, and in the tableau which conventionally ended the tribute he was flanked by his mother on one side and that paradigmatically respectable and iconically maternal comedy actress June Whitfield on the other. Clary runs definite risks now of being kept on in showbiz circles as a token of moderate naughtiness, what Alan Sinfield has called the 'court jester' role for the 'explicit queer' (1994: 146). Yet can much more be expected in popular culture? And aren't jesters allowed to say things forbidden to ordinary mortals? Clary is not the only contemporary queen whose persona and performances raise such questions. Paul O'Grady would be another fascinating test case. In his drag persona of Lily Savage, he moved from the raucous dens of the South London gay pub circuit to enormous mainstream acclaim, first still wearing Lily's frocks but later stepping out of them. O'Grady, in Savage guise, was once acclaimed by the gay comic and broadcaster Simon Fanshawe as more innovative and risk-taking than Clary (Fanshawe 1994), though I suspect such a view would need to be modified today. The Savage act might even be seen as a backward step, dishing out innuendo and invective from the safety of a frock decades after Howerd and Grayson ventured out of drag gear while maintaining a drag mindset. The television programmes Paul O'Grady has made since losing Lily seem to me to be rather more interesting, giving occasional glimpses of a ferocious queen who is far harder to assimilate into heterosexual expectations than Lily's (admittedly very entertaining) panto-harridan charades. Yet O'Grady's hosting of a hugely successful teatime chat show has placed him under stringent constraints which may well remove what's left of his bite.

Another candidate for scrutiny here would be Graham Norton, whose Irishness places him beyond the strict confines of this book (his popularity in Britain might indeed need to be viewed through a post-colonial lens) but who spent several years as the British Isles' most popular camp court jester. Norton's decision to play the mischievous imp (it might be said that his masterstroke was

to coat the long-standing and dubious stereotype of the Irishman-as-leprechaun with a fresh varnish of skittering effeminacy) has paid him handsome rewards, but too often he has seemed content to do little more than curate a space devoted to giggling at the dirtiness of sex – this was the core premise of *So Graham Norton*, the Channel 4 chat show which made his name. Any lingering sense of a political take on sexuality, which Clary wielded regularly and which even O'Grady has called on at times, vanished entirely in Norton's approach. (In a moment highly reminiscent of Kenneth Williams' concern at the emergence of Grayson and Inman, Julian Clary's 2003 stage tour took several swipes at how much Norton has, to put it mildly, borrowed from Clary himself.) The careers of Clary, O'Grady and Norton have all gravitated, either through choice or resignation, towards the genre of mainstream television light entertainment, thereby tying tighter that long-standing semiotic and ideological knot in English popular culture that pulls together effeminate homosexuality, depoliticised camp and glitzy frivolity. It is telling that the only recent significant comedy queen to escape those spangled shackles was a fictional one: Tom Farrell, the character played by James Dreyfus in Jonathan Harvey's blissfully extreme sitcom *Gimme Gimme Gimme*, though it is difficult when studying that text to take one's eyes off Kathy Burke's mesmerising performance as Tom's uber-grotesque flatmate Linda La Hughes. Tom and Linda inhabit a landscape so strewn with graphic sexual explicitness, unrepentantly misbehaving bodies and an all-purpose carnival delight in the low, the oozing, the smelly and the aroused that neither Norton's ingratiatingly prancing prankishness or O'Grady's occasional streetwise snarls can hope to compete.

As ever, in any debate about the politics of popular comedy, there can be no definitive verdict about what these queens might mean. As was the case with Frankie Howerd's routines, questions of tone and emphasis and inference can carry just as much weight as actual content. Look, for example, at Clary's Royal Variety Show appearance. He was the first performer to appear, which meant as the respectful strains of the British national anthem receded, there was Clary on stage, as if he had been summoned up by the crowded theatre singing 'God save our gracious queen'. Dressed as a Canadian Mountie, he proceeded to join several others who were similarly dressed in a startlingly camp song called 'Stout-Hearted Men' (written by Sigmund Romberg and Oscar Hammerstein for the 1929 Broadway musical *The New Moon*), subjecting its lyrics to an innuendo-laden running commentary – 'stout-hearted men can stick together man to man ... if you know what I'm saying'. The stage was then filled with an increasingly unfathomable succession of uniformed masculinities, including Tower of London Beefeaters, Chelsea pensioners, a Scottish pipe and drum regiment, an American football team, a martial arts club and the King's Royal Hussars. It was a blitzkrieg of testosterone, yet there in the middle of it all, spotlit as the unquestioned star and controlling events with blithely dictatorial effeminacy, was Julian Clary. How can such an image be read? Were some points being made about how military and sporting manliness can be reinterpreted as

high camp? What are the power relations of a queen confiding in the Queen (amongst others) about the joys of anal intercourse? Was Clary being conscripted to show that even fairies wave the flag? There are no straightforward answers, but then straightforwardness is hardly to be expected in the vicinity of the long strange history of the English comedy queen.

Lads in love

Gender and togetherness in the male double act

[A]n English marriage, missing out the sex as many English marriages do.
(John Mortimer describing Morecambe and
Wise: McCann 1998: 140)

Poof! I'm on the way to Uranus.
(Declan Donnelly to Anthony McPartlin in
Slap Bang It's Ant and Dec: ITV 2001)

This chapter is concerned with the meanings of the relationships between men who make comedy together. All available evidence indicates that the men looked at in detail here are wholly heterosexual, yet their twin-bodied comedy requires dynamics of interchange and intimacy between them that are so emotionally complex and interpersonally intense that they go well beyond simple friendship, let alone remaining at the level of a merely working relationship. As a homosexual man, I have always found the bonds between these straight comic men to be peculiarly fascinating case studies of how far male heterosexuality can allow itself to travel in the direction of same-sex non-sexual love. Doubtless, some might see my interpretation of these relationships as skewed by my queerness, as a classic case of 'over-interpreting' the texts, performances and personas this chapter will survey, and it may indeed be the case that, like all the gay critics who have ventured into similar territory (see Mellors 1978 for an early, naive but instructive example), I have a vested interest in making these readings. If that is so, it must also be the case that any such accusations of over-interpretation stem from another vested interest, vested in those so encased in an anxiety-fuelled need to protect straight masculinity from its apparent besiegers that they insist that there is an unbridgeably vast gulf between heterosexual and homosexual identities. Queers, in other words, have no monopoly on partiality. In any case, it is not my intention in this chapter to argue that the male comedy pairings it covers are 'really gay'. Such a statement is blatant nonsense. What I do want to say, however, is that the relationships between the pairs investigated here are shaped and driven by a recurring and often nervous fascination with the precise dimensions of love between men. In addition, since

humour thrives at flashpoints of cultural nervousness, offering soothing balm for such ideological ailments whilst rubbing salt into the very same wounds, the boundaries and complications of male devotion become an explicit part of the source material and subject matter of the comedies these men concoct with each other. Most obviously, this means recurring jokes about homosexuality, which is repeatedly invoked yet relentlessly mocked in an attempt to draw a firm line between 'us' (straight men who are devoted to each other) and 'them' (queer men who have sex with each other). In this way, comedy is used as a means of establishing how far, at any given social moment, one heterosexual man can go in expressing deep feelings for another.

I want to look at these comedies of lads in love by focusing on a handful of exemplary pairings. Firstly, I want to investigate how Morecambe and Wise, the benchmark double act in English popular comedy, drew on the ambiguities of their emotional closeness to forge comedic meaning. Secondly, I want to explore a comic narrative centred on the complexities of male relationships, the 1970s sitcom *Whatever Happened to the Likely Lads?*. Thirdly, I want to indicate how some other male duos, from the 1920s to the present day, have negotiated their ways through the minefield of masculine togetherness. The male–male dynamic I am interested in here is of course far from being only an English concern, since the paradigmatic relationship to which all twentieth-century male comedy duets are indebted is that between Laurel and Hardy, though Stan Laurel's roots in English music hall should not be overlooked. Neither is it confined to the cultural mode of comedy, as the histories of the war film, the Western and that notably nervy Hollywood sub-genre called the buddy movie will all testify. The couples covered in this chapter, then, are part of a much wider framework of gender relations, but I want to explore their particularities as English and comic, to see what happens when that broader cultural question of what happens to the meanings of masculinity within intensely close yet non-sexual male bonds is played out on a specifically English, specifically comic terrain.

Little Dinkies and accidental earrings

Eric Morecambe and Ernie Wise worked as a double act for forty-three years. Except for brief periods as solo child performers, their entire professional life was spent together, from their early days as painfully raw cross-talk comics, hauling their poor approximation of Abbot and Costello around the less salubrious variety theatres of Britain, to their peak years in the 1970s, when their BBC series and Christmas specials broke ratings records and established them, beyond question, as the country's favourite comics. In the words of Glenda Jackson, who worked with them on many celebrated occasions, 'it was not only that they were the best in their particular field, but ... there was a particular national identification with their shows' (Morecambe and Sterling 1994: 160). Their 1980s work for ITV showed them to be slipping past their best, but

the partnership remained far stronger than most conventional marriages, and professional divorce was never on the agenda. Only one thing could separate them, and that came with Eric Morecambe's death in 1984, after which Ernie Wise looked (and the nation felt) permanently bereaved. Such a sense of loss only underlined the extent to which the two men had been jointly responsible for a creation far profounder than the standard double act of funny man and stooge. That was how they started out, with Morecambe playing the fool and Wise playing it straight, but gradually those roles had been crafted into a far more complex and mutual relationship. They were, quite simply, there for each other, and one key reason that underpinned their sensational popularity was that they looked, when performing, like the happiest couple imaginable.

By their 1970s glory days, Morecambe and Wise were hardly two distinguishable people at all. They were two halves of one entity, interdependence personified, feeding each other lines, finishing each other's sentences, seizing each other's ideas and elaborating on them before handing them back so that the riffs could be further amplified, cutting each other down with loving scorn, setting each other tasks, seducing each other into traps, savouring each other's inventiveness and craft, cradling each other's talent with respect, tenderness and joy. All halfway competent double acts rely on empathy, but Morecambe and Wise swapped empathy for telepathy. They were like great dancing partners or tennis doubles players, not perhaps equally talented but perfectly suited to each other: they clicked, they fitted, they were one piece each in a two-piece jigsaw. They also, in a number of sketches during their great BBC years, occupied one half each of a double bed, and given the topic of this chapter, a little dwell at that bedside can hardly be avoided. Before sifting through the implications of those bed scenes, however, it's worth noting that they had been making comedy out of homosexuality throughout their career. This was one of their earliest gags, performed in the early 1940s when they were still both teenagers:

Eric would mince on stage with his hand on his hip.
Ernie: What're you supposed to be?
Eric: A businessman.
Ernie: A businessman doesn't walk like that.
Eric: You don't know my business.

(Morecambe and Sterling 1994: 26)

In many ways this is just another standard music hall pansy joke (you can hear George Formby saying Ernie's lines, and you can imagine a recycled version cropping up in *Are You Being Served?*), but it does show how even at the beginning of their partnership, Morecambe and Wise were happy to find comic mileage in a mocked acknowledgement of queerness. Decades later, they were still at it, as revealed by a film recording of one of their

1970s stage shows. At one point they discuss which song they might sing next:

Wise: 'You Do Something To Me'
Morecambe: I don't fancy that ...
Wise: 'I've Got A Lovely Bunch of Coconuts'
Morecambe: You're all talk.

The timing here is sublime, with Morecambe's last punchline romping in only microseconds after Wise says 'Coconuts', and the speed of the delivery clinches the innuendo of the gag. At another point, Wise slips his arm around Morecambe's shoulder and becomes, literally, too close for comfort. 'Get off', Morecambe cries, 'I'll smash your face in. I've read about you in *Woman's Own*'. In one of their BBC Christmas shows, Wise says to his partner, 'Seeing as it's Christmas, would you like to pull my cracker?'. This time there is no verbal response, but the look on Morecambe's face speaks volumes. It often did: in the filmed stage show there is an extended routine about Morecambe trying to play bongo drums. Eventually, Wise does it for him, reaching between his partner's legs to do so. As Wise beats out a rhythm in Morecambe's between-the-legs area, Morecambe's face is suffused with a complex and dazzlingly funny mixture of embarrassment, pain and strange, incommunicable delight.

As these examples show (and there are numerous others), inferred or threatened homosexuality was a core ingredient in the pair's comedic recipe. This not only makes the shared bed scenes part of a larger continuum, but also rubbishes their frequent and disingenuous protestations that the scenes had no queer undercurrents. The idea for the shared bed originated with Eddie Braben, the writer responsible for their finest BBC shows. Whereas their earlier television work had shown them either in character sketches or simply engaged in on-stage cross-talk, Braben had the idea of domesticating them, showing them sharing a flat in sitcom-like sketches. The domestic togetherness in these scenes was, for Braben, a way of spatially underlining the intensity of the pair's existing bond, and the bed took that togetherness to its logical conclusion; in Braben's words:

> one of the first things that struck me about their relationship was its closeness ... there shouldn't have been an 'and' in 'Morecambe and Wise', it should have been 'Morecambewise', because they were so close. So my idea was to put these two people into an enclosed space – the equivalent of being inside a music-hall horse-skin – so that they couldn't escape each other, they were closeted together ... at the start, they weren't too sure about this idea of two men being in bed together, and they were quite wary. They feared that people might read something into it that wasn't there. I remember that I said to them, 'Well, if it's good enough for

Laurel and Hardy, it's good enough for you!'. That did it. Eric said 'Sod 'em! We'll do it!' And they did.

(McCann 1998: 216)

What is most revealing about Braben's account is that it shows how there was concern from the outset about how these sketches might be read. (Does his use of 'closeted' suggest this? I confess I am unsure as to how familiar Braben would have been with gay subcultural slang, but it is an intriguing possibility.) Knowing this immediately undermines Morecambe and Wise's usual technique of dealing with questions about the bed scenes from journalists and critics, where they would usually try to laugh off any homosexual implications as simply ludicrous. In one 1971 interview, Ernie Wise issued a flat dismissal: 'There's no question of homosexuality' (Nathan 1971: 153). Yet in the very next sentence, he utilises the alibi Eddie Braben had given them: 'It goes back to old-style Laurel and Hardy humour'. The contradiction here is evident: if the sketches were as devoid of queer echoes as the denial claimed, then the use of comedic precedent to justify the image of the shared bed would hardly be necessary. Yet the paradox here is that Laurel and Hardy were hardly sexual innocents, but were brilliantly, deviously skilled in flirting with homosexual implications in their films – one showed shocked passers-by repeatedly discovering the duo undressing in back alleys, another has them discussing how much more Laurel means to Hardy than Hardy's wife does, and a third has them not just sharing a bed but sharing it with a baby which Laurel proceeds to suckle (see Sanders 1995 for an exhaustive account of their complex gender play). Long after Morecambe and Wise, the continued significance of the American duo as a clue or cue for hinting at undercurrents beneath male friendships can be seen in the prominent poster of Laurel and Hardy that adorns the wall of Joey and Chandler's apartment in the early seasons of *Friends*. Given this history of ambiguity, Eric Morecambe's tense insistence that there was a public perception of shared asexuality between Laurel and Hardy and himself and Wise fails to convince when read today: 'They accepted it from Laurel and Hardy and they accept it from Ernie and me, which is a great thing, and a great gift. I think it is because we're not offensive with it. We never say "Your feet are cold" or "Can you cuddle up a bit closer?", or "You go under the sheets and see". No, there's nothing like that going on' (Morecambe and Wise 1981: 37). Not those phrases exactly, perhaps, but he seems to have forgotten the sketch where they are in bed together discussing the toys that they played with as children:

Wise: I had a little Dinky.
Morecambe: You still have.

The allusion to childhood in that sketch is telling, since memories of youth and schooldays are favourite topics during their bedtime chats. On one level, no doubt, this is another attempt to insist on the innocence paradigm, in which

immaturity is proposed as a guarantee against adult sexuality, but it also connects with another, more interesting dimension of the bed scenes. That dimension is class, a factor which Morecambe and Wise invariably raised, usually just after their Laurel and Hardy gambit, when asked to reflect on their bed-sharing (Nathan 1971: 153). They pointed out that same-sex bed-sharing was a taken-for-granted element of working-class English family life, that economic necessity was a vastly more relevant issue than any implication of sexual activity. This is very true, and the element of class-specific nostalgia in their bed scenes, which the jokes about childhood reinforce, is a key part of the pleasure they offered to working-class audiences, especially older ones. Jokes of the 'little Dinky' variety, however, prove that sexuality is still always in the frame. The two men may have been reminiscing about pre-war childhood, but they were doing so in the early 1970s, an era when public awareness of homosexuality was far greater than it had been when Morecambe and Wise were young, and for all their talk of pre-pubescent memories, they were evidently two grown men sitting almost cheek-to-cheek in that far from massive bed, sharing sleeping space in a period when Larry Grayson was fretting over his Everard. Consequently, the spectre of queerness had to be raised, both in interviews and less often in the scenes themselves, in order to be comedically exorcised, but having been identified it could never be wholly forgotten. Besides, it offered too much good material, and Morecambe and Wise were never ones to pass up the chance of a great gag. One of the few times in their career when Wise was able to steal a laugh from under Morecambe's nose with a well-planted punchline came in a 1972 television interview with Michael Parkinson. They were asked about the queer possibilities of their bed sharing, and they poured out the usual cocktail of evasive explanation – the Laurel and Hardy reference, the context of class, and a third factor which Eric Morecambe was particularly obsessive about mentioning, his belief that his decision to smoke a pipe in many of the bed scenes erased any homosexual connotation. In one printed record of this curious rationale he said 'Pipe smoking and homosexuality just don't seem to blend' (Morecambe 1987: 10), but on the Parkinson show he was less circumspect: 'I've never yet met a queer with a pipe'. Wise, with unusual stealth and speed, dashes in to cap that line with a much better pay-off: 'The earrings are just accidental'.

As a gag like that shows, Morecambe and Wise were fully aware of the comic potential of their bed-sharing, just as many of their other jokes and routines merrily threw fragments of queerness into the overall comedic mix. They wore drag in several sketches (Wise more often than Morecambe, interestingly), they demonstrated an abiding love for Hollywood musicals, they grappled with alarmingly phallic props like ever-extending canes in dance routines, and Morecambe made frequent jibes at Wise for having a male fan who sends him 'scented letters in those pink envelopes'. One of their domestic sketches boasts a notably Laurel-and-Hardy moment when Wise announces his imminent marriage and his wife-to-be's intention of moving into the flat

he and Morecambe share. Morecambe asks 'What about me?', and though this is primarily played for laughs (and gets them), it is still shot through with genuinely wounded plaintiveness. There is, after all, only one bedroom in that flat – to have two would mean they had the option of *not* sleeping together, and exercising that option would have robbed them, and us, of some of the richest male relationship comedy imaginable.

Just a friend?

According to the influential academic Eve Kosofsky Sedgwick, a great deal of the prejudice directed against homosexual men stems from heterosexual men's need to insist on absolving the close emotional and social relationships they have with other heterosexual men from any suggestion of sexual meaning. She labels those intense hetero–hetero relationships 'homosocial', a term she sees as referring to 'social bonds between persons of the same sex' (1985: 1). For men linked by homosocial bonds, sexual relationships with women are crucial guarantors of heterosexuality, but their strongest emotional ties remain those with other men, resulting in a scenario where women become little more than 'exchangeable … property for the primary purpose of cementing the bonds of men with men' (25–6). Despite the presence and use of women within homosocial networks, however, inferences of homosexuality remain a constant threat. For Sedgwick and those who have developed and commented on her work, the seeds of anti-homosexual prejudice are sown here: 'the similarity between (socially acceptable) homosocial desire and (socially condemned) homosexuality lies at the root of much homophobia' (Van Leer 1995: 100). Hence, for example, the loudly expressed and vigorously pursued anti-homosexual prejudice found in homosocially dependent institutions such as the armed forces or at male-bonding rituals like football games. Comedy has a key role to play in this dynamic. In the previous chapter I cited Susan Purdie's assertion that laughter at effeminacy springs from the proximity of male homosexuality to male heterosexuality – the queen is the 'near neighbour' that the real man must distance. Jokes, then, are one method of policing that boundary between homosocial and homosexual, as should be clear from the above account of Morecambe and Wise. The adjective Sedgwick shrewdly chooses to characterise the relationship between homosocial and homosexual is 'shifty' (1985: 5), and much of the comedy that shuttles across the grey areas between those two relational zones could be similarly described. To see how that shiftiness can result in magnificent comedy, I want to look in detail at the 1970s BBC sitcom *Whatever Happened to the Likely Lads?*, the most sustained and impressive comic exploration of homosociality so far produced in English popular culture.

The precursor to that sitcom, *The Likely Lads*, ran for three seasons between 1964 and 1966. Written by Dick Clement and Ian La Frenais and set in Newcastle-upon-Tyne, it starred James Bolam as Terry Collier and Rodney Bewes as Bob Ferris, best friends since schooldays and now working in the

same factory. Spelling out all those men's names shows how the series, in both its 60s and 70s guises, was actually a text involving not just one but three couples of closely involved men – the writers, the actors, the characters. Most of the 1960s series humour revolved around Bob and Terry's largely unsuccessful attempts to find girlfriends, sometimes competing to woo the same one, often pursuing women who correspond to stock straight-male fantasies – a much older divorcee in one episode, a French woman met on holiday in another. Yet they are always happiest when simply spending time with each other. As the series' title indicates, the lads' friendship is the core of the text, their being single is the equilibrium which the narrative can never fully disrupt; like any standard sitcom, its shape is circular, returning at the end of each episode to the situational landscape found at its beginning, and that means returning to Bob and Terry's homosocial bond. Where homosociality flourishes, however, homosexuality must be kept simultaneously at a distance and under strict observation. That process would constitute a major theme when the series returned, revamped, in the 1970s, but at the 1960s stage of its incarnation any references to homosexuality could only be occasional, crude and glancing. Like lots of lads in homosocial love, Bob and Terry make mock-flattering comments on each other's appearance ('Ee, you're lovely' says Bob as Terry preens himself in the mirror before going out on a date), or parodically camp it up ('we've got no-one, just each other', lisps Terry, mock-effeminately, when they are asked at a dance where their girlfriends are). As part of the same emotional economy, they ridicule men whom they find lacking in appropriate masculinity. Terry is deeply scathing when his sister begins dating a hairdresser, until he finds out that the hairdresser likes a pint, follows rugby league and skilfully plays darts. In the very final episode of the 60s series, when Bob has left the factory to enlist in the army, Terry is greeted by the man taking over Bob's job. He is coded, somewhat tentatively, as a 1960s queen, who half-smiles and half-simpers at Terry, 'I'm Ferris' replacement'. Terry's reply: 'God help us all'.

The series ended in 1966, but returned with its expanded name and reworked agenda in 1973. England altered drastically in those seven years, and *Whatever Happened to the Likely Lads?* astutely places its key themes of the emotional ambivalences of growing older and the changing shape of friendship patterns within that wider context of social and especially sexual change. In the first episode, knowingly titled 'Strangers On A Train' in deference to the same-sexual ambiguities of the classic Hitchcock film, Terry is returning from several years in the army and meets Bob by chance on a train journey. In the narrative twist that ended the earlier series, Terry had joined the army to be with Bob just as Bob was being discharged on medical grounds, a story Bob summarises thus: 'This mate of mine couldn't take it, went to pieces, he couldn't function without me. I guess it was like losing your right arm. So he signed on just to be with me'. Rarely has the homosocial bond been so openly stated. For Terry, those years in the army meant he was denied access to crucial changes in English culture: 'social transformation ... I missed

it all ... swinging Britain ... death of censorship, new morality, *Oh Calcutta*, topless waitresses and see-through knickers ... Permissive society? I missed it all.' A missing item in his inventory of 60s sexual liberalisations is of course the change in attitudes towards homosexuality, but given the episode's need to re-ignite Bob and Terry's friendship, that touchy topic can hardly be casually thrown away as just another item in a list. It needs to be both singled out and robustly distanced, and it receives both treatments in a later scene. Bob has told Terry he is shortly to be married, and Terry's unflattering opinion of Bob's fiancee Thelma (she and Terry had clashed in the 1960s series) causes Bob to storm out of the train's buffet carriage. Terry turns to the buffet attendant and says to him 'I sacrificed the best five years of my life for that feller and now he tells me he's getting married'. The attendant gives Terry's hand a sly fondle and pouts 'Never mind, sailor, there's plenty more pebbles on the beach'. The studio audience shrieks, Terry is even more horrified than he was to meet Ferris' factory replacement, and the socio-sexual dynamic of the series is up and running. Bob's impending marriage to Thelma is the core narrative of each episode, but within that straightforwardly heterosexual storyline a much more resonant and ambitious emotional triangle is enacted, pivoting both on the deep homosocial bond between Bob and Terry and on Thelma's reaction to finding she has a serious rival for Bob's affections.

It would be gravely unfair to Brigit Forsyth's deft and subtle performance as Thelma to imply that she was nothing more than, to use Sedgwick's terms, an object of exchange between the two men. She is no passive counter in their game, indeed she is fully aware of the threat Terry poses, telling Bob early in the first episode, even before Terry has reappeared 'He's always been there you know, Bob, a nagging doubt, haunting me'. This discourse of doubt and haunt is oddly reminiscent of some of the lines spoken by Sylvia Syms in the 1961 film *Victim*, where she played a young wife confronted with the fact of her husband's past and present homosexual desires. *Whatever Happened to the Likely Lads?* is rarely as direct and never as melodramatic about homosexuality as *Victim*, but Thelma's insightful grasp of how close Bob and Terry once were, and how close they might again become, continues to hover over the series. In the third episode, Bob tries to explain to Terry why Thelma is troubled by his return, but by the end of the conversation all her fears seem exceptionally well founded:

Bob: You do represent a threat. You're the past, you're what we used to be. The lads, knocking it back and putting it about.

Terry: But can't she see that that is all over?

Bob: She's got to be made to. She's got to realise that you're just a friend now, not my bosom companion. She's my partner in life now, she's the one I'm going out to work for and building a future for and giving up all my spare time for.

Terry: Except Fridays of course.
Bob: Well, yes, except Fridays. That's always been lads' night.
Terry: What about Tuesdays? Tuesday's dart match?
Bob: Yes. Well, Tuesday's darts.
Terry: And midweek football.
Bob: Well, obviously we'll be going to that together. But she's got the rest.
 Except Sunday lunchtime.
Terry: And that isn't enough. Dear me, they're so demanding.

Note how in this dialogue, Thelma begins as Bob's partner in life, but before long he and Terry are 'we' while Thelma becomes part of an undifferentiated 'they', women who exist only to constrain male pleasure, especially those pleasures which men share with other men.

Running alongside this comedy of heterosexual skirmish is a paradoxical stream of jokes about queers, poofs and related insecurities that bubbles up in almost every episode – paradoxical because sometimes such jokes serve as points of displacement to swerve the audience away from speculating about Bob and Terry into laughing at some unequivocal mention of homosexuality, while at other times they positively invite such speculations by making the barrier between homosocial and homosexual potentially permeable. A selected list of both types, culled from across the thirteen episodes of the series, might be helpful here. A week after his buffet misunderstanding, Terry reminisces about an old army friend who slept in the next bed to him for five years, prompting Bob to say 'I'm surprised there wasn't talk'. Bob takes Terry to a modern 'unisex' Hairdressers where Terry is concerned about the men who work there – 'I wouldn't like to be blow-dried by any of that lot' – but is reassured by how much they know about football. Terry strains his back and asks Bob to massage him, but Bob finds the process difficult: 'I'm inhibited, aren't I? What if my mother came in and caught you with your pants down?'. Terry refuses to let a male assistant in a tailor's adjust his trousers until he hears the assistant mention that he has a wife and children. Enjoying a restaurant meal with Terry, Bob ponders the changes his marriage will bring: 'It's not Bob and Terry anymore, it's Bob and Thelma and their friend Terry'. The lads are obliged to share a bed the night before the wedding, a scenario that causes Terry to say 'I'm not sure Thelma would approve of this'. Lying side by side, they go on to swap sexual fantasies, about women of course. In an earlier episode they are arguing in a pub about the exact lyrics of an old pop song, Billy Fury's 'Halfway To Paradise'; Terry loudly declaims his version of them, 'I want to be your lover, but you'll only let me be your friend'. The barman hears this and orders them to leave: 'You two fairies – out'.

There are many more, but two instances deserve particular attention. In the scene at the hairdressing salon mentioned above, Bob decides to confront Terry about what he sees as his dated understanding of sexual identity. For Bob, very much a modern (for the 1970s) man in appearance and outlook,

Terry's knee-jerk assumption that all male hairdressers must be homosexual is embarrassingly retrograde, so he decides to shame his friend by wheeling on some amateur psychology:

Bob: Anybody who's always putting queer people down and being aggres-
 sively masculine, like you, is only masking their own latent tendencies.
Terry: Do you want me to stick one on you?
Bob: See – see how aggressively masculine you're being?
Terry: What do you expect me to do when somebody says something like
 that?
Bob: Hit them with your handbag?

Bob's recourse to the handbag cliché is the only way of defusing the tension that this exchange has stoked up. It's at points like this that *Whatever Happened to the Likely Lads?* almost becomes too clever for its own good, threatening to yank into the open the half-spoken insecurities which generate its humour. The second scene to highlight here is in the series' eleventh episode, two episodes before the climactic event of Bob and Thelma's wedding. Bob and Terry, as imminent groom and best man, are at Thelma's house, checking and fine-tuning the details of the ceremony. Reading from a book of wedding etiquette, Bob notes the advice to choose as a best man 'someone who is at the same time gay and reliable'. He pauses, briefly but noticeably, after the word 'gay', a space which propels Terry to simper, touch Bob's arm, and say 'I won't let you down, sailor'. (Connoisseurs of sexual slang should note this second use of 'sailor' in the series to denote queerness; there was a long-standing cultural assumption that ship life involved sexual variety, but the term was particularly rife in the early 1970s, possibly in relation to the then Prime Minister Edward Heath, who was both a noted yachtsman and the subject of unsubstantiated gossip about his sexual orientation.) They move on to a second book, containing a chapter of sex advice for newlyweds, at which point Terry climbs on to the startled Bob and launches into a mock-passionate declaration of love: 'Oh my darling ... the washing-up can wait ... lie back and think of England'. The two of them hurriedly and awkwardly disentangle when Thelma's mother enters the room. This is an unusually crass moment in such a beautifully crafted series, an eruption of hysteria in a text more typically composed of nuance and finesse, and both actors look uncomfortable with having to perform such a scene, yet it is a necessary point in the evolving dynamic between the characters. Its excess is generated by its narrative proximity to the wedding, the event which will, at least to some extent, resolve the problem over whether Thelma or Terry has primacy in Bob's affections, and it is also immediately followed by a scene at the tailor's, where Bob and Terry are trying on wedding suits, a plot device which requires them to spend some considerable time together trouserless in the confined space of the changing room. This is, after all, the early 1970s, when a sitcom audience can be expected (partly thanks to Larry Grayson) to

treat 'gay' a cue for laughter, when gay liberationist politics was news, and when the sexually adventurous iconography of glam rock was flavour of the pop month. Morecambe and Wise could try and pretend (not very convincingly) in this period that men in bed together were innocent of queer reverberations, but Bob and Terry were twenty years younger, much too young and too clearly products of the 1960s to plead naive ignorance. They had become so close by this stage in the series that the heavy-handed ludicrousness of the 'newlyweds' scene was needed to secure them for unequivocal heterosexuality. Looked at with three decades of hindsight, however, it isn't such excessive scenes that linger in the mind. The greatness of *Whatever Happened to the Likely Lads?* resided in its ability to rummage through the baggage that straight men carry, its determination to explore with knowing tenderness and dry Northern wit the oscillations and osmoses between homosocial and homosexual, and its wisdom in concluding that love between men can be nourishing and sustaining without having to resort to the geometrical banalities of sex. As Bob and Terry stand in the church, waiting for Thelma to arrive for the wedding, Bob is stricken with nerves. He clutches Terry and says, not once but twice, 'Don't let go', three repeated words which carry within them a lifetime of devotedness. Terry, ever the manlier of the two, is of course obliged to defuse this with a gag: 'Please, Bob, you'll confuse the vicar. He'll think you're marrying me'. That would be superfluous, however, since their life partnership has already been in existence for several years.

There was a second series the following year, a one-off Christmas episode some months later, and an uninspiring feature film in 1976. All have enjoyable moments, thanks to the skill and the care of the writing and acting, but they can only ever be aftermath texts, paddling in the backwash left by that incomparable first series. Once Bob and Thelma are married, what remains is an amiable, conventional marital sitcom, with Terry cast as the roguish pal leading the dutiful husband astray. Terry is, in effect, Bob's non-sexual bit on the side, and also his non-sexual bit of rough, given the class tension crucial to the series, in which Bob's toe-hold on the ladder of upward mobility, a ladder held in place by the firm grip of Thelma's steely ambitions, is constantly undermined by Terry's resiliently working-class outlook (unfortunately this chapter's focus on gender dynamics prevents me from fully considering the class issue). From the beginning of its second series, *Whatever Happened to the Likely Lads?* becomes a text predicated, like most traditional sitcoms, on repeated but undeveloped conflict, whereas the first series marked a real break with generic norms by constructing a series-long story arc, so that each episode did not return to narrative basics but edged ever closer to the wedding. (This is often done today, as witnessed by the ways in which unfoldingly intertwined narratives of *Friends* drew on soap opera conventions, but it was a new gamble in the early 1970s.) The second series is content to reheat its menu week after week, occasionally offering a garnish of minor variation. So there are some sprinklings of bedroom farce, including a scene where Terry is discovered in bed with

Thelma's father, and a small clutch of episodes where Thelma leaves Bob and Terry moves in, resulting in some knowing play around the theme of two men sharing domestic space ('this is just the first morning of our new life together, Robert, I'm just getting to know you', smirks Terry), but the depth and daring of the first series are long gone. There was real uncertainty in that series over Bob's fate, but once that has been settled, once the emotional turmoil and the narrative innovations have been left behind, there is little left to do other than tread water in conventional generic fashion. The film of the series went one sad step further, staging a scene where both lads separately climb into the same bed, clad only in underwear, expecting to find and fondle a woman there but encountering only each other. Whispers of love give way to noises of disgusted discovery, and the scene ends abruptly with them sitting upright in bed. There is no clever joke to ease the tension, no verbal debriefing (nor indeed debriefing of any other kind), no real resolution at all, just the disappointment of a truly special relationship finally snuffed out by the cheap joke of a coarse grope.

The tensions of tenderness

There are many other male pairings in English comedy that would merit similar analyses to those offered above. That quintessentially middlebrow middle-of-the-century musical comedy act Flanders and Swann would be one example, as would Jewell and Warriss, whose ruthlessly single-minded enactment of the sharp-guy-and-idiot structure made them the biggest double act in Britain in the late 1940s. No full study of this topic could overlook Flanagan and Allen, who in the 1930s and 40s were both a successful act in their own right and one-third of that homosocial hexagon the Crazy Gang (an ensemble which brought three male double acts together to make a six-man team). The tenderest moments shared by Flanagan and Allen were the sentimental and moving ballads they sang together, which usually featured lyrics about how their friendship would persist despite poverty and deprivation. They always sang them while enacting a curious set of steps that could hardly be called a dance, as Chesney Allen walked behind Bud Flanagan with a hand on his shoulder. This was both a memorable gimmick and a smart way of avoiding the awkwardness that might have ensued if they had sung the songs directly to each other. Lyrics like 'When I'm strolling with the one I love' or 'Underneath the arches, on cobblestones we lay' might have looked distinctly queer if delivered face to face. The fact that Flanagan's stage costume was a fur coat (a man's one, but still a fur coat) while Allen sported a dapper suit added another intriguing layer of gender ambiguity for those who wish to detect and enjoy such a thing. Intertextual confirmation of such a reading is supplied firstly by the appropriation of the duo's song 'Underneath The Arches' by the queer performance artists Gilbert and George, and secondly by Peter Nichols' play and film *Privates On Parade*, set in a 1940s army entertainment unit, in which the two men who impersonate Flanagan and Allen in the unit's nightly show are homosexual lovers, lending

an even more delicate poignancy to the on-stage togetherness. It is also worth noting here Morecambe and Wise's decision, at the height of their fame, to release an album on which they sang Flanagan and Allen's haunting, bonding songs.

Another pair worth marking out for future research are Cannon and Ball. They aspired to fill Morecambe and Wise's shoes in the 1980s, though their act was built less on the older couple's judicious interweaving of competitiveness and warmth than on curious extremes of hate and love, so that at one point the would-be ladies' man Tommy Cannon would be close to strangling the diminutively maddening Bobby Ball, and at another would carry him tenderly off stage after he had fallen asleep. Sometimes behaving like a displaced father and son, sometimes relating to each other like a ventriloquist beset by his malevolently alive dummy, and sometimes so desperately fearful of queer-ish closeness that they built whole routines out of the stressfulness of touching each other, Cannon and Ball were a small psychodrama clad in borrowed music hall threads.

Adding further twists to the already convoluted spiral of male relationships in comedy pairs, there have been double acts where one partner is homosexual, such as Fry and Laurie and the *Little Britain* pairing of Walliams and Lucas, and at least one where both were not just gay but performed entirely in female drag, namely the very bizarre Hinge and Bracket. One of the most complex couplings of all were Peter Cook and Dudley Moore, who chose to dramatise the social (and physical) inequalities between them in a sequence of high-risk comedic combats, culminating in the calculatedly disgusting Derek and Clive, whose dedication to use every swearword in the English language and to offend every social constituency in the known universe produced some of the most irredeemably extreme and extraordinarily funny comedy of recent decades (see Thompson 1996, Games 1999). Cook and Moore's interpersonal sado-masochism has more recently been taken into psycho-panto territory by Rik Mayall and Adrian Edmondson in the personas they use in the sniggeringly-named series *Bottom* and its film spin-off *Guest House Paradiso*. There they inhabit a cartoonish world of meticulously executed physical cruelty and all-too-knowing homoerotic teases, forever doomed to hit, slice, puncture and set fire to each other because it would be even more painful to admit that they might just prefer to use each other's bodies for less murderous purposes.

A less gruesome pairing worth consideration are Gary and Tony in Simon Nye's *Men Behaving Badly*, the laddish sitcom which secured huge audiences throughout the 1990s. The 1992 episode 'Rent Boy' is especially enlightening, since its narrative brings to the surface the homosexual panic which underpins so many homosocial comedies. In this episode, Gary (Martin Clunes) and Tony (Neil Morrissey) have been flatmates for only a short time, and Gary knows little about Tony's private life. Stitching together a few misunderstandings and infer-ences, he comes to the entirely incorrect conclusion that Tony is gay. Here we have moved on from those sitcoms I discussed in the previous chapter where an

effeminate stereotype is brought on in one episode to challenge but eventually reinforce the heterosexual equilibrium of the series' principal household; 'Rent Boy' is more threatening to sitcom norms than that, because it suggests the possibility of homosexuality existing full-time within the hetero-zone of the series' primary household itself, and thus the possibility that the ostensibly homosocial economy of the text might actually hide something else entirely. (That something else was the subject matter of Julian Clary's erratic but illuminating sitcom *Terry and Julian*, where he played an outrageous queen sharing accommodation with a heterosexual nerd.) Gary goes into spasms of embarrassment and anxiety over Tony's possible queerness, though the episode is clever enough to make Gary the butt of its jokes, indicating that in an intelligent 1990s sitcom, the comedy is not predicated on the failed masculinity of the queer (suspected or actual) but on the uptight masculinity of an illiberal and foolish heterosexual. The episode's trump card is Dorothy, Gary's no-nonsense girlfriend, who cuts through Gary's contorted equivocations to ask Tony outright what his sexuality is. The intelligence and wit of its chief female characters is what saved *Men Behaving Badly* from being just a gormless endorsement of grown men's desire to stay adolescent for ever, ensuring instead that it simultaneously articulated a piquant critique of that very desire. It wouldn't be too far-fetched to see Dorothy and Deborah (Tony's on-and-off girlfriend) as the heirs to Thelma from *Whatever Happened to the Likely Lads?*, twin Thelmas wised up by twenty years of feminism. In 'Rent Boy', once Tony's heterosexuality is confirmed and Gary is thus freed from the threat of unwanted carnal attentions, the pair of them can bond in lad heaven. The episode concludes with the paradigmatically homosocial tableau of them snuggled up on the sofa, eating takeaway curry and swigging canned beer, evaluating women they watch on TV in terms of fetishised body parts. They can become lads in love once the queer conundrum has been put to bed – or not, as the case may be.

If Gary and Tony are 1990s likely lads, then Reeves and Mortimer, their only rivals as the most important male comic pairing of that decade, are the postmodern Morecambe and Wise. That's an easy tag to stick on them, not least because of Reeves' uncanny and tirelessly exploited facial resemblance to (the younger) Eric Morecambe. More broadly, they merit that label because of their clear, if sometimes oblique, appreciation and continuation of English comedy's music hall heritage. The obliqueness is found in their determination to cross-fertilise a stand-up double-act banter which Morecambe and Wise would applaud with surreal flights and abstract stylings derived from the absurdist tradition exemplified by Spike Milligan and the Monty Python troupe. Those two comic strands have often been violently polarised against one another, and those poles often strongly relate to class, but Reeves and Mortimer succeed in arranging a shotgun wedding between them. As for their own spin on the comedy of male bonding, they draw on varied sources and offer an assortment of options. They enjoy extravagantly brutal *Bottom*-esque violence against each other, yet they have also, in a self-conscious nod to Morecambe and Wise,

done a sketch in a shared bed. Their surrealised spin on the male pairing theme can be seen in their characters The Bra Men, two gruff north-eastern lads who were forever accusing others of looking at their brassieres, and in the two farting Frenchmen they played, who took a carnivalesque and not un-queer interest in the capacities of each others' arses. It is also noteworthy that before they became famous, at least one observer assumed they were a sexual couple, seeing Reeves as the gifted figure who had 'a talentless lover ... he wants to elbow into the act' (Dessau 1998: 91) – shades here of the model epitomised by the 1960s queer playwright Joe Orton and his maligned, resentful and eventually homicidal partner Kenneth Halliwell. Reeves and Mortimer not only know the history of the homosocial/homosexual tension very well indeed but turn it into part of their act, as part of a wider deployment of postmodern self-awareness and cultural–historical referentialities which irrigate their comedy. To see this at its brilliant best, watch the opening sequence of their 1998 series *The Smell of Reeves and Mortimer*. Bob Mortimer sings lustily of his desire to succeed in Hollywood, only for Reeves to reveal, also in song, that he has stolen Mortimer's hopeful letters to film studios and 'buried them under a pile of farmyard shite'. Since Ernie Wise's delusions of Hollywood grandeur and Eric Morecambe's scepticism towards them were a much-milked theme in Morecambe and Wise's comedy, Reeves and Mortimer are evidently inviting knowledgeable audiences to connect the work of the two duos. By decking out the song in the bombastic orchestration of the American show tune and featuring a moment where Mortimer swivels around a lamp-post just like Gene Kelly in *Singin' In The Rain* (subject of one of Morecambe and Wise's best-loved parodies), the routine is both homage to and parody of the older pair. Morecambe and Wise's gender dynamic is also conjured up, with Reeves playing, as ever, the slightly more masculine Morecambe-half of the equation, exercising control over Mortimer's subtly feminised Wise-alike. Reeves reads out loud one of the letters Mortimer has written to 'an MGM movie mogul' and savours with appalled Morecambesque relish the line 'Although I am not bent I am willing to do stuff to get to the top'. It's a great routine (to be truthful, little they have done since is half as good), showcasing Reeves and Mortimer's skill in drinking deeply from the well of older comic traditions, but adding the blunter sexual directness and the absurdist inflection expected by a younger contemporary audience, summoning up and playfully tinkering with the homosexual fringes of comedic homosociality and processing it all through their particular brand of freewheeling mania.

Reeves and Mortimer are already an influence on younger double acts, most clearly of all on the Tyneside duo Ant and Dec. Although they later became most successful in and associated with the joint-host role in variety shows and game shows, Ant and Dec have made several attempts to explore male-bonded comedy. Their early work was done in children's television, which placed constraints on how much innuendo and gender play they could mobilise, but even in that generic context they were not shy of queer comedic dynamics, with

one recurring sketch featuring Ant as caped superhero who was always trying to lure Dec away for a drink or a chat or something implicitly more intimate. Their first series for non-child audiences, *Slap Bang It's Ant And Dec* (note the almost gushingly obvious tribute of that title to Reeves and Mortimer's series *Bang Bang It's Reeves and Mortimer*) was awash with sketches that flirtatiously explored the closeness and the power-dynamics of their relationship while simultaneously revelling in a taste for homosexual innuendo that even Julian Clary might regard as exorbitant. In one skit, Dec explained to Ant how he dreamed of becoming an astronaut, sketching various deep-space journeys he might make, concluding this speech with the line 'Poof! I'm off to Uranus'. It is telling that when in the summer of 2002 ITV sought to identify a sitcom vehicle for the duo, they returned them to their homosocial and regional roots by placing them in an updated remake of one episode of *Whatever Happened to the Likely Lads?* – the one with the hairdresser scene, no less – but the updating meant the sacrificing of the humour's original social context, leaving the attempt so flat and uninteresting that no further episodes have so far emerged. Audiences are too in on the homosocial/homosexual joke now, it seems, to respond to the more subtle exploration of the theme offered by that classic sitcom. We have become so acutely aware of the homosexual penumbra which shades any homosocial comedy that we have come to expect, and can comfortably digest, upfront jokes about queerness that once had to be buried deep beneath the surface of double-act interchange. Ant and Dec's Uranus line is evidence of how far things have shifted since the denials of Morecambe and Wise or the uncertainties of Bob and Terry – and just in case the figleaf of discretion offered by that penetrative pun wasn't evidence enough, the scabrous Channel 4 series *Bo Selecta*, which specialised in sexually graphic parodies of celebrities, later offered a weekly gag in which, silhouetted behind a screen, its caricature of 'Dec' was serially sodomised by suitably shaped objects ranging from a baguette to a snooker cue, while its 'Ant' stood sniggeringly by. Whether all of this, from wised-up audience awareness to an intrusively inserted loaf of bread, marks a new openness towards sexual diversity or whether it is just the postmodern way for straight men to distance queerness through laughter is a decidedly unresolved question.

Chapter 8

Thirty nibbles at the same cherry
Why the 'Carry Ons' carry on

I got sick of doing the pantomime – I'd say 'I really can't go back to the Palace Manchester with the same old thing for the fourth time' – but you see, the thing about English audiences is, they love the things they *know* – so you go somewhere you've been three times, and the fourth time you go better than ever.

(Cabaret comedian and pantomime dame Douglas Byng,
quoted in Wilmut 1985: 75)

Recall ... the fifty-year-old formality of seaside postcards: most of the year 'decent' working-class people would hardly approve of them, but on holiday they are likely to 'let up a bit' and send a few to friends – cards showing fat mothers-in-law and fat policemen, weedy little men with huge-bottomed wives, ubiquitous bottles of beer and chamber pots, with their endless repetition ... their extraordinary changelessness.

(Richard Hoggart 1958: 32)

In 1989, the American music critic Dave Marsh published a book in which he listed his personal choice of the one thousand and one greatest singles ever made. Each title in Marsh's chart is accompanied by a miniature essay, ranging from one line in length to several pages, that either seeks to justify the record's ranking, contextualise its cultural meanings, celebrate its pleasures, or amalgamate all three approaches. The result is a triumphant intermingling of dazzling erudition and salutary passion, and one aspect of it that is particularly admirable is the way that Marsh reflected on his own changing relationship with the music he loves. In one telling case, he discovered that a group he once expected to contribute numerous entries to the chart he was compiling were not in fact featuring that prominently after all:

When I began researching *The Heart of Rock and Soul*, I took it for granted that The Coasters would be one of its constant presences. But after listening for a few months, the scary fact came home: No way. It's certainly not that Jerry Lieber and Mike Stoller weren't great songwriters and among the best record producers who ever lived ... But over the years, their most

celebrated recordings, with The Coasters, have dated considerably, which says a lot about the ways context and timing shape meaning.

(Marsh 1989: 142–3)

There are two reasons for beginning this chapter with what might seem like an excessively tangential excursion. Firstly, Marsh's disillusioned relegation of The Coasters' records stems from his belief that it was precisely the comic elements in these songs (the group specialised in humorously exploring aspects of 1950s American urban life) which seem more problematic listened to decades later, with their use of black stereotypes a particular cause for concern – even though, or especially because, the group themselves were black. Such a shift, in which the sensitivities of one era find difficulty in negotiating texts that were thought uncomplicatedly comic in another, clearly relates to the project of this book. Secondly, and more pressingly because more personally, I have to admit to a pang of recognition when I read Marsh's words, for the truth is that even though I always took it for granted that the Carry On films would be a major touchstone in this book, I am increasingly sceptical about their status. It can hardly be denied that the Carry On films are hugely important for any account of English popular comedy, but I find it hard to suppress the observation that while they matter, they are often thin, limp and skimpy. In many ways, that is a side issue. A critical approach concerned with how cultural artefacts relate to their social moment and ideological implications can often find riches in texts that may not be entirely satisfying; it looks for signs and symptoms rather than merely celebrating excellence. So the Carry Ons do need to be in this book, if for no other reason that for audiences today they are by far the best-known reference point in the entire history of vulgar English film comedy – no other films in that tradition are broadcast so regularly on British television, are so readily available to buy through remarketing on video and DVD, sustain such an iconographic familiarity, or enjoy such a vibrant afterlife on the internet. Citing the names Frank Randle or Hylda Baker in most circles is unlikely to prompt one-hundredth of the recognition that would greet the words Carry On. The films are part of the nation's cultural furniture and the term Carry On itself is entrenched in the language as shorthand for naughty, gigglesome, mildly risqué humour. That cannot be changed, but it would be negligent of me not to note that, at least for my own personal palate, there is often far more comic richness in Hylda Baker and far more cultural risk-taking in Frank Randle. This is not to say that I find the Carry Ons joyless and sterile – many of them contain scenes, lines and images that have made me laugh since childhood and continue to do so – but I am disappointed that for many, the story of carnivalesque vulgarity in English film begins and ends with them, and consequently the rest of that life-enhancingly fertile field remains criminally neglected. In a small way I may have to take part of the blame for that – having written about them several times before (Medhurst 1992 is the best of the bunch) and spoken about them at conferences, festivals, exhibitions and in media interviews, I have

contributed to and been a beneficiary of their continued high profile. In the small (and often dank) pond that comprises British media studies, I fear I have become associated with the films, seen and cited as an expert on them and a champion of them, to the extent where one book review of a collection to which I contributed an essay on another topic entirely contained the charming line, 'Personally, I am delighted to report that, despite the presence of Andy Medhurst, there is no essay on the Carry On films' (Brooker 1999: 5). Yet here I am again, confirming some people's suspicions by raking over the Carry On ground one more time. Perhaps doing so will enable me to work through my ambivalent feelings about these essential but rickety films. I don't want to disown them, but neither do I want them to obscure other and often better work in the same tradition. I suppose, most of all, I want to put them in their place, in both senses of what that phrase can mean. With that cri-de-coeur over, let's carry on.

From Sergeant to Columbus

The history of the Carry On series is familiar, but needs retelling briefly here so that any reflections on the meanings and significance of the series can be put into context. (This means cutting corners and omitting some key titles – for fuller, more respectful versions see Eastaugh 1979, Hibbin and Hibbin 1988 and Ross 1996.) The series, interestingly, was not devised as a series, but was the offshoot of the unexpected success of a low-budget lowbrow farce about army life called *Carry On Sergeant*, made in 1958. That film's producer, Peter Rogers, scented the possibilities of a formula to be exploited, so he and director Gerald Thomas reunited most of the production team and several of the cast the following year, shifting the same basic narrative shape (a bunch of disparate misfits placed in conflict with authority) from one institution, the armed forces, to another, the health service. This was 1959's *Carry On Nurse*, which became the biggest British box-office hit of the year. *Carry On Teacher* and *Carry On Constable* followed swiftly and lucratively, still milking the institutional theme. After these the series briefly lost direction – *Carry On Regardless*, for example, is a rudderless collection of sketches – although members of the public sent in suggestions for potential titles and settings, ranging from *Carry On Coin Collecting* (perhaps not an idea exactly cascading with audience allure) to *Carry On Sewage Farming* (precisely what the series has always been accused of by its detractors). The series recalibrated and boomed by moving into the generic parodies which are often seen as including its finest flowerings: *Spying* gleefully slipped a whoopee cushion under James Bond's bottom; *Cleo* spoofed the Hollywood epic, in particular the Elizabeth Taylor/Richard Burton disaster *Cleopatra*; *Cowboy* had fun with the clichés of the Western; *Screaming* drove a mocking stake through the heart of Hammer's horrors; *Up The Khyber* took no prisoners in lambasting the conventions of the imperial adventure; *Up The Jungle* amused itself by laughing at Tarzan; *Dick* did the same with highwaymen. Alongside these

more knowing titles in the series, which often pleased otherwise-impervious film critics who enjoyed noting the accuracy of the generic jibes, the Carry Ons also found it profitable to return more than once to hospital, with *Doctor*, *Again Doctor* and *Matron* squeezing every last drop of chortling juice from that familiar terrain of bedpans, boils and curvy nurses.

Beyond the confines of generic parody and hospital farce, the series wavered. Whatever the setting, the films' popularity had come to rest on their unceasing dedication to innuendo, but in most 1970s Carry Ons this became increasingly monotonous, discarding the diversions of recognisable institutional locations or referential cultural pastiche in favour of an uninterrupted bombardment of sex jokes with no other choices on the menu. The Carry Ons of this period, in Leon Hunt's words, 'relocated to a place called Planet Smut' (1998: 38) – titles like *Loving*, *Girls* and *Behind* tell their own story. The turning point film in this gradual decline was 1969's *Carry On Camping*, where, as I have noted before (Medhurst 1986: 183), the scene where Barbara Windsor's bikini top flies off during an energetic exercise session can be taken as especially emblematic. Whereas an old-school-vulgar TV series like *Nearest and Dearest* responded to the new sexual permissiveness of the late 1960s by subjecting it to Hylda Baker's disapproving glare, the Carry Ons tried, half-heartedly, to embrace changing times, with Windsor's exposed breasts representing a mammary moment of moving on. Except, of course, that those breasts were noticeably *less* exposed than many others seen on cinema screens at that time. The Carry Ons were rooted in an era when sexual activity had to be laughed about because it could never be discussed more openly, and as such could never fully swim with the permissive tide. A new breed of sex comedies dominated British box offices in the 1970s, a monstrously popular procession of titillation-fests headed by the *Confessions Of ...* series and analysed definitively by Leon Hunt (Hunt 1998: 114–27). These films seized the Carry On template (saucy smirks in a racy farce) but took it in considerably more explicit directions, thanks to younger actors, more nudity, strong links with the pornography industry and an absence of that history of gentler joking which made any steps taken by the Carry Ons towards sexual directness look inevitably halting and compromised. The Carry Ons wearily expired – or should have – with 1978's *Carry On Emmanuelle*, a potentially promising attempt to spoof the very genre of soft-core porn that had created the semiotic climate within which the newer sex comedies were able to dislodge the Carry Ons' crown, but the result could most supportively be described as lacklustre. The 'should have' in the last sentence is important, because the Carry Ons did not, regrettably, stop with *Emmanuelle*. Peter Rogers, the series' indefatigable producer, sporadically announced new titles – *Carry On Dallas* was to revisit generic parody in turning its comedic guns on the excesses of big-budget television melodrama, while *Carry On Again Nurse* would mark yet another trawl through the wards. Neither of these materialised, but in 1992 *Carry On Columbus* was released, the thirtieth in the series and the first to be made without the participation of the performers most associated with them.

In their place were comedians launched by the 'alternative comedy' of the 1980s, such as Rik Mayall and Julian Clary, with a few older faces like Jim Dale and Leslie Phillips on board to maintain some linkage with the glory days. *Columbus* was better than *Emmanuelle*, but that was not a hard target to hit, and any fan of the series who watched was haunted by the ghosts of those absent. A Carry On without Kenneth Williams, Hattie Jacques, Charles Hawtrey and Sid James was a Carry On in name only. The story does not even stop there, with 2006 seeing the announcement that *Carry On London*, this time peopled primarily by refugees from British soaps, is shortly to go into production. The Carry Ons, it seems, are a tomb that still attracts grave-robbers.

Familiar faces and postcards home

As Douglas Byng observed in the quote at the head of this chapter, repetition guarantees success in English popular comedy. Other observers concur – it may be over seventy years since J.B. Priestley noted that:

> the English ... prefer a droll chunk of personality to comic acting. They do not like a comedian to be always different, but to be forever himself, or, if you will, to be more himself each time they see him.
>
> (Priestley 1929: 38)

The popularity of this kind of repetition shows no sign of vanishing and the delight in comics who trade in known quantities remains undimmed – how would fans of Jo Brand cope if she skipped on stage in a gingham mini-skirt and told jokes about how women would be much happier if only they obeyed men? The predictability of the Carry Ons is, then, one of the many aspects which puts them so squarely at the centre of the comic traditions considered in this book. If you enjoy one Carry On, you will find much to please you in the others, and a large part of that pleasure will be the fact of that familiarity itself (the same also applies in the opposite direction: if you loathe one, they will probably all dismay you and their repetitiousness will fuel and compound that dismay). The recognition of actors, the echoes of jokes and the consistency of tone across the series offers a pleasure that transcends individual titles. The series as a whole, at least in its unbroken run from *Sergeant* to *Emmanuelle*, can be thought of as one long super-text, almost a soap with each film as an episode. (The Carry Ons have another soap dimension in the continued speculation about the rumoured private relationships between some of the stars, notably Sid James and Barbara Windsor – the subject of Terry Johnson's memorable 1998 play, *Cleo, Camping, Emmanuelle and Dick*). As Jeffrey Richards put it, 'The Carry On series ... allegedly included twenty-nine films, but in fact were the same film made twenty-nine times' (Richards 1997: 165). This remark is not intended as a compliment, but it does identify the significance of continuity in understanding how the series works. Appreciating the continuity between

Figure 8.1 Kenneth Williams in *Carry on Regardless*, directed by Gerald Thomas, 1961. Courtesy of G.H.W/Anglo Amalgamated/The Kobal Collection.

films does not mean they all succeed equally – the later films, to me at least, enact a slow processional decline from the best 1960s titles, but even in the final phase there is a kind of residual grim fascination in seeing how what used to tickle becomes gradually exhausted, a waning away captured in the actors' ageing faces.

The ebbing of the films' vitality is most evident on those faces because it is, above all, the recurring troupe of Carry On performers who guarantee the pleasures of the series and reward the devotion of its fans. Kenneth Williams, Joan Sims and Charles Hawtrey were in over twenty of the titles, while Sid James, Kenneth Connor and Hattie Jacques reached the teens. Barbara Windsor is also indelibly linked to the series, although she appeared in just nine, while Carry On connoisseurs also relish the frequent contributions of second-rung performers like Peter Butterworth, Patsy Rowlands, Leslie Phillips, Liz Fraser, Esma Cannon, Jim Dale, June Whitfield and Bernard Bresslaw. Most of these had one act which they stuck to, or which stuck to them, throughout the length of their sentence – never straying far from the droll chunk of personality,

to return to Priestley's term, which audiences flocked to revisit, witness and savour. (An aside to complicate this picture: while Priestley's comments about the repetitions of comic routines referred specifically to stand-up comics and on-stage clowns, many of the regular Carry On team were in fact actors with previous track records outside of comedy; some of them resented the fact that the Carry Ons so fixed their image in the public mind that other kinds of more 'serious' work became hard to obtain – Kenneth Williams' diaries and letters are full of such complaints.) The public demonstrated an insatiable appetite for that favourite English dish, more of the same. So while Sid James' first appearance, in *Constable*, was a convincing piece of rounded comic acting, increasingly thereafter he played only minor variations on his expected image, the middle-aged but still laddish lecher, simply swapping hats from the Rumpo Kid's stetson in *Cowboy* to a suburban trilby in *At Your Convenience*, while Charles Hawtrey trotted out his spindly, lascivious brand of camp even when cast, however implausibly, as a randy heterosexual (see Dyer 2002 for an appreciation of Hawtrey's gluey loyalty to his stock persona). Certain stars had particular affinities with sub-sections of the series, with Hattie Jacques most iconic as a fearsomely starched matron in the hospital titles. Sometimes there were switches in direction, most strikingly in the case of Joan Sims, who moved during her long tenure from desirable younger woman to shrewish wife, while Kenneth Williams' earliest roles cast him as superior and bookish, before this was sidelined in order to highlight his more arresting brand of efflorescent effeminacy. Whatever the persona, the intensity of the stereotyping was unwavering. With very rare exceptions (Hattie Jacques in *Cabby* is probably the most impressive), the performers were never asked to characterise, in the sense of putting together credibly three-dimensional comedic individuals, but to inhabit, in the sense of slotting into an already established template in the English comic imagination. Rooted in music hall, well-known from downmarket films and the knockabout end of radio, doubly present during the seaside holiday through appearing both in end-of-the-pier shows and on saucy postcards, the stereotypes delivered by the Carry Ons added a deeper, almost primal level of familiarity to the reassurance offered by the recurrence of familiar actorly faces. It was not just the same performers being the same kind of types, but also the same kind of types signifying the same set of attitudes and beliefs.

No social or sexual predictability was neglected by those stereotypes, which offered a comfortingly simplified vision (or, if your tastes ran differently, a horrifically reductive caricature) of how the English lived. Life was a daily grind, money was never plentiful, marriage was a trap, wives were nags, husbands were devious (but usually thwarted), sex was yearned for (but never satisfactorily achieved), authority figures were mocked, pretension was ridiculed, foreigners were ludicrous, work was a chore (Marion Jordan has noted how the Carry Ons insistently expressed a 'preference for idleness', Jordan 1983: 316), drink was an escape, laughter was a consolation – and laughter in the Carry Ons,

both on screen and among audiences, was summoned up most frequently by the dirty joke. There are whole encyclopaedias of dirty jokes and their cultural implications (see Legman 1969 and 1975 – and, if you really must, Freud 1976), so a comprehensive account will not be feasible here, but it needs noting that the Carry Ons engineered the most extensive and enduring intertwining imaginable of innuendo and Englishness. The opening films in the series are not quite so besotted with sex jokes and toilet humour; those themes are present, but take their place alongside other techniques and modes (predominantly slapstick, farce and non-sexual wordplay), yet the reliance on innuendo increased – especially after Talbot Rothwell took over as scriptwriter from Norman Hudis in the early 1960s – until it and the Carry Ons became indissolubly synonymous with one another. The names given to characters is a quick indicator of how bottoms and bits dominated the humour – Miss Bangor, Dr Tinkle, Francis Bigger, Penny Panting, Citizen Bidet, Senna Pod, Dr Stoppidge, Tilly Willing, Jock Strapp, Linda Upmore, the Khasi of Kalabar, Cora Flange, Lord Hampton of Wick, Nurse Ball, Dan Dann (the lavatory man), Bertie Muffett, Miss Alcock, Gladstone Screwer, Cecil Gaybody, Sidney Fiddler, Mrs Pullitt, Detective Slowbotham, Private Widdle and, a personal favourite, the woman who wants to prevent the beauty contest from taking place in *Carry On Girls*, Augusta Prodworthy. If overseas readers find it hard to detect the snigger factor in some of those exhibits in that national museum of nomenclatured smut, this is one further index of the films' indelible Englishness. The scripts were so marbled with double entendres that hundreds of lines could be quoted, but perhaps three will suffice. From *Carry On Behind*: a butcher selling a joint of meat to a female customer tells her 'Give that to your old man and you're in for a night of romance'; she asks 'Can I do it in the oven?'; he replies 'Do it where you like, it's your kitchen'. From *Carry On Doctor*: a doctor insists 'It's my duty to keep myself fit and strong. You may not realise it but I was once a weak man'. The hospital matron's retort, 'Well, once a week's enough for any man'. And from *Carry On Cowboy*: Belle the saloon singer admires the Rumpo Kid's pistol. 'Ooh, haven't you got a big one'. 'I'm from Texas' he answers, 'We all got big ones down there'.

Double entendre, according to Angela Carter, is 'everyday discourse which has been dipped in the infinite riches of a dirty mind' (Carter 1997: 394). This delicious definition tells two truths: firstly, that innuendo is concerned with life's everyday basics, namely sex and other, even more unignorable lower bodily functions; and secondly, that linguistic creativity steps in to fill the gap left by a culture that cannot permit the regular use of either clinically descriptive terms or outright obscenities. A culture as committed to and constrained by propriety as the culture of Victorian and post-Victorian England needed some means of utterance for talking about reproductive and excretory imperatives, for sometimes they needed to be talked about, so new lexicons were required. One possibility was euphemism, once described as an attempt

'to cloak the naked body in decorous language, so that … women were never pregnant, they were "with child"' (Green 1976: 109), and another was innuendo, euphemism's sly, naughty, daring sibling. Innuendo was not an option that could be exercised everywhere; it belonged in certain spaces in the public sphere (the factory, the playground – out of the teacher's earshot, places of entertainment and enjoyment like the pub and the music hall), but not in others (the church, the town hall or the classroom), and certainly not in the private sphere of respectable domesticity, where euphemism held sway with its steely gentilities. The English working classes were accustomed, however, to take an annual break from euphemism, in the shape of the seaside holiday. These holidays were not wild, anything-goes, freewheeling carnivals, they had their own gradations of respectability and their own policing of behaviour, but at the same time they did make possible a gradual loosening of shackles. Holidaymakers were not encouraged to behave disgracefully, but a modicum of irresponsibility was allowed – there was, after all, no need to get up early for work the following day, and there was a chance to wear just a little less clothing than at home – and over time that modicum grew ever larger. The seaside was a zone for relaxing, within limits, the moral sense as well as the muscles, and the cultural form that showed this more clearly than any other was that English comic oddity, the saucy seaside postcard (reproduced and discussed in Buckland 1985, Green 1976, Howell 1977 and Wykes 1977).

These cards comprised a drawn illustration topped or tailed with a comedic caption, and traded in a staple diet of mild innuendo and a fixed iconography of (among others) fat ladies, buxom blondes, leering old men, mischievous children, nagging and/or endlessly child-bearing wives, shifty and/or weedy husbands, man-hungry or sex-phobic spinsters, flirtatious debutantes, shocked vicars, half-dressed hikers, inefficient though often alluring nurses, bossy doctors, nosy postmen, skittish parlourmaids, randy travelling salesmen, shy newlyweds, shameless nudists, kilted Scotsmen, amenable secretaries and drunken toffs. Sending some cards home became a central ritual of the seaside holiday and the jovial crudity of the comic cards fitted perfectly with the sensibility of misbehaviour and spree encouraged by the seaside resorts. (More demure holidaymakers, the kind who partook of the better-behaved seaside amusements like light opera and palm court orchestras, could send home cards with photographic images of the promenade or the floral clock.) Saucy cards were hugely popular from the 1920s onwards, and even in the 1970s a particularly successful card could expect to sell twenty thousand copies nationally during each English summer (Wykes 1977: 103). The comic world of the cards has an obvious affinity with the Carry Ons, but they also both echoed and influenced other comic sites from music hall songs to television sitcoms, and the resilience of the stereotypes that populate all these texts is testament to the persistence in English popular comedy of a relatively stable set of cultural groups and social situations deemed to be reliably funny. One of the first and

most influential cultural analyses to take English popular comedy was George Orwell's 1941 study of Donald McGill, the best-known writer and illustrator of seaside postcards (Orwell 1965). Orwell noted the rigid predictability of the cards (though he also, provocatively for the time, insisted that some highly respected forms of elite culture also stuck tightly to codes and conventions) and speculated that their popularity resided in how they offered a temporary release from prevailing moral constraints. In the 1950s, Richard Hoggart followed a similar analytical line, once again identifying the 'endless repetition' and 'extraordinary changelessness' (Hoggart 1958: 32) of the world the cards portray, and suggesting that the seaside holiday offered a place and a time when the social proprieties adhered to by most working-class families during the grinding months of the working year could be briefly set aside.

It is no surprise, then, that so many popular comedy films were set entirely in holiday resorts or featured visits to them to punctuate workplace-set narratives – key 1930s examples would include the Blackpool sections of Gracie Fields' *Sing As We Go* and George Formby's antics on the Isle of Man in *No Limit*. J.B. Priestley was the co-writer of the screenplay for the Fields film, and in the same year, 1934, he published *English Journey*, a proto-sociological travelogue around the country's different regions; its account of Blackpool is too evocative to resist quoting in detail:

> this huge mad place, with its miles and miles of promenades, its three piers, its gigantic dance-halls, its variety shows, its switch-backs and helter-skelters, its array of wine bars and oyster saloons and cheap restaurants and tea houses and shops piled high and glittering with trash; its army of pierrots, bandsmen, clowns, fortune-tellers, auctioneers, dancing partners, animal trainers, itinerant singers, hawkers; its seventy special trains a day; its hundreds and hundreds of thousands of trippers …
>
> (Priestley 1968: 265–6)

This brilliantly captures the sheer excess of the place and the period that jointly marked the apotheosis of the English seaside, the accumulated tidal wave of entertainment possibilities laid out in this Mecca of annual indulgence. Film representations could never encompass the whole sensory overload of a Blackpool holiday, but the utopia such holidays signified in the working-class imagination meant that the seaside recurs repeatedly in English popular comedy throughout the century (for more on the meanings of the seaside, and on Priestley, see Chapter 4). Under such circumstances, the Carry Ons could hardly resist a trip to the coast, though it is crucial to note that the Carry Ons were, in terms of comedic geography, very much texts concerned with the south of England. Consequently, Brighton is their Blackpool, featuring significantly in two of the 1970s titles in the series. In the seaside-set *Carry On Girls* we are told that the resort on screen is Fircombe-on-Sea, but the resort that we see is clearly Brighton. More interestingly, when the workers at the toilet-making

factory in *Carry On At Your Convenience* enjoy a communal outing to the coast, it is Brighton (this time not disguised by a smirky pun) that they choose to invade. As their coach speeds down the A23 towards a day of salty excess, one young woman asks what the town has to offer; the reply she gets is that 'We can do anything once we're there', and the sense of freedom and possibilities enshrined in the seaside resort have rarely been more effectively advertised.

The sequence in which the workers taste the pleasures of the Palace Pier is a suite in the key of carnival. They throw themselves around on funfair rides, they over-eat, they get drunk, they cross-dress (Sid James dragged up as a gypsy fortune teller is one of the most startling sights in the whole Carry On series), they flirt, they tell dirty jokes, concocting between them a set of social and cultural inversions which Bakhtin would recognise well, in particular the detail that the factory's owner (Kenneth Williams in haughty mode as the memorably named W.C. Boggs) becomes the most humiliated amid all the pranks and larks – a king humbled by his underlings in a bounded, licensed space of carnivalesque revolt. (For more on Brighton, film and comedy see Coleby 2002 and Medhurst 2002.) The carnival cannot last, as Bakhtin's sterner critics are fond of insisting (see Chapter 5), and the hierarchical order of the rest of the year must be re-imposed. In terms of *Carry On At Your Convenience* this means you have to leave the pier and get back on the coach. Seaside licence, English popular culture's very own cockle-and-candyfloss carnival, is always temporary, so the workers go back to toil for W.C. Boggs, Gracie Fields returns to her factory after the Blackpool binge of *Sing As We Go*, and the saucy postcards gather dust in their rusty racks from late September through until the following Easter. The appeal of seaside sprees in film comedy, perhaps, is that for the duration of an evening at the cinema, even or especially in the middle of winter, you could rekindle memories of past holidays and hatch plans for new ones. The average run of life might be a grind, but eventually next year's holiday would arrive and serve you a slender slice of escape, much as sooner or later the next year's Carry On would turn up, cajoling you to spend a little time nearer the edge of the acceptable, a space that flirted with outrage but never really risked it, saucy but never obscene, where taboos were gently loosened. The Carry Ons were the last sizeable cinematic expression of music hall's culture of consolation, trading in warmth and knowability, mapping out a playground which encouraged small-scale disobedience but lacked any really dangerous games, inviting audiences to run along the pier but always keeping the engine running in the coach that would take them back home.

The significance of abysmal films

In his curious but insightful study of Charles Hawtrey, Roger Lewis attempts to account for an apparent contradiction, a contradiction I niggled at myself

earlier in this chapter, that although the Carry On films are aesthetically poor, the series retains a cultural importance:

> They are abysmal movies, let's make no mistake about that … But though they are embarrassing … their appeal is that they transcend embarrassment. The boingggs! and poinggggs! of the music; the obsession with bodily functions; the caterwauling and absurdity: we are transported back to the world of the nursery or playground. The Carry Ons are about England's Never-Neverland, that demi-paradise and secret garden where you can side-step growing up.
>
> (Lewis 2001: 3–4)

This is an intriguing suggestion, that the Carry Ons have become a sort of national playpen, so that a desire to watch them becomes a yearning to avoid maturity. It is probably too neat a piece of cod-Freudianism to tell the whole story, but it may well tell part of it, especially as anyone growing up in England from the late 1950s onwards will most probably have seen the Carry Ons more than once and at different stages of maturity – in the cinema as a child, on television as an adolescent, on videotape as a younger adult, on DVD in middle age (well, that's my life story, anyway). They are one of the few bodies of film that have been scheduled, perfectly plausibly, for television broadcast at both family-viewing epicentres like Sunday teatimes and as post-pub fodder for drunks rolling home in the early hours of weekend mornings. To have seen them at both those times at different points in one's life shows how their repeated availability is not just a simple repetition but a revisiting that each time slightly differently inflects the audience/film relationship. To watch a Carry On for the third or thirteenth or thirtieth time is, among other things, to reflect on who you were on previous viewings – the film never changes (never changing is what Carry Ons do best) but our relationship to it, in particular our nostalgia for previous viewings and thus for other versions of ourselves, is always in a process of negotiated alteration. If this is so, it shows how even 'abysmal films' (I am tweaking Roger Lewis' term because the Carry Ons will never be 'movies' as long as the English use of the English language maintains any sort of distance from its imperialistic transatlantic offspring) can tap into deep waters. Complex, subtle and profound are perhaps the least likely adjectives ever to be applied to a Carry On, but they suit rather well these processes of revisiting our other, younger, different selves through this negotiation of cultural nostalgia. I have written elsewhere (Medhurst 1992) about how the Carry Ons also permit a similar set of reflections about class, in that one reason I have sometimes returned to the films is that they remind me of a working-class childhood in which I watched them supremely unaware that one day I would be watching them as part of the middle-class profession of academic analysis (these issues of class identity, social mobility, nostalgia and comedy will also be addressed in Chapter 11 in the context of Roy 'Chubby' Brown). It seems, not

for the first or last time in this book, that texts which are 'abysmal' by most conventional aesthetic standards can nonetheless have significant importance when considering the complicated dynamics of identity and belonging.

Perhaps, though, such observations mean that we may need to challenge the consensual models of cultural worth in which the Carry Ons can be so easily consigned to the ranks of the abysmal. This is not a matter of trying to shoehorn them into highly regarded canons by applying conventional criteria, for that way lies evaluative madness. Is Gerald Thomas as gifted a director as Pedro Almodóvar? Hardly. Does *Carry On Again Doctor* leave you as wracked and awestruck as *Vertigo*? Don't be silly. Yet is it useful or fair to judge the Carry Ons by the usual cinematic yardsticks just because they were made as films? Possibly not. Like those Mancunian Films products, discussed in Chapter 5, which saw their job as capturing stage performance for wider distribution and never fretted for a second about film form, the Carry Ons are comedies first and films second. They belong to a tradition of films where the word 'cinematic' is irrelevant. John Ellis has claimed, in a fascinating essay, that the series exemplified a strand of British cinema designed not to reward detached aesthetic contemplation but to come alive when greeted by audiences, meaning that for him the Carry Ons were the:

> most extreme example of the cinema of performance ... Uneven, loose or non-existent at the level of narrative, these films depended on the mise en scene of particular isolated sequences which are paced specifically to create and deliver a sense of audience communality. They depend upon stars and on a 'common knowledge' circulating between audience and film-makers.
>
> (Ellis 2000)

This is almost right. The Carry Ons do indeed work in this way; they share that core mission of all popular comedy, the eliciting of complicity. But to see them as the 'most extreme' examples of this tendency is to overlook the likes of Mancunian Films and other, even more shoestring, producers, whose output makes the Carry Ons look cinematically ravishing. (For an excellent overview of bargain-basement pre-war film comedy in England, see Sutton 2000.) Yet Ellis is nonetheless pinpointing two key aspects of how the Carry Ons operate, firstly in noting the centrality of stars to the processes of Carry On consumption, and secondly in suggesting that emblematic moments are more important in such films than linear narrative. Might this model of thinking about the Carry Ons offer a way around the apparent impasse of the abysmal/significant paradox identified by Lewis?

The importance of flagship performers to how we think about and respond to the films seems beyond doubt. In the revealingly pathological spheres of marketed memorabilia and internet fandom, the faces and personas of the recurring troupe loom particularly large. In discussion on fan websites such

as www.carryonline.com, acolytes of Sid or Hattie or either of the Kenneths declare their loyalties in a way that recalls pop fans pinning their longings on one favoured member of a favourite group. There are fan visits undertaken to Pinewood Studios (self-referential nods to *Convenience*'s factory outing, perhaps?), where surviving cast and crew personnel are wheeled out to meet, greet, sign autographs and answer questions. Via such websites one can purchase ceramic figures of the most iconic stars, or clothing, posters and (the frightfully modern option) computer screensavers emblazoned with their faces. As for the claim that the films are best digested in small portions rather than wholes, I can hardly disagree, having earlier in this chapter acknowledged my preference for 'scenes, lines and images' from the films to any of them in their entirety. Peter Rogers, the films' producer, has himself formally institutionalised this mode of fragmentary consumption, firstly in 1977 by releasing in cinemas a compilation of clips called *That's Carry On* (the title a cheeky lift from MGM's highlights-of-musicals compilations called *That's Entertainment*), and secondly by putting together thirty-minute clip shows for television broadcast. Today, watching the films on tape or disc, rather than in a formal cinematic screening, technologically facilitates this type of engagement. You can skip the padding, ignore the story, leap directly to well-loved jokes (Infamy! Infamy!), take out the narrative stuffing to cherry-pick the tastiest morsels, pause or search while you get another beer from the fridge and replay as often as you wish your favourite 'sight bites' (thanks to Phil Ulyatt for that phrase). The first twenty minutes of a Carry On are usually the best, as it is during those opening segments that the familiar faces will have to reintroduce themselves, often with personal catchphrases or visual gimmicks, thereby reassuring us that there is nothing as unwelcome as change on the agenda. After Sid's first throaty cackle or Hawtrey's initial 'Oh hello', things slide steadily downhill, as some threadbare semblance of plot splutters into half-life, while the endings (with the major exception of *Up The Khyber*'s justifiably legendary dinner party) all too often fizzle out into uninteresting chases or directionless slapstick mayhem.

If such declines and disappointments can be avoided when watching recordings, the films' more blatant ideological embarrassments of the films can also be glossed over by the press of a button. The issue of the Carry Ons' politics is treacherous ground, not least because the films are used by some fans as a totem against the perceived consensus of what is usually, lazily called political correctness. After finishing a lecture on the Carry Ons at the National Film Theatre in London, I was button-holed by one of the slightly unnerving ultra-fans (part vulgarity-trainspotters, part innuendo-zealots) that the series seems to attract, who was keen to tell me how great it was that I was sticking up for the films in the face of all that pleasure-hating, minority-obsessed, killjoy 'PC'. The lecture had indeed been positive about the films, but only because I chose to overlook some of the series' more reprehensible representations. It would, of course, be spectacularly pointless to expect mid-century films

rooted in music hall and seaside postcard vocabularies to speak a language of post-millennial, middle-class, feminist-influenced, ethnically sensitive liberalism, and there are many ways in which the carnival robustness of the series cuts refreshingly through the hypocrisies and stuffiness of bourgeois proprieties. At the same time, the films do not deserve a blank cheque – the ceaseless sexism rife across the series, the appalling racism of *Up The Jungle* (released, don't forget, not long after Enoch Powell's infamous speeches about immigration) and the callous homophobia in *Abroad* all need to be remembered before any uncritical celebration of the films takes hold. Yet there is, as so often in popular comedy, no consistent party line. If *Up The Jungle* is overflowing with racist stereotypes, *Up The Khyber* holds imperialism up to ridicule; if the scantily dressed giggling girlies become too wearisome, there is always Hattie Jacques to turn to; and if *Abroad* treats its main queer character with remarkable spitefulness, *Nurse* and *Constable* give us Charles Hawtrey at his outrageously queeny best. With so many films over so many years and viewed from so many angles, it is not surprising that evidence can be found to support a wide and conflicting range of ideological implications. (How else could one explain the seeming contradiction between the films' obsessive narrative commitment to heterosexual hegemonies and the decision by the organisers of Brighton's annual Pride event, one of Britain's biggest celebrations of queer identities, to theme the day as 'Carry On Pride' in 2006?) Only an Augusta Prodworthy could sustain a stance of implacable disapproval towards the whole series, but there are undeniably occasions where her censoriousness is very much required.

In lieu of a neat conclusion, let me offer one final speculation about why the Carry Ons persist in holding our attention. It is a matter of their relationship to Englishness, or more specifically to that corner of Englishness in which they so single-mindedly squat, characterised by thwarted appetites, unsatisfied urges, coping strategies and the solace of laughter. Given the battalions of comedies discussed elsewhere in this book which also occupy such turf, especially those rooted in what Peter Bailey has called the 'distinctive if slippery form of comic pragmatism' (Bailey 1994: 155) at the heart of music hall, this territory is hardly the Carry Ons' exclusive preserve. Yet since they still have a presence and a resonance which many other older comedies have lost, it is most often through the Carry Ons that modern English audiences will stumble across that particular set of sensibilities and try to make their peace with them. Roger Lewis sees the films as 'resplendently ordinary and makeshift ... They are about ... pokey small-town Englishness ... they are about our idea of failure as success – that happiness is to be found in small things' (Lewis 2001: 14). In this way, perhaps, they are another example of how popular comedy can be intensely national without ever becoming nationalistic, for while they could only ever be English, the England of the Carry Ons is hardly a country that would prompt anyone to wave a flag. It is an England where you can look but don't touch, where the safest way to avoid disappointments is never to have expectations, where

sensuality has shrivelled to the sensory desperations of the bug-eyed leer and the dirty laugh. They are films which for all their funniness also capture the poignancy of a culture cut off from deep feelings (or at least reconciled to the realisation that admitting deep feelings in most English contexts would cause more problems than solutions), a culture of hang-ups and let-downs, of trudges and traps, a culture where an endless cycle of carrying on stands in for actually getting or going anywhere. Is this another reason why we keep watching them and can't seem to let them go – because rather than just being crappy little English films, they are really films about the littleness and crappiness of Englishness?

Chapter 9

Bermuda my arse

Class, culture and 'The Royle Family'

> The living-room is the warm heart of the family and therefore often slightly stuffy to a middle-class visitor. It is not a social centre but a family centre … The hearth is reserved for the family, whether living at home or nearby, and those who are 'something to us', and look in for a talk or just to sit. Much of the free time of a man and his wife will usually be passed at that hearth; 'just staying-in' is still one of the most common leisure-time occupations.
>
> (Richard Hoggart 1957: 33–4)

> There'll be times when you're on the bones of your arse, but we'll always be there for you.
>
> (Jim Royle to his grandson David)

As the pun in its title indicates, *The Royle Family* is a comedy centred on the question of class. There are many interesting things to be said about how the series handles other formations and locations of identity (gender, sexuality, ethnicity, nation, region, age) but class is the core of the programme, its primary axis of orientation, its predominant vocabulary, its emotional lodestone, and the key issue in its critical reception and cultural placing. Consequently, class is the focus of this chapter, which aims to look at two interwoven questions. On a textual level, I want to consider how the series mines comedy from its acutely sensitive understanding of class dynamics, and on a wider cultural level I want to reflect on what its representations and its reputation disclose about how class identities function in an England moving from one century into the next. The first point to stress is just how successful *The Royle Family* has been. From unprepossessing beginnings in September 1998, tucked cautiously away in a 10 PM slot on BBC2 and saddled with the shaky label of 'comedy drama', it went on to secure massive critical praise, impressive ratings (given its scheduling), a move to the more mainstream pastures of BBC1, increased audience ratings as a result of that move and a sheaf of awards. *Royle Family* memorabilia (T-shirts, mugs, posters, calendars) had a brief heyday of popularity, especially amongst those social groups (students, teenagers, aficionados of 'cult TV') who would be the least likely to ever purchase Royal Family memorabilia.

Its status soon became such that in the BBC's Annual Report for 1999–2000, a document wherein the BBC trumpets its self-regard by instancing what it sees as its own most significant successes, it was the only comedy series mentioned more than once and the only comedy series to be singled out at all for citation in the Report's initial overview section. In effect, it had become the comedy series the BBC most liked to boast about, a comedy not just celebrated by a national institution but well on the way to becoming one itself, which must by any standards rank as a remarkable achievement for a relatively experimental, low-key sitcom in which a working-class Manchester family sit in their house apparently doing very little. The series has permeated the cultural bloodstream like few other comedies of its generation, and rightly so, since to my mind, although judgements of this kind need to respect the changes in perspective that hindsight may bring, only Victoria Wood's magnificent *dinnerladies* could contest *The Royle Family*'s claim to be the most outstanding English sitcom of recent years.

Dense textures and beached tricksters

Class, of course, is a recurring social and cultural theme throughout the history of English (and British) situation comedy. Given the centrality of class to English perceptions of self and other, this is scarcely surprising. The situation in which the comedy takes place in a sitcom needs to be recognisable, to fit a mould, to be culturally legible for the humour to work, and there is no more crucial social mould in England than class. Thus the history of sitcom here has been preoccupied, to the point of obsession, with class. There have been sitcoms content to offer serene suburban idylls which reassured the middle classes of their own social centrality (*Terry and June*, *Fresh Fields*, *My Family*), sitcoms which sought to question that serenity by hinting at or plunging into the neuroses that underpinned it (*The Fall and Rise of Reginald Perrin*, *Ever Decreasing Circles*), sitcoms which milked laughs from the abrasions caused by classes scraping against each other (*George and Mildred*, *Rising Damp*, *Birds of a Feather*, *Keeping Up Appearances* and scores of others), sitcoms which hilariously, poignantly and even cruelly showed the futility of dreaming of upward class mobility (*Hancock's Half Hour*, *Steptoe and Son*), and sitcoms which held the cultural worlds of particular class fractions up for ridicule (*Only Fools and Horses*, *Absolutely Fabulous*). Those titles are, it should be said, simply well-known tips of far larger icebergs, and the typology in which I have crudely placed them overlooks the extent to which many of them draw on more than one class-related theme (Rigsby in *Rising Damp* and Mildred Roper in *George and Mildred*, for example, also belong with the deluded yearners of the Hancock and Steptoe school). Even before a character speaks in an English domestic sitcom, their class belonging is usually disclosed by their wallpaper or their choice of evening meal, but class also looms large as a rich, ripe source of comic potential in those sitcoms set beyond the

confines of purely domestic space. Think of how Mrs Slocombe's aspirations to gentility in *Are You Being Served?* are capsized by the continual resurfacing of her working-class vulgarity, an identity lacquered into her baroque coiffures and embedded in her over-refined vowels, disguises which she so foolishly believes will conceal the very thing that they actually confirm; or of how Jean and Dolly's bickering in *dinnerladies* oscillates along a line where the clash between robust plain speaking and prim euphemism demarcates that especially volatile faultline where upper-working-class abuts lower-middle; or even how outer space is not free from class tensions in *Red Dwarf*, where Lister and Rimmer's conflicts are, among other things, conflicts between differently classed Englishnesses.

Great comedy usually requires the tension of difference, so it is only to be expected that in most cases, sitcoms that explore class clashes or class mobility tend to be more complex than those which simply idle about within one class location. One-class sitcoms like *Terry and June* and *Absolutely Fabulous* soon settle into deep ruts of predictability, though this does not prevent them continuing to be produced for several years after their limitations have been reached, provided there is an audience loyal enough to keep lapping up more of the same – the consolations of repetition are, after all, key elements in the pleasures offered by most of the comedy studied in this book. Sitcoms centred on class conflict, however, either between or (most intriguingly) within characters, tend to have access to a more diverse and resonant emotional palette. The way that Harold in *Steptoe and Son* is endlessly torn between the irreconcilable callings of cultural advancement and familial loyalty might serve as one example here, as might the playful tracings of the mismatch between military rank and social status in *Dad's Army*, where Captain Mainwaring's performance of authority always has to look anxiously over its shoulder at Sergeant Wilson's discreetly threatening air of elusive but entrenched class superiority. It is in those uncomfortably recognisable spaces of class insecurity that English sitcom has traditionally placed its most important insights into social hierarchy.

At first glance, *The Royle Family* might seem so welded to its own very specific and unwavering class location that it runs the risk of being one of those unadventurously inward sitcoms which play safe by staying put, and it is true that frictions between class groupings in the series only emerge in its later stages. Like everything else in the series, that theme moves only slowly, maturing like a rind around cheese, inching ahead with the daring unhurriedness of the slow burn. It is not until Anthony Royle's middle-class girlfriend Emma visits, thrusting her college-student hairstyle and her disconcerting vegetarianism into the family's hitherto uninvaded working-class sanctuary, that the series relies for its comedy on the overt clashing of class registers, and her visit does not happen until the last episode of the second series. Before and indeed after that, *The Royle Family* is mostly concerned with mapping a much more rarely seen cartography of class relations, the complex and shifting nuances of distinction within what is often sweepingly referred to, not least

by me, as the working class. The series has the ability to get behind sociological generalities in order to unravel the relentlessly and jealously policed gradations of everyday life, to reach a point where Barbara Royle can say with complete sincerity that she thinks certain other people are 'rough' or 'common', words which in a middle-class environment would be tagged, tacitly or otherwise, to Barbara herself. The series can confidently work with such levels of detail because it is committed to depth, not breadth. It is, in terms of social representation, a permanently zoomed-in close-up, the polar opposite of panoramic. This tight social focus, what might be called a demographic of deep narrowness, is both reinforced and facilitated by the much-praised stylistic innovations of the series. It is shot on film, there is no laugh track, the pace is unusually slow, the well-crafted pay-off punchline is (mostly) shunned in favour of studiously layered naturalistic dialogue, the camera often lingers on particular faces (including silent ones) or pieces of décor, and narrative ellipses of time are rare, leaving events to unfold in an approximation of real time. These devices combine to serve two functions. Firstly, they distance the series from the generic norms of English sitcom while simultaneously aligning it to more respected cultural forms (many have noted the series' indebtedness to the films of Mike Leigh, for example). Secondly, they are there to bolster the illusion of social credibility, of cultural authenticity, and they do this partly because the dense textures of each episode mark an attempt to get beyond sitcom's most frequent representational strategy, the stereotype. As many have argued (myself included, see Medhurst 1989), stereotyping is essential in many spheres of popular culture. Stereotypes guarantee immediacy, they are a short cut to meaning, and often, due to their inability to convey complexity, a short cut to misrepresentation. Sitcom's tendency to paint social characteristics with a very broad brush in order to reach the haven of laughter as swiftly as possible makes its recourse to stereotypes virtually unavoidable.

Yet *The Royle Family* is a hugely popular and extremely funny sitcom that tries its hardest to leave stereotypes behind, and it pretty much succeeds. It does this through the time and care it is able, thanks to those key decisions about style and form, to devote to its characters. Imagine a more conventionally shaped sitcom about a Northern family trying to get by in the teeth of financial hardship and emotional ups and downs. The family home would be the centrepiece, but the family members would also be seen in their workplaces, or at the social security office, or out drinking or shopping, or in the homes of the other people they know, or at churches or civic buildings when the occasion arose. All those spaces are pivotal to what happens in *The Royle Family*, but we are never shown them. All twenty episodes (three series of six and two Christmas specials) take place inside the Royles' house, indeed it is only on very rare occasions that we even see upstairs. Virtually every scene shot is in either the living room or kitchen. Back in that other non-Royle Northern family sitcom, we would have to be shown an ever increasing number of

other characters, to make the wider range of locations plausibly part of a large city; there would be extras and exteriors. Again, *The Royle Family* refutes such dilutions, showing just the family, immediate neighbours, and a small number of friends. The effect of all this is an intense concentration on the key figures, resulting in characterisations of extraordinary depth. That might seem an odd word to use, since most of the Royles and their associates are poorly educated and not especially articulate, living lives composed of chores, routines and low horizons. In other words, they are not the type of people customarily assumed to require in-depth treatment in cultural representation. Other texts have no qualms about stereotyping such people, because such people have little or no power to contest those representations, but *The Royle Family*, bravely and very politically, insists that such an easy option will not do. Compare that decision to the imaginary Northern family sitcom I have been imagining, or should I say remembering, since the programme I had in mind there was *Bread*, the extremely successful 1980s sitcom about a large, close, hard-up Liverpool family, written by Carla Lane.

In *Bread*, the family were vigorously sketched stereotypes – the heart-of-gold battleaxe mother, the feckless and sexually untrustworthy father, the bookish sensitive son, the garishly dressed romantic daughter, the cantankerous grandfather, and so forth. It was a text keen to box the family into the corner marked 'lovable rogues', it mapped a territory populated by rascals, with its Liverpool setting enabling it to plug into long-standing stereotypes of Liverpudlians as cheeky chancers, relentlessly wielding the Scouser-as-scally trope. Its overriding mission was to put an upbeat spin on being unemployed, to tell a tale of struggling through and coping with a smile, with a few well-meant jabs at the grim bureaucracies and social indifference of Thatcher's Britain thrown in along the way. In effect, bearing in mind some of the arguments I made in Chapter 5, it was a George Formby piece, warm-heartedly chronicling the cheery efforts of the masses, a celebration of pluck with some polite naughtiness around the edges. *The Royle Family* opts to take a very different route, one that might be seen as cleaving to Frank Randle in opposition to *Bread*'s reworking of Formby sensibilities. There is certainly enough carnivalesque corporeality in the Royle house to uphold a link to Randle. Jim Royle's habit of appending the words 'my arse' to any stray phrase would surely have tickled Randle, while the battery of farts and general attention to lower-stratum bodily matters throughout the series are, if you care to see them this way, Rabelais writ large. 'Nowhere like your own toilet, is there' is the sentiment expressed in one episode, taking 'there's no place like home' into a new realm of corporeal basics, while nothing is more alarming for Barbara during the well-to-do Emma's visit than Jim's loudly announced lavatorial needs and the shaming fact that someone in the house has evidently got dog shit on their shoe. Emma is from Cheshire (merely a few geographical miles from the Royles' Manchester home but semiotic and social light years away), a place where shit is never talked about and probably quite close to being banned entirely. It is even possible to

buy, as one of the many spin-off products generated by the series' huge success, Royle Family toilet paper, with a selection of shit- and fart-related lines from the show printed on each sheet. The Royles are in many ways Randle's children, yet the Formby/Randle dichotomy is never that clear-cut, as witnessed by Jim's fondness for singing the odd Formby song on those rare occasions when the television set is switched off and he entertains the clan with his banjo. Formby stands for the good times, for Blackpool, for those moments when the gloom lifts, there's beer to spare, and some laughs or songs can bestow brief succouring warmth on the bleak drabness of everyday life. Besides, though Jim shares Randle's fondness for orifices and extrusions, he never leaves his chair for long enough to resemble Randle's body in any other way. Randle's body was fearsomely malleable with its snake-like twists and sudden lurches, but Jim is stasis personified in his enveloping armchair, a beached and becalmed trickster, with only his bowels and mouth truly and fully alive.

Nonetheless, as the elaborateness of my description is intended to signify, he is no stereotype, and neither are the rest of the core cast. There is a degree of typing, otherwise recognisability would be impossible, but the Royles can never be hung on simplistic, stereotypical, conventional-sitcom pegs. We simply see too much of them for that, and just when a character appears to be folding neatly into a stereotypical pattern, a new facet of them is slowly unfurled. Denise may seem to be a monument to selfish laziness, but then comes the scene where she weepingly confesses her fears about motherhood to Jim. Barbara seems to get by as an easy-going drudge who alleviates the boredom with a smoke and a laugh, but then there is the episode where she almost leaves the family as a protest at how they exploit her. Even Anthony's friend Darren, gormlessly rooted at the bottom of the class heap with only a few television comedy catchphrases to lend some temporary joy, becomes overwhelmed with emotion when Anthony and Emma ask him to be their baby's godparent. These are profoundly ordinary people, cannon fodder for stereotyping, but revealed as the series progresses to be ordinary only in that the rest of the world tells them that they are and that they don't have the material or emotional wherewithal to challenge that categorisation. *The Royle Family* is a comedy, and often a sublimely funny one, but it is also impressively unafraid of hinting at tragedies unseen. The casting underlines this by consciously acknowledging the series' debt to British soap operas, the television genre most consistently interested in the emotional meanings of working-class life. Jim and Barbara are being played by Ricky Tomlinson and Sue Johnstone, previously best known as the Grants, fiery working-class mianstays of *Brookside*, family friend Twiggy played by *Coronation Street* veteran Geoffrey Hughes, and Andrew Whyment, who plays Darren, joined *Coronation Street* after his stint with the Royles. It is also worth noting that Liz Smith, giving a typically flawless performance as Barbara's mother Norma, has done memorable work with both Mike Leigh and Alan Bennett, whose different but complementary influences run through *The Royle Family* like twin veins – Leigh's shadow hangs palpably over the series' visual style and pacing

(his film *Meantime* is a particularly close, albeit Southern, precursor), while Bennett's love of the unforced absurdities and revealing absences of ordinary Northern speech echoes across the series' dialogue, though the Royles are some notches down the class hierarchy from Bennett's favoured social zone. Most crucially, as will be seen in the next chapter, Leigh and Bennett share a passionate commitment to insisting on the emotional complexities of disregarded lives. *The Royle Family* runs on precisely the same fuel.

At Hoggart's hearth

If Leigh, Bennett and soap opera are three important tributaries flowing into *The Royle Family*, it is also possible to identify a fourth. Richard Hoggart's book *The Uses of Literacy*, a socio-literary study of class and culture first published in 1957, has been such a pervasively influential text in England that it is often taken for granted, rendered invisible through ubiquity. Its most profound impact in terms of television was to bequeath its sensibility and cultural landscape to *Coronation Street* (see Dyer 1981), the soap opera that became such a benchmark representation of English Northern working-class family life that every subsequent televisual rendering of similar lives remains in its, and thus to some extent Hoggart's, debt. *The Royle Family* is no exception, indeed it is remarkable how close a match there often is between the series' domestic textures and Hoggart's detailed, loving and nostalgic evocations of the Northern working-class home where he was raised (I am indebted to Chris Kelleher for first pointing this out to me). This is not said to imply that Caroline Aherne and Craig Cash, the driving creative forces behind the series, sat planning the show with a much-thumbed copy of Hoggart's book at their elbows, but that the two texts are part of a shared, resonating, evolving discourse concerned both with representing English Northern working-class life and with considering the role and place of those representations within broader cultural and ideological spheres.

Look again at the quotation from Hoggart placed at the head of this chapter; could there be a crisper summary of how the Royles live, the space in which most of that living takes place, and the network of relationships acted out in it? It may be risky to suggest too neat a fit between Hoggart and the Royles, not least because the working-class rooms he evoked were rooms of the 1930s (he was writing retrospectively about his own childhood) rather than the 1990s. Nonetheless, the similarities are unmistakable, and an awareness of historical change should not blind us to the existence of cultural continuities. Elsewhere in the same section of his book, Hoggart's descriptions of the working-class home seem uncannily redolent of the Royle milieu: 'It is a cluttered and congested setting, a burrow deeply away from the outside world ... it is a gregarious group, in which most things are shared, including personality; "our Mam", "our Dad", "our Alice" are normal forms of address' (1957: 34). Food in this kind of home, Hoggart says, is not adventurous, and relies on

'a liberal use of sauces and pickles, notably tomato sauce and piccalilli' (35). In addition, 'cigarettes and beer ... are part of life; without them, life would not be life; there are rarely any other major interests to make these pleasures less relevant and worth forgoing' (50), while Jim Royle would not quibble with Hoggart's diagnosis that in such homes the 'husband is ... not really expected to help about the house' (49). Hoggart even cites the sentimental ballad 'I'll Take You Home Again Kathleen', which the Royles' neighbour Joe movingly sings in one episode, as one of the key popular songs which underline 'the force of home as a theme' (134). It would be misrepresentative, however, to suggest that Hoggart's view of these rooms and these lives is unambiguously positive. He was writing autobiographically, recalling at two decades' distance his own childhood in the early 1930s, but in the book's present tense he was a university academic, having made that move between classes (facilitated by the partial democratisation of the English education system) which was so formative in moulding the outlooks and interests of many who would go on to be influential figures in the early days of what became Cultural Studies (see Medhurst 1999). To put it bluntly, if he had been wholly under the sway of the attitudes enshrined in that emblematic room, he would not have passed his exams. He loved the room and its population, but he did not intend to stay there, so in the midst of his reverie about warmth and solidarity there are asides which bring sharply into focus the image of the studious scholarship boy trying to finish his homework – 'To be alone, to think alone, to read quietly is difficult' (34). The solitary intellectual was never entirely compatible with that piccalilli parlour.

This tension, too, has its Royle referent, for the series offers its own aspirant son in the shape of Anthony, whose nervously burgeoning quest for independence is one the series' slow-burning story arcs. He's not a bookworm like little Richard Hoggart, but he sees escape as a priority nonetheless, whether through the pop culture dream of moving to London to work in the music industry or through class elevation via marriage to his Altrincham girlfriend Emma. That latter narrative climaxes in the final episode of the series, where the Kavanaghs (Emma and her parents) visit the Royles at Christmas. The scenes played out here are richly tragicomic, superbly excruciating in their awareness of the stresses and signs of class stratification. Emma's father, Roger, seeks to bridge the class divide by trying to capitalise on the bluff masculinity he seems to share with the Royle men, discussing football with them and swapping dirty jokes. Her mother Valerie is more uneasy, and Barbara Royle more uneasy still, since they both know that in English matters of domesticity and class it is women who are the most assiduous and attuned monitors of social gradation and cultural capital, the most stringent inspectors of aesthetic and hygenic infringement. (This theme again highlights the series' debt to Alan Bennett – see the discussion of class and cleanliness in Chapter 10.) If the visit fails, Barbara stands to lose the most, since it will be her domestic management, and worse still, at this time of year, her Christmas competence, that will be judged as lacking.

Unsurprisingly, it is she who is the most wounded when class friction finally surfaces. It emerges that Roger grew up in very impoverished working-class circumstances, revealing him as only recently, and thus insecurely, middle class, and one way of shoring up that fragile status is by demeaning the way the Royles live, a ploy which depends on the implicit jibe that the Royles could also have 'improved' themselves if they had not been so feckless. Once the Kavanaghs have gone, the episode offers the security of the big laugh guaranteed by one of Jim's anal quips – 'Roger my arse' (even being buggered, it seems, is preferable to being a jumped-up boaster like Mr Kavanagh) – but the sour taste of the visit lingers. That this was the final episode of the series (before its one-off return in 2006) is significant, since it could have ushered in a class-conflict sitcom of the more conventional kind, thus losing the intensity of focus which makes *The Royle Family* unique. Once the outside world and the possibility of alternatives is let into the Royles' space, rather than simply being talked about or glimpsed on the television screen, the jewelled precision of the series made possible by its smallness of scale could not be sustained.

The fond and rosy picture of pre-war working-class culture offered by Richard Hoggart was not simply the product of nostalgia; that older way of life was strategically celebrated by him in order to denigrate the newer forms of popular culture taking shape in the 1950s. These, for Hoggart, represented homogenisation, Americanisation and decline, and television threatened to deposit those downward spirals smack in the heart and hearth of the working-class home. Once again, he eerily prefigures a vision of the Royles, though this time his tone is one of concerned lament:

> When you are taking part in some mass-activity, no matter how mechanical the activity may be, there is something warming in the feeling that you are with everyone else. I have heard people give as their reason for listening to a popular wireless programme, not the fact that it is amusing, but that 'it gives you something to talk about' ... The same kind of thing may sometimes be seen in an undiscriminating looking-in, night after night, at TV.
>
> (Hoggart 1957: 156)

Hoggart goes on to sketch out his fear that television would generate a massified, pacified audience, 'dead from the eyes down' (157), linked by a consumption of shared texts but in effect drip-fed by manipulative broadcasters. This is, of course, the stereotype of the zombified masses so often proffered in anti-television polemics, and those who spout such polemics could probably point to the Royles as precise embodiments of that stereotype. Except, of course, that they are no such thing. They do watch an enormous amount of television, but they are hardly hanging mutely on the teat of what Hoggart, in an uncharacteristic flourish of cheap Freud, calls 'the Great Mother' (157). They watch television in a variety of ways – with interest and with indifference, with real animation and just to kill time, they interact with programmes and use

them as background noise, they occupy, in short, a wide and diverse range of viewing positions. The defining image of the series in both critical discourse and everyday discussion has come to be a picture of the Royles as slumped, gawping couch potatoes, yet they are only like that for some of the time. If it is that image which has assumed iconic status, rather than (for example) the family's lively and knowledgeable discussions of popular TV genres and performers, then this discloses more about what some of its audiences would like the series to say than what it actually does say. Far from being an undemanding dupe, Jim Royle is one of the most astute television critics I have ever heard – as evidence, consider his withering summary of the home decorating game show *Changing Rooms* as 'watching a Cockney knocking nails into plywood', or his typically pithy way of showing how aware he is of the gap between the impossible dreams dangled by holiday shows that promote extravagant foreign travel and the limitations imposed by poverty on his own range of options: 'Bermuda my arse'. These might be comments lacking in discursive finesse, but they are hardly the words of an unthinking, bovine slob unaware of what he is watching, yet many persist in seeing the Jim and the other Royles as little more than that. Such a persistence only seems to be explicable if looked at once again through the lens of class, as I want to suggest in the final section of this chapter.

Class and the critical voice

The particular power of *The Royle Family* to bring to light questions of class was reinforced very strongly for me in the context of teaching. For several years, I taught a course that surveyed the intellectual traditions and critical methods that have been applied to the study of popular culture. One section of the course asked the students to nominate popular cultural texts (contemporary or historical) which they saw as particularly revealing in their representations of particular social identities. Those texts then became the subject of our detailed study. While finding texts for consideration under the heading of 'gender', for example, never presented my students with any difficulties whatsoever, being asked to locate fruitful case studies for exploring questions of class had always been a problem. Until 1998. Within weeks of its first broadcast, *The Royle Family* became the runaway winner, and it remained so for the duration of all three series. The students did not necessarily find it a comfortable object to discuss, as will be seen shortly, but there was no doubt in their minds that here was a text centred on class. There is something very telling about this: the students were not asked to select a text about working-class representation, simply 'class'. That they unerringly opted for *The Royle Family* discloses a great deal, since these were overwhelmingly middle-class, and occasionally upper-class, students, who with only very rare exceptions, came from London and the south-east of England; clearly they found it far easier to identify as a 'text about class' something that represented a classed (and regional) other,

rather than anything relating to their classed (and regional) selves. In many ways it is another example of how difficult it can be for members of privileged groups to see themselves as occupying a specific and bounded identity rather than blithely assuming themselves to be a norm so central that it needs no defining (white people and heterosexuals often commit the same arrogant error). When we discussed the series, a huge range of responses was uncovered. One student, who left the group in little doubt about how wealthy his family was, not only loved the show but informed us that he and his friends liked to leave answerphone messages for each other in the impersonated voices of Denise and her partner Dave. For him, the characters were just raw material for caricature, and any questions of recognition, empathy or depth of feeling were so wholly off his agenda as to be ludicrous. A student in another group, who articulately located herself as left-liberal middle-class, said she found the programme very difficult to watch as she felt it unfair to subject those kind of people to the mocking laughter of the more privileged. A third student, who pointed out that he was the first person in his working-class family ever to attend university, spoke warmly about how funny the programme was, how it reminded him of some homes and situations in his own immediate and extended family, and how uncomfortable it was to watch with fellow students, as he could never be sure what, and whom, they were laughing at.

It would be presumptuous to assume I could forensically unpick the entire workings of those students' minds, but all three responses invite a little speculation. I am particularly struck by the belief the first two shared that there is one overriding meaning of the series, even though they differed wildly in how they proceeded from that point – one simply revelled in what he saw as the chance to ridicule the characters from his vantage point of considerable privilege, the other read the text identically, but she recoiled with well-meant political affrontedness from the ridicule invitation. What neither of this pair could countenance was a reading of the series which saw its characters as anything more than victims. They responded in opposite ways ideologically but shared an identical interpretation of the series' intentions. The third student occupied a more complex position, both in terms of his mixed feelings of recognition and defensiveness, and in his awareness that any understanding of how cultural identity figures in a given text will be to some extent contingent one's own relation to that identity. In other words, we relate to texts in terms of who and where and what and when we are. The fusing of carnival filth, nuanced observation, deadpan wit, collective support and political tragicomedy that I detect in *The Royle Family* is very strongly connected to my own (convoluted) sense of class belonging. Not unlike that third student, I recognise the Royles' house, up to a point, from memories of my own working-class childhood – but the 'up to a point' is crucial here. To some extent, the recognition I feel is no doubt composed of nostalgia and projection, besides which I grew up in London, which puts a geographical distance between myself and the Royles that may well be just as significant as any kind of class equivalence (Northern English readers might

already have concluded that only a Southerner could even think of conflating
Leeds, where Richard Hoggart grew up, and Manchester, where the Royles
live). Even so, one of the strongest feelings I have watching *The Royle Family* is
one of remembered familiarity, and that factor inevitably colours not just what
I think about and do with the text, but also how I negotiate my way through
analytical and critical accounts of it.

The issue of class operates in complex ways in the reviews of the series in
British newspapers and magazines. What leaps out of these is both an abid-
ing concern with matters of authenticity – how real is *The Royle Family*, how
true? – and an underlying contradiction which ensures that the authenticity
question can never be adequately answered. That contradiction stems from the
fact that most critics acclaiming the series wish to praise its accuracy in depicting
the particularities of a specific social space, yet are compelled through various
overt and covert means to acknowledge that they themselves have no first-
hand experience of that space, leaving them little or no resources on which to
draw in order to judge the very accuracy to which they assign such importance.
The critical discourse around the series did not focus on authenticity issues by
chance. 'Realism', which is very likely one of the most treacherous words in
the English language, has a long history of being used primarily to describe texts
concerned with working-class lives, while the stylistic repertoires employed in
The Royle Family, its dense textures and its structures of feeling, indicated that
here was a text in which the usual sitcom priorities (jokes, narrative, stereo-
types) were sidelined. The vocabulary that materialised was then in many ways
inevitable: 'Awesomely realistic' (*Evening Standard*, 14/9/98), 'Comedy doesn't
get … more real-life than this' (*Daily Telegraph*, 14/9/98), 'a six-part comedy
drama which dares to go further than any television series I can remember in
replicating the comedy of real life' (*Mail on Sunday*, 20/9/98). In such accounts,
'realistic' is often related to the precise mise-en-scene of the Royles' home –
'a living room … so cramped that Denise has to squeeze between the armchair
and the couch when she wants to go into the kitchen' (*Sunday Independent*,
20/9/98) – or in the details of what the family eats, 'a gourmet supper of
pork chops, chips, beans and tea' (*Daily Telegraph*, 21/9/98). Already, how-
ever, another language is seeping through, a language concerned not just with
the critical evaluation of representational accuracy (the fantasy of 'realism'),
but with a strategy of distancing based on class. It is helpful here to glance
back to the beginning of this chapter and note Richard Hoggart's observa-
tion that the typical working-class living room would seem 'slightly stuffy to
a middle-class visitor', since that sense of class claustrophobia is plainly there
in the *Sunday Independent*'s characterisation of the Royle interior. It appears
'cramped' to middle-class eyes, accustomed to more spacious and differently
decorated accommodation, where what the likes of the Royles would call
a settee would be redesignated a couch, but it might simply be common-
place and familiar, even cosy, to audiences who don't only see such rooms
in television programmes but live in them all the time. And it does not take

a very large linguistic step to convert distance into hierarchy, to move from the registering of differentiation to outright snobbish condescension – note the smoothly waspish sarcasm of the *Daily Telegraph*'s phrase 'gourmet supper'. The metaphors of distancing vary. There is Royle-watching as scientific experiment, where scrutinising the series is 'like looking at mould through a microscope' (*Guardian*, 20/10/98). There is the social work case assessment – 'Lined up for our inspection were a family who were not so much dysfunctional as afunctional' (*Evening Standard*, 15/9/98). There is the generic switch which turns sitcom into nature documentary, recasting working-class people as animals and intrepid bourgeois viewers as the David Attenborough brave enough to peer into their lair: 'the family are … like … primates grooming each other in the Manchester rain forest' (*Guardian*, 20/10/98). There are the attempts to 'rescue' the series from its downmarket associations and justify the critic's approval via comparison to more venerated or fashionable cultural figures – 'probably the nearest mainstream television will ever get to the work of Samuel Beckett' (*Guardian*, 24/9/99), 'belongs with the Absurdist tradition of Ionesco and Pinter' (*Daily Telegraph*, 20/12/99), 'reminds one … of the work of Finnish director Aki Kaurismaki' (*Time Out*, 22/9/99). And there are moments when all metaphors subside and the critic is honest enough to acknowledge that 'We're not used to seeing such families on television' (*Sunday Independent*, 20/9/98), a use of 'we' which of course requires a 'they', the Royles themselves and the class fraction in which they are presumed to reside. Here the not-so-secret agenda of these distancing mechanisms is out in the open: those in the critic's class are more socially privileged than those in the Royles' class, and one way in which they exercise that privilege is to scrutinise, label and judge those who are without it.

This becomes unavoidably plain, and to my eyes uncomfortably sour, when critics move on from evaluating the series as a cultural representation to using it as a platform from which to pass class-based judgements on actual social groups. Several reviews cannot resist a speculation about how the series might be received by viewers who themselves live the kind of life the Royles lead (the woolly language that lets 'realism' bleed into 'real life' makes this elision of text and society all too easy). Thus: 'Presumably the idea behind *The Royle Family* was that if a certain type of family (though not the sort of family that is typically glued to BBC2) were to switch on … what they'd be staring at would be not so much a television show as their own reflection [in] … one of those mirrors you find in a fairground Hall of Mirrors, in which the reflection is distorted enough to make you smirk at the hideousness of the image, without ever being completely sure how much of the hideousness is due to the mirror's distortions' (*Times*, 15/9/98). Here an opposition is set up between those who, like the critic, can appreciate the series on several levels, and those too ill-equipped, presumably due to their under-exposure to BBC2, to respond to it with appropriate complexity. A year later, when the series moved to BBC1, that assumption was, a fraction more tactfully, reworked into a question: 'It's an

interesting gamble on the Beeb's part: will those who find themselves watching themselves on television find it funny ... will the wider viewing public get the joke?' (*Time Out*, 22/9/99). Rough translation: will the thickies get it? Not unlike the interpretation shared by my politically differentiated but similarly classed students, a discourse is offered here in which the series is reduced to an uncomplicated matter of 'us' (critics, broadsheet readers, devotees of Finnish film directors) laughing at 'them' (Royles, banjo players, fans of *Who Wants To Be A Millionaire?*). As a further example, which at least has the virtue of admitting ignorance about working-class lives rather than coding that ignorance into arrogance, consider this: 'coming from a different social background, I am also curious to know whether Royle families get the point of *The Royle Family*. Would you be amused to see your own inertia so accurately mirrored?' (*Daily Telegraph*, 20/12/99). Here again, the complexities and multiplicities of meaning that I see in the series are reduced to a dull, null singularity – there is apparently just one meaning, 'the point', and the point seems to be the serving up of allegedly eventless lives for the momentary amusement of those who have eventful ones. I am not sure what it is that appals me more about these loftily patrician pronouncements: is it their unruffled confidence that anyone from less privileged backgrounds than themselves will only be capable of the most rudimentary, grunting grasp of cultural texts, or their blind and fatuous determination to convince themselves that *The Royle Family* is nothing more than a freak show of underclass inadequacies? If those who hold such views (and I am aware I am caricaturing them, much as they like to caricature the Royles and the 'real Royles') genuinely do see the series in that way and that way alone, I can only presume that even at its moments of tenderness, affection, raw emotion and unapologetic sentiment, such as when Jim promises lifelong loyalty to his baby grandson, when Barbara is on the verge of falling apart, or when Joe serenades the room with a tear-prompting rendition of 'I'll Take You Home Again, Kathleen', they still erupt with brays of slumming laughter. But surely nobody, not even in the most stratospheric echelons of the English class hierarchy, could be *that* stupid?

If it does nothing else, *The Royle Family* explodes the myth, propounded by the Conservative Prime Minister John Major and propagated by the conservative Prime Minister Tony Blair, that England is a classless society. The ludicrousness of that view is perhaps most keenly obvious to those of us who have moved between classes, and thereby know and feel from first-hand experience what it is like to inhabit (always uneasily, always ambivalently) differently stratified social spaces. That knowledge and those feelings are what make *The Uses of Literacy* such an important and moving book, and what make *The Royle Family* such an important, moving and funny sitcom, a sitcom fiercely determined to see dignity and love and laughter where the prevailing powers see little more than grime and idleness and shame. Caroline Aherne and Craig Cash, like the Richard Hoggart of the 1950s, are working-class writers who have found themselves living middle-class lives. They, like he did, retain deep emotional

bonds with working-class cultures but can now, like he did, only see them through the poignant retrospective binoculars of affection and memory. The tensions of distance, nostalgia, defensiveness, status, advancement, betrayal, change and regret run through both his book and their comedy, producing texts streaked with the pangs of pining for lost certainties. Happily, Aherne and Cash also recognise the sharp, salty and bitter humour in that situation as much as the anxieties over treachery and loss, and they have chosen to make the former win out over the latter – but only just.

Chapter 10

Anatomising England
Alan Bennett, Mike Leigh, Victoria Wood

Alan Bennett first became famous in 1960, when he was one of the four performers in the satirical revue *Beyond the Fringe*; Mike Leigh's first feature film, *Bleak Moments*, was released in 1971; Victoria Wood's first success was her appearance on the television talent contest *New Faces* in 1974. This means that, as I am writing this sentence at the end of 2006, by my calculation they have between them amassed notable careers lasting for an amalgamated total of one hundred and thirteen years. It would be extravagantly deluded to imagine that a solitary book chapter can cover every aspect of their richly significant contributions to English culture, so what follows will need to subject them to the same violent selectivity imposed on the music hall heirs discussed in Chapter 5. My only aim in this chapter is to reflect on how English their work is, and what their work says about England. Putting them together makes sense in some ways, though not in others. The three of them do not, obviously, work in precisely the same spheres of cultural production – Leigh directs and writes films and plays; Wood is a stand-up comedian, writes and sings comic songs, and writes and performs sketches, stage shows, television films and sitcom; Bennett writes plays, television scripts and film screenplays, acts, and is an essayist, diarist and critic. Also, they have significant differences in terms of backgrounds: Bennett was born in the 1930s, Leigh in the 1940s, Wood in the 1950s; Leigh is Jewish, the others are not; Leigh and Wood are heterosexual, Bennett is not; Bennett's father was a butcher, Leigh's a doctor, Wood's an insurance salesman. Yet I have herded them into a shared chapter because of their recurring determination to consider the meanings and dilemmas of Englishness (not that this is, by any means, their only concern). Importantly, all three are northern, Bennett from Yorkshire, Leigh and Wood from Lancashire, and there are also notable and evocative overlaps in the performers that have appeared in their work – most importantly Patricia Routledge (for Bennett and Wood), Liz Smith (for Leigh and Bennett), Thora Hird (for Bennett and Wood) and Julie Walters (for all three). This chapter does not want to suggest that Bennett, Leigh and Wood can be mashed indistinguishably together, their significant individualities ignored in favour of an attempt to make them speak with a single voice, and Bennett and Wood in particular have been

compared so often that they are probably sick of the sound of each other's names. Victoria Wood has already been sharp enough to turn that repeated comparison into a characteristically knowing joke; during a television documentary which followed her on a railway journey around northern England and across Scotland, she remarked 'I'm not visiting Morecambe on this journey. I can't face strolling on the prom with my camera crew, elbowing Thora Hird and Alan Bennett out of the way with their camera crews'. On this chapter's journey, however, I hope that I can identify enough consonances and echoes between the work of Bennett, Leigh and Wood to make the comparison palatable.

Alan Bennett: Winnie the Pooh in the slaughterhouse

In the autumn of 1998, the BBC broadcast the second series of Alan Bennett's *Talking Heads*. The first series of these tragicomic monologues, shown ten years earlier, had secured beyond reasonable doubt Bennett's status as one of the most popular and acclaimed writers in the country. The second series started with *Miss Fozzard Finds Her Feet*, in which Patricia Routledge told the tale of how she, a middle-aged assistant in a department store's footwear section, found an unlikely but satisfying sideline in financially rewarded sexual encounters with a shoe fetishist. It was reviewed a few days later by a panel of cultural critics on the BBC2 arts programme *Late Review*. Most of the critics were interested in the monologue and some impressed, but one was not a fan:

> It's as if English history stopped in 1947 ... Tight-arsed, emotionally null, the whole theme is emotional constriction ... Anyone foreign, anyone black, anyone Asian, on the one hand they're a threat, on the other hand they're having fun ... England is so constricted and so narrow ... so hopeless ... It's utterly anodyne ... He writes English as if it's a dead language ... There is this dreadful, mean-spirited, nasty, controlling quality ... There's no comic potential in this, no comic anarchy, no fun. It's joyless ... miserable, drably cosy.

All of which goes to show that some people get awfully miffed by the combination of Patricia Routledge and suede bootees. The man who delivered that apoplectic tirade was Tom Paulin (a respected academic and poet with the complex identity formation of an Ulsterman working at Oxford University) and he seems to have four main objections to the monologue; since they are by implication dissatisfactions with Bennett's work in general, noting and evaluating them here might offer a starting point for thinking about what Bennett means. The first accusation is that Bennett is complicit with the blinkered parochialism inhabited by many of his characters, the second is that the whiteness of Bennett's England wilfully ignores contemporary multi-cultural realities, the third is that the brand of comedy Bennett uses lacks 'fun' and 'anarchy',

and the fourth is that Bennett's language is expired and inert. My answers to those objections are unlikely to convince anyone as Bennett-phobic as Paulin, but here they are anyway. Bennett's alleged complicity with his characters' narrow outlooks can be thought of instead as a sympathy with social types usually dismissed and easy to look down on, especially from the cosmopolitan eyrie lived in by people of the Paulin persuasion. Bennett deals in a comedy without sneers, a comedy unafraid of warmth, a comedy interested in the over-looked and the unfashionable. The question of ethnicity is an easy missile to throw at Bennett, since he creates not only an overwhelmingly white world but white characters (Miss Schofield in *A Woman Of No Importance*, for exam-ple, or Doris in *A Cream Cracker Under the Settee*) whose everyday talk casually includes racially prejudiced asides. This, however, is another outcome of his preference for writing from within the skin of such characters and withholding overtly authorial commentary; in the worlds in which his characters live, such asides (and, frankly, far worse ones) are commonplace, and the fact that there is no criticism of these comments within the text does not prevent the audi-ence from supplying criticisms of their own. In Bennett's own account of the *Talking Heads* monologues, he points out that the characters are 'artless. They don't quite know what they are saying and are telling a story to the mean-ing of which they are not entirely privy' (Bennett 1998: 32). As for Bennett's paucity of non-white characters, he is writing from inside his own English-ness, which is a white Englishness; would Paulin prefer him to parachute in a pre-agreed quota of black or Asian characters in order to soothe the con-sciences of the liberal and guilty? The accusation that Bennett's comic mode lacks anarchy is irrefutable, but many would say that there are other sorts of fun beyond the anarchic; Paulin is seeking to restrict comedy to one strand of explosive mania and to outlaw the wry smile, but this is just an attempt to transmute a personal taste into an aesthetic dogma. As for Bennett's language being 'dead', this again is a matter of taste, but a taste I find impossible to fathom, given his ability to write lines like 'Never mind Rwanda, can we deal with the matter in hand and get a middle-aged gentleman off the lavatory'. For Bennett-haters, the way such a line (it comes from the Paulin-enraging *Miss Fozzard*) seems to rate the appalling tragedies that happened in an African country as of less importance than everyday toilet needs in a Yorkshire suburb could furnish more proof of Bennett's insularity. For me, however, that joke contains a subtle ambivalence: it is partly a way of laughing *at* insularity, not endorsing it, and partly a comic swipe at those high-minded international-ists who think that everyday life in their own locale is a dismissible triviality, people that Tom Nairn once called 'activists who end up substituting the "inter-national struggle" for doing anything next door' (Nairn 1997: 32). Finally, since performance and linguistic relish are absolutely at the core of Bennett's style, it should be said that merely printing the line on paper cannot convey its delectable comedic musicality, especially when delivered with the flawless timing of Patricia Routledge.

One final word in Paulin's onslaught needs to be mentioned: cosy. Bennett's work has addressed themes such as domestic violence, paedophilia, sexualised serial killing, AIDS, dementia, sado-masochism, terminal illness and pornography, yet the word 'cosy' hovers over him like a small chintz cloud. This is partly because some of his critics seem so mesmerised by the domesticity and femininity which so interest him that they fail to see the deep, troubling concerns that he frequently explores in such settings. Even some of his admirers hardly help to dispel the cosiness paradigm: 'there are those people who, like hedgerow trees, grow into the shapes peculiar to our own landscape. One has only to listen to Alan Bennett reading *The House At Pooh Corner* on Radio Four to realise that British individuality has not perished' (Aslet 1997: 243). Faced with such a 'tribute', where Bennett is enlisted to serve in a conservative lineage of national exclusivity, Tom Paulin's bile is a little more explicable. Aslet's description comes from a book on English identity, which (as I discussed in Chapter 4) sought to deny the complexities of changing English life in favour of upholding supposedly traditional values – making exactly the move that Paulin accuses Bennett of making. Aslet exemplifies the line of argument which celebrates Bennett as a 'national treasure', a phrase which, as Jeremy Paxman has suggested, seems to regard Bennett 'as if he were … a pot of Women's Institute home-made raspberry jam' (Paxman 1998: 17). Paxman's survey of Englishness includes the story of how he wrote to Bennett, seeking enlightenment on the matter of English identity, only to receive this reply:

> I'm hopeless at his kind of thing … If I could put into words what I mean by Englishness (and what I like and detest about it) I wouldn't write at all, as coming to terms with it is what gets me going.
>
> (Paxman 1998: 18)

This is the best answer of all to Paulin. Bennett, more than any of the other figures studied in this book, has been directly engaged in a conscious and lengthy reflection on the ambivalences of Englishness. The cosiness persona, which led one journalist to call Bennett 'the National Teddy Bear' (quoted in Games 2001: 230), has no place for this other Bennett, the Bennett who so often anguishes over what Englishness might be and what England is becoming. The defining moment of the revival of conservative nationalism presided over by Margaret Thatcher in the 1980s was the Falklands War; Bennett's response to that war, and especially to the triumphalist discourses mobilised in support of it, was this:

> Not English I feel now. This is just where I happen to have been put down, No country. No party. No Church. No voice. And now they are singing 'Britannia Rules the Waves' outside Downing Street. It's the Last Night of the Proms erected into a policy.
>
> (Bennett 1994: 123)

Here, a writer often identified as exemplifying Englishness rejects it, rendering himself nationally homeless. This extremity of reaction was brief, in the sense that once the floodtide of Thatcherite jingoism receded, Bennett was able to resume his investigation of national belonging, but it remains a telling moment, and hardly 'cosy'. At less intense flashpoints, Bennett's response to being English has consistently been characterised by ambivalence, torn in opposite directions by the double impetus of the 'what I like and detest about it' he mentioned to Paxman. If those directions seem at first irreconcilable, they are more helpfully thought of as part of a spectrum, a shifting space where (except in moments of dislocating crisis like the Falklands War) this English writer so passionately interested in Englishness can look for clues, weigh the evidence and calculate the emotional cost. In Daphne Turner's useful phrase, Bennett's favoured approach to the question of national belonging consists of 'critiques in the teeth of attachment' (Turner 1997: xii). Exemplifying this, in the preface to his 1968 play *Forty Years On*, Bennett wrote:

> Today is Armistice Day and the fiftieth anniversary of the end of the First World War. I listen to the ceremony on the radio, and as I type this I hear the guns rumbling across the park for the start of the Two Minutes' Silence. I find the ceremony ridiculous and hypocritical, and yet it brings a lump to my throat. Why? I suppose that is what the play is trying to resolve.
>
> (Bennett 1994: 259)

Years later, speaking on television in 1992, Bennett recalled his memories of Queen Elizabeth's Coronation in 1953, noting 'as so often with the central rituals of English life, I was in two minds about it all'. As these comments (and there are dozens of others) disclose, Bennett is a key figure for this book because of the consistency and depth of these ambivalences, for his continued exploration of how being English involves the tension between feeling that you belong while striving to avoid the traps and trappings of an excessive investment in that belonging. He is also key because the cultural mode he has most often used to make these explorations accessible and meaningful is comedy. Even at the nadir of his Englishness, at that moment of crisis in the Falklands War, he still turned to humour to encapsulate his loathing for the hollow theatricality and bovine flag-waving of that neo-imperialist exercise; the line about the Last Night of the Proms may be an unusually sour and angry joke for Bennett, but it's still funny, and it shows his awareness that humour can make points more crisply and indelibly than other prone-to-ponderousness discourses.

Like so many of the other comedies covered in this book, the humour Bennett employs is centred on place, class and gender. The place he finds comedy in more than any other is the English North; as Ronald Bergan notes, 'Bennett country is situated in a Northern corner of England, usually hidden away from tourists and omitted from most literary maps' (Bergan 1989: 193).

There are Bennett comedies set elsewhere (London, Prague, Moscow) but it is Yorkshire and its neighbouring counties which are the most relevant locales for this discussion. Bennett often shows an acutely heightened, precisely nuanced grasp of how different northern towns, and even different districts within those towns, signify gradations of class and status. Recalling childhood holidays, he wrote:

> Places could be common too … particularly at the seaside. Blackpool was common (people enjoying themselves), Morecambe less so (not enjoying themselves as much) and Grange or Lytham not common at all (enjoyment not really on the agenda). If we ever did get to Blackpool we stayed at Cleveleys or Bispham, the refined end. To my brother and me (and I suspect to the local estate agents) refined just meant furthest away from the funfair.
>
> (Bennett 1998: 35)

This is not just, in its relishable cadences and sinuous wit, paradigmatic Bennett prose, it also shows an unerring eye for how class, space, culture and geography interweave in the stitching of English identities. Bennett's seaside is not the site of unbroken spree and slapstick found in Gracie Fields, George Formby and the Carry Ons. He prefers the melancholy side of the seaside coin, depicting in several of his 1970s television plays the seaside out of season, the seaside at its cheapest and dreariest, the seaside when the amusement arcades and gift shops are closed or eerily empty. In *Afternoon Off*, an East Asian waiter wanders disconsolately around the unwelcoming streets of Scarborough, making this a Bennett text where the shortcomings of white Englishness are plainly revealed by its determination to exclude the ethnically different (Tom Paulin, presumably, is unfamiliar with this play). In *All Day On The Sands* a working-class family eke out a seaside holiday of remarkable dullness, with light relief (for the audience if not for the family) provided by the deludedly pretentious owner of the boarding house, an aspirant cosmopolitan who serves breakfast in 'the Portofino Room' and boasts that his grottily English establishment has 'that Riviera feel'. In *Sunset Across The Bay*, one of Bennett's most accomplished studies of place, class and gender, an elderly couple from Leeds have to move home when their house is knocked down as part of the council's ruthless 'slum clearance' policy (the woman of the house is outraged by this term – 'Slums? They never are'). They move to Morecambe, but find that the shortcomings of a permanent life in a seaside resort are vastly different to the temporary pleasures of an annual visit. It is a place where old folks sit in bus shelters for hours in the absence of much else to do, or take as long as possible to sip tea in cafes, or go to the cinema in the afternoon, keeping their hats and coats on. The husband is particularly badly affected, as having retired from his job he no longer has a temporal map for charting his day, and the new routine-less routine of long, slow, lonely days hits him much harder than it hits his wife.

'I've got right stalled', he says, and the implication is that because so much of his masculinity was bound up in his job, retirement is not only boring but fem- inising. Whereas life in Leeds was a matter of known quantities, Morecambe means change, a change they are too rooted in their past, and their other place, to be able to adopt – the husband asks for 'a Leeds paper' in a Morecambe newsagent, the wife is disconcerted when their milkman suggests adding a new product to their usual delivery, chiding him 'you can't be branching out into yoghurt at our age'. At the end, the husband dies – a heart attack in that most bathetic of death sites, a public toilet – and we see the wife, alone in their once-shared bed, facing a life with all the other marooned widows in this waiting-to-die town. This brief summary might suggest that *Sunset Across The Bay* is hardly a comedy at all, but there is too much wittily observed evoca tion of working-class lives and language for it to be classed as anything else; it does, however, show how Bennett's comedy is able to incorporate depth and darkness, a blend refined much later in the stunning monologues of *Talking Heads*.

Although Bennett's abiding interest in the minutiae of social distinction is the main point where his work connects to Mike Leigh and Victoria Wood, he distrusts the imprecisions and generalisations of the word 'class'. In the 1988 television documentary *Dinner At Noon*, Bennett observes the daily goings on in a large northern hotel (the Crown in Harrogate), and in his voiceover commentary admits that 'I've never been able to get worked up about class and its distinctions ... I've never felt the conventional three-tier account of social divisions has much to do with the case'. He is fascinated, he says, 'not by class, which I don't like, but classes, types, which I do', and spends the film poring over that jigsaw of judgements used by the English to place, label and evaluate each other. *Dinner At Noon* superbly traces these subtle contours, with Bennett looking not for fixed identities but for specific instances of behaviour, the verbal and non-verbal interactions which are crucial in ascertaining hierarchies. What fascinates him in Harrogate, and it is a fascination he revisits and refines time and again in his writing, is the enactedness of social relations, the performativity of everyday life, the codes that demarcate conventions, the processes by which the way the English say things has become more telling than what they say. Part shuffling anthropologist, part prowling predator, he roams the shabbily genteel hotel in search of social climbers, social sliders and, on varied rungs of the ladder, those resigned or even happy to accept their social lot. He seeks out the clues about status that we let slip, in our accents and actions, like cake crumbs from a tea plate His conclusion is simple: 'What keeps us in our place is embarrassment'. That comment is a manifesto for all of his comedies about Englishness (and also a good number of Mike Leigh's), and it is never more evident than in his accounts of the domestic spaces of his own upbringing, where the concerns and constrictions of the national imaginary took a very specific shape in anxieties about dirtiness and strategies for staying clean. To be thought to be dirty was a particular fear in the England where Bennett grew

up, since dirtiness carried connotations of fecklessness, idleness and, worst of all, not caring what anyone thought of you – that last being worst because in a culture where judging others was a sacred duty, to be indifferent to such judgement was absolute heresy. The fear of being judged over your cleanliness, and being shamed if it failed to measure up, has not disappeared from English life, but it was much more intense in the era of Bennett's childhood, the 1930s and 1940s. Here is one of Bennett's accounts of his mother's extravagantly obsessive concern with domestic hygiene:

> My mother maintained an intricate hierarchy of cloths, buckets and dusters, to the Byzantine differentiations of which she alone was privy. Some cloths were dish cloths but not sink cloths; some were for the sink but not for the floor. There were dirty buckets and clean buckets ... One mop had a universal application while another had a unique and terrible purpose and had to be kept outside, hung on the wall. And however rinsed and clean these utensils were they remained tainted by their awful function. Left to himself my Dad would violate these taboos, using the first thing that came to hand ... but if Mam was around he knew it saved time and temper to observe her order of things.
>
> (Bennett 1994: 278)

Dirt is rich comedic soil, a humorously fruitful territory of taboo. The seeping muckiness dived into so gleefully across the decades by Frank Randle, the Carry Ons and Roy 'Chubby' Brown could not be funny if we did not on some level harbour huge anxieties about keeping ourselves both literally and metaphorically clean. The release offered by the dirt joke, which is often also the dirty joke, is an escape from this policing of hygiene, a policing which Bennett's mother pursued with such scouring fundamentalism, and which, as can be seen in the account of *The Royle Family* in Chapter 9, still lingers as one of the ways by which others judge and place us. Bennett's most unconstrained treatment of this theme comes in the 1984 film *A Private Function*, where a socially aspirant couple in the food-rationed 1940s hide a pig in their house so that there will be generous amounts of meat at a forthcoming gathering of the town's elite. The pig proceeds to fart and relieve itself all over their kitchen, an eruption of smells, liquids and solids that catapults the respectable home into the riotous world of carnival (on pigs and their meanings, see Stallybrass and White 1986). 'It's doing its business', shrieks Maggie Smith (as only she can) in the role of the horrified wife, trying to cap the flow of excremental scandal with a very English euphemism, but her term is also strangely accurate, since it is the business of muck and filth to remind us that whatever our social pretensions and facades of gentility we are all still bound to bodily basics.

When I look at that pigshit-spattered kitchen I don't see anything 'cosy'. Neither is there any cosiness in the second series on *Talking Heads*, which includes one monologue (*Waiting For The Telegram*) which risks comparing

how a generation of young men were senselessly wiped out in the First World War with the decimation of gay men by AIDS, another (*Playing Sandwiches*) which suggests that a culture that quite happily sexualises children through fashion and style codes might not have much of a moral high ground from which to condemn paedophilia, and a third (*Nights in the Garden Of Spain*) which chronicles how a suburban wife kills the abusive husband who has subjected her to degrading sexual games involving half the neighbourhood men, goes to prison for his killing but finds a brief lesbian romance with a former neighbour (who learns with horror that her husband was one of the sexual torture gang). The fact that the man responsible for some of the darkest English comedies imaginable can still be cartooned as the teddy bear purveyor of neutered northern niceties is, I suppose, one of the many ambivalences that Alan Bennett conjures up. Perhaps some see cosiness because he sets so much of his work in suburbia. Perhaps some observers cannot help equating an unashamed interest in the lives of middle-aged and elderly northern women with a cosy outlook (in which case, such observers need to reflect on their own ageism and regional prejudices). Perhaps the fact that he did indeed read the Winnie the Pooh stories on Radio Four has rubber-stamped him as cosy for always. If so, then those who are mired in such stereotyped views of what he means and does need to look at him more carefully. Bennett's panoramic span of Englishnesses does of course include elements which the short-sighted and the strenuously edgy stigmatise as 'cosy', but it also contains work that tackles the contradictions, limitations, irritations and poignancies of English identity with an almost unprecedented assurance and honesty. A rumpled teddy bear is not really up to that task. Interviewed on the BBC programme *A Taste of My Life* in 2006 about his memories of food, eating and cooking, Bennett talked about how he often accompanied his father, a butcher, to the slaughterhouse where animals were killed, and how this seemed a perfectly ordinary and unworrying thing to do. The interviewer looks moderately appalled, finding it difficult to reconcile Winnie the Pooh and the slaughterhouse, but to understand Bennett fully you need to see that he can encompass both, and that is one of the many reasons why he has, to borrow a phrase Andrew Motion once applied to Philip Larkin, 'turned his voice into one of the means by which his country recognised itself' (Motion 1993: 343).

Mike Leigh: Indigenous tragicomedies

Whereas Alan Bennett's career is marked, and perhaps on some level defined, by a constant, conscious and even self-conscious return to questions of Englishness, Mike Leigh has never sought to address that agenda with anything resembling Bennett's directness. In a 1991 interview, while Leigh acknowledged that he was 'committed to making indigenous film' and in some ways aiming to 'celebrate people and their particular culture', he also insisted that 'I don't make films that are exclusively or idiosyncratically English, the subject matter of

my films is not English, but universal' (Movshovitz 2000: 33–4). That last claim would be endorsed by some of Leigh's critical champions, including the North American authors of two book-length studies of Leigh's work (Carney and Quart 2000; Watson 2004), which despite their interpretive and methodological differences share a mission to present Leigh as an artist of world standing, not reducible to or containable by a single national context. A crude summary of their aim would be that they seek to uncouple Leigh from Englishness, to secure his cultural reputation by internationalising him away from home, and just as I used Tom Paulin's tirade against *Talking Heads* as a way into thinking about Alan Bennett and Englishness, I want to approach some issues around Leigh, national identity and comedy by looking at how he is critically represented in those two books and in other critical discourses. (For a more orthodox thematic overview of Leigh's work up to and including his 1993 film *Naked*, see Medhurst 1993.) For Ray Carney and Garry Watson, Leigh's status needs establishing on an international stage, so although their studies of Leigh relate his work to other British filmmakers (Ken Loach, Stephen Frears) and British literary icons (Shakespeare, Jane Austen, Charles Dickens, E.M. Forster) there is an abiding sense that Britain (let alone England) is not enough. Carney, for example, almost never mentions the English cities or counties in which Leigh's films are set – it's as if by admitting to their location, their magnitude will be diluted. (Leigh's only film to date placed outside England, the 1985 Belfast-located *Four Days In July*, is not given any sustained attention by Carney; for an interesting study of it, see Clements 1993). Watson is a little more sensitive to Leigh's cultural geographies, but only just.

Leigh, for these two critics, needs some international bolstering, and consequently a glittering battalion of anything-but-English heavyweights are cited and recommended as figures with whom Leigh might be compared or on whom a study of Leigh might fruitfully draw – writers and philosophers such as Hegel, Flaubert, Chekhov, Henry James, Sartre and Beckett, film directors including Ozu, Renoir, Olmi, Tarkovsky, Dreyer and Satyajit Ray, painters like Rembrandt and Degas. Several of those suggestions for connecting Leigh to a wider context are helpful and perceptive (Chekhov, Ozu and Renoir particularly so), but there is an underlying tendency at work here in which the bid to claim Leigh as a great world artist hinges at least partly on prising him out of his own culture. (In an analogous vein, one might note the cavalier disregard of historical context in this enlisting of such a temporally disparate range of cultural figures.) In Chapter 4, I noted an occasional indifference on the part of some North American critics to matters of detail and accuracy regarding British history, geography and culture, and it does not seem to me to be accidental that a fistful of similar errors intrude into the recent transatlantic study of Leigh (though it should be noted that Leonard Quart's 'Cultural Introduction' to Leigh does at least try to relate the director to his British contexts – Carney and Quart 2000: 1–13). Ray Carney's critical vision of Leigh is often stimulating, but it is also grandiosely internationalised and

sweepingly indifferent to the relevance of national specificities. Such indifference makes itself manifest in the small but telling rash of errors that Carney makes in his headlong rush to anoint Leigh as a genius without borders. The character of Andy in *Life Is Sweet* takes occasional refuge in impersonating Neddy Seagoon from the radio comedy *The Goon Show* – for Carney this makes him a 'figure in a Ned Seagoon movie' (2000: 208); Carney describes a very evidently West Indian character in *High Hopes* as 'Pakistani' (201) and in relation to the same film he renames the downmarket hamburger chain Wimpy 'Blimpy' (186; this could be a subtle, punning reference to the Colonel Blimp imperialism strain in British culture, but I have my doubts). Beverly and Laurence's everyday suburban house in *Abigail's Party* is described as a 'condominium' (97), while the council housing official who visits the Pollock family in *Meantime* is demoted to a 'maintenance man' (175) and Coxy in that film, sartorially and dispositionally a paradigmatic skinhead, is for Carney a 'punk' (168).

Enumerating these may seem petty and parochial, but when considering a filmmaker whose work is so 'rich in specific, filigree definition' (Coveney 1997: 125), and who relies (like Alan Bennett and Victoria Wood) so greatly on painstakingly precise nuances of signification and recognition, the accuracy of detail matters. To call the housing official a maintenance man, for example, is to nudge him down the class ladder and make him the Pollocks' equal, whereas the whole comic core of that scene (one of Leigh's absolute finest) resides in the clash of language and attitudes generated by the mismatch between the official's patronising, middle-class, social-worker verbiage and the family's no-frills proletarian pragmatism. To fail to notice how this moment is a comedy of classed and clashing Englishnesses does not inspire confidence in the rest of Carney's analysis (even after he decides, some pages later, to describe the official, a little more accurately, as a building supervisor). Nonetheless, Carney's reading of Leigh has points of real insight, but only when he considers what might be called the 'universal Leigh' rather than the 'English Leigh'. Garry Watson is less prone to misrecognitions of English specificity, but he shares Carney's concern that Leigh can never be appreciated fully if he is only seen in a national framework. Watson offers the observation that 'one main reason why Leigh's characters seem so exceptionally real is that they are so exactly situated within the English class system' (2004: 186), but he zooms so rapidly away from such matters that by the end of the following page he is mulling over Slavoj Zizek's account of 'the Lacanian Real in the films of David Lynch and Krzystof Kieslowski' (187). This is the proper meat of the Film Studies conference circuit, far more likely to be rewarded in the worldview and the pecking order of academic cosmopolitanism than admitting an interest in the colour of Lesley Manville's eye shadow in *Grown-Ups* or the differentiated geographical significances of Wakefield and Hartlepool in *Career Girls*. Such things would only detain a critical eye mired in parochialism, an eye like mine.

There are moments in their analyses of Leigh when Carney and Watson seem to feel, above all, impatient with most British critical accounts. They're trying to help our guy out, but are we grateful? Over here, it seems to them that we are too hung up on minutiae of detail to see the bigger picture, too determined to haggle over micro-details of dress, decor and accent to perceive Leigh's grander, greater themes. These themes – family, marriage, relation-ships, parenting, love, truthfulness, disappointment and redemption, and his recurring return to them – do indeed make possible a universalising reading of his work which minimises the importance of setting and locale and an evalua-tion of him in which comparisons to Chekhov, Ozu and Renoir make perfect sense. Yet there is an alternative, or parallel, reading of Leigh which especially savours his use of local particulars, to the extent where their locality and par-ticulars have built over the years to offer a developing, multi-layered portrait of English lives; in this view Leigh offers 'the story of a nation unrepresen-tative, on the whole, elsewhere ... a gallery of national characters' (Coveney 1997: xiii) and has pursued a 'deep, anthropological meditation on the drives, repressions, manners and behaviour of the British' (Fuller 1995: vii). Crucial to this take on Leigh is the sheer wealth and weight of what Leigh himself has called the 'textural, social accuracy' (Movshovitz 2000: 52) in the films. This familiar, finely meshed, pointillist-precise and palpable social landscape means that any English viewer encountering a Leigh text is not likely to see the wall-paper, the knitwear, the hairstyles, the crockery, the speech patterns, the food choices, the facial quirks and the physical gestures as *encumbrances* obscuring the deeper themes but as *enhancements* of them, giving them a concreteness and a recognisability that tethers them to their time and place and saves them from vanishing into humanist generalities and lofty ineffability. This presumes, of course, a favourable response; for those who dislike Leigh or are distressed by him, the weight of textures and the wealth of social accuracy become ends in themselves, so that he becomes a condescending judge of other people's lives, registering his verdict on them through his merciless rendering of their inter-personal clumsiness and their regrettable taste. The locus classicus of that view of Leigh is Dennis Potter's aghast and splenetic review of the first television broadcast in November 1977 of *Abigail's Party* (still Leigh's best-known piece, centred on the incomparable performance of Alison Steadman as Beverly); the sheer bilious relish of Potter's venom, so bracingly to-the-point when com-pared to the polysyllabic obfuscations of so much academic writing, means that quoting at length is irresistible:

> This play was based on nothing more edifying than rancid disdain ... it was
> a prolonged jeer, twitching with genuine hatred, about the dreadful sub-
> urban tastes of the dreadful lower middle classes ... horribly funny at times,
> stunningly acted and perfectly designed, but it sank under its own immense
> condescension. The force of the yelping derision became a single note of
> contempt, amplified into a relentless screech. As so often in the minefields

of English class-consciousness, more was revealed of the snobbery of the
observers rather than of the observed.

(quoted in Carney and Quart 2000: 96)

Watered-down versions of these accusations have followed Leigh ever since;
in such accounts, he dishes up the spectacle of 'their' constrained lives for 'our'
self-satisfied mockery, yet this charge rests on the presupposition that 'their' and
'our' are easily identifiable and uncontentious positions to occupy. As I aimed
to show in the previous chapter's discussion of *The Royle Family*, any response
to representations of class must be put in the context of the critic's or the
audience's own sense of classed identity, belonging and location – an obvious
point, yet one oddly lost on some of Leigh's North American admirers. To call
the Pollocks' flat in *Meantime* a 'South London slum' (the words of Ian Buruma,
quoted in Watson 2004: 29) shows either an insensitivity to the feelings of those
who live or have lived in flats like that, or a confident assumption that no such
people would be reading such as the analysis in question (it also, sorry to raise
this yet again, shows yet more American indifference to English geography –
the Pollocks live in *East* London).

Ray Carney's otherwise thoughtful analysis of *Grown-Ups*, meanwhile, is
hamstrung by its conviction that audiences will be caught off-guard by the
film's emotional narrative because they will have instinctively warmed to the
middle-class Butchers on first acquaintance and be less sympathetic to their
working-class neighbours Mandy and Dick. The latter pair, Carney claims,
'seem so rough, rude and coarse' that 'it is almost inevitable a viewer will con-
clude that the point of the juxtapositions is to reveal Dick and Mandy's faults ...
Dick and Mandy bicker and argue so continuously and the Butchers interact in
such a scrupulously polite and deferential way that it is almost inevitable that a
viewer assumes that the arguments are evidence of the former couple's inferior-
ity' (2000: 131). The only way to avoid greeting such a remarkably hegemonic
view of class, consumption and representations with nothing more than sheer
jaw-dropped derision is to take refuge in Carney's nervously repeated phrase
'almost inevitable'. Somewhere, it seems, on the outermost fringes of his com-
fortably professorial consciousness, lurks a faint awareness that there might be
people who look at *Grown-Ups* in quite a different way, who see the Butchers
not as 'polite and deferential' (and in which bizarre North American fantasy of
Englishness did deference become an attractive trait?) but as a communicatively
buttoned-up, emotionally strangulated and sensually null pair of class-crippled
victims. Indeed for English viewers of *Grown-Ups* from a working-class back-
ground, this seems to me to be the overwhelmingly likely response. If so,
the film's apparent volte-face (excitably lauded by Carney as 'shocking, upset-
ting ... assaultive and provocative', 2000: 132) cannot actually take place: we
cannot be startled and wrong-footed by having our sympathies switched to
Dick and Mandy (and to Mandy's maddening, tragic, hilarious sister Gloria)
because they were never anywhere else in the first place. If *Grown-Ups* holds

any surprise for this audience, the audience to which I belong myself, it is that by the end we are mildly startled to realise that Christine Butcher, if not her husband, might be a redeemable human being after all. I am not positing my view of the film as a given (although I am concerned that Carney does just this), I simply want to point out that both Carney and I see it from where we differently are, and what we think about a text, especially a Leigh text, depends on where we place ourselves in relation to class. Dennis Potter's dismay at the snobberies and jibes he saw as structuring *Abigail's Party* was rooted in a certainty about how class was conceived, figured and consumed within and in response to that text, but is that certainty really so easy to achieve and maintain? Isn't the play, like all of Leigh's best work, much more about ambiguities than certainties?

There is one reasonably easy, ambiguity-avoiding way of watching *Abigail's Party*, and that is to fall in with Potter and see it as the unforgiving, heartless caricature of suburban pretensions that so mortified him. When in 1997 the BBC decided to mark the twentieth anniversary of the play's first broadcast, it did so by offering an 'Abigail's Party Night' on BBC2. Alongside a repeat of the play itself and an interesting documentary profile of Alison Steadman, this also incorporated, between the programmes, elaborately parodic graphics depicting lines of dialogue and 1970s-style domestic objects and no less than eight actresses, all in costume as Beverly, offering a mass impersonation of Steadman's nasal, cajoling, controlling vocal gymnastics. The evening also included a short film about the career of Demis Roussos, the Greek singer so revered by Beverly's lower-middlebrow sensibility, and a small clutch of 'lifestyle TV' experts comparing the tastes in fashion, cars, food and drink offered in the play with tastes in those fields in the present day. The cumulative effect of these frivolous but telling extras was to propose to the 1997 audience that the play was best enjoyed as a time-capsule of risible kitsch topped off with a panto turn of a central performance. Dennis Potter would have felt vindicated, and indeed so might Carney or Watson, since this BBC 'theme night' could be seen to stand as a good example of what happens when the 'English Leigh', to some just a comedic chronicler of passing styles and a painter of minor domestic interiors, is privileged over the 'universal Leigh', the piercer of souls and the explorer of depths. There are two linked reasons why such a verdict would be hasty, however. Firstly, engaging properly with the 'English Leigh' is not, at least to my helplessly English mind, a matter of merely extracting the local detail as sufficient in itself and deeming it fit only for the retro-kitsch appreciation purveyed that evening by the BBC. Secondly, even when slotted into this overdetermining context, *Abigail's Party* itself remained as arresting, funny and shattering as ever. Beverly and her guests may indeed introduce themselves as caricatures, not far removed from the inmates of so many 1970s sitcoms, but to see them as stuck there is to deny the tonal complexities of both this piece and Leigh's wider aesthetic. Similarly, to regard Beverly as nothing but an easily copied drag act of nightmare-hostess mannerisms (and there have been performances

of the play where Beverly was played by a man in drag) is to remain blind to the journey the play requires her, her guests and us to take. Leigh has never been averse to caricature – 'my job … involves processes of detail and heightening and distillation, That is in the nature of caricature in the best sense' (Movshovitz 2000: 27) – yet it remains just one of the tools he uses, and it is never, unless you are incontrovertibly unpersuaded by what he does, the end of the story. Geoff Brown has noted 'Leigh's gift for wrenching deep feelings out of social caricature' (2000: 34) and the ending of *Abigail's Party* – where a room that at first houses just some marital sniping and a natty line in 1970s soft furnishings later becomes the setting for one death, two broken marriages, a mother in crisis, a ballet of vindictiveness and recrimination, a ruthless demonstration of the links between taste and class, an atmosphere made sulphurous from the unleashing of so many damaging truths and a textbook definition of the word tragicomic – would be a perfect example of this.

That revealingly misbegotten Abigail's Party Night was not the only unwelcome anniversary gift Leigh received in the autumn of 1997. Almost exactly twenty years after the televised play prompted Potter's infamous review, that agenda-setting bugle call for anti-Leigh tendencies, the critic Gilbert Adair published a short article reflecting on why, despite admiring Leigh's earlier work, he so disliked Leigh's new film, *Career Girls*. (That film, in many accounts of Leigh's career, was a small-scale enterprise, almost a chance to catch breath after the critical acclaim, festival awards and relative commercial success of *Naked* and *Secrets and Lies* and the unexpected move to the lavish period setting of *Topsy-Turvy*. This is not the place either to accept or question received wisdom about *Career Girls*, as it is Adair's response to it that is most relevant here.) Somewhat tendentiously, Adair cross-references what he perceives as the shortcomings of *Career Girls* with the news coverage given that same week to the death of Kelly Yeomans, a teenage girl in Derbyshire who had committed suicide after being systematically bullied at school. He then tries to bring fact and fiction together:

> It was after reading about Kelly's suicide that I knew why I so abominated *Career Girls*. Leigh picks on his characters. He ridicules them. He bullies them. He jeers at them as fat and smelly and bristling with tics … It's true, Leigh's characters exist. We've all known them or passed them in the street. Yet is there anyone who still believes the weary old myth that art should confine itself to 'holding up a mirror to reality' … .What do mirrors know?
>
> (Adair 1997: 6)

This is the Potter critique of Leigh, but updated and sensationalised, to the extent where the director is not simply accused of encouraging an audience to laugh at characters on the grounds or class and taste, but of creating and endorsing a power dynamic in which an audience is thrown some afflicted characters to chew on like Roman-arena lions were tossed a few tasty Christians.

This seems dubious, not least in its co-option of the real-world personal tragedy of an abused teenager as some sort of circumstantial evidence, but it is useful, in the sense that Adair's accusations get close to the core of what some people, from Dennis Potter onwards, do not like about Leigh. Ricky, the most 'bullied' character in *Career Girls*, is offered up as a figure of fun, but primarily to the other characters and not in any unmediated way to audiences. He is overweight and twitchy, agonisingly shy and emotionally vulnerable (his being smelly or not is Adair's own invention or projection – there are no scenes in which other characters imply any whiffiness issues), and Hannah and Annie, the two female friends whose story is the narrative that drives the film, do find him ludicrous. Yet, in a typically Leigh it's-never-that-easy fashion, they also genuinely like him, and are so concerned when he vanishes from the college that all three of them attend that they travel several hundred miles to visit him to see if he is well. That he rejects their guilt-driven display of concern and in later years has become homeless and remains psychologically distressed is all part of the film's complex play with memory, consequences and regret. To imply, as Adair does, that Ricky (and also the almost-as-shy, almost-as-twitchy Annie) is simply pinned up as a target for audience mockery, seems as limited a reading as Dennis Potter's insistence that Beverly is only a lurid compendium of faux-pas taste errors. Annie's rejection of Ricky is not pleasant, and does damage, but we are not left unaware of that damage; instead we are invited to reflect on the impact of the choices we make when we negotiate human relationships. This hardly sounds like an invitation to 'jeer', to use the one verb that Potter and Adair have in common.

If there is one Leigh film which resorts to the jeer, and thus affords some substance to the Potter and Adair schools of Leigh critique, it is *High Hopes* (1988), which schematically counterpoints three connected couples differentiated by social backgrounds and ideological outlooks. Cyril and Shirley are financially the poorest but, in a not unpredictable inversion that is one of the film's many broad strokes, the most emotionally stable. Cyril's sister Valerie and her husband Martin are nouveau-riche beneficiaries of and enthusiasts for the 'enterprise culture' of Margaret Thatcher's Britain. Laetitia and Rupert are relatively recent arrivals in the rapidly gentrified street in which Cyril and Valerie's elderly mother, Mrs Bender, is the last remaining council tenant; John Hill has claimed in an uncharacteristically inaccurate moment that this last pair are 'yuppies' (Hill 1999: 193), but this misreads them. As can be deduced from Laetitia's description of lunching with her mother, from Rupert's job 'in wine', and from their utterly unconcerned callousness towards Mrs Bender, they stand for 'old money', confident in their wealth, wholly assured about their high social rung and thus standing in stark contrast to the anxieties and desperation that having 'new money' induces in Valerie. As I and others have pointed out before (Medhurst 1993; Hill 1999), *High Hopes* lacks much of the nuance and precision expected of Leigh. Those qualities are not entirely missing (Edna Doré's performance as Mrs Bender is wondrously exact and

exceptionally moving), but the contrasts drawn between the three couples border on the crass. This emerges most notably in the different registers of the acting: Cyril and Shirley are performed with the developed, naturalistic warmth familiar from other Leigh protagonists, while the other four, especially Valerie and Martin, are much less rounded (this sometimes works brilliantly – Lesley Manville's Laetitia is a beautifully cruel portrayal of clear-eyed, flint-hearted privilege). Compared to Cyril and Shirley, the other couples are rapid sketches frequently ill-at-ease in the film's more measured textural landscape, they play notes of jarring discord in its emotional score, they are there, in Potter/Adair terms, to attract our jeers. In John Hill's words, 'if Leigh's visual style, based on a paring down of camera movement and cutting, is … "quiet" … it is also crossed with styles of performance that are conspicuously "loud" ' (Hill 1999: 195). Astutely observed though this is, inasmuch as it is precisely this unresolved clash of quietude and noise which makes *High Hopes* one of Leigh's less aesthetically satisfactory works, it fails to pay enough attention to two other aspects of the film.

Firstly, it is a comedy (although being Leigh, a comedy with considerable sadnesses), and the cruder, 'louder' scenes and performances need to be seen in that generic context. Ray Carney has shrewdly noted that Cyril and Shirley are like 'vaudeville troupers' (2000: 192) in the sense that a great deal of their emotional intimacy expresses itself in a discourse of mutual humour, private jokes and a shared devotion to playfulness. Extending this, we might see the other couples as, among other things, the butts of Cyril and Shirley's jokes. Comedy, as we have seen many times in this book, is not always kind, and it often favours the quick-witted by setting them against the duller and dumber. Valerie in particular acts as a kind of uncomprehending 'straight man' in the film, there to be mocked because there are bigger things at stake than her dignity. (Uncharitable as this may sound, Heather Tobias' performance as Valerie adds to the character's victim status – she delivers what frequently resembles an unconvincing second-hand version of Alison Steadman's Beverly, a Beverly of depthless gestures, the Beverly that Dennis Potter thought he saw.) The most significant of those 'bigger things' is the film's precise historical context, which is the second aspect needed to qualify Hill's critique. *High Hopes* is a propaganda film, an undisguised attack on the greed-is-good materialism of Thatcherite culture. It has its more typically Leigh dimensions, those close-woven subtleties seen in the figure of Mrs Bender, but it is above all interested in making an uncharacteristically simple political point, which is why Leigh has no qualms in one interview about describing the films' characters as 'goodies and … baddies' (Fuller 1995: xx). So Laetitia, Rupert, Martin and Valerie may be un-Leigh-like in their monstrous one-dimensionality, despicable creatures inviting our jeers, but then so were the Nazis in British films made during World War Two. *High Hopes* is a film made in another time of profound national crisis, a telegram from a war zone, which makes its decision to elevate political expediency over complexity of texture morally justified if aesthetically disappointing. (The only

other Leigh film which might be said to have a propaganda-like political message is the much later *Vera Drake*, its message being a protest against the laws forbidding abortion in post-war Britain, but it eludes the emotional simplifications of *High Hopes* through offering a spectrum of responses to Vera's actions.) The Thatcher years sent many of us crazy, and *High Hopes* was Leigh's way of staying sane.

From what I can see, Leigh has resorted to the unrepentant jeer just that once. Outside *High Hopes*, he is too preoccupied with tracing what Peter York (in his contribution to the BBC profile of Alison Steadman) has called 'the precise ramifications of class in quite small spans' to pass snap judgements on his characters and the worlds they inhabit. He shows us characters who think they have a right to judge others – Keith and Candice-Marie in *Nuts In May*, for example, forever (Peter York again) 'forcing their wholemeal aesthetics and their ghastly music on other people and saying "this is right"' – and then proceeds to dislodge their self-image by undermining their certainties and subjecting them to comic exposure. Yet in almost every case, he remains a filmmaker of benevolence and generosity, and in that sense his work is always comic. The English comedy character actress Athene Seyler once claimed that comedy was 'inextricably bound up with kindliness … and must be charitable and compassionate at heart' (Seyler and Haggard 1943: 10) and Leigh's work, even deep in the boiling cauldron of *Naked* or trapped in the ration-book-Kafka of *Vera Drake*, tries its

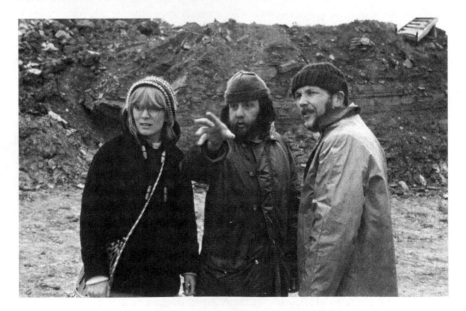

Figure 10.1 Alison Steadman, Mike Leigh and Roger Sloman, 1976. Courtesy of The Kobal Collection.

best to hold to that view. Jeering is also comic, but it is a one-dimensional kind of comedy, simplistic and punitive (although strategically sometimes forgivable, as might be the case with *High Hopes*), with none of the emotionally layered, tragicomic ambivalences which are Leigh's representational hallmark. The richest characters in his best work (Sylvia and Peter in *Bleak Moments*, Keith and Candice-Marie in *Nuts in May*, the whole houseful in *Abigail's Party*, Gloria in *Grown-Ups*, Mark and Colin in *Meantime*, Wendy and her daughters in *Life Is Sweet*, Cynthia in *Secrets and Lies*, Annie in *Career Girls*, Kitty in *Topsy-Turvy*, Maureen and Rachel in *All Or Nothing*) all have qualities that could be jeered at in shallower texts or by the kind of audiences-for-Leigh that both Potter and Adair seemed to fear. In the finished products, however, they are all characters that invite, in varying proportions, laughter, compassion, recognition and empathy – and that list could be much longer. Leigh's much-discussed method of developing characters over long discussion, improvisation and rehearsal periods in creative conjunction with his actors should be noted here (for the best accounts of this see Clements 1993 and McDonald 1999), since this 'creates characters in whom the experience of everyday life is distilled to its essence' (Clements 1993: 167). Some Leigh-sceptics are distrustful of this aspect of his work, uneasy at any talk of 'essence' and preferring to measure his characters against more sociologically grounded understandings of 'representativeness', a preference exemplified, perhaps, by Moya Luckett's hesitant concern that the figure of Hortense in *Secrets and Lies* might be too comfortably middle-class and too untroubled by racism to be wholly credible as a black Londoner in the era of the murder of Stephen Lawrence and the police response to it (Luckett 2000: 97–8).

Yet this is to place a social responsibility grid on to a film pre-eminently concerned with personal responsibility – the two are not of course unconnected but Leigh almost invariably prefers to emphasise the personal (or the connections). This means that although all Leigh's characters inhabit social and cultural identity categories, not least in their complexly differing Englishnesses, these are never allowed to overshadow or hollow out their emotional, domestic, familial and interpersonal singularities. If we are attuned to what the films are hoping to do, we respond to the characters as individuals rather than filing them away as types. The critic Kenneth Tynan once confided epigrammatically to his diary that 'Characters – in plays and films – are intimate friends whose sufferings we can enjoy with moral impunity' (Lahr 2002: 109). This may well apply to most texts, but Leigh's characters, built incrementally and inter-responsively in the demanding crucible of his development process, invite a less distanced response: the intensity of the intimacy makes any impunity very difficult to sustain. In other words, Leigh offers a comedy in which our impulse to laugh is always in a negotiated tension with our impulses to care or recoil or weep, and in that respect his is a comedy very different to many of the tougher and more robust comic traditions analysed elsewhere in this book. In some of his more recent films, in *All Or Nothing* and especially *Vera Drake*, comedy in

the sense of something-to-laugh-at all but vanishes, though that straightforward belly-laugh notion of comedy has never entirely interested him. Yet even those two films, despite their inclination towards dourness (both could be titled *Life Is Not Sweet*), still offer glimpses of warmth, inclusiveness and shared purpose that in their refusal to capitulate to all-out despair might be termed comic – though their comedy is close to being at the end of its tether, and that's a very long way from the end of the pier.

Victoria Wood: This is how our life is

I began my discussions of both Bennett and Leigh by addressing issues raised in critical commentaries on their work, but with Victoria Wood that option is not available, for the simple but perplexing reason that despite a career spanning three decades and an unquestionable status as one of the most popular comedy performers and writers in Britain, Wood has attracted remarkably little detailed critical study. There are many journalistic reviews, some useful interviews, a helpful if brief biography, and some passing remarks in more general studies, and I will be drawing on these as appropriate, yet she languishes relatively undiscussed. There could be several reasons for this, and they are reasons related to that sometimes vague but always useful concept, cultural capital. There are no 'cool points' on offer for liking Victoria Wood, indeed she shows every sign of being utterly indifferent to the whole concept of cool. She has been too consistently successful to need reclaiming or rediscovering at any point, and far too talented to be venerated through the backhanded compliment of kitsch. She appeals primarily to middle-of-the-road audiences. She sells too many tickets to be a cult. She has no significant international reputation, she went to neither Oxford nor Cambridge, and, at the time of writing, she has never worked on a theatrically released feature film. She has used television as the major cultural reference point throughout her career. She seems entirely happy to work on a wholly English canvas. She attracts remarkably little negative press and is never hated (except perhaps by a groupuscule or two of professional malcontents). She is largely immune from the gossip machines of celebrity culture, and maintains a level of popularity that rules her out of comeback narratives. She has no wild past (or has kept it astonishingly quiet). She belongs to no minorities unless we hold to that somewhat outmoded view that women are 'a minority', and even in that regard she does not produce the kind of angry, politically driven material that could earn her kudos as a figurehead of feminist comedy. (Her gender *is* of course significant, and I shall return to it shortly.) She has never set out to be scandalous, provocative or outlandish. She has no special association with any subcultures (except for a rather fawning gay fanbase). She has shown no desire to advertise any signs of nervous breakdowns or mental instabilities. She does not produce work full of darkness, edginess or dread, and prefers using established traditional forms to experimentation. She likes to be judged on the craft, quality and wit of her work. She is not

given to making political pronouncements. She has never been flavour-of-the-month fashionable, yet is too widely liked to ever be unfashionable. She is beginning, the more I prolong this paragraph, to sound boring – though this perhaps reveals more about what we are culturally conditioned to find 'interesting' – but what I am aiming to do with this list is to indicate that sometimes in popular culture there are figures whose appeal transcends the usual petty categorisations and critical tricks we usually rely on to label, box and file away the vast majority of participants in the entertainment game. The only danger with such an enviable position is that it can lead to such a figure being overlooked and taken for granted, and this, I suspect, is what has happened to Victoria Wood.

None of the above should be read as suggesting her success was inevitable, however. She has stated in several television interviews that after winning the talent show *New Faces* in 1974, it took some years to establish herself securely, because the pigeonholes available in mid-70s British showbiz did not fit her. She recalled, to Michael Parkinson, that her abilities were recognised but not accommodated, resulting in her being told 'We don't know how to place you. We don't know what you do. You don't look right. You don't wear dresses. I was always being told "no"'. As her mention of 'dresses' reveals, her gender seemed especially problematic in these scenarios. She did not occupy a recognisably comedic femininity. Comedy in that era was full of women, but they primarily occupied one of two polarised paradigms, either decorative support to male comics (the dizzy dolly bird) or uncomplainingly domesticated in normative narratives (the doting sitcom wife). Wood's determination to exercise creative control over what she did, rather than surrendering that independence to occupy predetermined and often demeaning spaces, marked her out as an awkward customer. Facing two options – drastic self-alteration to satisfy prevailing norms or taking the risk of working to her own agenda – she chose the latter, in particular insisting on writing her own material. Her pioneering status can, however, be over-estimated, as there is an impressive roll-call of British comic women preceding her who also carved out a degree of autonomy. So when, in 1996, the ITV arts documentary series *The South Bank Show* broadcast a profile of Wood, and described her, with all the untroubled assurance of the introductory voiceover, as 'Britain's first female stand-up comedian', this was a grand claim, a great marketing device, but completely untrue.

Although British comedy, like the rest of British culture, has always been male-dominated, there is a long list of pre-Wood women who stood on stage, in front of a film camera, or in a radio or television studio, and made audiences laugh. Marie Lloyd, Nellie Wallace, Lily Morris, Florrie Forde, Suzette Tarri, Gladys Morgan, Jeanne de Casalis, Mabel Constanduros, Gracie Fields, Hylda Baker, Elsie and Doris Waters, Joyce Grenfell, Beryl Reid, Joan Turner and Marti Caine would be the best known in their respective times – although few are well-remembered today, since popular cultural history has been much more

forgetful about funny women than funny men. It might be argued, to try and restore some validity to the Wood-was-first case, that few if any of those women listed practised pure stand-up, as they also sought laughs through comic songs and character sketches (Beryl Reid had a schoolgirl routine, Elsie and Doris Waters impersonated Cockney charladies), but Wood also punctuates her stand-up shows with songs and characters. Neither are her visual style or her favoured kinds of source material unprecedented. In the northern clubs in the 1970s there was a female stand-up comic called Pat Mills. She wore trousers rather than skirts, had a not unfeminine but not glamorous hairstyle, cracked gags about the shortcomings of Londoners and told shrewdly observed jokes about the ridiculous codes and conventions of TV ads and cookery shows. Given all of the above, clearly Wood is not unique, but she is uniquely successful, having secured a centrality in the national comic consciousness that no previous female performer has achieved.

Another misconception about Wood's career is that she was a benefi-ciary of the 'alternative comedy' boom of the 1980s (a cultural trend best, if uncritically, chronicled in Wilmut and Rosengard 1989). While this move-ment did open doors for a number of female comics, including French and Saunders and Jo Brand, Wood predates it and was removed from it both geographically (she was rooted in Lancashire while 'alternative comedy' was very London-centred) and temperamentally (she offers warmth and inclu-siveness, whereas 'alternative comedy' was flecked with bile and designed to divide). The difference emerges most crucially around the question of the comic past. Whereas some of the loudest 'alternatives' proclaimed their iconoclastic determination to distance themselves completely from previ-ous modes of comedy (most of them have subsequently reneged on this), Wood has always seen herself as part of comedic continuity, telling one interviewer that:

> comedy … is a timeless profession, and I felt very plugged into a tradition of people trudging from town to town telling jokes. That's kept me going when I've been in some great barn of a place on a Sunday when it's raining. I've walked down the steps to get on the stage, feeling that lots of people have walked down these stairs to do this job, and that's actually cheered me up … I'm part of the music hall.
>
> (Oddey 1999: 195)

That last claim is no more strictly accurate than calling Wood the first female stand-up, but what is important is that she felt motivated to make it, committed to seeing herself as a link in a comic chain. She respects tradition, and although this has led some to claim that she offers a less 'overtly radical' (Gray 1994: 171) comedy than the kind of material favoured in the more politicised stand-up comedy clubs, it also means that she is able to reach far wider audiences. She draws on the comic past, but is not unaware of the social dynamics of the present,

and the good-naturedness of her tone has not prevented her from making an ideological impact. By comedically exposing the ludicrous expectations placed upon women by prevailing models of domesticity, by exposing the absurdities of television codes through her knowing parodies, and by establishing, though her enormous success, that now 'female comedians [can] work on their own terms' (Gray 1994: 171), she has redrawn the English comic landscape.

The remainder of this chapter will explore three dimensions of Wood's work: her interest in domestic life, her comic tone and use of language, and her observations on the role of television. (In a world without word limits I would also trace her abiding interest in class and regionality.) The protocols, expectations and limitations of women's social roles constitute a major theme of Wood's stand-up routines, both on television and on stage, and she also sets sketches in spaces like shoe shops, cafeteria queues and exercise classes. They are not women-only spaces, but how many men have thought to craft comedy from them? Like Alan Bennett and Mike Leigh, she uncovers the humour hidden behind daily lives in domestic interiors, but unlike them she can invest stories of breast-feeding and menstruation with an autobiographical dimension that elicits roars of recognition from the women in her audience. She knows how to take words from feminine and/or domestic vocabularies and reassign them comic meaning – 'gusset', 'raffia', 'J-cloth', 'grouting', 'pop-socks'. When she describes being confronted with 'the ugliest baby in England, the one that failed the audition for *Gremlins*', this is funnier from her than it would be from a male comedian, as women are more conventionally obliged to coo and cluck at infants. Noting that the gym she attends 'used to be an abattoir, so there's plenty of hooks for your leotard', she speaks as a sometimes-overweight woman all too aware of the pressures on women to bodily conform. Describing an acquaintance as having 'everything middle-class – a ceramic hob, a loft insulation, a daughter with anorexia', she shows an unsentimental eye for the class specifics of femininity. Many of her most popular sketches rely on interactions between women, putting the rivalries and intricacies of female friendships under close comic scrutiny. She has often been able to make jokes about other women ('if her bum was a bungalow she'd never get a mortgage on it') that would sound misogynistic if made by men, but which escape that charge because they are comments made between two women about a third one. A running theme in her sitcom *dinnerladies* was the way in which the male characters, already in the minority, had to retreat from the kitchen when the central core of females began talking about 'women's things'. (That superlative series offered an English televisual matriarchy rivalled only by *Coronation Street*, a connection made plain by the fact that three of its regular actresses had previously appeared in the *Street* and two more would do so later.)

The overall tone of Wood's work should also be noted, since one of the key ways in which she relates to older English comic traditions is her full-on commitment to the notion of humour as succour, comedy as communality,

laughter as a social embrace. With a handful of exceptions, some considered below, hers is a comedy without sourness, lacking moody fringes and tragic undercurrents, and this may have contributed to her critical neglect. Whereas a certain critical mindset can applaud Bennett and Leigh for their ability to fuse the comedic with darker discourses, as if this somehow rescues them from being 'merely funny' (and I have probably colluded with this approach myself earlier in this chapter), Wood offers a world unapologetically premised on the healing properties and the social truths of the well-crafted comic observation. This could lead to a view of her work as slight and superficial, but to buy into such an attitude would be to subscribe to the verdict that comedy itself is always a minor mode. Wood is important because her work is the best contemporary refusal of that verdict. Asked on *The South Bank Show* what she thought she offered her audiences, her reply was 'Like every comedian, it's saying "this is how our life is"', and this seems to me to get to the nub of why popular comedy matters. It forges togetherness through joyousness, it unites and uplifts, and though there are squabbles to be had and doubts to be raised about exactly who the 'our' in Wood's 'our life' includes and excludes, I will leave those tasks for others to undertake.

The comic device which Wood uses more successfully than any other is the strategic use of language. Like Bennett, but often eclipsing even him, she has a pin-sharp understanding of how the rhythm of a line, the flow of syllables or the placement of particular words can transmute what sounds at first like everyday speech into comedic gold. In *We'd Quite Like To Apologise* (one of a series of six short comic plays Wood wrote for the BBC in 1989), a long-suffering wife is spelling out her husband's flaws, and says 'His underwear habits *alone* would baffle a psychiatrist'. It is the 'alone' here which propels the line into great-ness, and for proof you just have to remove it and then see how well the line works. Without it, the line still humorously captures the wife's dismissive dis-may at her husband's oddness, but once it is restored a far wider comic picture of sexual irregularity opens up, suggesting untapped hinterlands of hang-ups and complexes that the wife dare not venture into describing, her failure to specify ensuring that everything is still kept within the bounds of a recog-nisable English comedic tradition of spousal disapproval. Rhythm, resonance, cadence, placement, emphasis, inference, vocabulary – all work in seamless har-mony. (Wood is also a songwriter, and has often commented on her interest in the musicality of language.) The utterly masterful skill of the composition is never flaunted, there is no trace here of the attention-seeking desperation that Kenneth Williams used in his chat show party-pieces or the parodically orotund prolixity of Les Dawson's lavishly worded monologues, instead there is a natu-ralistic plausibility to the line which actively works against it being singled out for attention – until, that is, you pause, inspect and notice how quietly assured, finely tuned and unbeatably exact it is. Wood's writing overflows with this kind of unobtrusively brilliant linguistic finesse, its comic impact heightened still further by the performance skills of her carefully chosen casts (which include,

of course, herself). When Thora Hird, in *Pat and Margaret*, is asked by the adult son whose life she rules with adamantine selfishness whether he can change the television channel, she continues to attend to the soft toy she has been making and replies 'When I've stuffed this penguin to my own satisfaction, possibly'. Hird's evident relish of the line, with its perfectly weighted pause before the final word (a pause in which the old woman savours her continued control of the domestic environment) and its undertows of violence, self-centredness and absurdity, only adds further layers of comic effect. Comparable marriages of script excellence and performative bravura run through Wood's work. Think of how Julie Walters brings to life the scrofulous, deluded Petula Gordeno in *dinnerladies*, erupting like an extravagantly grotesque one-woman carnival into an otherwise largely naturalistic text. Walters is very clearly doing 'a turn', but then so is Petula, with her ever-fanciful stories about her celebrity acquaintances (Leonardo di Caprio, she confides, has 'a scrotum like a boxing glove') offering brief detours into comic mania to offset the more workaday concerns of the factory kitchen. Also relevant here are the 'Kitty' sketches in *Victoria Wood As Seen On TV*. Patricia Routledge's Kitty (a warmer, less tragicomic cousin, perhaps, to the Miss Schofield Routledge played in Alan Bennett's *A Woman Of No Importance*) appears in several episodes to pontificate from her armchair on matters like declining moral standards and the right kind of gravy boat; in one monologue she describes her journey to the television studio: 'I fixed up a lift with Mr Culverhouse in flat nine. Well, he owed me a favour and he has got a very roomy Vauxhall. It was no bother to drop me off because he has an artificial arm from the Western Desert and he was coming through to Roehampton anyway to have his webbing adjusted'. If the writing here is sublime in its cross-stitching of everyday chatter, mild innuendo, national memory and the pinpoint placement of words like 'webbing', the delivery more than matches it. Routledge takes that long, last sentence in one gulp, stretching her breath to breaking point as she not only has to draw deeply on her own physical resources but also to ensure that the audience doesn't puncture the momentum by laughing too conclusively too soon. She reaches the end with the triumphant radiance of an athlete crossing the line secure in the knowledge that they have strained every sinew to set a new personal best.

In Wood's sitcom *dinnerladies*, the comedy of language frequently springs from the unexpected juxtaposition of words from different linguistic registers, as when Dolly has knitted what she thinks is an attractive scarecrow doll, only for her friend Jean to dub it 'a little woolly pervert'. Discussing whether or not it is usual for couples to make love before getting up on the morning of December 25th, the same pair exchange dialogue that even by Wood's high standards is dizzyingly gifted:

Dolly: Who has sex on Christmas morning?
Jean: The Dalai Lama.
Dolly: Well he must peel his sprouts the night before.

In Chapter 2, I reflected on how the micro-detailed explanation of individual gags can suffocate the humour out of them, but Wood's words here are so densely packed with allusion, play, deftness, and poise that they are perfectly able to withstand the laboured unravelling that I cannot resist inflicting upon them. The only caveat here is that the printed version, as ever, is only part of the story; to get everything that is going on here, one needs to see and hear the peerless performances of Thelma Barlow as Dolly and Anne Reid as Jean, and ideally to have seen how they have built and honed their characters in preceding episodes. The rapport between them underlines how, more broadly, *dinnerladies* is an ensemble piece, and not, to quote one of its less generous critics, 'a lot of different people all doing solo stand-up comedy at the same time' (Graham 2000: 23). Dolly's prim disquiet about her friend's erotic appetites is a staple of the series and it motivates the exchange I am (over)analysing here. Dolly's fear that, as ever, Jean has a more vigorous sex life than her underpins the question she asks, a question that hides at least two other unspoken questions, namely 'Does everyone, and Jean in particular, have sex much more often than I do?' and 'Why don't such people realise that there are more important tasks on Christmas morning, such as conforming to the pressurising demands to prepare a traditional Christmas dinner?'. Jean's deadpan reply has its own unspoken subtext, inasmuch as in her view it is obvious that every couple would or should be making love at that time, so Dolly doesn't deserve a straightforward answer; yet by choosing the option of ridiculing Dolly's question by selecting the unlikeliest candidate for festive coitus that she can imagine, a degree of surrealism enters the frame. Dolly runs with this, and her response throws up two gloriously bizarre images, firstly of the hyper-spiritual Dalai Lama succumbing to the base, carnal temptations of masturbation (this, surely, is one of the meanings of 'peel his sprouts'), and secondly recasting that same exotic figurehead of religion and resistance as a stressed Northern housewife harassed by fears of not having time to cook that most unpleasant of traditional English vegetables.

Evidently, if I were to impose such protracted readings on the full range of Wood's writings, this book would never end, yet by examining one minuscule example in such detail I hope it is clear exactly how much is going on in her work. Her critical neglect seems all the more curious given the complexities of her writing, and also given the range of stylistic traditions on which she draws. One critic has compared her use of language to Harold Pinter and Joe Orton (Gray 1994: 164). Echoes of Bennett are widely perceived, and there are Leigh-like touches in the underlying plaintiveness of the spoof documentaries she incorporated into the *As Seen On TV* series. Considering Wood's fondness for the comic potential of place names and her delight in the cordial inclusiveness of moderate innuendo, I might also propose an indebtedness to Noel Coward and George Formby (an unlikely coupling, but both indelibly English). Add to those names the earlier list of female forebears, of whom Gracie Fields, Hylda Baker and Joyce Grenfell would be the most direct influences, and

Wood's investments in English comedic heritage are impressively broad and deep. Yet she wears all of this lightly, much as she self-effacingly prefers not to draw attention to the immense skill of her comic technique. There have been occasions, however, where a steelier side of her has emerged, particularly when faced with what she perceives as intrusive critical curiosity. During that *South Bank Show* profile, she was asked by Melvyn Bragg whether the two sisters in *Pat and Margaret*, one a put-upon canteen worker and one a successful television star, represented two aspects of her own personality, pre-fame and post-fame. Her response, almost a snap, is 'that's a bit perspicacious of you', followed by a purposefully timed sip of water which indicates, alongside the defensive/aggressive elaborateness of the adjective used, that discussion of that nature is not welcome and will not be pursued.

Pat and Margaret is one of many Wood texts concerned with the ambivalent impact of the media on contemporary life, a theme that threads throughout her work. Her attitude towards television fluctuates between love and distrust. She often displays an unapologetic fondness for British popular television's history and wishes to celebrate its status as a cultural glue uniting us through memories – in *dinnerladies*, for example, the characters test and cement the boundaries of their friendships through swapping references to *On The Buses*, *Stars in their Eyes*, *Rag Tag and Bobtail*, Pam Ayres, Alan Titchmarsh, Pinky and Perky, Mary Hopkin, Charlie Caroli, Alma Cogan and *Coronation Street*. Similarly, the parodies of television shows that are the backbone of *As Seen On TV*, most celebratedly the *Crossroads* spoof of *Acorn Antiques*, are affectionate send-ups of the ludicrousness of generic clichés, and this knowingly sharp but never savage tone returns in 1992's *Victoria Wood's All-Day Breakfast*. There is another strand in Wood's work, however, where television is an industry full of back-biting unpleasantness and an increasing contempt for audiences. The hideously snobbish continuity announcer in *As Seen On TV* is an early indicator of this, pausing in her task of reading out children's birthday greetings to draw conclusions about class from glancing at photos of the children's families – 'I think Mummy must be a little bit common, judging by the sun lounger'. By 1989's *Over to Pam*, new flavours of bitterness and vitriol have appeared, with Julie Walters cast as one of Wood's few irredeemable monsters, a demanding diva who hosts a daytime talk show, unforgettably described by another character as 'a heat-seeking missile in slingbacks'. Walters' Pam recurs, to some extent, in Pat, the star actress reunited with her impoverished sister Margaret via a manipulative television 'reunion show' (based without much camouflage on ITV's *Surprise Surprise*). The lengthier narrative of *Pat and Margaret* allows more complexity to emerge than was possible in the tight thirty minutes of *Over To Pam*, so although the central theme of media artifice versus real-world genuineness is comparable, the resolution is more rounded and the characters not quite so starkly tagged as evil or good.

By 2000, Wood's view of television refocused, with *Victoria Wood With All The Trimmings* representing a one-off update of *As Seen On TV* for the

new media millennium. Like the 1980s series, it was awash with sharp-as-ever parodies of televisual tropes, but placed them in a context of proliferating post-Murdoch 'choice', imagining a range of splintered BBC channels: BBC Upmarket (for literary adaptations), BBC Good Old Days (vintage variety shows), BBC Tea-Time (old films), BBC Braindead (docusoaps) and BBC Wartime (entirely obsessed with the Second World War). This cleverly created the space for an array of spoofs, including a Jane Austen-esque costume drama repeatedly capsized by intruding innuendos ('could you not stick your hands in your muff?') and a pastiche wartime newsreel in which an upper-class voiceover announced over footage of cheery Blitz-era Cockneys 'take note Adolf, these salt-of-the-earth working-class folk are totally dispensable to the British government and what's more there's lots of 'em'. Running parallel with these textual treats, however, is a deeper cultural lament, made unavoidably and poignantly obvious by the scheduling of this programme. *All the Trimmings*, as its title suggests, was a Christmas show, broadcast on the evening of Christmas Day on BBC1. This was the third time the BBC had placed Wood in such a position – *All-Day Breakfast* in 1992 and *Live In Your Own Home* in 1994 were similarly scheduled – and to anyone sensitive to British television history this cannot help but seem like a repeated attempt to make her the national televisual focal point once occupied by Morecambe and Wise. What Wood knew, and chose to lament, albeit comedically, in *All the Trimmings* was that thanks to changes in broadcasting structures, the Morecambe and Wise days of a nation united by a single comic communion were becoming impossible to recapture. Their kind of comedy, and their Christmas shows in particular, epitomised the project of popular culture as national resource which British audiences found so sustaining for so long, and which can be seen still flourishing in the television-based banter in *dinnerladies*. For Wood, raised and steeped in that notion of television as shared cultural currency, the contemporary stampede towards audience fragmentation can only provoke regret. *All the Trimmings* tried to fight back against this decline into narrowcasting by lampooning the multi-channel results, but for all the timeliness of its jibes it seemed suffused with nostalgia and out of step with the prevailing cultural winds. This should come as no surprise, since those winds seem hell-bent on blowing away everything on which popular English comedy relies, while Wood has been staging a determined struggle for decades now to build on what was best in those traditions and histories. Perhaps it is that determination above all which has made her adored by audiences, who hunger for the sustenance of those traditions and recognise her as their leading embodiment, but left her shunned by the discourses of intellectual criticism, with their abiding preference for the spiky, the unsettling and the sour.

Togetherness through offensiveness

The importance of Roy 'Chubby' Brown

> Vulgarity is ... an affirmation of the rightness of the ordinary, the common-place and the plebeian.
>
> (Hodgkins 1977: 445)

> Assemblies of working people, large or small, indoors or outdoors, alehouses or football crowds, have always constituted a threat to authority and to moral reformer alike.
>
> (Yeo and Yeo 1981: 138)

> The quest for community is ... a way of seeking sanctuary from the incessant disruptions in the modern experience of capitalist society.
>
> (Pickering and Green 1987: 5)

Roy 'Chubby' Brown is the most significant English male comedian of the past quarter-century. That's a bold, bald claim to make, and should probably and immediately be hedged in with a thicket of disclaimers, but I'll let it stand, and cultivate that hedge throughout the rest of this chapter. Before considering the reasons behind and the meanings of his significance, it might be helpful to begin with a sketch of who he is and what his comedy is like, since one of the more arresting aspects of his career is that while he is a hugely popular figure, nothing short of a hero, to his core audience, there are many who have only heard of him, if at all, by reputation. His stand-up act cannot be shown on broadcast media because of its two chief characteristics, the relentless use of swearwords and the unvarnished expression of strong and contentious views. So a word of warning may be in order here: to censor either of those components would be to make discussing him impossible, so readers of especially sheltered dispositions should brace themselves accordingly.

The rise of the helmet

Born in 1945 in the steel industry town of Grangetown on Teesside in the north-east of England, Royston Vasey began his career in comedy almost

accidentally. (Royston Vasey, Brown's real name, was later adopted, with his permission, by the League of Gentlemen as the name of the fictional village where their grotesque comedy is set.) It was an unplanned offshoot from his membership of a succession of unambitiously pedestrian musical groups that toured the circuit of northern working men's clubs. Telling gags between songs, he realised that audiences appreciated his comedy more than his music, so in search of a more lucrative life he began touring as a solo stand-up comic in the early 1970s. After unsuccessful auditions for and appearances on television talent shows, his manager persuaded him to ditch his conventional act and rebrand himself as a 'blue' comedian, telling jokes about sex where everyday swearwords replaced the euphemisms that mainstream comics were obliged to use. His popularity mushroomed, and he began to release audio cassettes of his act. There were fourteen of these (with titles such as *Thick As Shit*, *Fucked If I Know*, *Kiss My Arse* and *Hairy Pie*) and sales increased throughout the 1980s. In 1990 the first video to capture his stand-up act, *From Inside the Helmet*, sold 250,000 copies. Further videos appeared annually (titles include *The Helmet's Last Stand*, *You Fat Bastard* and *Clitoris Allsorts*) and secured comparable sales, while his tours are guaranteed sell-outs and he holds box-office records at many theatres. He has made one narrative feature film, *UFO* (1993), a coarsened Carry On in which he is abducted by militant feminists from outer space, and he has successfully toured in Australia, New Zealand, Hong Kong and Canada. His live shows attract around 350,000 people each year.

Each recording (with the exception of 1993's *Exposed*, a spoof documentary about his childhood and growing up) consists of an hour or so of on-stage jokes, sometimes bookended with scenes of him arriving at venues and talking to fans. One or two have tried to broaden their remit by including short animated scenes, but the core of each is the stage show, comprising a torrent of jokes and the punctuation of a few equally obscene songs. The visual grammar on offer might best be described as basic, yet the videos convey a much better sense of Brown's range of skills than the audio tapes, since although he is primarily a verbal joke-teller he is also a very visual comic. His odd and unvarying stage costume, for example, plays a specific role in placing his persona. He always wears a multi-coloured patchwork suit with tails and too-short trouser legs, white socks and suede moccasins, a red bow tie, and a flying helmet with goggles pushed on to the top of the head, hence the use of the word 'helmet' in his first three video titles ('helmet' is also English slang for the unsheathed head of the penis, lending a further meaning to a title such as *From Inside The Helmet*). He is also very agile, given to breaking out into brief flurries of manic and often parodic dance steps, and uses to the full a range of gestures and facial expressions. The jokes pour out tumultuously, fast and filthy, with the overwhelming majority about sex. There are also jokes about celebrities (especially, and unsurprisingly, their sexual tastes and activities), topical events, ethnic and sexual minorities, and assorted reference points drawn from the

everyday life of white, working-class England – or more specifically, white, working-class, non-Southern England, as almost all the performances have been filmed in Northern or Midlands theatres (Blackpool several times, Sheffield, Newcastle-upon-Tyne, Derby, Birmingham).

Brown's sex jokes are dispatches from the front line of marital warfare; he takes that tradition of heterosexual skirmishing found in music hall, seaside postcards and earlier generations of stand-up comics and douses it deep in graphic physical detail. He is, in some ways, George Formby thirty years into an arduous marriage, or Les Dawson cross-referenced with toilet graffiti, or as Geoffrey Macnab (1993: 18) has pointed out, Frank Randle at last freed from censorship constraints. Here are some Brown jokes about the battleground of married life: 'My wife's too domineering. I caught her sucking the milkman's cock and she made me promise not to tell the window cleaner'. 'My wife is great in bed. Until I fucking get in'. 'My first wife died. I didn't notice for a week. The fucks were the same but the dishes piled up'. 'My wife's getting very, very selfish. Went downstairs this morning, forgot to dress me. If she showed me how to pack a case I'd fuck off'. As even that small sample should show, it is not easy to point accusingly at him and label his humour sexist. He tells joke after joke about the female body, its attractions, its disappointments, its constituent parts, its noises and its odours – no Bakhtinian detail is left out. Yet there are also plenty of jokes about male failings and shortcomings, and Brown's audience contains plenty of women who laugh as loudly as the men. He relishes telling jokes which position him as a sexual adventurer, dispensing advice on how to stage successful conquests ('Women are like turds. The older they are the easier they are to pick up'. 'You can always get a fuck off a fat girl. Just throw a Mars Bar on the bed'.), yet these are always rendered ludicrous by his palpable failure to measure up to norms of male attractiveness, and they are in any case counterbalanced by jokes which catalogue both his failures to seduce and the feistiness of the women who turn him down. In these narratives, his own body is crucial, with the costume accentuating his fatness and a running theme centred on the gap between the delusions of desirability that he seems to suffer from and the actual spectacle evident on stage. In his own words, 'The same joke from a slim, good-looking comedian wouldn't have been half as funny as from a fat, balding lump dressed in a multicoloured suit and flying helmet' (Brown 2006: 262).

When he turns his attention to topical events and the foibles of celebrities, he is merciless, and often finds ways of saying the otherwise unsayable through the licensed space his commitment to obscenity has afforded him. He returns more than once to the royal family, especially in the context of the death of Princess Diana. 'If she'd have been a fat tart with boils nobody would have fucking sent one bastard flower', is one interesting thought he shares, before speculating on how her campaign against landmines increased the likelihood of unemployment for those who worked in factories that made artificial limbs. Elsewhere he notes

that Elton John sang at Diana's funeral because 'he's the only queen that gives a fuck'. As these Diana jokes show, one of Brown's favourite tropes is the provocation of outrage. He and his audience are engaged in a game of dare – will he dare to say these outrageous things and will they dare to laugh at them? He rampages through taboo areas, unleashing jokes about paedophilia, making fun of disabilities, treating famines in Africa and earthquakes in India as source material for jibes. When even his audience finds the going hard, he rounds on them – 'Just got out of church, have you?' – and after especially on-the-edge remarks he takes satisfaction in confirming his status as the man who will go further than any other – 'Only me that can get away with that one'. Very occasionally, he miscalculates and pays the price – performing in a town at the centre of a much-publicised child abuse investigation, his opening line was 'I'm surprised there are so many of you here, I thought you'd all be at home fucking the kids', and his reward was to be booed off stage (Brown 2006: 332). His reputation, perceived attitudes and turbulent private life have led several local councils to propose banning him from appearing in venues that they administer (see Quade 1997; Brown 2006). Unsurprisingly, such incidents only add to his scandalous appeal in the eyes of his devotees. He is the censor-baiter, the scourge of municipally funded cultural policing, the speaker of the unspeakable. This relish for disrespecting boundaries is often seen at its fullest and richest in his parodic songs, which take a special delight in shredding decorum and undermining codes of taste, rewriting the lyrics of hitherto innocuous pop songs so they are rendered gapingly obscene through the introduction of excessive detail. Brown performs a kind of carnival surgery on these songs, for example turning a saccharine ballad like Ronan Keating's 'When You Say Nothing At All' into a saga of farting, menstruation and unusually messy oral sex, hauling into the public sphere the sounds, secretions and suctions conventionally hidden away beneath the surface pieties of romantic love. Romance is always a fake in Brown's gleefully corporeal world, a deception that must be erased to reveal the pulsations, juices, lusts, embarrassments and compromises that make up the actuality of sex.

In addition to casting himself as both the risk-taker and the taboo-breaker, Brown has an occasional habit of electing himself as a political spokesman. Politicians across the political spectrum are fair game, since it isn't any specific policies he wants to attack but the sheer fact that such people have power over the ordinary folk he sees as his peers. As with his jokes that make fun of teachers or social workers or the legal system, it is authority figures who are targets – those who control, those who clamp down, those who make decisions that compel the less powerful to comply. There are other moments, however, when he flexes rhetorical muscles against even less powerful groups than the white working-class English whose self-appointed jester figurehead he has become. Hence his overtly racist jokes, a handful of which can be found on most of his videos – in 2001's *Stocking Filler*, for example, he announces 'If there's any asylum seekers in [the audience], fuck off home' – and 'home' here does not

mean indoors, but overseas. The cheer that greets this line barely leaves the theatre roof intact. Such a line is startling not so much for the viewpoint it expresses, a viewpoint entirely congruent with the outlook of Brown's core following, but for its abrupt directness, jettisoning any pretence of wordplay or comic invention in favour of the articulation of undisguised prejudice. In an earlier video the line 'If there's any poofs in, fuck off' serves an identical purpose and garners an equally rapturous roar. Such lines are unusually explicit in the way they draw lines between those who belong and those who do not, the lines which are essential to any comic utterance or event, though they are rarely so nakedly revealed. It is moments like these which make it easy to label Brown a mouthpiece for bigotry, and it is undeniable that the jokes he makes about ethnic and sexual minorities only work for audiences who are unassailably convinced that whiteness and heterosexuality are higher in any conceivable social and cultural pecking order than non-whiteness and non-heterosexuality. Many reading these pages would doubtless proceed from that point to damn the man and all he stands for, banishing him to the lands of the ideologically irredeemable where, to invoke the names of two other English comedians often accused of ultra-conservative views, Jim Davidson is heir apparent to Bernard Manning's ageing monarch. Nonetheless, as this book has argued on every available occasion, the politics of comedy are rarely free of ambiguity, and this chapter will later argue that alongside such crowd-pleasingly reactionary lines there are other, deeper facets of what Brown says and means which deserve closer consideration and even respect.

Clowning, class and carnival

If Brown is to be fully understood rather than peremptorily dismissed, then he needs to be seen in relation to the traditions of English popular comedy which feed into his act. His costume might be one useful starting point here. Its obvious antecedents are the lurid suits worn by the Cockney variety comic Max Miller, one of the pivotal stars of English comedy in the 1930s, whose act was a string of near-the-knuckle innuendos so riskily risqué that he lured audiences into exactly the kind of dare game (dare he say it? dare we laugh?) offered by Brown. Miller's attire, most famously a plus-four suit made of lavishly floral silk, nudged him in the direction of sexual ambiguity, thereby slightly softening the blow of his taboo-testing sex gags. Likewise, though nobody could call Brown camp, the oddities of his outfit serve to soften the onslaught of his sex-crazed patter, since nobody dressed like that could be a real sexual threat; Brown's garb places him at an oblique angle to conventional masculinity while simultaneously aligning him to circus codes of clowning and the uniform of the court jester. Gerald Mast (1979) has written of how texts and performances can signal their intention to make us laugh through what he calls their comic climate, so that a title of a text or its setting can cue us to expect laughter before any actual jokes are made, and costumes like Miller's and Brown's are the comic climate

stitched into sartorial form. Lois Rutherford's invaluable study of music hall sketch comedy includes a description of how one Edwardian-era comic 'zany' would walk on stage dressed in 'a frock coat too small, tiny white waistcoat, horrible shepherd's plaid trousers, a small coloured shirt front with collar ... sticking out, brown boots ... an old fashioned high hat which is two sizes two small for him', a rig-out which she interprets as indicative of this comic's 'disregard for social graces and good taste' (1986: 148). Brown's costume differs in surface detail, but the similarities are nonetheless plain, and his deployment of such venerable codes shows his links to long-standing comedic traditions in which clothing becomes in itself a carnival space, freeing up its wearer from conventional constraints.

Another great English comedian who realises the liberating potential of jester-like dress is Ken Dodd, and there are a number of interesting comparisons to be made between him and Brown, not least the exceptional skill both of them have in generating a carnivalesque atmosphere of anti-restraint during live performances. Dodd, coming from an older generation, prefers creative innuendo to Brown's full-frontal filth, but both share a commitment to loosening an audience's hold on respectable conventionality. Asked to give a thumbnail sketch of the subject matter of his act, Dodd replied 'I'm celebrating sex, celebrating nostalgia, celebrating our ordinariness, celebrating man's curiosity, celebrating man's delight in woman and woman's contempt for man' (Billington 1977: 5), and that list sounds remarkably like the Brown's core concerns too. Nostalgia is a minor but steady theme in Brown's joke routines, with both verbal references back to childhood poverty (also detailed at length in his autobiography – Brown 2006) and the use of old family photographs as visual punctuation in his live shows, all offered as an attempt to reassure his audience that although he may now be a very rich man, his roots are their roots, securing a bond which transcends more recent differentials of wealth. This is a crucial ploy (and to my mind an effective one), since Brown's act, centred as it is on his status as people's spokesman, can only work if he has credible working-class credentials. Thus when he discusses food in his act, he takes it as read that an ordinary meal will be 'pie and chips, or egg and chips'. When he talks about visiting a supermarket, the one he names is Asda (a store chain which has northern roots and a history of targeting a working-class clientele). When he uses television programmes as triggers for jokes, he opts for mass-audience successes such as *Coronation Street*, *Blind Date* and *Who Wants To Be A Millionaire?*. When he wants to sketch the ultimate ambition, he talks about winning the National Lottery. When he builds comedic routines about holidays, the locations he confidently emphasises are Blackpool and the Spanish Costas. All these ring true as indices of white, working-class English life, underscoring the 'ordinariness' that Dodd mentioned and which Brown needs to keep at the forefront of his comedic world. Dodd and Brown also share a commitment to milking laughs from sex, though they differ wildly in their preferred method. Penelope Gilliatt, reviewing Dodd's 1965 show at the

London Palladium, noted: 'he has a trick of innocently just missing a filthy meaning that stares everyone else in the face, like a baby behind the wheel of a sports car careering at a brick wall and swerving at the last moment' (quoted in Billington 1977: 36). Brown, by contrast, drives smack into that wall, preferring the shock tactics of collision to the foreplay of allusion. If Dodd's sex gags are a knowing tease, Brown's shun flirting for the rough thrills of a quick back-alley shag. This difference stems originally from nothing more elaborate than economic pragmatism – Brown switched from conventional stand-up to blue comedian because the latter pathway offered less competition and thus easier pickings – but its end result has been to bestow upon Brown an outsider status, since the language he uses means that his act is impossible to broadcast on television, still the swiftest route to substantial success for any aspiring comic. By building his audience through live performance, word of mouth, and the snowballing sales of his cassettes, videotapes and latterly DVDs, his fame has accrued an against-the-odds flavour, a tang of scandal, lending him the aura of the comedian who succeeds through bypassing official channels, a rebellious truth-teller who speaks directly to his people. Today that is largely, of course, a romantic myth (he speaks 'directly to his people' through the auspices of Polygram Video), but it does have some validity in the context of his early career, when it was the low-budget, locally produced audio tapes which initiated his rise from just another club comic to a performer capable of filling large theatres.

Like Dodd, Brown also repays consideration under the rubric of carnival. Firstly, there is the unquenchable relish he takes in bodily functions. His sex jokes frequently pause their narrative flow to linger over the cavities and crannies of the female body, while his often-professed preference for 'fat tarts' and his abiding interest in such things as pubic hair ('Ee, she had the *bushiest* minge') and menstruation are easily readable through the prisms of Rabelais and Bakhtin. The classical body is nowhere to be seen in Brown's sexual imaginary, every body he encounters (not least his own) oozes, drips, emits, sags, sprouts and slobbers. Brown's addiction to swearing also has its place here, with his live shows becoming carnival spaces where the policed speech of the official world outside the theatre gives way to a linguistic economy where unfettered crudeness rules; Bakhtin's claim that a 'vague memory of past carnival liberties and carnival truth still slumbers in ... modern forms of abuse' (1968: 28) may be as romanticising and speculative as all his other claims, but it is nonetheless very evocative of how Brown's performances can feel. When Brown is on stage, the emphatic insistence on corporeality, the primacy of collective merriment over individual squeamishness, and the overriding atmosphere that the tethering chains of respectable behaviour have been temporarily shrugged off, all combine to forge an environment that is deeply carnivalesque. In any Brown performance, as in all carnivals where pleasure and the body are in charge, dignity is an early casualty, since as the anthropologist Mary Douglas noted, stressing 'the physical pattern of events takes the dignity out of the moral

pattern' (1975: 95). Brown's dignity is already gone the moment he materi-
alises, thanks to that absurd costume, while the audience's dignity buckles and
ruptures the moment he launches into his first aria of bodily function refer-
ences, genital slang and fart jokes. In the words of the literary critic Morton
Gurewitch, 'scatological outbursts have always been nonpareil in exploding the
system of things' (1975: 141), and Brown puts that theory into practice every
night of his working life.

A comedy of resistance

A recurring concern of this book is the relationship between comedy and
belonging, a relationship that is intensely important when considering the com-
edy of Roy 'Chubby' Brown. In an era characterised by the fragmentations of
postmodernism and the disorientations of globalisation, his comedy waves a
battered, often shabby, but always defiant flag for wholeness and locality. His
comedy offers its white working-class English audiences a welcome, a place of
refuge, a sense of belonging, a space that is simultaneously warmly familiar to
those whose faces fit and ferociously unforgiving to those who faces do not.
To borrow a phrase from the social theorist Anthony Giddens, Brown is in
the business of dispensing ontological security. There is, perhaps, something
unavoidably absurd in using such a luridly highbrow term to explain the appeal
of such a ruthlessly lowbrow comic, but this is yet one more way in which
Brown crystallises and focuses some of the key agendas of this book. Anyone
who approaches popular comedy intent on academic analysis must encounter
the risk of being told one is 'reading too much into things', but it seems pro-
foundly implausible to me that Brown should attain such heroic significance
for his audience simply as a result of his technical skills in joke-telling, brilliant
though these are. The intensity of his success in this precise period of English
cultural history suggests that he is tapping into complex and troublesome issues
of identity, belonging, location, community and home, and I want to explore
how he does so over the next few pages.

In Chapter 3, I looked briefly at those debates over globalisation and cos-
mopolitanism which contend that contemporary life, especially for those in
affluent cultures, is defined by its rootlessness, its migrationary drift, and its
dissolution of established boundaries in favour of unfixed, mobile and hybrid
identities. Economic and technological change have led, it is argued, to new
forms of cultural self-understanding in which we are unable to rely on older
versions of making sense of ourselves and our relationship to social life. In the
appropriately unfettered words of Alberto Melucci:

> Individuals find themselves enmeshed in multiple bonds of belonging
> created by the proliferation of social positions, associative networks and
> reference groups ... We are migrant animals in the labyrinths of the world
> metropolises; in reality or in the imagination, we participate in an infinity

of worlds ... The rhythm of change accelerates at an extraordinary pace. The multiplication of our social memberships, the constant surge of possibilities and messages floods the field of our experience. The traditional co-ordinates of personal identity (family, church, party, race, class) weaken. It becomes difficult to state with certainty who we are ... we search for permanent anchors, and question our own life stories. Are we still who we were?

(Melucci 1997: 61–2)

Melucci is not expecting any other answer to that question but 'no', but Brown's comedy is, in effect, a sustained and resounding shout of 'yes'. Such an answer may be a fiction – a harking back to a romanticised and selective version of the past, a denial of diversity in the present, and a refusal to embrace the changes offered by the future – but it remains a source of comfort to Brown's core audience, and collective comfort is the heart and soul of popular comedy. What the proponents of hybridity and fragmentation have often overlooked is that the opportunities such cultural shifts make possible are not equally open to all, or indeed beneficial to all, and it could be argued that one of the groupings least able to benefit from what Melucci calls the 'surge of possibilities' is that segment of the white English working class whose identities were rooted in traditional heavy industries. (For a spirited and moving defence of white English working-class culture, albeit in a southern rather than a northern setting, see Collins 2004.) Years before he reinvented himself as Roy 'Chubby' Brown, Royston Vasey, it should be remembered, was born in the steel industry fiefdom of Grangetown, the same Grangetown that the black writer Darcus Howe nominated in *White Tribe*, his astute Channel 4 series about changing ideas of Englishness, as emblematic of the declining, abandoned, stranded-by-change, hope-starved white English North. Michael Billig has written of how people excluded by postmodern and globalising cultures, people for whom 'there is no rapture in ambiguity', feel themselves to be 'dispossessed and insecure' (1995: 136), and that pair of adjectives seems very telling in this context. Those who see Brown's comedy as nothing more than bigotry rendered comedic would be delighted to note that Billig's prime examples of where such feelings of dispossession and insecurity can lead are the figures of the 'fascist thug and ethnic cleanser' (ibid.), but I would regard it as shockingly reductive to put Brown in such company. He does indeed make racist jokes and ethnically prejudiced asides, and these are inexcusable. They are also, however, explainable, if the concept of ontological security is looked at more closely.

For Anthony Giddens, ontological security means 'the confidence that most human beings have in the continuity and constancy of their self-identity and in the constancy of the surrounding social and material environments' (1990: 92). The key words here are continuity and constancy, since it is they which are most under threat from the dislocations and fragmentations

of postmodern life. Giddens sees postmodern existence as characterised by a process of 'disembedding', which he defines as 'the "lifting out" of social relations from local contexts of interaction and their restructuring across indefinite spans of time-space' (1990: 21). There could hardly be a more concise antithesis of what popular comedy strives to do, since popular comedy is a practice founded on embedding, on knowable locality, on the recognition of shared and familiar reference points. It is a discourse of demarcation, of drawing lines rather than erasing them, it operates according to an imperative of unification, of sealing its reciprocal participants (comedian and audience, joke-giver and joke-receivers) into tight networks of manageable parameters. Brown's comedy is exemplary in this respect, forever patrolling its same small patch, its closely meshed landscape of white, working-class, mostly Northern, wholly heterosexual, English life. Hence the constant mention in Brown's routines of everyday occasions, familial rituals, marital conventionalities, shared cultural touchstones, routine consumption practices, familiar holiday resorts, long-established leisure activities, and unquestioned presumptions about sexual and ethnic norms. 'Ontological security', Roger Silverstone once said, 'is sustained through the familiar and the predictable ... expressed and supported by a whole range of symbols and symbolic formations. The symbols of daily life ... are our attempts, as social beings ... to manage others, and to manage ourselves' (1994: 19), and this is precisely what Brown's recurring iconography of everyday life – pie and chips and egg and chips, Blackpool and Asda, nagging wives and boozing husbands, smelly farts and bushy fannies, ridiculed queers and resented immigrants – sets out to achieve.

Brown's comedy offers, in effect, a rallying point for resisting globalisation. It is not a carefully thought-out political programme (it would be gauche, at best, to expect such a thing from a stand-up comedian), but a gut reaction, a beer-gut reaction perhaps, against changes that are consigning whole ways of life to the scrapheaps of outmodedness and irrelevance. He encapsulates a sensibility that can also be seen in films like *The Full Monty* and *Brassed Off*, which, although they employ a far less abrasive tone than Brown and are consequently far more exportable across both class and national borderlines, manifest a similar anger about the dismantling of working communities (Brown has explicitly incorporated the first of those films into his act, performing a typically grotesque parody of its celebrated striptease routine). For some cosmopolitan critics, that anger is misplaced, a soft-hearted amalgam of nostalgia and sentimentality; consider, as an example, Iain Chambers' insistence that the 1980s Miners' Strike, that pivotal battle between organised labour and the government of Margaret Thatcher, was 'articulated around the closed prospects of a single-economy working "community" and the guarded secrets of a skilled trade ... out of step not only with the temporality of modern capital, but also with modern life' (1993: 159). Such a view, where entire working cultures are written off with clinical accountancy and the word community can only be used if it is incarcerated within quotation marks that mark it out as delusional, is the polar opposite

of the sensibility given comedic shape by Brown. In his act, as in the two films cited above (and in other vital tragicomedies such as Mike Leigh's film *Meantime* and Debbie Horsfield's BBC TV series *Making Out*) the sacrificing of community in order to fall at the feet of rapturous fragmentation is not an option. Such comedies cannot hope to overturn those social and cultural changes, but they can at least register the emotional damage that they cause and they can become temporary shelters where those ripped apart by and reeling from that damage can gather. There are, no doubt, dangers here of sentimentalising what Brown's success and sensibility represents, but it is highly debatable as to whether that is a greater folly than loftily regarding his audiences as so much human silt washed away by the Melucci's tidal surge of change or as stumbling dinosaurs doomed by their inability to read the runes of postmodernity as perceptively as Chambers. As with most important comedians, Brown is a contradictory and ambivalent figure. Some of his jokes undoubtedly hinge on intolerant attacks against minorities, yet the sensibility he personifies is itself rooted in the life experiences and structures of feeling of another stigmatised group, those white working-class English left behind by the turn towards hybridised, globalised culture.

This is a sticky paradox, and not resolvable through any kind of facile check-list of trying to work out who is more oppressed than whom. Ien Ang, in a thoughtful article on the complexities of identity in contemporary life, has noted how 'struggles for or on behalf of identity tend to be conservative, even reactionary ... aimed at restoring or conserving established orders of things and existing ways of life ... keeping at bay the unsettling changes that a globalising world brings about' (2000: 4), and this description fits Brown's comedy very well, up to a point. Brown's comedy, self-evidently, posits an established order of things in which it is axiomatic that whiteness equals Englishness, that foreigners are made for ridicule, that homosexuals are inferior and that feminism is an untenable nonsense – so far, so reactionary. But the established order that Brown's comedy yearns for is also an order where white working-class identities are valid and valuable, where 'classlessness' is revealed as a pernicious lie, where defending embattled communities against unemployment and deskilling still matters, where men and women mock each other's weaknesses but find ways of accommodating them within a framework of unvarnished but mostly amiable disputatiousness, and where humour helps people to make the best of low-expectation lives. The defining difference between those two lists is the place of class. In terms of sexual and ethnic politics, the outlook of Brown's comedy is far from progressive (though I would nonetheless still argue that his marital sex jokes find humour in the see-saw power struggles of heterosexual everyday life rather than in unrelieved misogyny); yet when studied through a class lens the picture is very different. That particular lens, however, is rarely used in contemporary academic studies of culture and identity, where works centred on gender, sexuality and ethnicity are immensely more numerous than those which place class centre stage. Yet to understand Brown, to understand

English comedy, and to understand Englishnesses in general, class must always be a prominent framework of analysis.

In a Britain so recently captivated by Tony Blair's New Labour project, however, class is a guilty secret, and the white working-class audiences who cheer Brown's every utterance are a cultural embarrassment. To understand why, it's revealing to look at a dazzlingly prescient essay written in 1982 by the historian Raphael Samuel. At that cultural moment, the Labour Party was in crisis following the defection of several prominent self-proclaimed moderates who had resigned in order to form the Social Democratic Party. The SDP, buoyed along by favourable media coverage, was briefly seen as threatening to replace Labour as the main opposition party to Margaret Thatcher's Conservative government. The relevance of that essay to this chapter lies in Samuel's brilliant anatomising of how the SDP's messianic faith in new technologies and new industries was intimately connected to its distaste for organised working-class politics (in the shape of the trade union movement) and indeed to working-class life more generally. In doing so, he prefigures many of Giddens' arguments about the disembedded culture of postmodern society, with its concomitant undermining of settled identity and ontological security. For the SDP, according to Samuel, traditional working-class lives, cultures and politics were 'anachronistic ... backward-looking ... insular ... suspicious of progress and change ... Luddite in relation to new technologies' (1998: 265), all of which made them 'offensive' to the SDP's 'vision of society as a frontierless open space' (ibid.). The end result of this, he argued, was that the SDP 'do not want to represent or help the working class ... They want to abolish it. In their mind's eye, with a speculative gaze fixed on the microchip revolution, and the impact of "sunrise" technologies, the day does not seem far distant when the country may be inhabited by people as radical and reasonable, as up-to-date and mobile, as themselves' (1998: 271). Some of the language here is dated, but the underlying point seems indisputable: established working-class cultures were the product of specific industrial and economic practices in the process of being undermined by new technological changes. For the SDP, entranced as they were by rhetorics of newness and mobility and open spaces, that situation made working-class people, as traditionally conceptualised, supremely surplus to requirements. (And, as Sharif Mowlabocus has pointed out to me, how much better it has proved for the profit margins of globalised capitalism to transfer work from the politicised and truculent British proletariat to the non-unionised sweatshops of the developing world, filled with a much more docile and exploitable workforce.) The people traditionally accustomed to labouring in Britain's heavy industries could, in this SDP vision, either reinvent themselves and join the new world (though by waving which particular magic wand was never made clear), or risk becoming a dead weight, stranded by change. This, it should be clear by now, is the same kind of argument fostered in more theoretical circles by writers like Melucci and Chambers, and more importantly it is precisely the mindset of Tony Blair's New Labour, which swallowed whole

the SDP's fetish for change, its managerialist rationalism, its trusting romance with technology and its impatient dismay at those people who failed to go with (what were selectively perceived as) the flow of the times. Worse still, to any cultural Blairite, it is exactly those same recidivists who failed to scramble on to the bandwagon headed for new times who compound their crime by insisting on spending time with Roy 'Chubby' Brown. He is an important figure precisely because his popularity is a flagrant testament to the persistence of class as a meaningful category, an indispensable tool which English people use in recognising, understanding and placing themselves. As long as he continues to flourish, then the specificities of white, working-class, heterosexual, Northern Englishness – with all its warm humour and inspiring solidarity, all its insular suspiciousness and its embittered fear of difference, all the gruff discourteous banter of its sex wars, and all its other ambivalences and contradictions – will still have their comedic champion.

An academic question

Given the intensity of the reciprocal connections between Brown and his core audience, it is not surprising that he is a difficult figure to approach or appreciate if you have no connections with that core. Anyone rooted in social and cultural locations very different to those inhabited by Brown and his followers is likely to find the man, his act and perhaps most of all his success very problematic. To choose an example very close to home, such problems have been made unavoidably plain on those occasions when I, fuelled by a cocktail of missionary zeal, sheer foolhardiness and a determination to provoke, have engineered a meeting between Brown's material and audiences in the academic world. Some years ago, while teaching a course about the politics of comedy, I mentioned to the students concerned that I was shortly going to see Roy 'Chubby' Brown live on stage. Brown had been a contentious topic of debate during the course, so I was not entirely surprised that my plan to see him stirred up more concern, with one student presenting me the following week with an essay entitled (just a little archly) 'How would you try to dissuade Andy Medhurst from going to see Roy "Chubby" Brown?'. It was an eloquent attempt, springing from the student's simultaneous dismay at Brown's comedy and at my seeming collusion in supporting its perceived ideological indefensibility. I still went to the show, though as I described in Chapter 2 the occasion was not an entirely comfortable one, especially when Brown made jokes about homosexuality. Those jokes underlined how much I could not fully belong in one of Brown's audiences, where universal heterosexuality is one of the baseline givens, one of the demarcations between us and them without which his comedy is meaningless. All comedy draws boundaries, but Brown's comedy, determined as it is to speak up for its disregarded constituency, does so with particular vehemence. The student who wrote that essay would have been particularly pleased that Brown's queerbashing jokes were where my evening's enjoyment came unstuck, since

he was a gay student appalled that his gay tutor could countenance spending time in the audience of a man who struck him as blatantly homophobic. Yet it is not that simple. The student and I may have shared one identity category, sexuality, but we differed in others, particularly class. When I respond favourably to the majority of Brown's jokes, as I did then and do still, is it because of my working-class upbringing, however much my lifestyle and selfhood today occupies a middle-class terrain? Asking such a question threatens to reduce the complexities of class identity and cultural consumption to a self-serving attempt on my part to clothe myself in some sort of man-of-the-people authenticity, yet the question represents a set of feelings that refuses to go away. Reductive as this will sound, I cannot avoid the speculation that you need some in-depth personal experience of working-class culture to fully understand and appreciate what Brown does and means. So does this mean that he has no place in an academic context, where the overwhelming majority of those who might encounter him there will be securely-and-always middle-class?

I have no definitive answer to that, but I propose that it is an important question to ask, not least because class is still one of the trickiest topics to negotiate in British education, both as a topic for discussion and as a power dynamic in any given academic setting. One reason that I have given Brown his own chapter in this book, and placed it at the end, is because he more than any other comic practitioner confirms the difficulties and risks of looking at popular comedy through an academic lens. He is so much less manageable than the other case studies offered in earlier chapters, he is still an untamed beast prowling through the outermost fringes of cultural consensus, a fresh scar on the cultural body politic not yet scabbed over by the distancing of history. George Formby has a secure if usually minor place in British film history, Morecambe and Wise are sanctified by nostalgia, Mike Leigh is regularly acclaimed as an artist, *The Royle Family* has been drenched in critical praise (however misplaced some of it was), Victoria Wood and even Hylda Baker can shelter under the relative respectability of a 'gender studies' approach, the Carry Ons have become emblems of national kitsch, and so on and so forth – but Roy 'Chubby' Brown is *the* test case for the study of the politics of popular comedy in England, and for those who regularly gather together in the pages of certain newspapers to berate the very existence of academic studies of popular culture he could very well be the breaking point. (In his day Frank Randle could have taken this title, but Randle's threat-potential is somewhat neutralised by his having been dead for decades.) For me, Brown matters hugely, and for these reasons: firstly, he is a living, breathing, swearing, shocking (to some) reminder that class matters. In his own words, his most loyal fans are 'rough people from rough houses on rough estates' who know that 'I was just like them, except I struck lucky and found a way out' (Brown 2006: 265). Secondly, he represents a continual and raucous refusal of that creeping homogenisation which seeks to dissolve all class differences in England into a smothering blancmange of middle-class gentility (a process sometimes lauded as the aim for a 'classless society'). In the

1930s, J.B. Priestley wrote, with wickedly funny accuracy, that Blackpool was 'a complete and essential product of industrial democracy. If you do not like industrial democracy you will not like it. I know people who would have to go into a nursing home after three hours of it' (Priestley 1968: 266). Seventy years on, 'Chubby' Brown, today the comedy king of Blackpool, still has the power to induce a fit of the vapours in the irredeemably bourgeois (imagine the damage he could do to a vegan Buddhist social worker who regularly cycles to men's anti-sexist consciousness-raising workshops). Thirdly, Brown keeps alive and palpably vibrant that tradition of bad-behaviour comedy which has contributed so much to English popular culture – he is the heir of Frank Randle, the Crazy Gang, Max Miller and the Carry Ons (though he is far more challenging and troublesome than anything in those films). Fourthly, he brings into the sharpest focus the core issue this book has tried to consider, the issue of belonging.

There is, however, a tenaciously influential vein of cultural criticism in Britain, sprawling across academic and journalistic fields alike, which is not interested in the slightest in people who belong. That critical mindset takes its cues from diluted versions of romanticism and modernism, and its preferred archetypes from the same sources – from the former comes the sensitive intellectual seeking refuge from the encroachments of early industrialisation, from the latter comes the alienated outsider gazing with horror at the regimentations of modern mass society. This vein of thinking therefore champions those it can place in either of those archetypes or a fusion between them, choosing to venerate the rebels, the misunderstood, the exquisite malcontents, the tortured artists, the beautifully doomed, the existentialists, those who refuse to conform and see fitting in as selling out. The ideal artist for this worldview would, if I may be permitted to illustrate through caricature, carry the spliced-together DNA of Keats, Van Gogh, Orson Welles, Camus, James Dean, Sam Peckinpah, Syd Barrett and Morrissey. Popular comedy, conversely, cannot see discontented loneliness as a source of nobility or superiority because its basic premise is the celebration of communality. Popular comedy performers are not, like some outsider-artists have been, discovered after their death in a retrospective act of reclaiming misunderstood genius – for the blindingly obvious reason that popularity in popular culture is about success in the here and now. An alienated, misunderstood creative type can only appear in popular comedy as a figure to be mocked, a fool ridiculed for the satisfaction of audiences who don't have the privilege or luxury of having the time to feel alienated. The only comedy, it is worth noting, that came directly out of modernism was the tradition of 'the absurd' (the plays of Beckett or Ionesco for example), and what characterises that comedy is how it lacks any appeal for the large popular audience. This is, of course, utterly deliberate – the whole point of modernism is that the masses can't understand it and furthermore must not be allowed to do so – because if the romantic/modernist alienated individual is trying to get away from one thing more than any other, it is precisely the industrialised throng who make

up the audiences for popular comedy. Those audiences are the people who did not, could not or did not want to escape, they make up the multi-headed other against which the alienated artist types define their feverishly individuated selves. Critics who buy into the myth-narratives of romanticised alienation have tastes in comedy that fit snugly into the contours of those myths, as can be seen in an essay by George Paton which lambasts Les Dawson as 'routinised' and 'conservative' while lionising Spike Milligan as 'radical' and 'surreal' (Paton 1988: 213–22). This is a telling choice of names to contrast – Dawson an evident heir of music hall, as I discussed in Chapter 5, and Milligan the paradigmatic outsider-hero in British comedy for male middle-class intellectuals (Milligan's long history of mental illness also helps here – outsiderhood, eccentricity and mental instability are often fused into the same package by those who worship such figures). The romantic/modern discourse is a language wherein elite intellectuals can talk to each other, whereas popular comedy is about the comforts of mass togetherness. Popular comedy is a discourse of daily survival – getting by, rubbing along, making the best of it – from the culture of consolation that so disappointed those Marxist analysts of music hall to the carnivals of confirmation presided over by Roy 'Chubby' Brown. Popular comedy has no faith left in large-scale social transformation and it is sceptical about the self-indulgences of individual rebellion. This means that popular comedy, especially comedy from and for the white working class, can seem impregnable to many academic and critical ways of thinking, constituting from that romantic/modernist viewpoint a sullenly lumpen mass-text of no interest to the refined individualised mind, and not even worth recuperative celebration through an identity-politics rhetoric as it stems from the 'wrong' minority.

One last anecdote may be helpful. After an academic paper I gave which included some clips of Brown in action, a psychoanalytic critic who happened to be there said that the most interesting people in the clips were the one or two audience members who were not laughing along with everybody else – and that remark, on reflection, seems to me to get to the absolute core of why popular comedy and academic investigation can be hard to reconcile. To zoom in on the isolatedly discontented few at a 'Chubby' Brown performance is an academically respectable choice (if a rather predictable one, given that psychoanalysis is another of those rebel-worshipping, alienation-savouring discourses that are endemically prone to romanticise discontent and see mental instability as creativity's twin); but to make that choice, to prioritise the handful who are not enjoying themselves as more worthy of study than the majority who are having a wonderful time, is a very political decision, since it involves downgrading any consideration of the happiness of the many. Popular comedy is about achieving collective delight through communal recognition, but it is very difficult to find ways of reflecting on that phenomenon when so much academic thinking is predicated on the primacy of the isolated mind and the superiority of outsiderhood. A pertinent, if unkind, question at this point might

be: so why bother? The only partial answer I can offer is that if the happiness of the many matters, if the lives of ordinary people in twentieth-century England deserve attention and understanding, then what they laughed at needs to be explored alongside the rest of their culture and society. And at the end of that century the man that many of them laughed at more than anyone else was Roy 'Chubby' Brown.

Chapter 12

Conclusion

A national sense of humour?

> [T]oday all cultures are border cultures.
>
> (Nestor Garcia Canclini 2001: 507)

> You can't top English comedy.
>
> Björk Gudmundsdottir (Harris 2001: 73)

Eric Morecambe held particularly strong views about national vocabularies. Although he and Ernie Wise took their double act to the United States on several occasions, they never achieved sustained success there, and it was suggested they might improve their chances by internationalising (which in this case, as it almost always does, meant Americanising) the way they spoke. Morecambe refused to budge, declaring that he would never say 'sidewalk' or 'garbage' instead of pavement or rubbish. This was not knee-jerk parochialism – he made no secret of how influenced he and Wise had been by American comedy and how much they continued to admire it – but it does indicate a revealing commitment to remaining determined to tell a national joke. Not every double act shares that commitment, since at the time of writing it is rumoured that Ant and Dec are on the verge of taking 'elocution lessons' so that their seemingly impenetrable Tyneside accents will not hinder their planned move into the American market. As these anecdotal examples suggest, very English performers can have very different attitudes towards their Englishnesses.

Given the complexities and contingencies of the relationship between popular comedy and cultural identities, it would be inappropriate and most likely impossible to use this Conclusion to actually conclude. So much of the material this book has covered is contentious, ambivalent and open to disputatiously irreconcilable interpretations that any neat tying up of loose ends would be against the spirit of the enterprise. What might be useful, I hope, is to offer just a few final speculations about the relationships between the comic and the national, and to give both myself and the reader a very brief break from English examples, I want to begin by reflecting on Jean-Pierre Jeancolas' notion of the 'inexportable'. Through a consideration of French popular film in the 1950s,

Jeancolas (1992) coins the term inexportable for those films which attracted and entertained large domestic audiences, but stood no chance of being exported to foreign markets. These were films that drew on codes of entertainment established outside cinema, primarily radio; which were centred on favourite performers who tended to portray either recurring, stereotyped figures or elaborated versions of their own already established personas; which relied heavily on verbal and musical codes, with little no interest in visual textures; which were aesthetically unambitious in terms of cinematic technique, though they often showcased very talented performances; which were aimed squarely at popular, often regional tastes, and were indifferent to the negative comments of critics; and in which the role of the director was so minimal as to preclude any chance of these films being hailed by critical discourse as recuperable for 'auteur' cinema. Jeancolas is oddly shy of using the word 'comedy' about these films, yet it seems evident from his brief descriptions of them that comedy was their primary mode of expression, even if they sometimes purveyed a generic hybridity which makes labelling them with total certainty somewhat difficult.

Looking at Jeancolas' list of attributes, the parallels with English popular comedy are too obvious to miss. The films of George Formby and Frank Randle, for example, all fit Jeancolas' schema with uncanny ease – Randle's especially, with their robust and enduring scorn towards both cinematic and social niceties. The tendency of the stars in inexportable films to play the same persona, or a very slightly recalibrated version of it, also chimes with English equivalents. John Fisher once said of George Formby that his 'persona remains so concretely formed, the antithesis of a chameleon' (1975a: 66) and this neat formulation maps comfortably on to a large number of the comic performers studied in this book (Chapter 8 discusses how this tendency operated in the Carry On films). Jeancolas, it should be said, is no fan of the inexportable French films, calling them 'insignificant ... unintelligible ... to spectators outside a given popular cultural area ... uncouth ... in all respects of poor quality ... no artistic ambition' (1992: 141–2), but this inventory of invective is probably little more than an elite metropolitan's disdain for texts that were never meant for him in the first place. More importantly, even though he abhors the films, he puts together a shrewd account of how they work, realising how they succeeded through mobilising known and familiar pleasures for their destined audience, inviting that audience to participate in a process of what he calls '(reassuring) complicity' (141). The core factors of popular comedy have rarely been more succinctly pinpointed. Popular comedy offers solace, identification, confirmation, belonging – and at their most intense, texts trading in such sensibilities are so tightly bound up with particular cultural locations that they offer no way in for outsiders, those placed beyond the charmed circle of a familiarity so ingrained it needs no explaining.

Moving in more closely from these broad structural and functional aspects to look at specific textual details of Jeancolas' inexportables, even here there

are cross-channel consonances. He describes the popular comic figure Piedalu as a 'gauche, wily peasant' (143), a label that could be fitted easily to Formby or Norman Wisdom, while the French fondness for inexportables that spoof historical periods and military settings conjures up a whole catalogue of similarly inexportable English films that relish mocking the same targets, from 1915's *The Kaiser Catches Pimple* to virtually half the Carry On series (Pimple, it might need pointing out, was a popular clown who made almost two hundred short silent films). Turning from Jeancolas to another essay in the same collection, the account by a group of Finnish scholars about the comedic character Uuno Turharpuro also needs noting (Hietala *et al.* 1992). Turharpuro is a national institution in Finland but unknown elsewhere, his persona is lazy, greedy, sexually hopeful but mostly disappointed, his films are frequent, cheap, episodic, farcical, and deal in a comedy centred on disrespect and the grotesque, and each one sets his established persona in a different institution or familiar locale. The films manifest a 'symbiosis of conservatism and subversion' (1992: 140), mocking social norms and the hegemonies of accepted common sense and approved behaviour, but in doing so they in many ways reinforce the categories of appropriateness and inappropriateness and police the boundaries between them.

This is all starting to sound very familiar. What these French and Finnish examples seem to be indicating is there are comparable themes and personas in popular cinematic comedy that cross national boundaries, even if the texts that contain them do not. Does this wreck my insistence throughout this book that there are particular Englishnesses in English popular comedy that need understanding and assessing? Not exactly, as I don't think I have tried to claim that the broad underlying structures of 'my' comedies are inherently English, merely that the usage of those structures within an English context needs relating to other discourses surrounding English identities. Additionally, several of the comedies and comic practitioners I have analysed in these pages work in cultural spheres far removed from the downmarket, lowbrow, carnivalesque film-series zone (you would have difficulty slotting Mike Leigh, Alan Bennett, Julian Clary or *Whatever Happened To The Likely Lads?*, for example, into the French/Finnish model). One thing this book *has* tried to argue, however, is that popular comedy has been woefully neglected in recent debates about what England and Englishness can or might mean. I have mooted some reasons for this in earlier chapters, but in order to throw another international light on the matter, I want to look at Alan McKee's work on national identity in Australian gay pornography (McKee 1999). That sounds, perhaps, like one of those topics made up by conservative commentators to discredit the discipline of Cultural Studies, but then so do several of the chapters in this book; happily McKee's article is not just real but is one of the most stimulating recent pieces about national identity. He takes as a starting point his concern that too much analysis of the 'national dimension' of texts looks only at elevated texts in respectable genres, whereas if 'the national' is a quality that can be textually

represented, no categories of text should be excluded from exploration under this rubric – hence his admirably provocative decision to use the figuration of Australia and Australian-ness in gay male porn videos as his case study.

The word he gets considerable mileage from is 'proximity', since for him 'the fact of proximity' (1999: 194) is what most persuasively denotes the national-ness of a text. Yet, just like Benedict Anderson's formulation of the imagined community, proximity is always 'imaginary' (ibid.), in that we imagine our-selves to be close or closer to something produced in 'our nation'. Any such imagined proximity is never merely spatial, it supposes a proximity of sensibility, a proximity of disposition, a proximity of cultural vocabulary, and furthermore these proximities *are* only approximate (the adjective) and *can* only approxi-mate (the verb). They can never be either exact or exclusive, because all senses of belonging, national and otherwise, are contingent and subject to historical change and ideological reconfiguration. As an instructive and poignant exam-ple, look at a book published in the late 1980s (Ziv 1988) about differences between different national senses of humour, each chapter written about a dif-ferent country by a scholar based in that country. The chapters are rather too schematic to be anything other than sketchy overviews, but what is striking now is there is a chapter on 'the Yugoslav sense of humour', just a very few years before that country ceased to exist as a single entity – telling proof that national affiliations are not nearly as fixed as they can sometimes seem. For McKee, a text aiming to secure our attention through the imagining of proximity must set out to persuade, and McKee suggests that 'persuasiveness' is another key term in trying to think about the nation and the national. At the banal level of gay pornography (and trust me as a middle-aged homosexual on this – few genres are more banal), these attempts to persuade might take the hard-not-to-ridicule form of editing footage so that a scene of open-air gay love-making in the Australian bush suddenly cuts to a shot of a kangaroo minding its own business in a similar landscape, or, for the urban inflection, repeatedly show-ing the Sydney Opera House through the window of a bedroom in which two men are coitally interwoven. Texts like this signal their national identity through these rather desperate devices, but are they really that different from a 'swinging London' film that shrieks its locale through an overload of red postboxes and double-decker buses? What I most like about McKee's article is how it demonstrates that to note the 'national-ness' of a cultural artefact is not remotely the same as celebrating through discourses of nationalistic fervour. I would like to think that very few of the texts I have analysed in this book are quite as crass as those kangaroo-riddled porn videos, but vulgar comedy is often seen as belonging to the category of 'despised cultural objects', to borrow McKee's term for the pornography he has looked at (1999: 178), which is why I found his analysis so useful.

To finish (but not conclude), I want to refer to one final quote from Victoria Wood. During an interview in 1997, she reflected on how she had built up a familiarity with different towns and cities:

I've been touring since 1984 and I've been to every place before ... I have
a pretty good sense of each town and how it is. I am very familiar with
all these places, theatres and sorts of people, so I can make jokes about
the town ... I would never make a joke about a town I had never walked
around.

(Oddey 1999: 187)

This is strikingly reminiscent of John Betjeman's comments about the insights
yielded by cultural familiarity, which I quoted in Chapter 4 and which might
bear repeating here:

I only enjoy to the full the architecture of these islands. This is not because
I am deliberately insular, but because there is so much I want to know
about a community, its history, its class distinctions, and its literature,
when looking at its buildings, that abroad I find myself frustrated by my
ignorance. Looking at a place is not just for me going to the church or the
castle or the 'places of interest' mentioned in the guide book, but walking
about the streets and lanes as well ... I like to see the railway station, the
town hall, the suburbs, the shops, the signs of local crafts carried on in
backyards. I like being able to know for certain where to place what I am
looking at ... This I can do in my own country, but am not so sure about
in someone else's.

(Betjeman 1956: 4–5)

The dimension that Wood adds to Betjeman's broader canvas is the issue of
comedy. Wood feels she cannot achieve even the most approximate form of
imagined proximity without some first-hand experience, however brief, of the
places where she finds herself. She would find it impossible to joke about
unfamiliar places, because cultural familiarity is a pre-requisite for her kind of
humour, and my guiding principle for choosing which texts and individuals to
cover in this book was very similar: they needed to be examples of comedy that
you cannot fully understand unless you know some reasonably detailed things
about England. Please note that this is not the same as being English: I overheard
two entirely English students in one of my university classes discussing where
The Full Monty was set; one asked, in all sincerity, 'Where *is* Yorkshire?'. The
reply, again sincere as far as I could tell, was, 'It's in the middle, there's no
seaside'.

To look at comedies and Englishnesses together is to highlight both. English
comedies do not exist in utter isolation from wider, more-than-national comic
traditions, but those traditions are reworked in relation to specifically English
concerns and placed in a specifically English network of cultural, historical, geo-
graphical and political reference points, ranging from the one-off, strategically

laugh-seeking placement of a brand name to a deeper negotiation with partic-
ularly national notions of class relations or the sexual politics of domesticity.
Studying comedy is part of the broader project which Peter Bailey has evoca-
tively labelled 'the history of the good time' (Bailey 1986: xviii), in other words
the attempt to understand the roles played by leisure, pleasure and popular
culture in how people have made sense of themselves and the world they
inhabit. Do I think there is such a thing as an English national sense of humour?
In the singular, no, but I strongly suspect that humour is crucial in the English
sense of nation.

Bibliography

This bibliography lists all texts cited in this book and others consulted during the research.

Adair, Gilbert (1997) 'See Me After School, Leigh'. *The Guardian*, 11 October, 6.

Aitken, Maria (1996) *Style: Acting in High Comedy*. New York: Applause.

Anderson, Benedict (1983) *Imagined Communities*. London: Verso.

Ang, Ien (2000) 'Identity Blues', in Paul Gilroy, Lawrence Grossberg and Angela McRobbie eds, *Without Guarantees: In Honour of Stuart Hall*. London: Verso.

Apte, Mahadev L. (1985) *Humor and Laughter: An Anthropological Approach*. Ithaca: Cornell University Press.

Archer, Robyn and Simmonds, Diana (1986) *A Star Is Torn*. London: Guild.

Ascherson, Neal (2002) *Stone Voices: The Search for Scotland*. London: Granta.

Ashton, Brad (1983) *How To Write Comedy*. London: Elm Tree.

Askey, Arthur (1975) *Before Your Very Eyes*. London: Woburn.

Aslet, Clive (1997) *Anyone for England? A Search for British Identity*. London: Little, Brown.

Bailey, Peter ed. (1986) *Music Hall: The Business of Pleasure*. Milton Keynes: Open University Press.

Bailey, Peter (1994) 'Conspiracies of Meaning: Music Hall and the Knowingness of Popular Culture', *Past and Present*, 144, August.

Bailey, Peter (1998) *Popular Culture and Performance in the Victorian City*. Cambridge: Cambridge University Press.

Bailey, Peter (1999) 'The Politics and Poetics of Modern British Leisure: A Late Twentieth-Century Review', *Rethinking History*. 3:2, 131–75.

Bailey, Andrew and Foss, Peter eds (1974) *George Formby Complete*. London: Wise.

Bakhtin, Mikhail (1968) *Rabelais and His World*. Cambridge: MIT.

Balakhrishnan, Gopal ed. (1996) *Mapping the Nation*. London: Verso.

Balibar, Etienne (1991) 'The Nation Form: History and Ideology', in Etienne Balibar and Immanuel Wallerstein eds, *Race, Nation, Class*. London: Verso.

Band, Barry (1999) *Blackpool's Comedy Greats, Book Two: the local careers of Dave Morris, Hylda Baker, Jimmy Clitheroe*. Blackpool: Barry Band.

Barber, Susan Torrey (1993) 'Insurmountable Difficulties and Moments of Ecstasy: Crossing Class, Ethnic and Sexual Barriers in the Films of Stephen Frears', in Lester Friedman ed., *British Cinema and Thatcherism: Fires Were Started*. London: UCL Press.

Barker, Martin (1981) *The New Racism*. London: Junction.

Barnett, Anthony (1989) 'After Nationalism', in Raphael Samuel ed., *Patriotism: The Making And Unmaking of British National Identity, Volume 1: History and Politics*. London: Routledge.

Barr, Charles (1977) *Ealing Studios*. London: Cameron and Tayleur/David and Charles.

Basker, Paul (2002) *Polari: The Lost Language of Gay Men*. London: Routledge.

Baucom, Ian (1999) *Out of Place: Englishness, Empire and the Locations of Identity*. Princeton: Princeton University Press.

Baxendale, John (2001) '"I Had Seen a lot of Englands": J.B. Priestley, Englishness and The People', *History Workshop Journal*, 51, 87–111.

Beaver, Patrick (1979) *The Spice of Life: Pleasures of the Victorian Age*. London: Elm Tree.

Bennett, Alan (1984) *A Private Function*. London: Faber.

Bennett, Alan (1985) *The Writer in Disguise*. London: Faber.

Bennett, Alan (1994) *Writing Home*. London: Faber.

Bennett, Alan (1998) *The Complete Talking Heads*. London: BBC.

Bennett, Alan (2000a) *The Lady in the Van*. London: Faber.

Bennett, Alan (2000b) *Telling Tales*. London: BBC.

Bennett, Alan, Cook, Peter, Miller, Jonathan and Moore, Dudley (1987) *The Complete Beyond The Fringe*. London: Methuen.

Bentley, Eric (1965) *The Life of the Drama*. London: Methuen.

Bergan, Ronald (1989) *Beyond The Fringe … And Beyond*. London: Virgin.

Berger, Peter L. (1997) *Redeeming Laughter: The Comic Dimension of Human Experience*. Berlin: Walter de Gruyter.

Betjeman, John (1956) *The English Town in the Last Hundred Years*. Cambridge: Cambridge University Press.

Bhabha, Homi K. (1990) 'DissemiNation: Time, Narrative and the Margins of the Modern Nation', in Bhabha ed., *Nation and Narration*. London: Routledge.

Billig, Michael (1995) *Banal Nationalism*. London: Sage.

Billington, Michael (1977) *How Tickled I Am: A Celebration of Ken Dodd*. London: Elm Tree.

Blain, Neil, Boyle, Raymond and O'Donnell, Hugh (1993) *Sport and National Identity in the European Media*. Leicester: Leicester University Press.

Boogaart, Pieter (2000) *A272: An Ode to a Road*. London: Pallas Athene.

Bowie, Fiona (1993) 'Wales From Within: Conflicting Interpretations of Welsh Identity', in Sharon Macdonald ed., *Inside European Identities*. Providence and Oxford: Berg.

Braben, Eddie (1974) *The Best of Morecambe and Wise*. London: Woburn.

Bracewell, Michael (1998) *England Is Mine: Pop Life in Albion from Wilde to Goldie*. London: Flamingo.

Bratton, J.S. ed. (1986) *Music Hall: Performance and Style*. Milton Keynes: Open University Press.

Brennan, Tim (1997) *At Home in the World: Cosmopolitanism Now*. Cambridge: Harvard University Press.

Bret, David (1999) *George Formby: A Troubled Genius*. London: Robson.

Bright, Morris and Ross, Robert (1999) *Carry On Uncensored*. London: Boxtree.

Brome, Vincent (1988) *J.B. Priestley*. London: Hamish Hamilton.

Brooker, Joe (1999) 'England's Screening', *Film-Philosophy*, Vol. 3, www.film-philosophy.com

Brown, Geoff (2000) 'Something for Everyone: British Film Culture in the 1990s', in Robert Murphy ed., *British Cinema of the 90s*. London: British Film Institute.

Brown, Roy 'Chubby' (2006) *Common as Muck: My Autobiography*. London: Time Warner.

Brown, Roy 'Chubby', Leigh, Mark Brown and Lepine, Mike (1995) *Unzipped*. London: Boxtree.

Brunsdon, Charlotte (2000) *The Feminist, the Housewife and the Soap Opera*. Oxford: Clarendon.

Buckland, Elfreda (1985) *The World of Donald McGill*. Poole: Javelin.

Burgess, Muriel with Keen, Tommy (1980) *Gracie Fields*. London: W.H. Allen.

Burke, Peter (1997) 'Frontiers of the Comic in Early Modern Italy', in Jan Bremmer and Herman Roodenburg eds, *A Cultural History of Humour*. Cambridge: Polity.

Campbell, Beatrix (1989) 'Orwell Revisited', in Raphael Samuel ed., *Patriotism: The Making And Unmaking of British National Identity, Volume 3: National Fictions*. London: Routledge.

Canclini, Nestor Garcia (2001) 'Hybrid Cultures, Oblique Powers', in Meenakshi Gigi Durham and Douglas M. Kellner eds, *Media and Cultural Studies: Keyworks*. Oxford: Blackwell.

Carney, Ray and Quart, Leonard (2000) *The Films of Mike Leigh: Embracing the World*. Cambridge: Cambridge University Press.

Carter, Angela (1997) *Shaking A Leg: Journalism and Writings*. London: Chatto and Windus.

Carter, Erica, Donald, James and Squires, Judith eds (1993) *Space and Place: Theories of Identity and Location*. London: Lawrence and Wishart.

Chambers, Iain (1993) 'Narratives of Nationalism: Being "British"', in Erica Carter, James Donald and Judith Squires eds, *Space and Place: Theories of Identity and Location*. London: Lawrence and Wishart.

Chapman, Anthony J. and Foot, Hugh C. eds (1977) *It's A Funny Thing, Humour*. Oxford: Pergamon.

Chapman, Malcolm (1993) 'Copeland: Cumbria's Best-Kept Secret', in Sharon Macdonald ed., *Inside European Identities*. Providence and Oxford: Berg.

Charlesworth, Simon J. (2000) *A Phenomenology of Working Class Experience*. Cambridge: Cambridge University Press.

Chiaro, Delia (1992) *The Language of Jokes: Analysing Verbal Play*. London: Routledge.

Clary, Julian, Leigh, Mark and Lepine, Mike (1992) *How To Be A Real Man*. London: Virgin.

Clements, Paul (1993) '*Four Days in July*', in George W. Brandt ed., *British Television Drama in the 1980s*. Cambridge: Cambridge University Press.

Cohen, Anthony P. (1986) 'Of Symbols and Boundaries, or Does Ertie's Greatcoat Hold the Key?', in Cohen ed., *Symbolising Boundaries: Identity and Diversity in British Cultures*. Manchester: Manchester University Press.

Cohen, Phil (1998) 'Who Needs An Island?', *New Formations*, 33, Spring 1998.

Coleby, Nicola ed. (2002) *Kiss and Kill: Film Visions of Brighton*. Brighton: Royal Pavilion, Libraries and Museums.

Colley, Linda (1992) *Britons: Forging the Nation, 1707–1837*. New Haven: Yale University Press.

Collins, Michael (2004) *The Likes Of Us: A Biography of the White Working Class*. London: Granta.

Colls, Robert (2004) *Identity of England*. Oxford: Oxford University Press.

Colls, Robert and Dodd, Philip eds (1986) *Englishness: Politics and Culture 1880–1920*. London: Croom Helm.

Condor, Susan (1996) 'Unimagined Community? Some Social Psychological Issues Concerning English National Identity', in Glynis M. Breakwell and Evanthia Lyons eds, *Changing European Identities: Social Psychological Analyses of Social Change*. Oxford: Butterworth-Heinemann.

Cook, Judith (1997) *Priestley*. London: Bloomsbury.

Cook, Lin ed. (1998) *Peter Cook Remembered*. London: Arrow.

Cook, Pam (1996) *Fashioning the Nation: Costume and Identity in British Cinema*. London: British Film Institute.

Cook, William (1994) *Ha Bloody Ha: Comedians Talking*. London: Fourth Estate.

Corrigan, R.W. ed. (1981) *Comedy: Meaning and Form*. New York: Harper and Row.

Coveney, Michael (1992) *Maggie Smith: A Bright Particular Star*. London: Gollancz.

Coveney, Michael (1997) *The World According to Mike Leigh*. London: Harper Collins.

Cressy, David (1994) 'National Memory in Early Modern England', in John R. Gillis ed., *Commemorations: The Politics of National Identity*. Princeton: Princeton University Press.

Crick, Bernard (1991) 'The English and the British' in Crick ed., *National Identities: The Constitution of the United Kingdom*. Oxford: Blackwell.

Critchley, Simon (2002) *On Humour*. London: Routledge.

Cubitt, Geoffrey ed. (1998) *Imagining Nations*. Manchester: Manchester University Press.

Dacre, Richard (1991) *Trouble in Store: Norman Wisdom, A Career in Comedy*. London: T.C. Farries.

Davey, Kevin (1999) *English Imaginaries: Six Studies in Anglo-British Modernity*. London: Lawrence and Wishart.

Davies, Christie (1996) *Ethnic Humor Around the World*. Bloomington: Indiana University Press.

Davies, Russell ed. (1994) *The Kenneth Williams Letters*. London: Harper Collins.

Davis, Murray S. (1993) *What's So Funny? The Comic Conception of Culture and Society* Chicago: University of Chicago Press.

Dawson, Les (1985) *A Clown Too Many*. London: Elm Tree.

Dessau, Bruce (1997) *The Funny Side of Victoria Wood*. London: Orion.

Dessau, Bruce (1998) *Reeves and Mortimer*. London: Orion.

Disher, Willson M. (1974) *Winkles and Champagne: Comedies and Tragedies of the Music Hall*. Bath: Cedric Chivers (first pub. 1938).

Donald, James (1993) 'How English Is It?', in Erica Carter, James Donald and Judith Squires eds, *Space and Place: Theories of Identity and Location*. London: Lawrence and Wishart.

Donald, James and Rattansi, Ali eds (1992) *'Race', Culture and Difference*. London: Sage.

Doran, Amanda-Jane ed. (1989) *The Punch Book of Utterly British Humour*. London: Grafton.

Douglas, Mary (1975) *Implicit Meanings: Essays in Anthropology*. London: Routledge.

Durant, John and Miller, Jonathan eds (1988) *Laughing Matters: A Serious Look at Humour*. London: Longman.

Dyer, Richard ed. (1981) *Coronation Street*. London: British Film Institute.

Dyer, Richard (1992 first published 1976) 'It's Being So Camp As Keeps Us Going', in *Only Entertainment*. London: Routledge.

Dyer, Richard (1994) 'Fashioning Change: Gay Mens Style', in Emma Healy and Angela Mason eds, *Stonewall 25: The Making of the Lesbian and Gay Community in Britain*. London: Virago.

Dyer, Richard (2002) 'Charles Hawtrey: Carrying On Regardless', in *The Culture of Queers*. London: Routledge.

Dyer, Richard and Vincendeau, Ginette eds (1992) *Popular European Cinema*. London: Routledge.

Eagleton, Terry (1986) *Against the Grain: Essays 1975–1985*. London: Verso.

Eagleton, Terry (1989) 'Bakhtin, Schopenhauer, Kundera', in Ken Hirschkop and David Shepherd eds, *Bakhtin and Cultural Theory*. Manchester: Manchester University Press.

Eastaugh, Kenneth (1979) *The Carry-On Book*. Newton Abbot: David and Charles.

Easthope, Antony (1999) *Englishness and National Culture*. London: Routledge.

Eco, Umberto (1984) 'The Frames of Comic "Freedom"', in Thomas A. Sebeok ed., *Carnival!*. Berlin: Mouton.

Eliot, T.S. (1948) *Notes Towards the Definition of Culture*. London: Faber.

Ellis, John (2000) 'British Cinema as Performance Art', in Justine Ashby and Andrew Higson eds, *British Cinema, Past and Present*. London: Routledge.

English, James F. (1994) *Comic Transactions: Literature, Humor and the Politics of Community in Twentieth-Century Britain*. Ithaca: Cornell University Press.

Evans, Eric (1995) 'Englishness and Britishness: National Identities c.1790–c.1870', in Alexander Grant and Keith J. Stringer eds, *Uniting the Kingdom? The Making of British History*. London: Routledge.

Everett, Wendy ed. (1996) *European Identity in Cinema*. Exeter: Intellect.

Fanshawe, Simon (1994) 'Standing Up and Standing Out: Lesbian and Gay Comedy', in Emma Healy and Angela Mason eds, *Stonewall 25: The Making of the Lesbian and Gay Community in Britain*. London: Virago.

Fawkes, Richard (1978) *Fighting for a Laugh: Entertaining the British and American Armed Forces 1939–1946*. London: Macdonald and Jane's.

Featherstone, Mike (1996) 'Localism, Globalism and Cultural Identity', in Rob Wilson and Wimal Dissanayake eds, *Global/Local: Cultural Production and the Transnational Imaginary*. Durham: Duke University Press.

Fergusson, Jean (1997) *She Knows You Know: The Remarkable Story of Hylda Baker*. Derby: Breedon.

Fields, Gracie (1960) *Sing As We Go*. London: Frederick Muller.

Fisher, John (1975a) *George Formby*. London: Woburn-Futura.

Fisher, John (1975b) *What a Performance*. London: Seeley.

Fisher, John (1976) *Funny Way to be a Hero*. St. Albans: Paladin.

Flanagan, Bud (1961) *My Crazy Life*. London: Frederick Muller.

Flowers, Charles ed. (1995) *Out, Loud and Laughing: A Collection of Gay and Lesbian Humor*. New York: Anchor.

Foster, Andy and Furst, Steve (1996) *Radio Comedy 1938–1968*. London: Virgin.

Freud, Sigmund (1976) *Jokes and Their Relation to the Unconscious*. Harmondsworth: Penguin.

Friedman, Jonathan (1999) 'The Hybridization of Roots and the Abhorrence of the Bush', in Mike Featherstone and Scott Lash eds, *Spaces of Culture: City, Nation, World*. London: Sage.

Frost, David and Jay, Antony (1967) *To England With Love*. London: Hodder and Stoughton/Heinemann.

Fuller, Graham (1995) 'Mike Leigh's Original Features', in Mike Leigh, *Naked and Other Screenplays*. London: Faber.

Games, Alexander (1999) *Pete and Dud: An Illustrated Biography*. London: Andre Deutsch.

Games, Alexander (2001) *Backing into the Limelight: The Biography of Alan Bennett*. London: Headline.

Garrett, John M. (1976) *Sixty Years of British Music Hall*. London: Cassell.

Giddens, Anthony (1990) *The Consequences of Modernity*. Cambridge: Polity.

Giles, Judy and Middleton, Tim eds (1995) *Writing Englishness 1900–1950*. London: Routledge.

Gillies, Midge (1999) *Marie Lloyd: The One and Only*. London: Gollancz.

Gillis, John R. ed. (1994) *Commemorations: The Politics of National Identity*. Princeton: Princeton University Press.

Gilroy, Paul (1987) *There Ain't No Black in the Union Jack: The Cultural Politics of Race and Nation*. London: Routledge.

Gilroy, Paul (1993) *Small Acts: Thoughts on the Politics of Black Cultures*. London: Serpent's Tail.

Gilroy, Paul (1996) 'British Cultural Studies and the Pitfalls of Identity', in James Curran, David Morley and Valerie Walkerdine eds, *Cultural Studies and Communications*. London: Arnold.

Gilroy, Paul (2000) *Between Camps: Race, Identity and Nationalism at the End of the Colour Line*. London: Allen Lane.

Gilroy, Paul (2004) *After Empire: Melancholia or Convivial Culture?*. London: Routledge.

Glazener, Nancy (1989) 'Dialogic Subversion: Bakhtin, the Novel and Gertrude Stein', in Ken Hirschkop and David Shepherd eds, *Bakhtin and Cultural Theory*. Manchester: Manchester University Press.

Goldstein, Jeffrey H. and McGhee, Paul E. eds (1972) *The Psychology of Humour: Theoretical Perspectives and Empirical Issues*. New York: Academic Press.

Gorer, Geoffrey (1955) *Exploring English Character*. London: Cresset.

Graham, Alison (2000) 'And My Winners Are …', *Radio Times*, May 13–19, 22–25.

Grant, Alexander and Stringer, Keith J. eds (1995) *Uniting the Kingdom? The Making of British History*. London: Routledge.

Gray, Frances (1994) *Women and Laughter*. London: Macmillan.

Grayson, Larry (1980) *Larry Grayson's Parlour Fun Book*. London: Hamlyn.

Grayson, Larry (1983) *Grayson's War*. London: Macmillan.

Green, Benny (1976) *I've Lost My Little Willie: A Celebration of Comic Postcards*. London: Arrow.

Greene, Graham (1980) *The Pleasure Dome: Collected Film Criticism 1935–40*. Oxford: Oxford University Press.

Grenfell, Joyce (1977) *Joyce Grenfell Requests the Pleasure*. London: Futura.

Grenfell, Joyce (1984) *Turn Back the Clock*. London: Futura.

Gurevitch, Aaron (1997) 'Bakhtin and his Theory of Carnival', in Jan Bremmer and Herman Roodenburg eds, *A Cultural History of Humour*. Cambridge: Polity.

Gurewitch, Morton (1975) *Comedy: The Irrational Vision*. Ithaca: Cornell University Press.

Hackforth, Norman (1979) *Solo for Horne*. London: Coronet.

Hall, Stuart (1981) 'The Whites of their Eyes: Racist Ideologies and the Media', in George Bridges and Rosalind Brunt eds, *Silver Linings: Some Strategies for the Eighties*. London: Lawrence and Wishart.

Hall, Stuart (1991) 'The Local and the Global: Globalization and Ethnicity', in Anthony D. King ed., *Culture, Globalization and the World-System*. Basingstoke: Macmillan.

Hall, Stuart (1992) 'New Ethnicities', in James Donald and Ali Rattansi eds, *'Race', Culture and Difference*. London: Sage.

Hall, Stuart (1996) 'Introduction: Who Needs Identity?', in Stuart Hall and Paul du Gay eds, *Questions of Cultural Identity*. London: Sage.

Hall, William (1992) *Titter Ye Not!: The Life of Frankie Howerd*. London: Grafton.

Hannerz, Ulf (1990) 'Cosmopolitans and Locals in World Culture', in Mike Featherstone ed., *Global Culture: Nationalism, Globalization and Modernity*. London: Sage.

Harper, Sue (1992) 'Studying Popular Taste: British Historical Films in the 1930s', in Richard Dyer and Ginette Vincendeau eds, *Popular European Cinema*. London: Routledge.

Harper, Sue (1997) ' "Nothing to Beat the Hay Diet": Comedy at Gaumont and Gainsborough', in Pam Cook ed., *Gainsborough Pictures*. London: Cassell.

Harris, John (2001) 'Behind the Mask', Q, Summer 2001, 71–4.

Harvey, David (1989) *The Condition of Postmodernity*. Oxford: Blackwell.

Hawkes, Terence (2000) 'Speaking To You In English', *Textual Practice*, Vol. 14 No. 2.

Healy, Murray (1995) 'Were We Being Served? Homosexual Representation in Popular British Comedy', *Screen*, Vol. 36 No. 3.

Heath, Chris (1990) *Pet Shop Boys, Literally*. London: Viking.

Henkle, Roger B. (1980) *Comedy and Culture: England 1820–1900*. Princeton: Princeton University Press.

Hibbin, Sally and Hibbin, Nina (1988) *What A Carry On*. London: Hamlyn.

Hietala, Veijo, Honka-Hallila, Ari, Kangasniemi, Hanna, Lahti, Martti, Laine, Kimmo and Silvonen, Jukka (1992) 'The Finn-Between: Uuno Turhapuro, Finland's Greatest Star', in Richard Dyer and Ginette Vincendeau eds, *Popular European Cinema*. London: Routledge.

Higson, Andrew (1995) *Waving the Flag: Constructing a National Cinema in Britain*. Oxford: Clarendon Press.

Hill, John (1992) 'The Issue of National Cinema and British Film Production', in Duncan Petrie ed., *New Questions of British Cinema*. London: BFI.

Hill, John (1999) *British Cinema in the 1980s*. Oxford: Clarendon.

Hirschkop, Ken and Shepherd, David eds (1989) *Bakhtin and Cultural Theory*. Manchester: Manchester University Press.

Hjort, Mette and Mackenzie, Scott eds (2000) *Cinema and Nation*. London: Routledge.

Hodgkins, William (1977) 'Vulgarity in Humour' in Chapman and Foot eds, *It's A Funny Thing, Humour*. Oxford: Pergamon.

Hoggart, Richard (1957) *The Uses of Literacy*. Harmondsworth: Pelican.

Hole, Anne (2000) 'Fat History and Music Hall', *Women's History Notebooks*, Vol. 7 No.1, Winter, 3–9.

Horton, Andrew S. ed. (1991) *Comedy/Cinema/Theory*. Berkeley: University of California Press.

Howarth, W.D. ed. (1978) *Comic Drama: The European Heritage*. London: Methuen.

Howe, Stephen (1989) 'Labour Patriotism 1939–83', in Raphael Samuel ed., *Patriotism: The Making and Unmaking of British National Identity, Volume 1: History and Politics*. London: Routledge.

Howell, Georgina (1977) *The Penguin Book of Naughty Postcards*. Harmondsworth: Penguin.

Howes, Keith (1993) *Broadcasting It: An Encyclopaedia of Homosexuality on Film, Radio and TV in the UK 1923–1993*. London: Cassell.

Howkins, Alun (1986) 'The Discovery of Rural England', in Robert Colls and Philip Dodd eds, *Englishness: Politics and Culture 1880–1920*. London: Croom Helm.

Hoy, Mikita (1994) 'Joyful Mayhem: Bakhtin, Football Songs and the Canivalesque', *Text and Performance Quarterly*, 14, 1–7.

Hudd, Roy with Hindin, Philip (1998) *Roy Hudd's Cavalcade of Variety Acts*. London: Robson.

Hunt, Albert (1993) 'Talking Heads: Bed Among the Lentils', in George W. Brandt ed., *British Television Drama in the 1980s*. Cambridge: Cambridge University Press.

Hunt, Leon (1998) *British Low Culture: From Safari Suits to Sexploitation*. London: Routledge.

Husband, Charles (1988) 'Racist Humour and Racist Ideology in British Television, or I Laughed Till You Cried', in Chris Powell and George E.C. Paton eds, *Humour In Society: Resistance and Control*. London: Macmillan.

Ignatieff, Michael (1993) *Blood and Belonging*. London: BBC/Chatto and Windus.

Irwin, Ken (1972) *Laugh with The Comedians*. London: Wolfe.

Jacobson, Howard (1997) *Seriously Funny*. London: Viking.

Jeancolas, Jean-Pierre (1992) 'The Inexportable: the Case of French Cinema and Radio in the 1950s', in Richard Dyer and Ginette Vincendeau eds, *Popular European Cinema*. London: Routledge.

Jefferson, Ann (1989) 'Bodymatters: Self and Other in Bakhtin, Sartre and Barthes', in Ken Hirschkop and David Shepherd eds, *Bakhtin and Cultural Theory*. Manchester: Manchester University Press.

Jennings Paul and Gorham, John eds (1974) *The English Difference*. London: Aurelia Press.

Johnson, Terry (1998) *Plays: 2*. London: Methuen.

Jordan, Marion (1983) 'Carry On … Follow That Stereotype', in James Curran and Vincent Porter eds, *British Cinema History*. London: Wiedenfeld and Nicolson.

Joyce, Patrick (1991) *Visions of the People: Industrial England and the Question of Class 1848–1914*. Cambridge: Cambridge University Press.

Kearney, Hugh (1991) 'Four Nations or One?' in Bernard Crick ed., *National Identities: The Constitution of the United Kingdom*. Oxford: Blackwell.

Kift, Dagmar (1996) *The Victorian Music Hall: Culture, Class and Conflict*. Cambridge: Cambridge University Press.

King, Anthony D. ed. (1991) *Culture, Globalization and the World-System: Contemporary Conditions for the Representation of Identity*. London: Macmillan.

King, Geoff (2002) *Film Comedy*. London: Wallflower.

Kravitz, Seth (1977) 'London Jokes and Ethnic Stereotypes', *Western Folklore*, 36:4, 275–301.

Kureishi, Hanif (1989) 'London and Karachi', in Raphael Samuel ed., *Patriotism: The Making and Unmaking of British National Identity, Volume II: Minorities and Outsiders*. London: Routledge.

Lahr, John ed. (2002) *The Diaries of Kenneth Tynan*. London: Bloomsbury.

Laing, Dave (1996) 'Roll Over Lonnie (Tell George Formby the News)', in Charlie Gillett and Simon Frith eds, *The Beat Goes On: The Rock File Reader*. London: Pluto.

Lambert, Gavin (2000) *Mainly About Lindsay Anderson: A Memoir*. London: Faber.

Langford, Paul (2000) *Englishness Identified: Manners and Character 1650–1850*. Oxford: Oxford University Press.

Lauter, Paul ed. (1964) *Theories of Comedy*. New York: Anchor.

Lawrence, Errol (1982) 'Just Plain Common Sense: The "Roots" of Racism' in Centre for Contemporary Cultural Studies, *The Empire Strikes Back: Race and Racism in 70s Britain*. London: Hutchinson.

Leacock, Stephen (1922) 'Have the English Any Sense of Humour?', in *My Discovery of England*. London: Bodley Head.

Lee, C.P. (1998) 'The Lancashire Shaman: Frank Randle and Mancunian Films', in Stephen Wagg ed., *Because I Tell A Joke Or Two: Comedy, Politics and Social Difference*. London: Routledge.

Lee, Edward (1982) *Folksong and Music Hall*. London: Routledge and Kegan Paul.

Legman, Gershon (1969) *Rationale of the Dirty Joke: An Analysis of Sexual Humour* (First Series). London: Jonathan Cape.

Legman, Gershon (1975) *Rationale of the Dirty Joke: An Analysis of Sexual Humour* (Second Series). New York: Breaking Point.

Lewis, Roger (2001) *The Man Who Was Private Widdle: Charles Hawtrey 1914–1988*. London: Faber.

Light, Alison (1991) *Forever England: Femininity, Literature and Conservatism Between the Wars*. London: Routledge.

Linfield, Eric G. and Larsen, Egon eds (1963) *Laughter in a Damp Climate: An Anthology of British Humour*. London: Herbert Jenkins.

Linsell, Tony ed. (2000a) *Our Englishness*. Thetford: Anglo-Saxon Books.

Linsell, Tony (2000b) 'Nations, Nationalism and Nationalists', in Linsell ed., *Our Englishness*. Thetford: Anglo-Saxon Books.

Littlejohn, Geoffrey (2000) 'Our Englishness', in Tony Linsell ed., *Our Englishness*. Thetford: Anglo-Saxon Books.

Lucas, Ian (1994) *Impertinent Decorum: Gay Theatrical Manoeuvres*. London: Cassell.

Luckett, Moya (2000), 'Image and Nation in 1990s British Cinema', in Robert Murphy ed., *British Cinema of the 90s*. London: British Film Institute.

Lusted, David (1998) 'The Popular Culture Debate and Light Entertainment on Television', in Christine Geraghty and David Lusted eds, *The Television Studies Book*. London: Arnold.

Lyon, Wenonah (1997) 'Defining Ethnicity: Another Way of being British', in Tariq Modood and Pnina Werbner eds, *The Politics of Multiculturalism in the New Europe: Racism, Identity and Community*. London: Zed.

MacDonald, Ian (1994) *Revolution in the Head: The Beatles' Records and the Sixties*. London: Fourth Estate.

MacInnes, Colin (1967) *Sweet Saturday Night*. London: MacGibbon and Kee.

Macnab, Geoffrey (1993) 'Inside the Belly', *Sight and Sound*, Vol. 3 No. 8.

Macnab, Geoffrey (2000) *Searching for Stars: Stardom and Screen Acting in British Cinema*. London: Cassell.

Macrae, David (1916) *National Humour: Scottish, English, Irish, Welsh, Cockney, American*. Paisley: Alexander Gardner.

Maguire, Susie and Young, David Jackson eds (1997) *Hoots!: An Anthology of Scottish Comic Writing*. Edinburgh: Polygon.

Mair, Michael and Kirkland, John (1977) 'Mirth Measurement: A New Technique', in Anthony J. Chapman and Hugh C. Foot eds, *It's A Funny Thing, Humour*. Oxford: Pergamon.

Manzo, Kathryn A. (1996) *Creating Boundaries: The Politics of Race and Nation*. Boulder: Lynne Rienner.

Marsh, Dave (1989) *The Heart of Rock and Soul: The 1001 Greatest Singles Ever Made*. London: Penguin.

Martin, Andrew (2006) 'The Poet of the Provinces', *New Statesman*. 4th September, 54–55.

Massey, Doreen (1994) *Space, Place and Gender*. Cambridge: Polity.

Massey, Doreen (2000) 'Travelling Thoughts', in Paul Gilroy, Lawrence Grossberg and Angela McRobbie eds, *Without Guarantees: In Honour of Stuart Hall*. London: Verso.

Mast, Gerald (1979) *The Comic Mind: Comedy and the Movies*. Chicago: Chicago University Press.

Matless, David (1998) *Landscape and Englishness*. London: Reaktion.

Matless, David (2000a) 'The Predicament of Englishness', *Scottish Geographical Journal*, 116(1), 79–86.

Matless, David (2000b) 'Action and Noise Over a Hundred Years: The Making of a Nature Region', *Body and Society*, 6(3–4), 141–65.

McArthur, Colin (1985) 'Scotland's Story', *Framework*. No. 26–27, pp. 64–74.

McArthur, Colin (1998) 'The Exquisite Corpse of Rab(Elais) C(opernicus) Nesbitt', in Mike Wayne ed., *Dissident Voices: The Politics of Television and Cultural Change*. London: Pluto.

McCann, Graham (1998) *Morecambe and Wise*. London: Fourth Estate.

McDonald, Paul (1999) 'Secrets and Lies: Acting for Mike Leigh', in Alan Lovell and Peter Kramer eds, *Screen Acting*. London: Routledge.

McKee, Alan (1999) 'Australian Gay Porn Videos: the National Identity of Despised Cultural Objects', *International Journal of Cultural Studies*, 2:2, 178–98.

McKenney, Ruth and Bransten, Richard (1951) *Here's England*. London: Rupert Hart-Davis.

Medhurst, Andy (1986) 'Music Hall and British Cinema', in Charles Barr ed., *All Our Yesterdays: Ninety Years of British Cinema*. London: British Film Institute.

Medhurst, Andy (1989) 'Introduction: Situation Comedies', in Therese Daniels and Jane Gerson eds, *The Colour Black: Black Images in British Television*. London: British Film Institute.

Medhurst, Andy (1992) 'Carry On Camp', *Sight and Sound*, Vol. 2 No. 4, 16–19.
Medhurst, Andy (1993) 'Mike Leigh: Beyond Embarrassment', *Sight and Sound*, Vol. 3 No. 11, 6–11.
Medhurst, Andy (1994) 'One Queen and his Screen: Lesbian and Gay Television', in Emma Healy and Angela Mason eds, *Stonewall 25: The Making of the Lesbian and Gay Community in Britain*. London: Virago.
Medhurst, Andy (1996) 'Negotiating the Gnome Zone: Versions of Suburbia in British Popular Culture', in Roger Silverstone ed., *Visions of Suburbia*. London: Routledge.
Medhurst, Andy (1997) 'Camp', in Andy Medhurst and Sally R. Munt eds, *Lesbian and Gay Studies: A Critical Introduction*. London: Cassell.
Medhurst, Andy (1998) 'Sex, Smiles and Stereotypes', programme for *Cleo, Camping, Emmanuelle and Dick*. London: Royal National Theatre.
Medhurst, Andy (1999) 'If Anywhere: Class Identifications and Cultural Studies Academics', in Sally R. Munt ed., *Cultural Studies and the Working Class: Subject to Change*. London: Cassell.
Medhurst, Andy (2001) 'King and Queen: Interpreting Sexual Identity in "Jason King"', in Bill Osgerby and Anna Gough-Yates eds, *Action TV: Tough Guys, Smooth Operators and Foxy Chicks*. London: Routledge.
Medhurst, Andy (2002) '"We Can Do Anything Once We're There": Comedy, Carnival And Brighton on Film', in Nicola Coleby ed., *Kiss and Kill: Film Visions of Brighton*. Brighton: Royal Pavilion, Libraries and Museums.
Mee, Arthur (1941) *Arthur Mee's Book of the Flag: Island and Empire*. London: Hodder and Stoughton.
Mellor, David ed. (1987) *A Paradise Lost: The Neo-Romantic Imagination in Britain 1935–55*. London: Lund Humphries.
Mellor, G.J. (1970) *The Northern Music Hall*. Newcastle-upon-Tyne: Frank Graham.
Mellors, Bob (1978) *Clint Eastwood Loves Jeff Bridges True: 'Homosexuality', Androgyny and Evolution, A Simple Introduction*. London: Quantum Jump.
Melly, George (1970) *Owning-Up*. Harmondsworth: Penguin.
Melucci, Alberto (1997) 'Identity and Difference in a Globalized World', in Pnina Werbner and Tariq Modood eds, *Debating Cultural Hybridity: Multi-Cultural Identities and the Politics of Anti-Racism*. London: Zed.
Middles, Mick (1999) *When You're Smiling: The Illustrated Biography of Les Dawson*. London: Chameleon.
Middles, Mick (2000) *Frankie Howerd: The Illustrated Biography*. London: Headline.
Middleton, Drew (1958) *The British*. London: Pan.
Midwinter, Eric (1979) *Make Em Laugh: Famous Comedians and their Worlds*. London: Allen and Unwin.
Mikes, George (1964) *How to Be an Alien*. London: Andre Deutsch (31st impression, first published 1946).
Morecambe, Eric and Wise, Ernie (1973) *Eric and Ernie*. London: W.H. Allen.
Morecambe, Eric and Wise, Ernie (1981) *There's No Answer To That!!*. London: Arthur Barker.
Morecambe, Gary (1987) *The Illustrated Morecambe*. London: Queen Anne Press.
Morecambe, Gary and Sterling, Martin (1994) *Morecambe and Wise: Behind the Sunshine*. London: Robson.

Morley, David (2000) *Home Territories: Media, Mobility and Identity*. London: Routledge.

Morley, David and Chen, Kuan-Hsing eds (1996) *Stuart Hall: Critical Dialogues in Cultural Studies*. London: Routledge.

Morley, David and Robins, Kevin eds (1995) *Spaces of Identity: Global Media, Electronic Landscapes and Cultural Boundaries*. London: Routledge.

Morton, H.V. (1927) *In Search of England*. London: Methuen.

Motion, Andrew (1993) *Philip Larkin: A Writer's Life*. London: Faber.

Movshovitz, Howie ed. (2000) *Mike Leigh Interviews*. Jackson: University of Mississippi Press.

Mulkay, Michael (1988) *On Humour: Its Nature and Its Place in Modern Society*. Cambridge: Polity.

Murphy, Robert ed. (2000) *British Cinema of the 90s*. London: British Film Institute.

Naficy, Hamid ed. (1999) *Home, Exile, Homeland: Film, Media and the Politics of Place*. London: Routledge.

Nairn, Tom (1977) *The Break-Up of Britain*. London: NLB.

Nairn, Tom (1997) *Faces of Nationalism: Janus Revisited*. London: Verso.

Nathan, David (1971) *The Laughtermakers: A Quest for Comedy*. London: Peter Owen.

Neale, Steve and Krutnik, Frank eds (1990) *Popular Film and Television Comedy*. London: Routledge.

Nelson, T.G.A. (1990) *Comedy: The Theory of Comedy in Literature, Drama and Cinema*. Oxford: OUP.

Nichols, Peter (1984) *Feeling You're Behind: An Autobiography*. London: Weidenfeld and Nicolson.

Nuttall, Jeff (1978) *King Twist: A Portrait of Frank Randle*. London: Routledge.

Nuttall, Jeff and Carmichael, Rodick (1977) *Common Factors/Vulgar Factions*. London: Routledge and Kegan Paul.

O'Day, Marc (1994) 'Mutability is Having a Field Day: The Sixties Aura of Angela Carter's Bristol Trilogy', in Lorna Sage ed., *Flesh and the Mirror: Essays on the Art of Angela Carter*. London: Virago.

Oddey, Alison (1999) *Performing Women: Stand-Ups, Strumpets and Itinerants*. Basingstoke: Macmillan.

Orwell, George (1965) 'The Art of Donald McGill', in *Decline of the English Murder and Other Essays*. Harmondsworth: Penguin.

Orwell, George (1970) 'The Lion and the Unicorn', in *Collected Essays, Journalism and Letters Volume 2: My Country Right or Left 1940–1943*. Harmondsworth: Penguin.

Osborne, John (1994) *Damn You, England: Collected Prose*. London: Faber.

Owen, Maureen (1986) *The Crazy Gang: A Personal Reminiscence*. London: Weidenfeld and Nicolson.

Palmer, D.J. ed. (1984) *Comedy: Developments in Criticism*. London: Methuen.

Palmer, Jerry (1987) *The Logic of the Absurd*. London: BFI.

Palmer, Jerry (1994) *Taking Humour Seriously*. London: Routledge.

Paton, George E.C. (1988) 'The Comedian as Portrayer of Social Morality', in Chris Powell and George E.C. Paton eds, *Humour in Society: Resistance and Control*. London: Macmilan.

Paton, George E.C., Powell, Chris and Wagg, Stephen eds (1996) *The Social Faces of Humour*. Aldershot: Arena.

Paxman, Jeremy (1998) *The English: A Portrait of a People*. London: Michael Joseph.

Pearsall, Ronald (1975) *Edwardian Popular Music*. Newton Abbot: David and Charles.

Phillips, Andrew (2000) 'The Resurrection of England', in Tony Linsell ed. *Our Englishness*. Thetford: Anglo-Saxon Books.

Pickering, Michael and Green, Tony (1987) 'Towards a Cartography of the Vernacular Milieu', in Pickering and Green eds, *Everyday Culture: Popular Song and the Vernacular Milieu*. Milton Keynes: Open University Press.

Pocock, J.G.A. (1995) 'Conclusion: Contingency, Identity, Sovereignty', in Alexander Grant and Keith J. Stringer eds, *Uniting the Kingdom? The Making of British History*. London: Routledge.

Pointon, Marcia (1998) 'Money and Nationalism', in Geoffrey Cubitt ed., *Imagining Nations*. Manchester: Manchester University Press.

Potter, Stephen (1954) *Sense of Humour*. London: Max Reinhardt.

Powell, Chris and Paton, George E.C. eds (1988) *Humour in Society: Resistance and Control*. London: Macmillan.

Power, Lisa (1995) *No Bath but Plenty of Bubbles: An Oral History of the Gay Liberation Front*. London: Cassell.

Priestley, J.B. (1929) *English Humour*. London: Longmans.

Priestley, J.B. (1968) *English Journey*. London: Heinemann (first pub. 1934).

Priestley, J.B. (1975) *Particular Pleasures*. London: Heinemann.

Purdie, Susan (1993) *Comedy: The Mastery of Discourse*. Hemel Hempstead: Harvester Wheatsheaf.

Quade, Anita (1997) 'A Slap in the Face', *Brighton and Hove Leader*. 9th January, 1.

Quinlan, David (1992) *Quinlan's Illustrated Directory of Film Comedy Stars*. London: Batsford.

Radstone, Susannah (1996) 'Heroes For Our Times: Tommy Cooper', *Soundings*. No. 3, Summer 1996.

Rees, Jasper (1999) '*Dinnerladies* Is Served', *Radio Times*, 20–26 November, 20–22.

Richards, Jeffrey (1997) *Films and British National Identity*. Manchester: Manchester University Press.

Ripley, A. Crooks (1945) *Spectacle: A Book of Things Seen*. London: Barclay and Fry.

Robbins, Bruce (1998) 'Actually Existing Cosmopolitanism', in Pheng Cheah and Bruce Robbins eds, *Cosmopolitics: Thinking and Feeling Beyond the Nation*. Minneapolis: Minnesota University Press.

Rodway, Allan (1975) *English Comedy: Its Role and Nature from Chaucer to the Present Day*. London: Chatto and Windus.

Ross, Alison (1998) *The Language of Humour*. London: Routledge.

Ross, Robert (1996) *The Carry On Companion*. London: Batsford.

Rowbotham, Sheila (2001) *Promise of a Dream: Remembering the Sixties*. London: Penguin.

Rowe, Kathleen (1995) *The Unruly Woman: Gender and the Genres of Laughter*. Austin: University of Texas Press.

Russell, Dave (1991) ' "What's Wrong with Brass Bands ?": Cultural Change and the Band Movement c.1918–c.1964', in Trevor Herbert ed., *Bands: The Brass Band Movement in the 19th and 20th Centuries*. Milton Keynes: Open University Press.

Russell, Dave (1997) *Popular Music in England 1840–1914: A Social History*. Manchester: Manchester University Press.

Rutherford, Jonathan ed. (1990) *Identity: Community, Culture, Difference*. London: Lawrence and Wishart.

Rutherford, Jonathan (1997) *Forever England: Reflections on Masculinity and Empire*. London: Lawrence and Wishart.

Rutherford, Lois (1986) '"Harmless Nonsense": the Comic Sketch and the Development of Music Hall Entertainment', in J.S. Bratton ed., *Music Hall: Performance and Style*. Milton Keynes: Open University Press.

Samuel, Raphael ed. (1989a) *Patriotism: The Making and Unmaking of British National Identity, Volume 1: History and Politics*. London: Routledge.

Samuel, Raphael ed. (1989b) *Patriotism: The Making and Unmaking of British National Identity, Volume 2: Minorities and Outsiders*. London: Routledge.

Samuel, Raphael ed. (1989c) *Patriotism: The Making and Unmaking of British National Identity, Volume 3: National Fictions*. London: Routledge.

Samuel, Raphael (1994) *Theatres of Memory: Volume 1, Past and Present in Contemporary Culture*. London: Verso.

Samuel, Raphael (1998) *Island Stories: Unravelling Britain, Theatres of Memory Volume II*. London: Verso.

Sanders, Jonathan (1995) *Another Fine Dress: Role-Play in the Films of Laurel and Hardy*. London: Cassell.

Schwarz, Bill (1984) 'The Language of Constitutionalism: Baldwinite Conservatism', in *Formations of Nation and People*. London: Routledge.

Schwarz, Bill (1996) 'Introduction: the Expansion and Contraction of England', in Schwarz ed., *The Expansion of England: Race, Ethnicity and Cultural History*. London: Routledge.

Scruton, Roger (2000) *England: An Elegy*. London: Chatto and Windus.

Sedgwick, Eve Kosofsky (1985) *Between Men: English Literature and Male Homosocial Desire*. New York: Columbia University Press.

Seyler, Athene and Haggard, Stephen (1943) *The Craft of Comedy*. London: Frederick Muller.

Sheridan, Paul (1952) *Late and Early Joys at the Players' Theatre*. London: Boardman.

Silverstone, Roger (1994) *Television and Everyday Life*. London: Routledge.

Sinfield, Alan (1994) *The Wilde Century: Effeminacy, Oscar Wilde and the Queer Moment*. London: Cassell.

Sinfield, Alan (1999) *Out On Stage: Lesbian and Gay Theatre in the Twentieth Century*. New Haven and London: Yale University Press.

Skeggs, Beverley (1997) *Formations of Class and Gender*. London: Sage.

Skeggs, Beverley (2004) *Class, Self, Culture*. London: Routledge.

Smith, Anthony D. (1991) *National Identity*. Harmondsworth: Penguin.

Speight, Johnny (1986) *The Garnett Chronicles*. London: Robson.

Stallybrass, Peter and White, Allon (1986) *The Politics and Poetics of Transgression*. London: Methuen.

Stedman Jones, Gareth (1982) 'Working-Class Culture and Working-Class politics in London, 1870–1900: Notes on the Remaking of a Working Class', in Bernard Waites ed., *Popular Culture: Past and Present*. London: Croom Helm.

Stephen, Andrew (2001) 'Back to the Land of Leg Shackles', *New Statesman*, 30 July, 20–1.

Stokes, Jane (2000) 'Arthur Askey and the Construction of Popular Entertainment in *Band Waggon* and *Make Mine A Million*', in Justine Ashby and Andrew Higson eds, *British Cinema, Past and Present*. London: Routledge.

Stychin, Carl F. (1998) *A Nation by Rights: National Cultures, Sexual Identity Politics and the Discourse of Rights*. Philadelphia: Temple University Press.

Summerfield, Penelope (1981) 'The Effingham Arms and the Empire: Deliberate Selection in the Evolution of Music Hall in London', in Eileen Yeo and Stephen Yeo eds, *Popular Culture and Class Conflict 1590–1914: Explorations in the History of Labour and Leisure*. Brighton: Harvester.

Sutton, David (2000) *A Chorus of Raspberries: British Film Comedy 1929–39*. Exeter: University of Exeter Press.

Sypher, Wylie ed. (1956) *Comedy*. New York: Doubleday.

Taylor, Rod (1994) *The Guinness Book of Sitcoms*. London: Guinness.

Thompson, Harry (1996) *Peter Cook: A Biography*. London: Hodder and Stoughton.

Thomson, David (1994) *A Biographical Dictionary of Film*. London: Andre Deutsch.

Took, Barry (1981) *Laughter in the Air: An Informal History of Radio Comedy*. London: Robson.

Took, Barry (1992) *Star Turns: The Life and Times of Benny Hill and Frankie Howerd*. London: Weidenfeld and Nicolson.

Took, Barry (1998) *Round the Horne: The Complete and Utter History*. London: Boxtree.

Took, Barry and Feldman, Marty (1976) *The Bona Book of Julian and Sandy*. London: Robson.

Took, Barry and Coward, Mat (2000) *The Best of Round the Horne*. London: Boxtree.

Turner, Bryan S. (2001) 'Edward W. Said', in Anthony Elliott and Bryan S. Turner eds, *Profiles in Contemporary Social Theory*. London: Sage.

Turner, Daphne (1997) *Alan Bennett: In a Manner of Speaking*. London: Faber.

Tynan, Kenneth (1990) *Profiles*. London: Nick Hern.

Van Leer, David (1995) *The Queening of America: Gay Culture in Straight Society*. London: Routledge.

Vernon, James (1998) 'Border Crossings: Cornwall and the English (Imagi)nation', in Geoffrey Cubitt ed., *Imagining Nations*. Manchester: Manchester University Press.

Villiers, Sara (1990) 'Sticky Memories', *Marxism Today*. September 1990, 36–7.

Wagg, Stephen ed. (1998) *Because I Tell A Joke Or Two: Comedy, Politics and Social Difference*. London: Routledge.

Watson, Garry (2004) *The Cinema of Mike Leigh: A Sense of the Real*. London: Wallflower.

Watt, John (1939) *Radio Variety*. London: Dent.

Weight, Richard (2002) *Patriots: National Identity in Britain 1940–2000*. London: Macmillan.

West, Christopher (2000) 'Limp Wrists and Laser Guns: Male Homosexuality and Science Fiction', DPhil thesis, University of Sussex.

White, Allon (1993) ' "The Dismal Sacred Word": Academic Language and the Social Reproduction of Seriousness', in *Carnival, Hysteria and Writing: Collected Essays and Autobiography*. Oxford: Clarendon Press.

Willemen, Paul (1994) 'The National', in *Looks and Frictions: Essays in Cultural Studies and Film Theory*. London: BFI.

Wills, Clair (1989) 'Upsetting the Public: Carnival, Hysteria and Women's Texts', in Ken Hirschkop and David Shepherd eds, *Bakhtin and Cultural Theory*. Manchester: Manchester University Press.

Wilmut, Roger (1980) *From Fringe to Flying Circus: Celebrating a Unique Generation of Comedy 1960–1980*. London: Methuen.

Wilmut, Roger (1985) *Kindly Leave the Stage!: The Story of Variety 1919–1960*. London: Methuen.

Wilmut, Roger and Rosengard, Peter (1989) *Didn't You Kill My Mother-In-Law?: The Story of Alternative Comedy in Britain from the Comedy Store to Saturday Night Live*. London: Methuen.

Wilson, A.E. (1954) *East End Entertainment*. London: Arthur Barker.

Wilson, Rob and Dissayanake, Wimal eds (1996) *Global/Local: Cultural Production and the Transnational Imaginary*. Durham: Duke University Press.

Wood, Victoria (1996) *Chunky*. London: Methuen.

Wood, Victoria (1998) *Plays: 1*. London: Methuen.

Wood, Victoria (1999) *Dinnerladies: First Helpings*. London: Methuen.

Worpole, Ken (1989) 'Village School or Blackboard Jungle?', in Raphael Samuel ed., *Patriotism: The Making and Unmaking of British National Identity, Volume 3: National Fictions*. London: Routledge.

Wykes, Alan (1988 [1977]) *Saucy Seaside Postcards*. London: Bloomsbury.

Yeo, Eileen and Yeo, Stephen (1981) 'Ways of Seeing: Control and Leisure versus Class and Struggle', in Eileen Yeo and Stephen Yeo eds, *Popular Culture and Class Conflict 1590–1914: Explorations in the History of Labour and Leisure*. Brighton: Harvester.

Ziv, Avner ed. (1988) *National Styles of Humour*. New York: Greenwood.

Zizek, Slavoj (2000) 'Camp Comedy', *Sight and Sound*. April, 26–9.

Index

Absolutely Fabulous 6, 145–6
Acorn Antiques 185
Adair, Gilbert 173–5
Aherne, Caroline 150, 157–8
Akomfrah, John 33–4
Ali G 15
Anderson, Benedict 26–7, 207
Anderson, Lindsay 77
Ang, Ien 197
Ant and Dec 126–7, 204
Apte, Mahadev 12–14
Are You Being Served? 103, 113, 146
Askey, Arthur 64
Aslet, Clive 43–4, 52, 162
Aubrey, Gus 89–90, 104, 106
Austen, Jane 168, 186
Ayres, Pam 185

Bailey, Peter 65–8, 76, 82, 142, 209
Baker, Hylda 7, 64, 71, 77–82, 84, 94, 129, 131, 179, 184, 200
Bakhtin, Mikhail 13, 63, 68–71, 74–5, 97, 138, 193
Baldwin, Stanley 40–1, 43–5, 47–8, 55–6
Balibar, Etienne 27
Barbara 7
Barr, Charles 7
Barraclough, Roy 3, 6, 81
Barrett, Syd 201
Barrymore, Michael 42
Baxendale, John 50, 54
Beckett, Samuel 156, 168, 201
Bellwood, Bessie 79
Bennett, Alan 7, 59, 69, 83, 149–51, 159–69, 178, 181–2, 184, 206

Benson, E.F. 42
Betjeman, John 61, 208
Beyond the Fringe 159
Billig, Michael 27, 34–5, 195
Birds of a Feather 145
Blackadder 15
Blackpool 41–2, 47–8, 74–5, 79, 83, 89, 137–8, 149, 164, 192, 196, 201
Blackwood, Maureen 33
Blair, Tony 50, 157, 198
Bo Selecta 71, 127
Bogarde, Dirk 99
Boogaart, Pieter 44, 47
Bottom 124–5
Bowie, David 41, 104
Braben, Eddie 114–5
Brancusi, Constantin 82–3
Brand, Jo 7, 132, 180
Brassed Off 196
Bratton, J.S. 2, 4
Bread 148
Brief Encounter 42
Brighton 21–25, 35, 84, 137–8, 142
Brookside 149
Brown, Roy 'Chubby' 1, 6, 7, 13, 17, 24, 29, 54, 63, 65, 69, 139, 166, 187–203
Brunsdon, Charlotte 60
Burke, Kathy 6, 71, 109
Byng, Douglas 132

Caine, Marti 179
Calvert, Phyllis 42
Campbell, Beatrix 51–2
Camus, Albert 201
Cannon, Esma 133
Cannon and Ball 128–9
Carney, Ray 168–72, 175
Caroli, Charlie 185
Carroll, Lewis 77

Carry On films 7, 15, 17, 63, 69, 71, 76, 87, 96, 98, 102, 128–43, 164, 188, 200–1, 205–6
Carter, Angela 135
Carthy, Eliza 42
Cash, Craig 150, 157–8
Chambers, Iain 60, 196–8
Changing Rooms 153
Chaplin, Charlie 84
Chekhov, Anton 168, 170
Churchill, Winston 201
Clary, Julian 6, 11, 54, 93, 106–10, 125, 127, 132, 166, 206
Cogan, Alma 185
Colley, Linda 28
Colls, Robert 39
Connor, Kenneth 133, 141
Coogan, Steve 6
Cook, Pam 30–2
Cook, Peter 85, 124
Cooper, Tommy 15
Condor, Susan 45
Constanduros, Mabel 179
Coronation Street 42, 104, 149–50, 181, 185, 192
Coward, Noël 92, 184
Crazy Gang, the 13–14, 17, 63, 123, 201
Crick, Bernard 44–5
Cubitt, Geoffrey 27–8

Dad's Army 15, 146
Davey, Kevin 54
Davidson, Jim 38, 54, 191
Davis, Murray 9, 20
Dawson, Les 3, 6–7, 21, 64, 81–5, 94, 182, 189, 202
Dean, James 201
De Casalis, Jeanne 179
Demobbed 6, 76, 84

Desmond, Florence 73
Diana, Princess of Wales
 189–90
Dickens, Charles 168
dinnerladies 6, 69, 71–2,
 145–6, 181, 183–4, 186
Dion, Celine 29
Dodd, Ken 5–7, 17, 64, 82,
 84–6, 192–3
Dodd, Philip 39
Donald, James 28, 30, 50, 60
Douglas, Mary 193
Dreyer, Carl 168
Dreyfus, James 109
Dury, Ian 42

Eagleton, Terry 70–1
Ealing Studios 7, 10, 43,
 48–9, 73
Easthope, Anthony 36
Eco, Umberto 69–70
Eliot, T.S. 41
Ellis, John 140
English, James 14, 25
Evans, Norman 84, 94
Ever Decreasing Circles 145
Everage, Dame Edna 84
Everett, Kenny 24

Falklands War 51–2, 162–3
Fanshawe, Simon 108
Fawlty Towers 7
Featherstone, Mike 15,
 29, 32
Feldman, Marty 98
Field, Sid 5–6, 63, 90–1,
 93–5, 103, 106
Fields, Gracie 15, 41, 63,
 137–8, 164, 179, 184
Fisher, John 13, 205
Flanagan and Allen 123
Flanders and Swann 123
Forde, Florrie 179
Formby, George 7, 15, 38,
 64, 71–7, 81–2, 88–91,
 85, 107, 113, 137, 148–9,
 164, 184, 189, 200, 205
Forster, E.M. 168
Four Weddings and a
 Funeral 15
Frears, Stephen 168
French, Dawn 21–3, 49, 180
Friends 115, 122
Fry and Laurie 123
Full Monty, The 196, 208

Gallagher, Noel 35
Garland, Judy 105

Garnett, Alf 38
Gay Liberation Front 87,
 104–7
Genevieve 15
George and Mildred 145
Giddens, Anthony 194–6
Gilbert and George 81, 123
Gilliatt, Penelope 192
Gimme Gimme Gimme 6,
 71, 109
Good Old Days, The 79
Goodness Gracious Me 10, 38
Goon Show, The 7, 169
Grayson, Larry 2, 11, 87, 91,
 94, 103–7, 109, 116, 121
Great Yarmouth 24
Grenfell, Joyce 15, 179, 184

Hall, Stuart 2, 18–20, 28, 30,
 32, 56, 58
Hancock, Tony 7, 15, 98,
 100–1, 145
Hannerz, Ulf 31
Harvey, David 29–30
Hawtrey, Charles 6, 74,
 132–3, 138, 142
Hay, Will 63, 76
Heath, Edward 121
Henry, Lenny 22–3
Hepworth, Barbara 82
Hill, Benny 15, 64, 84
Hill, Harry 7
Hill, John 34, 174–5
Hinge and Bracket 124
Hird, Thora 159–60, 183
Hoggart, Richard 57, 137,
 150–2, 155, 157
Hole, Anne 70
Holloway, Stanley 15
Horsfield, Debbie 42, 197
Howe, Darcus 195
Howerd, Frankie 3, 6, 15,
 63, 88, 91, 93–8, 100,
 103–4, 106, 109
Hoy, Mikita 70
Hudson, Rock 99
Hunt, Leon 131

Iannucci, Armando 6
Ignatieff, Michael 33
Inman, John 87, 103, 109
Inspector Morse 42
Ionesco, Eugene 156, 201
It Ain't Half Hot Mum 38, 91

Jacobson, Howard 17, 84
Jacques, Hattie 132–4, 141–2
James, Sid 132–4, 138, 141

Jeancolas, Jean-Pierre 204–6
Jewell, Jimmy 80, 123
Johnson, Boris 42
Jordan, Marion 134
Joyce, Patrick 71, 74
Julien, Isaac 33
Just a Minute 101

Kaurismaki, Aki 156
Kay, Peter 7
Keating, Ronan 190
Keats, John 201
Keeping Up Appearances 145
Kelleher, Chris 150
Kift, Dagmar 65–8, 86
King, Anthony 29
Kinks, The 42
Kitt, Eartha 84
Kydd, Sam 42

Lambert, Gavin 76
Lamont, Norman 107–8
Lancashire 47, 71, 82, 89,
 159, 180
Lane, Carla 148
Langford, Paul 42
Larkin, Philip 167
Last of the Summer Wine 48–9
Last Night of the Proms 35,
 162–3
Laurel and Hardy 112, 114–6
Lee, C.P. 71–2
Leigh, Mike 7, 12, 147,
 149–50, 159–60, 165,
 167–78, 181–2, 184, 197,
 200, 206
Lejeune, C.A. 41, 43
Lewis, Roger 138–9, 142
Light, Alison, 47
Little Britain 7, 124
Lloyd, Marie 79, 179
Loach, Ken 168
Lucan, Arthur 63
Luckett, Moya 177

Major, John 41, 48, 157
Mancunian Studios 73, 75,
 80, 140
Manning, Bernard 54, 191
McGill, Donald 137
McKee, Alan 33, 206–7
Macnab, Geoffrey 189
Manzo, Kathryn 27
Matless, David 15, 47–8,
 61–2
Mast, Gerald 191
Mayall, Rik 124, 132
Mayhew, Henry 66

Melucci, Alberto 194, 197–8
Men Behaving Badly 124–5
Midwinter, Eric 77, 84, 95
Miller, Max 63, 191, 201
Milligan, Spike 7, 85,
 125, 202
Mills, Pat 180
Mind Your Language 38
Mr Blobby 71
Monty Python 7, 42, 125
Moore, Dudley 124
Morecambe and Wise 6, 16,
 63, 112–7, 122, 124–7,
 186, 200, 204
Morgan, Gladys 179
Morley, David 15
Morris, Lily 179
Morrissey 201
Mowlabocus, Sharif 198
Mulkay, Michael 4
Murray, Chic 46

Nairn, Tom 161
Nearest and Dearest 17,
 78–81, 131
Norton, Graham 108–9
Not On Your Nellie 80–2, 91
Nuttall, Jeff 65, 72–4
Nye, Simon 49, 124

Office, The 15
O'Grady, Paul 108–9
Only Fools and Horses 145
Orton, Joe 58, 102, 126, 184
Orwell, George 40–2, 48,
 51–2, 58, 137

Paddick, Hugh 98–100
Passport to Pimlico 10
Paulin, Tom 160–2, 164, 168
Paxman, Jeremy 41, 162
Pet Shop Boys 52–3
Pinter, Harold 156, 184
Pointon, Marcia 27
Potter, Dennis 170, 172–5
Powell, Enoch 36, 38,
 41, 142
Priestley, J.B. 33, 54, 61, 90,
 132–3, 137, 201
Purdie, Susan 21, 107, 117
Pym, Barbara 42

Rab C.Nesbitt 46
Randle, Frank 7, 11, 48, 64,
 71–7, 82, 89–90, 104,

129, 148–9, 166, 189,
 200–1, 205
Rattansi, Ali 50
Read, Al 7
Red Dwarf 146
Reeves and Mortimer 63,
 125–7
Reid, Beryl 179–80
Renoir, Jean 168, 170
Richards, Jeffrey 43–4, 46,
 72, 74, 132
Rising Damp 91–3, 145
Robins, Kevin 15
Round the Horne 6, 17, 87,
 98–102, 104, 107
Routledge, Patricia 159–61,
 183
Royle Family, The 7, 71, 83,
 144–58, 166, 171, 200
Russell, Dave 38, 65
Rutherford, Jonathan 15, 50,
 52, 55
Rutherford, Lois 76, 192

Said, Edward 32
Samuel, Raphael 4, 15, 198
Saunders, Jennifer 22, 180
Schwarz, Bill 57
Scruton, Roger 43, 52–3
Seabrook, Jeremy 50
Sedgwick, Eve Kosofsky 117
Shakespeare, William 10, 16,
 46, 168
Silverstone, Roger 196
Sims, Joan 133–4
Sinfield, Alan 89, 100, 108
Skeggs, Beverley 71
Smith, Liz 149, 159
Smith, Maggie 3, 6, 166
Spice Girls 35
Steadman, Alison 170, 172,
 175–6
Stedman Jones, Gareth 64–5
Steptoe and Son 91–3, 145–6
Stychin, Carl 28
Summerfield, Penny 64–5

Talking Heads 160–1,
 165–6, 168
Tarri, Suzette 179
Tate, Catherine 7
Territories 35
Terry and Julian 107, 125
Terry and June 145–6
Thatcher, Margaret 36, 51–2,
 148, 162–3, 174–6,
 196, 198

Thompson, E.P. 57
Took, Barry 98
Turharpuro, Uuno 206
Turner, Bryan S. 32
Turner, Daphne 163
Turner, Joan 179
Tynan, Kenneth 5, 177

Ulyatt, Phil 72, 141
Up Pompeii 87, 94, 96

Vicar of Dibley, The 49
Victim 119
Viz 13, 71

Wallace, Nellie 63, 179
Walters, Julie 71, 159,
 183, 185
Warhol, Andy 77
Waters, Elsie and Doris
 179–80
Watson, Garry 168–70, 172
*Whatever Happened to the
 Likely Lads?* 6, 112,
 117–123, 125, 127,
 206
White, Allon, 16–18, 35
Whitfield, June 108, 133
*Who Wants To Be A
 Millionaire?* 157, 192
Wigan 42, 47, 71, 84
Wilde, Oscar 56, 89–93
Williams, Kenneth 11,
 88, 93, 96–103, 106–7,
 109, 133–4, 138,
 141, 182
Williams, Raymond 57
Willemen, Paul 33–5, 53
Wilton, Robb 15, 63
Windsor, Barbara 131–3
Wisdom, Norman 63, 71,
 90, 95, 206
Wood, Victoria 7, 48, 63,
 66–7, 72, 145, 159–60,
 165, 169, 178–86, 200,
 207–8
Woolf, Virginia 79
Wyatt, Robert 42

Yes, Minister 4
York, Peter 176
Yorkshire 47–8, 159, 161,
 164, 208

Zizek, Slavoj 71, 169

Lightning Source UK Ltd.
Milton Keynes UK
UKOW021211250112

186023UK00001B/37/P